The Portrayal of Love

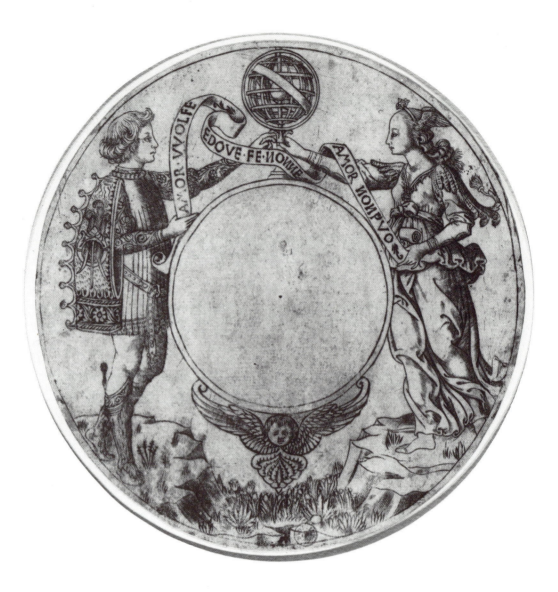

The
Portrayal
OF
Love

Botticelli's *Primavera* and
Humanist Culture at the Time of
Lorenzo the Magnificent

BY

CHARLES DEMPSEY

PRINCETON
UNIVERSITY PRESS

Published with the assistance of the Getty Grant Program

Library of Congress Cataloging-in-Publication Data
Dempsey, Charles.
The portrayal of love : Botticelli's Primavera and humanist culture at the time of
Lorenzo the Magnificent / by Charles Dempsey.
p. cm.
Includes index.
ISBN 0-691-03207-6 (CL)
1. Arts, Italian. 2. Arts, Renaissance—Italy. 3. Love in art. 4. Botticelli, Sandro,
1444 or 5-1510. Spring. 5. Ut pictura poesis (Aesthetics) I. Title.
NX552.A1D46 1992 759.5—dc20 92-3056

This book has been composed in Linotron Bembo

Princeton University Press books are printed on acid-free paper,
and meet the guidelines for permanence and durability of the
Committee on Production Guidelines for Book Longevity of the
Council on Library Resources

Printed in the United States of America by Princeton University Press,
Princeton, New Jersey

10 9 8 7 6 5 4 3 2 1

10 9 8 7 6 5 4 3 2 1
(pbk.)

Designed by Laury A. Egan

FOR ELIZABETH CROPPER

CONTENTS

LIST OF ILLUSTRATIONS

Primavera (color plates)

Plate 1. Sandro Botticelli, *Primavera*. Florence, Uffizi. Photo: SCALA/ART RESOURCE, NY. K 105284.

Plate 2. Detail of plate 1, *Primavera*, right-hand side: Venus, Flora, Chloris, and Zephyr.

Plate 3. Detail of plate 1, *Primavera*, left-hand side: Venus, the Graces, and Mercury.

Plate 4. Detail of plate 1, *Primavera*: Chloris's head.

Plate 5. Detail of plate 1, *Primavera*: Flora.

Plate 6. Detail of plate 1, *Primavera:* Venus.

Plate 7. Detail of plate 1, *Primavera*: Cupid.

Plate 8. Detail of plate 1, *Primavera*: the Graces.

Plate 9. Detail of plate 1, *Primavera*: Mercury.

Plate 10. Detail of plate 1, *Primavera*: Mercury's caduceus dispersing the clouds.

Plate 11. Detail of plate 1, *Primavera*: Mercury's boots with swirling seed clusters.

Plate 12. Detail of plate 1, *Primavera*: Mercury's *harpe*.

Plate 13. Detail of plate 1, *Primavera*: the Graces (upper half).

Plate 14. Detail of plate 1, *Primavera*: Flora's head.

Plate 15. Detail of plate 1, *Primavera*: Venus's head.

Plate 16. Detail of plate 1, *Primavera*: Mercury's head.

Comparanda (black-and-white figures)

Frontispiece. Anonymous. *Youth and Nymph* (Otto print). See figure 17.

Figure 1. Anonymous, *Deathbed Scene*. Woodcut illustration from Girolamo Savonarola, *Predica dell'arte del bene morire*, Florence, 1496–1497. Photo: James T. Van Rensselaer.

ACKNOWLEDGMENTS

THIS BOOK was written for the most part during leaves of absence from Bryn Mawr College and the Johns Hopkins University that I spent at the Harvard Center for Renaissance Studies at Villa I Tatti in Florence, at the Institute for Advanced Study in Princeton, and at the Charles S. Singleton Center for Italian Studies of the Johns Hopkins University at Villa Spelman in Florence. In their different but complementary ways, each of these institutions perfectly fulfilled its individual mission as a home for creative research and writing, and I am deeply grateful to them, to their respective directors and staffs, and to the many friends I made in the course of my work under their beneficent auspices. I am also grateful to them and to Bryn Mawr and Johns Hopkins for material assistance in the form of fellowships, research support, and replaced salary, as well as to the National Endowment for the Humanities for a Senior Research Fellowship.

Chapter 3 was first presented as the Eric Cochrane Lecture in Renaissance History at the University of Chicago, providing a lively audience and an occasion I remember with affection, and for which I would especially like to thank Julius Kirshner and Lydia Cochrane. Chapter 1 incorporates, in considerably revised form, material originally published in the *Journal of the Warburg and Courtauld Institutes* for 1968 and 1972. My thanks go to the editors for permission to integrate this material into the argument of this book, as well as to Elizabeth McGrath, Keeper of Photographs at the Warburg Institute, for her help in acquiring several illustrations. I am grateful to Carl Brandon Strehlke for his help in prizing loose one important photograph, and I am especially indebted to Macie Hall, Curator of Art History at Johns Hopkins, who took general responsibility for sending away for photographs and arranging for permission to reproduce them. It has been a pleasure working with the editors at Princeton University Press, and I would like to express special gratitude to Elizabeth Powers, Timothy Wardell, and to my copyeditor, Jane Lincoln Taylor.

Over many years colleagues, students, and friends have helped in manifold ways, and though I cannot name them individually here I want them all to be assured of my gratitude. In particular, I single out a few without whose friendship and support this book could not have been completed in its present form. I owe special debts, different in kind and unrepayable, to the friendship of Richard Longaker, the former provost of Johns Hopkins, to the encouragement of the late Charles Singleton, and to the unflagging goodwill of Michael Fried. Herbert Kessler, Carol Mattusch, and Richard Mason each read versions of the manuscript and provided support and guidance when it was most needed. David Quint, Hellmut Wohl, and Arthur Field gave

me the special benefits of their knowledge of Renaissance Florence and their intellectual taste as readers, and I am more grateful for their painstakingly helpful criticism and magnanimity than I can adequately say. My greatest debt is to the unfailing generosity, encouragement, and companionship of Elizabeth Cropper, to whom this book, which is about love, is dedicated.

The Portrayal of Love

INTRODUCTION

"MUCH has been said with regard to the *Primavera*, and much of it is untrue." So wrote Raimond van Marle in the twelfth volume, published in 1931, of *The Development of the Italian Schools of Painting*.[1] Much more has been said since, and yet there are many who would still agree, despite—or perhaps even because of—the high quality of thought and writing that have been devoted to the painting. So excellent and so important has this been that to trace one's way through the bibliography devoted to the *Primavera* is in a significant way to outline the historiography of the study of Renaissance art, and even in a broad sense the history of art itself during the past century. And yet, if scholars of the stature of Aby Warburg, Edgar Wind, Pierre Francastel, Erwin Panofsky, and others of comparable distinction may be found to disagree in the accounts each has given of Botticelli's imagery and its historical context, then casual students of the painting and its period may well wonder whether our understanding has been advanced, and whether some new hypothesis, as yet untried, might fruitfully be put forward. Indeed, more than one recent writer has complained that the painting has become obscured by accumulated interpretive veils, like so many layers of old varnish, so that direct access to its physical and conceptual beauty is impeded by a dark and confused web of mutually contradictory preconceptions. One of the most recent writers, Ronald Lightbown, has gone so far as to suggest that if we look at the painting afresh, and carefully describe what we see, then many of the problems imposed on it by a large and complex interpretive literature might simply resolve themselves.[2] Fortunately for his interpretation, Lightbown instead relied extensively on the work of earlier scholars, all of whom had themselves, needless to say, looked at the *Primavera* freshly, and very closely too. But the sense of frustration he felt in the face of so many rival interpretations, among which understanding had seemed to become mired in the contingencies of methodological preference, is one of long standing. As Ernst Gombrich wrote in his well-known study of Botticelli's mythologies, "Anyone interested in problems of method can do no better than study the conflicting interpretations of the *Primavera* and the discussions which centred round them."[3]

Except as otherwise noted, translations of quoted passages are mine; for classics, I have generally followed the Loeb Classical Library editions, with occasional minor revisions.

[1] R. van Marle, *The Development of the Italian Schools of Painting*, The Hague, 1923–1938, XII, p. 76.

[2] R. Lightbown, *Sandro Botticelli*, London, 1978, I, pp. 69–81 (republished as *Sandro Botticelli: Life and Work*, London, 1989, pp. 114–145).

[3] E. H. Gombrich, "Botticelli's Mythologies: A Study in the Neoplatonic Symbolism of His Circle," in *Symbolic Images: Studies in the Art of the Renaissance*,

The Gordian knot is not so easily cut. The problems of the whole of the accumulated literature devoted to the *Primavera* are much the same as the problems of the *Primavera* itself; as things now stand, an understanding of the literature must go hand in hand with renewed investigation of the painting. Because the question of the literature has largely been begged, it having been reduced merely to a perception of rival hypotheses in mutually exclusive conflict, no true controversy can be said to exist regarding the *Primavera*. Different interpretations instead stand in oddly disjunctive relation to one another, appearing to have almost no common ground, so that choice among them becomes virtually a matter of individual taste. There being no true controversy but only "conflicting interpretations," it has come about that we are in danger of losing sight of the very materials necessary for raising our understanding. As the humanist Lorenzo Valla put it, "Truth is knowledge of the matter of controversy, and falsity is indeed lack of knowledge of the same thing."[4] We now possess not one *Primavera* but many. Simply to look at the painting afresh will not help us in this situation, for the only possible result would be to create yet another *Primavera*.

The state of the question, in other words, is not now very well understood, and to grasp it requires an appreciation of the considerable contributions to knowledge that have been made since Warburg wrote the first serious study of the *Primavera* a century ago.[5] These contributions have greatly added to what may now be safely assumed to be known about Botticelli's painting, and they will naturally be incorporated in their place in the pages that follow. There I hope to show, among other things, that the many "conflicting interpretations" of the *Primavera* are not necessarily in genuine conflict at all, that in fact each of the serious interpretations of the painting responds in its own way to a valid perception of Botticelli's imagery, and that of the much that has been said about the picture, van Marle to the contrary notwithstanding, much should be accepted as probably true. Although there have indeed been many interpretations of the *Primavera*, there has been remarkably little true methodological debate in the literature devoted to the painting. Differences among scholars have grown up around matters of emphasis and detail, and disputes have arisen more at the technical than at the methodological level. Indeed, for more than a century scholars have sought to contextualize the painting in one or another of three ways, each of which was anticipated by Warburg.

These contexts are: (1) the humanist study and cultivation of ancient and vernacular poetry, centered on the figure of Politian and the poets closely associated with Lorenzo de'Medici and members of his near family; (2) the Neoplatonic philos-

London, 1972, pp. 31–81, esp. p. 37 (first published in the *Journal of the Warburg and Courtauld Institutes*, VIII, 1945, pp. 7–60).

[4] L. Valla, *Repastinatio dialectice et philosophie*, ed. G. Zippel, Padua, 1982, II, p. 378. Valla is here merely repeating a philosophical and methodological commonplace, one later invoked, for example, by Lessing in the opening paragraphs of *How the Ancients Represented Death*.

[5] A. Warburg, *Sandro Botticellis "Geburt der Venus" und "Frühling"* (first published in 1893), in *Gesammelte Schriften: Die Erneuerung der heidnischen Antike*, ed. G. Bing, Leipzig and Berlin, 1932, I, pp. 5–68 and 307–328; published in Italian translation as "La 'Nascita di Venere' e la 'Primavera' di Sandro Botticelli," in *La rinascita del paganesimo antico: Contributi alla storia della cultura*, ed. G. Bing, Florence, 1966, pp. 1–58.

ophy of Ficino and his followers, also intimately associated with Lorenzo and Medicean patronage; and (3) the civic festivals, such as that of the Calendimaggio, and public celebrations, such as the jousts sponsored and taken part in by Lorenzo and other members of his family and *brigata*, to which may be added the scarcely less public celebration of Medici marriages. Clearly, the three contexts substantially overlap, and they have in common a perception of the *Primavera* as a capital manifestation of Florentine humanist culture under the leadership and sponsorship of Lorenzo de'Medici. Moreover, because of its very early date as a painting of monumental size (about ten feet long by six and a half feet high) that takes as its subject the gods and goddesses of antiquity, and because of the ambience in which it was painted, close to the person of the Magnificent himself, it occupies a critical place in that tradition—a perception that has escaped no interpreter of its imagery. Whether understood in the context of civic celebrations and weddings, or as a Neoplatonic meditation on beauty or *humanitas*, or as a myth of the springtime replete with evocations of a rich poetic tradition, the *Primavera* has also been understood to be a touchstone to an expanded knowledge of the new humanist culture sponsored, and to a large part guided, by Lorenzo. For this reason, interpreters of its imagery have of necessity, implicitly or explicitly, built into their exegeses their own theories of the Renaissance. The true controversy of the *Primavera* revolves around this question of the Renaissance, and raises issues that are quite distinct from merely iconographical disputes. This is especially true insofar as iconographical studies are narrowly conceived as efforts to establish textual "sources" only (an activity falsely identified with Warburg's method in recent art-historical writing), rather than as the deployment of true philological methods. However, since the state of the question as it exists today entails coming to grips with the material that has been contested by iconographical interpreters, any renewed investigation of the *Primavera* must begin with that material and the special problems it poses.

There are at present two dominant hypotheses claiming to explain the phenomena appearing in Botticelli's picture. The first hypothesis, maintained with varying emphases by Warburg, Francastel, and me, holds that the appearances of the ancient gods shown by Botticelli may be explained by recourse to the characterization of them given in ancient poetry known by humanists close to Lorenzo de'Medici, Politian in particular, and imitated by them in their poetry, both in Latin and in the vernacular.[6] Moreover, all serious scholars of the *Primavera* (by whom I mean those who are fully cognizant of the philological issues), with the single and notable exception of Gombrich, have taken Warburg's remarkable demonstration of this hypoth-

[6] Ibid.; P. Francastel, "La fête mythologique au Quattrocento: Expression littéraire et visualisation plastique," in *Oeuvres II: La réalité figurative: Éléments structurels de sociologie et de l'art*, Paris, 1965, pp. 229–252, and idem, "Un mythe poétique et social du Quattrocento: La Primavera," ibid., pp. 253–266 (first published, respectively, in *Revue d'esthétique*, VI, 1952, pp. 376–410, and, under the title "Un mito poetico y social

del Quattrocento: La Primavera," in *La torre: Revista general de la Universidad de Puerto Rico*, V, 1957, pp. 23–41); C. Dempsey, "*Mercurius Ver*: The Sources of Botticelli's *Primavera*," *Journal of the Warburg and Courtauld Institutes*, XXXI, 1968, pp. 251–273; see also idem, "Botticelli's Three Graces," ibid., XXXIV, 1971, pp. 326–330.

esis as their own point of departure. As Pierre Francastel, for example, observed, "La comparaison fondamentale est celle des *Sylves* et des *Stances* de Politien avec le fameux *Printemps* de Botticelli."[7] Edgar Wind agreed, writing that "for some time there has been among historians of art a remarkable unanimity about the literary sources relevant to Botticelli's *Primavera* and *Birth of Venus*. . . . Botticelli's poetical trappings are unmistakably indebted to Politian's muse and to those ancient poems (particularly the Homeric Hymns, Horace's Odes, and Ovid's *Fasti*) with which Politian and Ficino had made him conversant."[8] Erwin Panofsky added, "We may thus accept Politian's *Giostra*, supplemented by his *Sylvae*, and the classical sources of both, as the 'basic text' of Botticelli's *Primavera*."[9]

The second hypothesis, championed with varying emphases by Gombrich, Wind, and Panofsky, is the Neoplatonic model. As the quotations in the previous paragraph suggest, it is a hypothesis that depends on the first, and seeks to incorporate Warburg's poetic model by maintaining that neither the classical texts alone, nor the Renaissance poems they inspired, are sufficient to account for Botticelli's invention. It therefore becomes necessary to summon forth the Neoplatonic doctrines of Ficino and his immediate followers in order to explain the phenomena appearing in the painting. Wind expressed the reason for this most succinctly: "In none of these cases do the parallels [between Politian's poetry, its ancient sources, and Botticelli's *Primavera* and *Birth of Venus*] extend beyond single traits or episodes. They establish a connexion of mood and taste, and a community of literary interests, but they do not explain the programme of the painting."[10] In other words, ancient and humanist poetry could account for the figures and the setting depicted in the *Primavera*, but did not seem able to explain them systematically, establishing a coherent pattern of thought and sensibility underlying them and uniting them generically and expressively.

It might be suggested at once that there is a prima facie case for regarding this second, Neoplatonic hypothesis with caution, in part because of the unexamined assumption that a painting such as the *Primavera* must have been conceived on the basis of some "programme" (Wind) or "basic text" (Panofsky). Both terms imply a passive adoption on the part of the painter of a kind of syllabus that had been handed down to him, which would deny him his own proper interpretive role based on an active and sympathetic engagement with the values of the very poetry to which it has been agreed he is giving pictorial expression. On a more fundamental level, however, the Neoplatonic model as it has thus far been conceived has not been sufficiently integrated with the poetic traditions that its proponents acknowledge to be the starting point for Botticelli's invention. Rather than growing naturally out of the poetry, Neoplatonic readings instead have been artificially superimposed on it, or even viewed as contradictions of the poetic model altogether, with the result that conjecture quickly parts company with the phenomena actually appearing in the *Pri-*

[7] Francastel, "Fête mythologique," op. cit., p. 240.

[8] E. Wind, *Pagan Mysteries in the Renaissance*, New Haven, 1958, pp. 100–120, esp. p. 100.

[9] E. Panofsky, *Renaissance and Renascences in Western Art*, Uppsala, 1960, pp. 191–200, esp. p. 194.

[10] Wind, op. cit., pp. 100f.

6

mavera. Panofsky was clearly aware of the interpretive dilemma that had thus been created when he wrote that, even though he agreed that Politian's poetry and its classical sources provided the fundamental rationale for Botticelli's imagery, he was nevertheless prepared to conjecture freely and admit "any number of such [Neoplatonic] metaliteral interpretations, even of an apparently contradictory nature, as we see fit"—adding the disclaimer that he was "not forgetful of the fact that, in the words of Henry James, the 'loyal entertainer' of a 'happy thought' is 'terribly at the mercy of his own mind.' "[11] Gombrich was also explicitly aware of the same dilemma, which had attained near interpretive impasse with the passage of time, when he wrote, "One methodological rule, at any rate, should stand out in this game of unriddling the past. However daring may be our conjectures—and who would want to restrain the bold?—no such conjectures should ever be used as a stepping stone for yet another, still bolder hypothesis."[12] Because of this, he added, his own "interpretation of Botticelli's mythologies in the light of Neo-Platonic philosophy remains so conjectural that it should certainly not be quoted in evidence for any further Neo-Platonic hypothesis that could not stand on its own feet." As it used to be written on certain jars containing strong medicines in the old pharmacies (which Panofsky himself was fond of quoting), *Cautius*.

If we were to choose now among the various readings of the *Primavera* positing a Neoplatonic model (which naturally differ among themselves), Wind's certainly deserves primacy. Panofsky's interpretation depended on the assumption that the *Primavera* and the *Birth of Venus* were painted for the same Medici villa at Castello and for the same patron, Lorenzo di Pierfrancesco de'Medici, the second cousin and ward of Lorenzo the Magnificent. He argued that the paintings were a pair, forming what André Chastel had called "une sorte de diptyque," and that they hence bore a programmatic relationship to each other, the *Primavera* representing Natural Venus and the *Birth of Venus* showing Celestial Venus. However, as I shall argue in chapter 1, recent research has shown this to be impossible, insofar as it is now certain that neither painting was commissioned for Castello, and it is moreover likely that the *Birth of Venus* was not even a Medici commission.

Gombrich's earlier interpretation, which Wind, Francastel, and Panofsky have all criticized with great acuity, was seriously imperiled by his disregard for Warburg's discussion of the role played by Politian and ancient poetry in the invention of the *Primavera*, while the classical and Renaissance texts he put forward instead (though acknowledging by their very presence the primacy of the philological methods employed to great effect by Warburg), unlike those that Warburg had earlier advanced, bore no relationship to one another or to the imagery of the *Primavera*. It has always been difficult to see, for example, the relevance to Botticelli's portrayal of Venus, the three Graces, and Mercury of Apuleius's obscene account of an ass watching a strip-tease performance in which three women reenact the Judgment of Paris. This proposal, which encouraged Mirella Levi d'Ancona to make the further suggestion that

[11] Panofsky, op. cit., p. 194.

[12] Gombrich, op. cit., pp. 21f.

Botticelli initially intended to paint a *Judgment of Paris*,[13] is especially difficult to follow when, as Panofsky pointed out in criticizing Gombrich's use of Apuleius on philological grounds, it further depends on a presumptive misreading of the text by a humanist of the Medici household. Nor is the direct relevance to the painting of a letter written by Marsilio Ficino to the young Lorenzo di Pierfrancesco de'Medici at all clear, either as an explanation of the role of Venus in the painting or as it relates to Apuleius's very different text. Ficino's purpose was to explain Lorenzo's horoscope, telling him the moon was in favorable aspect to the sun, Venus, Jupiter, and Mercury and not in bad aspect to Mars and Saturn. This in turn suggested the possibility of an astrological reading of the *Primavera* to Levi d'Ancona and Janet Cox-Rearick,[14] despite the absence of the sun, moon, Mars, Saturn, and Jupiter from the painting, even though their presence would seem to be required if Botticelli really intended to refer to the planetary virtues affecting the star chart of Lorenzo. Warburg's and Fritz Saxl's celebrated studies of the frescoes in the Palazzo Schifanoia and in the Farnesina indicate clearly, on the other hand, that when astrological meaning is intended the imagery of the paintings points to this quite openly.[15]

Gombrich has conceded the point, writing that "it was not on these texts that I rested my proposal but on the reconstruction of a historical situation," adding that "it seems to me that an iconological analysis should not be confined to the search for textual sources."[16] No one had ever claimed it was, least of all Warburg, whose philological research went hand in hand with many hours in the archives, and who was profoundly inspired by the desire to understand historical situations in all their cultural and social complexity. Indeed, serious students of the *Primavera* have set themselves the same goal Warburg did when he acknowledged that though his work might seem erudite and complex to some, he had always been guided by the words of his teacher, Justi, who said that "erudition must only be the discovery of the point of view from which the work of art was made in the past."[17] The straw man named

[13] M. Levi d'Ancona, *Botticelli's Primavera: A Botanical Interpretation Including Astrology, Alchemy, and the Medici*, Florence, 1983.

[14] J. Cox-Rearick, *Dynasty and Destiny in Medici Art*, Princeton, 1984.

[15] A. Warburg, "Arte italiana e astrologia internazionale nel Palazzo Schifanoja di Ferrara," in *La rinascita del paganesimo antico*, ed. cit., pp. 247–272; F. Saxl, *La fede astrologica di Agostino Chigi: Interpretazione dei dipinti di Baldassare Peruzzi nella Sala di Galatea della Farnesina*, Rome, 1934.

[16] Gombrich, op. cit., p. 33.

[17] A. Warburg, "L'ingresso dello stile ideale anticheggiante nella pittura del primo rinascimento," in *La rinascita del paganesimo antico*, ed. cit., pp. 283–307, esp. p. 307. As Felix Gilbert wrote of Warburg in an excellent essay, written in response to the publication of E. H. Gombrich, *Aby Warburg: An Intellectual Biography*, London, 1970, "Probably his most important influence on Renaissance scholarship has been the spur which he gave to the careful and detailed investigation of interrelationships. . . . [T]he manner in which Warburg saw the complexity of interrelationships between the various fields of Renaissance life— economic, social, intellectual, religious, political—was new and proved to be extremely fruitful." This scarcely corresponds to a view of Warburg and his followers as scholars "confined to the search for textual sources." Indeed, as Gilbert further observed of the implications of Warburg's work, "it might be said that it was inevitable in the course of events that scholarship would turn to research in the economic and social developments of the Renaissance." See F. Gilbert, *History: Choice and Commitment*, Cambridge, Mass., and London, 1977, pp. 423–439, esp. pp. 438f. (originally published in *Journal of Modern History*, XLIV, 1972, pp. 381–391).

"iconological analysis" by Gombrich is a caricature of the philological method (which is historical to the core) fundamental to such recovery: if the particular texts adduced are not the basis on which his proposal rests then we can have little faith in the reconstruction of the historical or cultural situation that follows. Rather than building on the rather considerable amount of fruitful work already done by his predecessors, or seeking to integrate knowledge previously acquired with the premises of his own argument in order to arrive at a more precise understanding of the relationship between painter and humanist, Gombrich instead assembled random alternative quotations and images without demonstrating any underlying unity that connected them either to the *Primavera* or to each other. As Wind rightly observed when criticizing the resulting lack of generic unity in Gombrich's reading, "In dealing with philosophical propositions, enumeration is not a substitute for analysis. . . . The resulting aggregate of Neoplatonic quotations, unrelated to their formative principle, amounts to an error of description like mistaking a vertebrate for a jellyfish."[18]

Only Wind, in fact, undertook a reading of the *Primavera* that tried to prove the Neoplatonic model in a way that possessed generic consistency and that took into account all the phenomena appearing in the painting itself. His philological technique was impressive, and his philosophical equipment easily the most sophisticated of all possessed by the various interpreters of the painting. It is to Wind that we are indebted for one essential perception (itself not specifically Neoplatonic), which is that the group appearing at the right of the painting represents, on the principle of an Ovidian metamorphosis, the transformation of Chloris into Flora. This discovery rendered null a problem that had perplexed earlier writers—which of the two nymphs shown actually was Flora—and it also established the essential way in which Botticelli's gloss of Ovid's *Fasti* to Lucretius's description of the springtime gods transformed the meaning inherent in both poems and gave the group as a whole its own, new meaning and character. Nevertheless, despite the sharp light this cast on the creative way in which Botticelli adapted his poetic models, Wind and (later) Panofsky were both encouraged to propose a Neoplatonic interpretation because of two apparent anomalies in the painting that did not otherwise seem easily susceptible of explanation. The first of these was the presence of Mercury, who had no known connection with the season of spring and hence seemed out of place in the company of otherwise perfectly conventional gods of the season. The second, due in large part to Mercury's unexplained presence, was the apparent impossibility of deriving any conceptual or narrative coherence either from the appearances of the gods as they are shown in the painting or from the various ancient texts motivating their presence and actions.

However, in an article published in 1968 I was able to show that both anomalies are more apparent than real. In remotest antiquity Mercury was in fact a god of the spring and was so designated in the ancient agrarian calendar; moreover, his appearance together with the clothed Graces and Venus can be explained with reference to

[18] Wind, op. cit., p. 101.

9

the material of the *Scriptores rerum rusticarum*.[19] The presence and behavior of Mercury, in other words, could be accounted for by the poetic model alone, without the need for additional recourse to the Neoplatonic hypothesis. This demonstration in turn provides a conceptual coherence motivating the appearance and actions of the ancient gods shown in the *Primavera*, while at the same time pointing toward a genre for it, which may be identified as a form of *carmen rusticum*. The evidence in support of this is set forth in chapter 1.

If it be understood that the poetic models informing the invention of Botticelli's *Primavera* define it as a species of rustic song, then it becomes evident that the Neoplatonic hypothesis as it has thus far been conceived is misplaced. It is not misplaced, however, insofar as the possibility and even the likelihood of Neoplatonic content inhering in Botticelli's imagery is concerned (and an argument for this is put forward in chapter 5). But it has certainly been misplaced insofar as it presupposes the necessity for superimposing a philosophical genre on the poetic, rather than as discovering Neoplatonic content emerging from the poetry itself. Once it has been shown that there is a generic consistency uniting the *materia* derived from the primary ancient texts motivating the "traits and episodes" shown in the *Primavera*, the justification collapses for turning to additional texts that alter the meaning inherent in those poetic models that throughout the past century have been agreed upon as fundamental. It was, after all, the apparent absence of such generic consistency, not disagreement with the relevance of the ancient texts per se, that led Wind to "dare to propose" a solution positing a philosophical genre. However, once it appears that the *materia* deriving from those texts is the same as the *materia* of the *Scriptores rerum rusticarum*, thereby accounting for the phenomena of the gods and their interrelationships as represented in the *Primavera* on the basis of ancient poetic traditions alone, then the reason for appending to this a Neoplatonic genre vanishes. To assume the Neoplatonic hypothesis is in effect to deny the poetic conception on which it actually depends as a hypothesis, for to adopt it as it has thus far been conceived and argued has meant supposing that the painting conforms to a genre other than that indicated by the primary ancient texts on which scholars have all but universally agreed Botticelli's invention is based.

Thus Wind argues, for example, that "in the guise of an Ovidian fable, the progression Zephyr-Chloris-Flora spells out the familiar dialectic of love: *Pulchritudo* arises from a *discordia-concors* between *Castitas* and *Amor*."[20] But surely it is more likely that the Ovidian fable, which is derived from the *Fasti*, a poem celebrating the feasts of the Roman calendar and their rustic origins, is in no guise at all, and that its meaning as an explanation of the ancient spring festival of the Floralia is integral to the meaning of a painting depicting Flora and her companions that Vasari described as denoting the springtime.[21] Similarly, while it is true that other ancient and Renaissance texts could be appended to Horace's and Seneca's unique descriptions of Mer-

[19] Dempsey, op. cit., 1968.

[20] Wind, op. cit., p. 103.

[21] G. Vasari, *Le vite de' più eccellenti pittori, scultori ed architetti moderni*, ed. G. Milanesi, Florence, 1906, III, p. 312 ("Venere . . . dinotando la Primavera").

cury together with the clothed and dancing Graces, in order to show that the clouds dispelled by Mercury's caduceus are metaphorical mists that obscure the reason, and that the Graces endow the mind and soul thus clarified with the gifts of pure love and beauty, it is surely more likely, once we know that the Mercury described by Horace and Seneca is the fertile wind god of ancient Mays, and the Graces who accompany him the spirits of the earth's liberality, that it is as gods of the season that they appear in the *Primavera*. When Peter Paul Rubens, in his allegory of the *Education of Marie de'Medici*, painted nearly a century and a half later, showed Mercury waving his caduceus in front of the young princess's cloudless brow, together with the nude Graces standing in attendance on her as she studies philosophy at the feet of Minerva, he left us in no doubt of the Platonic content of his allegory, especially since he did not omit to place a bust of Plato himself in the foreground of the painting.[22] Wind's masterful treatment of the theme of Mercury and the Graces indeed perfectly illuminates the invention of Rubens's painting, even as it delicately obscures Botticelli's. For the nude Graces shown by Rubens, and their companionship with Mercury, as Wind demonstrated so well, descend from a quite different and later ancient tradition than do the clothed and dancing Graces described by Horace and Seneca.[23] The former may indeed stand as a symbol for love, inviting Neoplatonic meditations, while the latter are not Neoplatonic at all. They derive instead (as Wind showed) from Seneca's discussion of a Stoic exemplum of liberality that Chrysippus and Hecaton— as Politian also observed in his comments to Statius's *Sylvae*—had been the first to define philosophically on the basis of the ancient nature goddesses of the spring that the Graces originally were.[24] Even earlier than Politian, Leon Battista Alberti was already aware of this meaning when he described the Graces on the basis of Seneca (whom he did not specifically cite), identifying them correctly with the primitive goddesses sung by Hesiod; Alberti thus based his conception of them directly in the context of georgic poetry, and avoided any appeal to Neoplatonism.[25]

As I noted at the outset, there have been those who have complained that access to the physical and conceptual beauty of the *Primavera* has actually been impeded rather than eased by the complexity and density of the interpretive literature devoted to it; and there have been some who have recoiled from such attempts to interpret Botticelli's painting, and to understand it in its own cultural context, on the grounds that the very acts of interpretation and historical reconstruction are difficult and often seem to imply an implausibly high degree of learning on the part of the artist. But the proposition I have thus far set forth is a simple one, which is that a painting

[22] S. Saward, *The Golden Age of Marie de'Medici* (UMI Research Press Studies in Baroque Art History, 2), Ann Arbor, Mich., 1982, pp. 40–51.

[23] Wind, op. cit., pp. 31–38; see also Dempsey, op. cit., 1971. The locus classicus for the later antique tradition whereby the Graces are shown nude and standing still appears in Servius, *In Vergilii Aeneidem*, 1.720.

[24] See A. Poliziano, *Commento inedito alle Selve di Stazio*, ed. L. Cesarini Martinelli, Florence, 1978, pp.

205f.

[25] L. B. Alberti, *De pictura*, 54 (in L. B. Alberti, *On Painting and On Sculpture: The Latin Texts of De Pictura and De Statua*, ed. C. Grayson, London, 1972, p. 96). Politian's characterization of the Graces on the basis of Seneca (*Commento inedito*, ed. cit., pp. 201ff.) treats of the origins and attributes of the Graces as nature goddesses, and also without Neoplatonic interpolations.

entitled *Primavera*—the springtime—in which the ancient gods of the springtime are represented derives its imagery from ancient characterizations and poetic evocations of these selfsame spirits of the eternally regenerative spring. Complexity arises when we try to understand the *Primavera* and these ancient texts not only in themselves but also in the context of a humanist culture at half a millennium's remove from our own. We must be careful not to confuse, as is all too often done, the complexity of philological and historical argumentation required to penetrate this distant culture with the simplicity of this hypothesis. Van Marle, for example, expressed an all-too-typical sentiment (first appearing in Gustav Pauli's review of Warburg's thesis) when he disdainfully wrote that "with much more erudition than Botticelli certainly ever possessed, the late Professor Warburg has gone deeply into the question as to what passages might have inspired our artist."[26] With all due respect to van Marle, whose own quite differently deployed erudition was extensive, this is otiose, as is especially evident in the sentences that immediately follow, in which he concedes that Warburg was right to identify the context of the *Primavera* with humanist literary culture and the revival of ancient letters, with all this entails regarding the relevance of philological investigation to the understanding of the painting. Warburg's formidable erudition was of course directed, not to demonstrating that Botticelli was his scholarly alter ego, but to attempting to understand—he had hoped in the spirit of Justi—the *Primavera* in its own critical, historical, and cultural context.

This context included not only the recovery of the poetry and literature of the ancients but also its assimilation into the forms and traditions of a rich vernacular heritage that had descended directly from Dante, Petrarch, and Boccaccio, and which was undergoing a progressively more profound transformation in the poetry of the Pulci brothers, Lorenzo the Magnificent himself, and Angelo Poliziano—Politian. Lorenzo's stated aim in actively promoting cultivation of the vernacular together with the ancient languages was thereby to transform it on lines identical to those advocated by his teacher Cristoforo Landino in the prolusion to his lectures on Petrarch's *Canzoniere* of around 1465, raising Tuscan expression and literature to a new level that might equal that of the Greeks and Romans. The result in poetry was a newly heightened Latinity and purity of language, and in an analogous way nothing so refined and purely classical as the poetic foundation to Botticelli's disposition of the ancient gods in the *Primavera* had ever before been devised. Nevertheless, notwithstanding the unity given the conception of the painting by its foundation in the *materia* of the *Scriptores rerum rusticarum*, Botticelli's disposition of that material finds no clear parallel with any of the classical forms of *carmen rusticum*, and certainly not with georgic poetry. The *Primavera* does, on the other hand, and not least in its contemporaneity of effect, find clear parallels with many characteristic features of vernacular *ballate* and *canzoni d'amore*. It is therefore appropriate to return to the third of the principal contexts in which discussion of the *Primavera* has been placed, even though it has been comparatively muted in scholarship of the past fifty years:

[26] Van Marle, op. cit., XII, pp. 80–82; see also G. Pauli's review of Warburg's "*Geburt der Venus*," "Antike Einflusse in der italienischen Frührenaissance," *Kunstchronik*, n.s. 5, 1894, pp. 144–147.

namely, that of Florentine civic festivals such as the Calendimaggio, for which both Lorenzo and Politian composed canzoni, and the public celebration of times of peace enacted in jousts and tournaments, especially the joust won in 1475 by Giuliano de'Medici, Lorenzo's younger brother.

For a long time, interpretation of the *Primavera* in a civic and vernacular context dominated the scholarly and even the semipopular literature devoted to it. This derived from Warburg's compelling demonstration of the closeness of Botticelli's imagery to the descriptive particulars of several episodes, as well as to the general aesthetic, of Politian's famous poem commemorating Giuliano's victory, the *Stanze per la giostra di Giuliano de'Medici*. Attention once focused on his observation that Politian's description of Simonetta Cattaneo, the young wife of Marco Vespucci and the lady to whom Giuliano had dedicated his joust, so closely coincided with Botticelli's figuration of Flora in the *Primavera* that it seemed likely she was portrayed there in mythical guise. Less influential was his discussion (though it was surely rightly conceived) of analogous expressive qualities discernible in both painting and poetry—an aesthetic of restless movement manifest in the description of windblown hair, for example, or of shifting draperies and the agitated motion of hemlines around quickstepping feet. (Lincoln Kirstein indeed has suggested that Botticelli's women are shown performing dance steps, which is certainly true with regard to the slow *rondo* danced by the Graces, while Flora seems to step forward in a lively *moresca*.) Such qualities Warburg found to be characteristic of a common pathos informing the expressive needs and desires of the age, a pathos that also finds abstract expression in Botticelli's sinuous and nervously moving contours. Nevertheless, after Gombrich's sharp rejection of what he called in his article of 1945 the "romantic legend" of Simonetta, real discussion of the *Primavera* in relation to Politian's *Stanze* all but ceased among art historians (though not among literary scholars), despite two brilliant articles published by Pierre Francastel in the following decade.[27] Scholarly energies instead concentrated on attempts to establish the Neoplatonic hypothesis, with the result that Francastel's contributions to the state of the question have never been properly assimilated.

Francastel was skeptical of the Neoplatonic interpretation of the *Primavera*, not so much on the ground of specific detail as on the conceptual level, positing as it did a high and remote realm of courtly and academic culture that he thought at odds with certain essential expressive characteristics of Botticelli's painting. He insisted that both Botticelli and Politian in the *Stanze* responded in their works of art to real experiences and events, not on a single cultural plane, high or low, but in a way that united the general experiences of the present with a conception of art at its most refined and sophisticated. The particular, highly individual imaginative creations of

[27] Francastel, op. cit., 1952, and op. cit., 1957. Virtually the only writer after the appearance of Gombrich's article in 1945 to put forward an interpretation of the *Primavera* as an allegorization of the love of Giuliano de'Medici for Simonetta Cattaneo was W. Welliver, *L'impero fiorentino*, Florence, 1957, and idem, "The Meaning and Purpose of Botticelli's *Court of Venus* and *Mars and Venus*," *Art Quarterly*, XXXIII, 1970, pp. 347–358.

artists and poets also had a public dimension closely connected with the myths en-
acted in the rituals of the city. This appears, for example, in the poetic competitions
mourning the deaths of young beauties like Albiera degli Albizzi and Simonetta Cat-
taneo, in the songs and spectacles created for the feast of Saint John the Baptist or
the Calendimaggio, and in the jousts ordained to celebrate treaties of peace, for
which numerous descriptions survive in prose and in poetry, in Latin and in the
vernacular (of which Politian's *Stanze* is merely the most famous).[28] The challenge
to interpretation in Francastel's view was to bring together the effects of the individ-
ual imagination as objectified in the work of art with the structure of the public
imagination as expressed in the common culture, traditions, and rituals of the city
and its rulers.

The leading citizen of Florence, as well as the chief sponsor of the developing
new culture of humanism, was Lorenzo de'Medici, and Francastel, in an attempt to
meet the challenge to interpretation as he had defined it, introduced into discussion
of the *Primavera* and the *Stanze* a third work of art that carried with it its own inter-
pretive guide, Lorenzo's *Comento sopra alcuni de' suoi sonetti*. The story of love told in
Lorenzo's sonnets and commentary to them, like Dante's *Vita nuova* (on which it is
partly modeled), unfolds against the backdrop of the city and its public moments of
grief (for the death of Simonetta Cattaneo) and celebration (when Lorenzo first be-
held his own beloved, Lucrezia Donati). Francastel with great precision and acuity
set the problem of interpreting Botticelli's *Primavera* in the context of the interpretive
decorum that explicitly informs not only Lorenzo's *Comento* but also the great tra-
dition of vernacular love poetry on which the Magnificent's poetry was predicated.
Since the protagonist of Botticelli's painting is Venus, by definition its subject too is
love, and the theme of love, as I shall argue in chapter 2, like those of the *Comento*
and the *Stanze*, is enacted in the Florentine present by figures who appear in the
costumes of contemporary festival celebration—in costumes and in actions, Francas-
tel had insisted, that Botticelli had actually seen. Among other analogies noted by
Francastel between contemporary poetry and painting was the descriptive and sen-
timental similarity of the various women they portrayed. In particular, he observed
that Albiera and Simonetta as described by Politian were sisters under the skin, and
sisters too to the women described in works of art. Whether appearing as portraits
of real women, as in Jacopo della Quercia's tomb effigy of Ilaria del Carretto or the
Leonardesque sculpture of the *Lady with the Violets*, or as wholly imaginative crea-
tions, all of them seemed to respond to the same normative ideals of beauty. This
general observation was then given technical precision by Elizabeth Cropper in 1976,
when she demonstrated that all the women shown in the *Primavera* conform to the
descriptive canons of *effictio*, or *descriptio pulchritudinis*, which govern the portrayal of

[28] See P. O. Kristeller, "Un documento sconosciuto
sulla giostra di Giuliano de'Medici," in *Studies in Re-
naissance Thought and Letters*, Rome, 1956, pp. 437–
450, esp. pp. 437f.: "Il vivo interessamento con qui
questi spettacoli cavallereschi furono seguiti anche
dalle persone di cultura risulta dalle numerosissime
descrizioni di giostre che ci sono pervenute e formano,
accanto alle altre descrizioni di feste, quasi un proprio
genere letterario."

the outer lineaments of female beauty in the conventions of the vernacular lyric and of the vernacular romance epic.[29]

The descriptive canons of *effictio* were moreover specific to the vernacular tradition, at least until the time of Lorenzo the Magnificent, when they began to make their appearance in Neo-Latin poetry. Though certain metaphors do derive from ancient poetry, the convention itself is no more ancient than are the costumes worn by the gods figured in the *Primavera*. The implications of this observation are developed in the argument set forth in chapter 2. There it is suggested that, even though the *materia* of Botticelli's invention is entirely derived from a profound understanding of the ancient gods, its deployment and function in the work of art, as is also true of Politian's *Stanze* and Lorenzo's sonnets, are conceived in accordance with the conventions of vernacular love poetry. This in turn sheds sharp light on the value of Francastel's perception that the expression of the *Primavera* functions simultaneously on two levels, public on the one hand, and private to the artist and poet and their immediate audience on the other. The conventions of the vernacular require the presence of a real beloved (whether named Beatrice Portinari or Lucrezia Donati) who opens the heart of the lover to an abstract idea of love itself (whether conceived as Amore, as Caritas, or as Venus), with which, as the understanding of the lover gradually deepens, she is seen to be identified. In other words, the portrait of the beloved, particular and real, and the portrayal of love, normative and ideal, are one and the same. The portrait of the beloved represents private experiences, hopes, and aspirations, the portrayal of love a public idea. This being so, in chapter 3 I shall take up the question of Lorenzo de'Medici's love for Lucrezia Donati, showing the reality of that love as it is revealed in the letters of his friends, through close readings of Luigi Pulci's *Da poi che 'l Lauro* and *La giostra*, as well as through Lorenzo's own early poetry, and showing how that love was simultaneously mythologized in that poetry and in the joust won by Lorenzo in 1469, which he had dedicated to Lucrezia both as his real beloved and as a poetic and chivalric myth of love. In chapter 4 I shall again raise what might be called "the question of Simonetta," treating her both as a real person with historical existence and as the embodiment of a poetic fiction that properly should be viewed as a subdivision of the poetic myth of Lucrezia Donati, the *donna* of Lorenzo de'Medici's poetry and the true muse of the new humanist culture in Florence.

Put another way, the figure of the beloved stands for the real experiences of the present while the idea of love represents acculturated memory, and the terms interact in dynamic and mutually transforming ways. Dante's beloved Beatrice—Beatrice Portinari—had real existence, and in Dante's poetry she came to represent a new idea of love that forever altered (and perfected) the cultural idea previously figured in Guido Cavalcanti's *donna* Giovanna. So too had Petrarch's Laura real existence, and in the poet's experience of love for her as measured against the idea of love inherited

[29] E. Cropper, "On Beautiful Women, Parmigianino, *Petrarchismo*, and the Vernacular Style," *Art Bulletin*, LVIII, 1976, pp. 374–394.

from the poetry that came before, Laura is seen to embody the idea of love itself, but a new concept of love that has been transfigured by the poet's experiences of the present, by Laura. The present is formed by history, and in this process becomes a part of history, renewing and perfecting the past even as it enters into it. Lorenzo's poetry, as well as that of the poets he sponsored, is profoundly shaped by the traditions of the Italian past, by Cavalcanti, Dante, and Petrarch. As he wrote in the letter introducing the *Raccolta Aragona*, the collection of poems he assembled for Federico, son of the king of Naples, their tradition and its accomplishment provided the eternal models for a renewed eloquence and an even more highly perfected expression. This renewed perfection is the creation of the particular image of the beloved carried uniquely in each human heart. As he wrote in the prose section of his *Comento* just preceding his telling of the initial discovery of his particular beloved, every man seeks happiness in his own way, "each according to his own nature and disposition, from which is born the variety of human studies and the ornamentation and greater perfection of the world through the diversity of things, like the harmony and consonance which results from the concordance of different voices."[30] But before Lorenzo could truly know his own happiness—figured in the beloved he is about to meet for the first time—he was constrained to proceed from a general idea of happiness, an idea of love known to all men from general cultural inheritance, for "there is no doubt at all that an understanding of things in general is easier than in species and particulars; I am speaking in accordance with the methods of human intelligence, which cannot possess the true definition of anything unless first preceded by universal knowledge of it."[31] It is in the tension between the two, the universal and the particular, the public and the private, that the world finds renewal and transformation, and the present can enter into the past, transforming and increasing the sum total of human achievement.

On the private level of the artist and his audience, then, the more profound interest inherent in the beloved derives less from her actual human existence—and I believe that the figures of Lucrezia Donati and Simonetta Cattaneo haunt the *Primavera* to the same degree they do the *Stanze* and the *Comento*—than it does from the particular and new idea of love she represents, an idea that emerges from and transforms the past. In the fifth and final chapter there is accordingly offered a reading of the *Primavera* that attempts a definition of the particular idea of love figured by Botticelli in Venus and her companions, whereby the beloved is seen to become identical with a transformed idea of love itself. This reading follows the interpretive principles governing the making and reading of vernacular poetry, especially as these principles are explicitly applied in Lorenzo's *Comento* and its own sources, notably Dante's *Vita nuova* and *Convivio*. It permits, on the one hand, a more precise understanding of Botticelli's imagery in relation to the tradition within which it is profoundly rooted, and on the other it allows a more precise definition of the novelty, and indeed unique-

[30] *Comento del Magnifico Lorenzo de'Medici sopra alcuni de' suoi sonetti*, in Lorenzo de'Medici, *Opere*, ed. L. Cavalli, Naples, 1969, p. 359.
[31] Ibid.

ness, of its conception. Such a reading is not based on hypothesizing a literal corre-
spondence between the meaning of these different works of art, each of which is on
the contrary the independent expression of a particular artistic imagination. It rather
follows the traditions and decorum of interpreting poetry in the vernacular, with its
characteristic tension between memory and experience. Though Lorenzo's *Comento*
and Politian's *Stanze* are indispensable guides to reaching such an understanding of
the way in which Botticelli's imagery is conceived and read, neither of them provides
a "basic text" or "programme" for the *Primavera*, any more than the *Vita nuova* func-
tions as a program for the *Comento*. All are interconnected, however, not least be-
cause each treats the common theme of love.

Within the vernacular tradition, the idea of love objectified in the figure of the
beloved is closely linked to the concept of human ennoblement and fulfillment,
whether defined as Dante's *nobiltà* or as Lorenzo's notion of *gentilezza*, a gentility
that proclaims in its very name an allegiance to a more purely Tuscan concept exalted
in verse before Dante ("Amore e 'l cor gentil sono una cosa," as Dante wrote in a
paraphrase of Guido Guinizelli).[32] For Lorenzo, gentility takes its origin from an
appetite for beauty that is completed in love. It is love that turns the heart from
hardness and cruelty, that instills a desire for human perfection and hence (in Lo-
renzo's argument) creates and defines our very humanity. Here, I think, we find the
proper gloss for Ficino's characterization of Venus as *humanitas* in the letter placed in
evidence by Gombrich, which the philosopher sent to Lorenzo di Pierfrancesco
de'Medici explaining his horoscope. Here too we begin to see a means to reconcile
the poetic and the philosophical interpretations of the *Primavera*, in particular with
reference to Lorenzo's Neoplatonic comment to his own sonnets (of which even the
brief quotations in the previous paragraph give a flavor), which sets forth an idea of
love that is greatly in the debt of Ficino's *De felicitate*.

It is in precisely this philosophical, Neoplatonic grounding that Lorenzo's con-
cept of love distinguishes itself from that of the poets of the *stil novo*, from Dante's,
and from Petrarch's; that grounding opens the way to refining our understanding of
the concept in both its traditional and its novel aspects. So far as the *Primavera* is
concerned, two things also distinguish Botticelli's invention and define its newness,
not only with respect to the relationship it bears to the inherited tradition of the
poetry of love but also to the content of Lorenzo's *Comento*. The first of these appears
in the completeness and perfection of its classical content, wholly absorbed and re-
made in a way that finds its best analogy in Politian's *Stanze*, of which it has been

[32] Dante, *Vita nuova*, xx. See also *Comento*, ed. cit.,
p. 339 ("Perchè, se gli è vero, come dice Guido bo-
lognese, che amore e gentilezza si convertino e sieno
una cosa medesima") and p. 383 ("Pare solamente al
presente necessario, perchè spesse volte nelli nostri
versi si truova questo vocabulo di 'gentilezza' e 'gen-
tile,' difinire una sola volta per sempre quello che sia
gentilezza secondo la mia opinione. Né arei presunto
di far questo, se Dante, clarissimo poeta, in quella can-
zone dove si difinisce la gentilezza, non si fussi ristretto
alla difinizione della gentilezza dell'uomo, la quale lui
chiama quasi 'nobilità.' Ma, essendo questo vocabulo,
secondo il vulgare uso, quasi comune a tutte le cose,
non mi pare inconveniente dire quello che ne intendo,
massime perchè, nella significazione che si usa, è vo-
cabulo nuovo ed al tutto vulgare, del quale non può
essere né per difinizione né per l'uso degli antichi al-
cuna certa proprietà.").

truly written that for the first time the Tuscan tongue speaks a perfect Latin, and Latin itself an unblemished Tuscan. The second is that love appears embodied as Venus. Botticelli does not merely figure Venus as the goddess of love, which had often been done before; he presents her as the manifestation and fulfillment of the true idea of love itself. As such, as I shall argue in the final chapter, the new concept she represents is profoundly ancient and just as profoundly rooted in the life of the world. It is quite distinct from the idea of Christian Caritas revealed through Beatrice, for example, or from the more purely poetic idea expressed in Laura, or yet again from the philosophical idea of the summum bonum as it appears in a Lucrezia Donati who, for all Lorenzo's classical allusions, remains more at home in her villa at Santo Miniato than in the world of Lucretius or Virgil.

I remarked at the outset that, given the nature of the problems Botticelli's *Primavera* poses to interpretation, and given the quality of the scholarship devoted to the painting, interpreters of its imagery must, explicitly or implicitly, build into their accounts their own understanding of the Renaissance. The view that has prevailed for a long time (among those who have not despaired of the concept altogether) understands the Renaissance as fundamentally defined by a revival of antiquity, especially as inspired by the work and creative energies of the humanists, who were professional scholars, teachers, and writers of the ancient languages. Thus, for Panofsky, whose conception was the theme of his book *Renaissance and Renascences*, the idea inherent in the very word "renaissance" could only find its full meaning when the ancient ideas expressed in the figures of the gods and heroes were reunited with their ancient forms; in his argument, though the uniting of classical form and content was adumbrated in Botticelli's *Primavera*, full fusion of the two was accomplished for the first time in Florentine art with his *Birth of Venus*, painted only a few years later. Yet the concept embodied in the term *renovatio litteris* (from which the idea of "renaissance" derives) carries with it the connotations not only of rebirth but also of renewal, of making new again, as in the concept of *renovatio mundi* that is the subject of the *Primavera*. The first spring of the world is forever the archetype of the thousands of springs to follow, and each spring is new just as love itself is eternal, yet perpetually new in each new lover's heart, which contemplates the particular image and idea of love that it alone has experienced and it alone created. The renewal of letters and of art was never directed literally and anachronistically toward reproducing the ancient past, identifying the needs and values of the present with those of antiquity; it was bent toward the creation and enhanced perfection of a new culture based in the assimilation and transformation of traditions and histories that were not single but complex. If, as has been written of Landino's prolusion to Petrarch, this constitutes "perhaps the most decisive text of the 'refoundation' of Italian literature on humanist grounds," we see the first fruits of that refoundation in the imaginative and newly refined expressions of that art, both verbal and plastic, produced in the course of the following decade.[33] In the *Primavera*, as in Politian's *Stanze* and in the

[33] See C. Landino, *Scritti critici e teorici*, ed. R. Cardini, Rome, 1974, p. 32. See further R. Cardini, *La* *critica del Landino* (Istituto Nazionale di Studi sul Rinascimento, Studi e Testi, IV), Florence, 1973, pp. 85–112.

evolution of Lorenzo's poetry over the span of his short lifetime, we see the two great cultures of Italy, the ancient Latin and the old Tuscan, slowly being brought together in indissoluble union for the first time, renewing both pasts even while transforming them in the crucible of present-day life and events into something never before seen.

It is my conviction that the iconographical problem posed by the *Primavera*, insofar as this has been conceived primarily as a retrieval of the textual foundations of Botticelli's invention, is fairly well resolved in its essentials, and that the materials necessary for reaching such a resolution have been available for some time. This does not mean the problem of the *Primavera* has been resolved, or that this book is conceived as a "solution" to that problem. It does mean that the phenomena to be taken into account have been increased and the state of the question altered with the passage of time. The problem as we have inherited it entails not so much establishing what particular texts may have inspired Botticelli's invention as it does coming to grips with the *Primavera* in its fullest possible cultural and imaginative context, attempting to understand the myth portrayed there as one defined by history, one that itself creates a new myth of the present that transforms history and in so doing takes on and expresses historical actuality. Only then will we arrive at an understanding of Botticelli's invention both in history and as a new, independent artistic creation.

The question, in other words, no longer requires searching out the poetic sources that helped form Botticelli's invention, but rather entails learning how to read the new poem encoded in the *Primavera*. What does it mean (an extraordinary thing!) that Botticelli has not simply illustrated a story taken from Ovid or Dante but instead given expression to an independent invention bringing together material derived from and rationalized by a large number of ancient authors? If the *Primavera* is indeed the material manifestation of a poetic invention, how then are we to interpret it, to read it as an independent poetic expression? As an expression of the new humanist culture and the renewal of letters, what is its true relation to the tradition of poetry that not only found its most important sponsor but also one of its greatest practitioners in the person of Lorenzo de'Medici? Are we to understand it only as the expression of a revived antique idea, Latinate and aulic, or does it also respond to the forms and experiences of a broader, shared vernacular culture undergoing a process of self-conscious renewal and change? If its conception is rooted in the traditions of vernacular poetry, which is by definition a poetry of love governed by endlessly repeated inventive conventions and tropes, what does it mean that the idea there expressed is represented in Venus, who is herself by definition the figurement of love? And can the familiar and long-established interpretive conventions for reading vernacular poetry help us understand her both in the antiquity of the idea she represents and in its newness? The answers to such questions will determine how we understand the Renaissance in Florence at the time of Lorenzo the Magnificent, and it is in seeking this understanding that the true controversy about Botticelli's *Primavera* is to be found. What is the myth, the true reality that finds its expression in the *Primavera*?

("Il Landino e la poesia") and 113–232 ("Cristoforo Landino e l'umanesimo volgare"), and A. Field, *The Origins of the Platonic Academy of Florence*, Princeton, 1988, pp. 231–268 ("Cristoforo Landino and Platonic Poetry").

ONE

POETRY AS PAINTING

The Classical *Materia* of Botticelli's

Invention for the *Primavera*

THE EARLIEST description of Botticelli's *Primavera* (plate 1), and of his *Birth of Venus*, appears in the first edition, published in 1550, of Vasari's *Lives*, and it is not very accurate: "In diverse houses throughout the city he did tondos in his own hand, and a number of female nudes as well; among which, there are two paintings still today in the villa of Duke Cosimo at Castello, the one showing the birth of Venus and the breezes and winds that carry her to land with the loves, and likewise another Venus, whom the Graces bedeck with flowers, denoting the springtime."[1] An inventory of the Medici villa at Castello made in 1598 records that in the room where the grand duke took his meals there was a painting, and it is certainly the *Primavera* that is described, showing "three goddesses dancing, with Cupid above, and Mercury, and other figures."[2] The so-called Anonimo Gaddiano, writing about 1540, was no doubt referring to the paintings when he wrote that "in the house of Signore Giovanni de'Medici at Castello there are more paintings [by Botticelli], which are among the most beautiful works he made."[3] It has been inferred from this that Botticelli's two most famous paintings were at Castello at some time before 1526, the year of the death of Giovanni de'Medici, better known as Giovanni delle Bande Nere, the father of Duke Cosimo. The villa had been bought

[1] G. Vasari, *Le vite de' più eccellenti pittori, scultori ed architetti moderni*, ed. G. Milanesi, Florence, 1906, III, p. 312: "Per la città, in diverse case fece tondi di sua mano, e femmine ignude assai; delle quali oggi ancora a Castello, villa del Duca Cosimo, sono due quadri figurati, l'uno, Venere che nasce, e quelle aure e venti che la fanno venire in terra con gli Amori; e così un'altra Venere, che le Grazie la fioriscono, dinotando la primavera; le quali da lui con grazia si veggono espresse."

[2] See J. Shearman, "The Collections of the Younger Branch of the Medici," *Burlington Magazine*, CXVII, 1975, pp. 12–27. The passage from the 1598 inventory reads: "1 quadro grande in tavola dipintovi tre dee, che ballano, e cupido sopra, e Merchurio, e altre fiure, senza adornamento, anticho."

[3] For the Anonimo Gaddiano, see H. Horne, *Alessandro Filipepi, Commonly Called Sandro Botticelli, Painter of Florence*, London, 1908, appendix II, document II: "A castello in casa il Sr. Giovannj demedici più quadrij dipinse che sono delle più belle opere che facessj."

in March 1477 (in modern reckoning, probably 1478) by Giovanni delle Bande Nere's uncle, Lorenzo (1463–1503), and father, Giovanni (1467–1498), who were the sons of Pierfrancesco de'Medici (1430–1476), and at that time the wards of Lorenzo the Magnificent (who managed their inheritance), but who later adopted the name of the Popolani when the Medici were expelled from Florence in 1494. Because of the date of purchase for the property at Castello it has also been inferred, ever since Herbert Horne's publication and discussion of the documents in 1908, that the *Primavera*, conventionally dated 1477–1478, and the *Birth of Venus*, conventionally dated five or six years later, were commissioned for the villa by the older of the two brothers, Lorenzo di Pierfrancesco de'Medici.[4]

Recent archival investigation and analysis by John Shearman and Webster Smith have fairly conclusively shown this last inference to be impossible.[5] When Giovanni di Pierfrancesco died in 1498, a complete inventory of the *substantie e beni* owned jointly by his brother and heirs was drawn up (dated 1499), listing the contents of their various properties at Castello, Trebbio, Cafaggiolo, Fiesole, and in the Via Larga in Florence. No painting is named or described at Castello that could possibly be identified with either of Botticelli's two masterpieces, nor is there any mention of them in a second, though less complete, inventory of the same properties made in 1503, the year of Lorenzo di Pierfrancesco's death. There is, however, good reason for supposing that the *Primavera* is indeed listed in these inventories, not as being in the villa at Castello, but instead as being in the *case vecchie de'Medici* in the Via Larga.

The *casa vecchia* had been the residence of Cosimo de'Medici (d. 1464), *pater patriae*, and his brother Lorenzo (d. 1440), who were business partners and who held all property in common.[6] When Lorenzo died intestate in 1440, Cosimo continued to live in the house, now owned jointly with his ten-year-old nephew and ward, Pierfrancesco di Lorenzo. During the time Cosimo lived there he increased its size by joining it to two neighboring houses (hence the subsequent designation *case vecchie*), but then, presumably at the time he moved into the Medici Palace he had caused to be built two doors away in the Via Larga, the *case vecchie* were deeded to Pierfrancesco as part of his share of his father's property. From that time the house belonged to the cadet branch of the family. On Pierfrancesco's death in 1476 it passed to his two sons, Lorenzo and Giovanni, then thirteen and nine years old respectively, who became in their turn the wards of their older cousin, and Cosimo's grandson, Lorenzo the Magnificent. It was with the advice and authority of the Magnificent that the two boys acquired the property at Castello the following year.

It seems highly likely that the *Primavera* was fitted into the wainscoting of a wall in a ground-floor room in the *case vecchie*, a room described in the 1499 inventory as located next to the *camera terrena di Lorenzo*. The inventory mentions in this room a

4 Ibid., document xv.

5 Shearman, op. cit., and W. Smith, "On the Original Location of the 'Primavera,'" *Art Bulletin*, LVII, 1975, pp. 31–39.

6 For the *case vecchie de'Medici*, see Shearman, op. cit.; see also W. A. Bulst, "Die Ursprungliche innere Aufteilung des Palazzo Medici in Florenz," *Mitteilungen des Kunsthistorischen Institutes in Florenz*, XIV, 1970, pp. 369–392, esp. p. 376, note 22.

pinewood *lettuccio* (a chest-bench or daybed fitted into or set against the wainscoting of the room), five and one-half *braccia* long (3.19 meters), together with "a painting on wood affixed over the *lettuccio*, on which is painted nine figures of women and men." (For an illustration of a *lettuccio*, see fig. 1, which shows a woodcut from Savonarola's *Predica dell'arte del ben morire*, and in which the *spalliera*, or back of the daybed—which is in this case not set against the wall but pulled out into the room—is fitted with intarsia panels instead of a painting.)[7] The corresponding entry in the 1503 inventory refers to a "large painting with nymphs."[8] This second entry seems to confirm the mythological subject matter of the picture, relatively rare for the time, while the material, proportions, and very large size of the *Primavera* (2.03 by 3.14 meters), as well as the number of figures represented, all agree precisely with the inventory and with a site over the *lettuccio* listed there. As for the *Birth of Venus*, there is no indication of its existence in any of the properties owned by the two brothers, nor is it mentioned in a third inventory drawn up in 1516 listing Giovanni delle Bande Nere's share in the inheritance of the contents of the *case vecchie*. Much of the material listed in this last inventory went to the villa at Castello, and if Shearman's conjecture is correct it must have been at about this time that the *Primavera* was moved to Castello, the refurnishing of which with items taken in part from the *case vecchie* was probably occasioned by the betrothal of Giovanni delle Bande Nere to Maria Salviati in 1516.[9]

Because the *Primavera* and the *Birth of Venus* have for so long hung together under one roof, first at Castello, then in the Accademia and the Uffizi, because it has therefore been thought they were painted for the same patron, and because of the close similarity of their subject matter, the two paintings have not unnaturally been intimately associated ever since Vasari described them both in the space of a single sentence. It has on occasion been suggested that the two bear a programmatic relation to each other, which in any event seems excluded by the facts that they are painted on different surfaces (wood for the *Primavera*, linen for the *Birth of Venus*), are of different sizes, and differ stylistically—as the different dates conventionally assigned them indicate. On the evidence of the inventories it also appears highly unlikely that the *Birth of Venus* belonged to the descendents of Pierfrancesco

[7] Shearman, op. cit., pp. 18 and 25. The inventory of 1498 mentions first "Uno letuzo di pino di br. 5 1/2 col capilinaro et cassone, et con la predella dappie," and second "Un quadro di lignamo apicato sopra el letucio, nel quale è depinto nove figure de donne ch'omini." Shearman exemplifies the *lettuccio* with a splendid specimen from the Horne Museum, and others may conveniently be found in A. Schiapparelli, *La casa fiorentina e i suoi arredi nei secoli XIV e XV*, Florence, 1908. See also the following note.

[8] Shearman, op. cit., p. 26. The entry in the 1503 inventory reads "Uno quadro grande con ninfe," and the corresponding entry in a third inventory drawn up in 1516 (ibid., p. 27) reads "Uno quadro dipinto a figure, cornice bianche." For the "white frame," see M. Tinti, *Il mobilio fiorentino*, Milan and Rome, 1928, p. 29, for a discussion of the decoration of *lettucci* and their frames, which are characteristically described as being built of "white wood," i.e., poplar or ash (*pioppo o frassino*), and which were then stained *a noce* and decorated with paintings or intarsia. There is, in other words, nothing out of the ordinary about the siting of the *Primavera* over a *lettuccio* fit into the wainscoting of the wall.

[9] Shearman, op. cit., p. 16.

de'Medici until it was acquired at some time between 1516 and 1540 either by Giovanni delle Bande Nere or by Duke Cosimo, whether through purchase or confiscation. Nor does it seem likely that the painting ever belonged to the primary branch of the family, since nothing answering its description appears in the famous inventory made on the death of Lorenzo the Magnificent in 1492. There is now general agreement, therefore, that the patronage and the subjects of the *Primavera* and the *Birth of Venus* are not directly related.

Although the *Primavera* can be traced to the joint ownership of the children of Pierfrancesco de'Medici in the last year of the century, remarkably little can be inferred on this basis. The inventory of 1499 establishes only a *terminus ante quem* for the painting, and for excellent stylistic reasons no one has been tempted to think the *Primavera* was painted so late in Botticelli's career. The conventional view, as noted, is that the painting dates to 1477–1478, and it has been thought that these years at least may be taken as a secure *terminus post quem*, since they coincide with the date of the purchase of the property at Castello, for which it used to be thought the picture was painted. Now that it seems that the *Primavera* was in the *case vecchie de'Medici* by the end of the fifteenth century, and could not have gone to Castello until some time after that, the earlier *terminus* vanishes. If the *Primavera* was commissioned only one year earlier, in 1476, then Pierfrancesco de'Medici might have been the man who gave that commission. If it was commissioned at some point during the next five or six years (that is, within the period almost all scholars have dated the picture for stylistic reasons), then it is quite possible, and even likely, that Lorenzo the Magnificent, as the guardian of Pierfrancesco's children and the man who advised them in their purchase of Castello, was directly involved.[10] More often, it has been suggested that Lorenzo di Pierfrancesco was the patron—and most recently that he may have commissioned it on the occasion of his marriage in 1482. This latter is a rather uncomfortably late date, though not an absolutely impossible one, for the painting—but the grounds for accepting it are tenuous at best.[11] Lorenzo di Pierfrancesco was just thirteen when his father died in 1476 (and his brother only nine), and the *Primavera* did not descend by inheritance to his own children but went instead to Giovanni delle Bande Nere, the son of his brother, Giovanni di Pierfrancesco. Moreover, Lorenzo di Pierfrancesco lived as a member of the Magnificent's family until he came of age in 1484, at which time he and his brother promptly initiated an action against their cousin for mishandling monies he had been managing in trust for them. As part of the settlement, they acquired the Medici villa at Cafaggiolo together with many possessions of the older branch of the family, and there is evidence that they continued to acquire from various collections, including those of the older branch. At the time of the 1499 inventory many of the objects listed had already been moved from one house to another, and even the mounting of the *Primavera* in the *spalliera* of a

[10] Ibid., p. 21 (noting that Gombrich had also hinted at the possibility that the painting was commissioned for the children of Pierfrancesco by Lorenzo the Magnificent).

[11] R. Lightbown, *Sandro Botticelli*, London, 1978, I, pp. 69–81, and II, no. B39, pp. 51–53.

daybed (itself a piece of movable furniture) in the room in the *case vecchie* does not necessarily indicate that it was painted for that site.[12] As Shearman wisely remarked, it is best to make no assumptions about individual patronage on the basis of the Medici inventories, which contain the earliest evidence we have regarding the *Primavera* and other paintings by Botticelli. One of these, the *Pallas and the Centaur*, shows the principal figure clad in a white dress embroidered with the Magnificent's device of the diamond ring, and it is hard to understand this picture in any context other than the poetic and chivalric celebrations sponsored by Lorenzo himself, who stood at the head of his city no less than of a house that had always been remarkably fluid in its definition of family property.[13] We are in the end thrust back on the primary evidence of the *Primavera* itself, about the subject of which the inventories are characteristically even less illuminating than they are concerning its date and commissioning. Vasari's notice of 1550 remains the earliest clear indication of Botticelli's theme, giving this as "Venus . . . denoting the springtime."

Having remarked on the all but universal consensus among scholars in support of Warburg's demonstration that the imagery of the *Primavera* is based in a combination of various particular models from ancient poetry (principally, as I shall show, from the fifth book of Lucretius's *De rerum natura*, the fifth book of Ovid's *Fasti*, the first book of Horace's *Carmina*, and Seneca's essay *De beneficiis*), together with Renaissance imitations of them (notably Politian's *Sylvae* and the *Stanze per la giostra*), I shall begin with two observations. The first is that the very multiplicity of texts involved indicates that Botticelli was not illustrating an episode from some ancient poem or fable, but was instead conceiving the invention of his painting as a new poem in imitation of the imaginative decorum established in both ancient and vernacular models. The second is that disagreement among contending hypotheses claiming to interpret his invention is at bottom a dispute about its genre. As a *favola*, or mythic representation, the theme of the *Primavera* is by definition made up of a new invention making imaginative use of fictions that had been established in ancient poetry. Renaissance scholars and mythographers universally agreed that such fictions invoked the gods and goddesses of antiquity, not as being in themselves true, but as instead being metaphorical and allegorical expressions of some other truth. Much of the novelty of Botticelli's painting derives from this conception, for which there is virtually no direct precedent in painting, and this is only one of the many and various attributes that give the *Primavera* its special importance and interest. It is also the source of many of the particular interpretive problems posed by its imagery. What form or genre does Botticelli's *favola* take? Is it a lyric invocation of the ancient gods? Is it a philosophical allegory based on them? These questions are especially important insofar as Botticelli has combined in a new way several classical texts of quite differ-

[12] See Shearman, op. cit., pp. 21f., for a discussion of the ambiguity of the documents and the difficulties of interpreting them. Shearman is himself perhaps too quick to assume that the siting of the *Primavera* in 1498 indicates that it was then in the position originally intended for it twenty years earlier, and he cites provocative examples of the moving about of works of art among various Medici households.

[13] For *Pallas and the Centaur*, see Lightbown, op. cit., II, no. B43, pp. 57–60.

ent natures in order to create an image that simultaneously invokes all of them and reproduces none of them. He transformed each to the point that, as Wind wrote, while they collectively account for the "traits and episodes" depicted, they do not seem to account for the new image that emerges from their combination.

An important fact about the *Primavera*, already noted, is that it is perhaps the first painting on such a scale to be conceived as a pure mythology. This in itself at once poses a problem of interpretation. It is preferable not to refer to the subject of the *Primavera* as a "mythology," but better instead to call it, as I have been doing, a *favola*, which is the word invariably used by Renaissance writers to designate the subject of a painting or poem based on the material of ancient myth. The modern meanings that have become attached to the word "myth" derive for the most part from the nineteenth century, whereas the concept embodied in the word *favola* (the meaning of which has also altered in modern usage) much more directly translates the Greek *mythos*, which originally meant the telling of a story. As used by Homer, *mythos* applied equally to truth and to fiction, but from the time of Pindar the word always connoted a fictitious account (directly translated into Latin as *fabula*), and it was distinguished from *logos*, a later word that in its original sense denoted the telling of a true story.[14] It was with Plato that *logos* came to refer to a philosophic form of discursive reasoning, or dialectic (*ratio* in Latin), the goal of which was the truth, and which he directly opposed to the fictitious narratives of *mythos*. For Plato, the term *mythos* denoted a species of narration without demonstrative force, the characteristic form of which is the enthymeme, which is really a kind of metaphor; the term *logos* denoted formal and rational discourse, the characteristic form of which is the syllogism.

Plato's well-known hostility to the fictions of poetic and rhetorical utterance defines the grounds on which the concept of *fabula* was debated from the very beginning of the recovery of letters, when the claims of poetry to be able to represent truth allegorically rather than to set forth its principles logically and axiomatically were reasserted by Petrarch and by Boccaccio in his famous defense of poetry. For Boccaccio, "Fiction [*fabula*] is a form of discourse, which, under the guise of invention, illustrates or proves an idea; and, as its superficial aspect is removed, the meaning of the author becomes clear."[15] It is important to stress Boccaccio's use of the word *inventio*, which he makes all but synonymous with *fabula*, and to stress too the great importance of the familiar concept of fiction thus conceived as an outer cortex with which the poet allegorically covers or ornaments the truth. It was Plato's ancient charge that poets dealt only in fictions and not with truth that defined the battle-

[14] The opposition of *mythos* to *logos* is fundamentally Platonic, where indeed the two terms are virtually antonymic. For Plato, whose opposition to the forms of poetry and rhetoric is well known (see the *Republic* and *Phaedrus*), *mythos* denoted a form of narration without demonstrative force, while *logos* denoted logical discourse, or dialectic (see *Protagoras*). See also H. Morier,

Dictionnaire de poétique et de rhétorique, Paris, 1975, s.v. "mythe," and Y. F.-A. Giraud, *La fable de Daphne*, Geneva, 1968, pp. 11ff.

[15] Translation by E. H. Wilkins. See Boccaccio's famous defense of poetry, in *Genealogie deorum gentilium*, xiv.

ground between the humanists and the logicians, and that provoked the following outcry from Boccaccio:

> Some railers against poetry are so rash as to say, on no authority but their own, that only an utter fool would think the greatest poets have hidden some other meaning in their fictions, and that rather they have invented them only to show off the power of their eloquence and to show how easily weak minds will believe the false to be true. O the iniquity of men! O what ridiculous folly! O what an impertinent outrage! While they put down others, in their ignorance they imagine they are exalting themselves. Who but an ignoramus would dare to say that poets purposely make their inventions void and empty, trusting in the superficial appearance of their tales to show their eloquence, as though the power of eloquence were unable to display itself with the truth?[16]

Recent research on the development of humanist thought has indeed stressed its philosophical rehabilitation of poetics and rhetoric as legitimately alternative forms of discourse, in fact superior alternatives to the crabbed formulas and bad Latin of Scholastic logic. Both Lorenzo Valla and Politian, for example, maintained that grammar and rhetoric were master sciences that preceded logic in the task of linguistic inquiry. Thus it has been claimed for Valla that "eloquence and poetry are sisters, two diverse expressions of a highest humanity that endeavors to discover the objective in the concrete."[17] In the *Panepistemon*, most significantly, Politian located his own profession of letters neither in the active nor in the contemplative intellects, but in a branch he called the rational (or what Aristotle named the deliberative) intellect, thereby indicating that he considered letters neither as arts nor as sciences but instead as expressions of a rational power that intellectual historians have identified as a humanist concept of dialectic (*mythos*) set at war with the philosophical dialectic (*logos*) of the Schoolmen.[18] It was around this paradox—finding in the subjective discoveries of individual experience, and indeed of poetic fictions, the path to objective truth— that the enterprise of humanism evolved. The expression of such truth, made manifest in all its concrete and palpable beauty, was a function not of *logos* but of the inventive (literally, the discovering) capacities of the mythopoetic imagination.

Although the opposing claims of the transcendent imagination on the one hand and Scholastic reasoning on the other are central to the history of humanism and its later decline in the period of the Reformation and its aftermath, nevertheless the

[16] Ibid., XIV.10, under the heading "It is a fool's notion that poets convey no meaning beneath the surface of their fictions [*Stultum credere poetas nil sensisse sub cortice fabularum*]."

[17] H.-B. Gerl, *Rhetorik als Philosophie: Lorenzo Valla*, Munich, 1974, pp. 190–191. See further C. Trinkaus's seminal chapter on Valla in *In Our Image and Likeness: Humanity and Divinity in Italian Humanist Thought*, London, 1970; S. Camporeale, *Lorenzo Valla: Umane-*

simo e teologia, Florence, 1972; and the very useful and stimulating article by N. Struever, "Lorenzo Valla's Grammar of Subject and Object: An Ethical Inquiry," *I Tatti Studies*, II, 1987, pp. 239–267.

[18] For Politian's *Panepistemon*, see *Omnia opera Angeli Politiani et alia quaedam lectu digna*, Basilea, 1553; see also C. Dempsey, review of David Summers, *Michelangelo and the Language of Art*, in *Burlington Magazine*, CXXV, 1983, pp. 624–627.

concept of *fabula* (in other words, *mythos*) as the organizing power of the human imagination, whether valued highly or lowly, remained constant. This concept is the foundation for the sisterhood of the arts of painting and poetry, for it is in the exercise of invention (which does not denote subject matter as such so much as it does an imaginative process of discovery) that poetry, rhetoric, and painting find their common ground. The primary statement of this humanist position is from the hand of Alberti, who defined *pictura* as a dominant and embracing concept made up of three subordinate, enabling categories that soon after came regularly to be defined as *disegno*, *colore*, and *invenzione*, terms that have long been recognized as deriving respectively from the rhetorical *dispositio*, *elocutio*, and *inventio*. Alberti's concept of one essential part of the painter's art, *inventio*, unambiguously identifies that sphere of his activity not as analogous but as identical to the same sphere in the activity of the poet and orator. This means that the problem of understanding the imagery of the *Primavera* is not so much simply identifying its subject (which is not difficult to do), but rather understanding Botticelli's imaginative process: how he conceived and deployed the gods metaphorically and allegorically in support of a theme that is an independent and wholly original invention, based on the conventions and decorum of fictive expression.

As a *favola*, the term used to designate painting and poetry with mythic subject matter in the Renaissance, the *Primavera* does not, so far as anyone has been able to determine, literally illustrate an episode or story taken from a particular ancient text or Renaissance imitation of one (for which there are many precedents). It does not, in other words, borrow its invention from another source, and it accordingly belongs to that class of paintings known shortly afterwards as *poesie*. (Titian, for example, habitually refers to his paintings of independent mythological inventions as *poesie*.)[19] It is moreover quite possibly the first painting of the Renaissance that can be so classified, for the earliest use I know of the word *poesia* to characterize a painting appears in the inventory of the Medici Palace made on the death of Lorenzo de'Medici in 1492. In this inventory one picture is listed as "una poesia con due fighure e più paesi."[20] The earliest definition of a painted *poesia* appears less than a decade later, in a letter of 1501 written by the Venetian painter Jacopo de'Barbari to Frederick the Wise, in which he argues for the acceptance of painting as a liberal art (following Alberti), and points out that "*poesia* is necessary for the invention of the work, this arising from grammar, rhetoric, and dialectic."[21] Barbari here identifies *poesia* with

[19] A great deal has been written about Titian's *poesie*, not much of it focused and almost none setting the issue in its true literary context. Suffice it to cite D. Rosand, "*Ut pictor poeta*: Meaning in Titian's *Poesie*," *New Literary History*, III, 1971–1972, pp. 527–546, and G. Padoan, "*Ut pictura poesis*: Le 'pitture' di Ariosto, le 'poesie' di Tiziano," *Tiziano e Venezia: Convegno internazionale di studi*, Verona, 1980, pp. 91–102. In his famous letters to Philip II, incidentally, Titian uses the word *poesia* virtually interchangeably with *favola*, for

which see M. Tanner, *Titian: The Poesie for Philip II*, Ph.D. dissertation, Institute of Fine Arts, New York University, 1976.

[20] E. Muntz, *Les collections des Médicis au XVe siècle*, Paris, 1888, p. 85: "Item—uno colmetto dipintovi su una poesia con 2 fighure e più paesi."

[21] "Oltra di questo necesita la poesia per la invention de le hopere, la quale nase da gramatica e retorica ancor dialetica. E de istorie convien essere pitori copiosi." For the letter, dated 1501, see L. Servolini, *Jacopo*

inventio, which Alberti had claimed to be an essential attribute of the painter, and his reference to the *trivium* indicates, also following Alberti, that the painter must have an acquaintance with letters and be able to invent new subjects of his own on that basis. The same position, by this time a commonplace, is stated in the Venetian Paolo Pino's *Dialogo di pittura* of 1548, where it again follows a discussion of the liberal arts. Once again the art of painting is divided into its three conventional parts, *disegno*, *colorito*, and *invenzione*, and of the last Pino writes, "This means the finding of *poesie* and stories in and of themselves; because Painting is properly speaking *Poesia*, that is, Invention."[22]

We find here expressed the familiar Renaissance equation of painting with poetry, encapsulated in the famous Horatian phrase "ut pictura poesis." That both Barbari and Pino equate the activities of the painter and poet specifically through their common exercise of *inventio* is especially significant. The concept of invention has deep roots in the literature of both poetics and rhetoric, and it is to the former tradition that both writers are referring when they specifically identify *poesia* with *invenzione*. To quote Boccaccio again, for example, "Poetry, which ignorant triflers cast aside, is a sort of fervid and exquisite invention, with fervid expression, of that which the mind has discovered."[23] Indeed, the equation of invention with poetry appears with the origins of vernacular poetry in Italy, when the poet was called a

de'Barbari, Padua, 1944, pp. 105f., or P. Kirn, "Friedrich der Weise und Jacopo de'Barbari," *Jahrbuch der Preuszischen Kunstsammlungen*, XLVI, 1925, pp. 130–134.

[22] P. Pino, *Dialogo di pittura*, Venice, 1548 (republished in *Trattati d'arte del Cinquecento*, ed. P. Barocchi, Bari, 1960–1962, I, pp. 93–139, esp. p. 115): "L'arte della pittura è imitatrice della natura nelle cose superficiale, la qual, per farvela meglio intendere, dividero in tre parti a modo mio: la prima parte sara disegno, la seconda invenzione, la terza e ultima il colorire. . . . Or alla seconda parte, già detta invenzione; questa s'intende nel trovar poesie e istorie da se (virtù usata da pochi delli moderni), et è cosa appresso di me molto ingeniosa e lodabile. . . . E perchè la pittura è propria poesia, cioè invenzione, la qual fa apparere quello che non è, però util sarebbe osservare alcuni ordini eletti dagli altri poeti che scrivono, i quale, nelle loro comedie e altre composizioni vi introducono la brevità, il che debbe osservare il pittore nelle sue invenzioni, e non voler restringere tutte le fatture del mondo in un quadro."

See also the famous letter, also of 1548, written to Vasari by Annibale Caro, commissioning a painting from him and again emphasizing both original invention and brevity (K. Frey, *Die literarische Nachlass Giorgio Vasaris*, Munich, 1923, pp. 220ff.). He requires a painting with two figures, "but as to the invention I leave that to you, remembering another similarity that painting has with poetry, all the more so since you are

as much a poet as a painter." He goes on, however, to suggest that Vasari borrow Theocritus's invention of the encounter of Venus with Adonis, but since Theocritus is overelaborate he urges Vasari to be free with the poem and invent on his own in order to express his own poetic idea. The same distinction also occurs more than a century later, as appears in Bellori's description of *Apollo and Daphne* in a letter inscribed *Sic pictura poesis erit*. There Bellori acknowledges that Maratta "took the argument from Ovid and followed the poet's invention," but not, he continues, "without earning praise for his own *ingegno*, for in translating the poetic forms he did not act simply as a pure translator, as though the painter could invent nothing for himself." Maratta's own invention, it turns out, was an elegant little conceit that embellished the story by representing three beautiful naiads in allusion to the Graces, thereby likening Daphne's beauty, sufficient to win the love of a god, to that of Venus, mistress of the three Graces and the divine prototype of beauty itself. Although the invention bears the unmistakable stamp of *seicentismo*, it also exemplifies an unchanging concept of the painter's independent capacity for poetic invention that can be traced through time in the same way the conventions of a Petrarchan lyric can be traced, even as we can easily identify the style and invention of each poem taken individually as unmistakably those of Marino, or Bembo, or Petrarch himself.

[23] Boccaccio, op. cit., XIV.7.

trovatore. Invention means, as Boccaccio indicates and Pino merely repeats in abbreviated form, the illustrating or proving of an idea, and it is in such original discovery that painters and poets find their identity with one another. It does not mean simple illustration of a story invented earlier by another poet or painter (which was often called translation). A most impressive statement of the character of the painter's invention, claiming utter independence of the fictive, fabulizing imagination from the other parts of painting, comes from Alberti. In a famous passage in the *De pictura*, Alberti discusses invention as that activity painters have in common with poets and orators, and does so in the most extraordinary terms:

> I want the painter, so far as he is able, to be learned in all the Liberal Arts, but especially in geometry. . . . Next, it will be of advantage if [painters] take pleasure in poets and orators, for these have many ornaments in common with the painter. Literary men, who are full of information about many subjects, will be of great help in preparing the composition of a representation, and the great virtue of this consists primarily in its invention. Indeed, invention has such power that even by itself and without being painted it can give pleasure. [*Atque ea quidem hanc habet vim, ut etiam sola inventio sine pictura delectet.*] The description that Lucian gives of Calumny painted by Apelles excites our admiration when we read it. I do not think it inappropriate to tell it here, so that painters may be advised of the need to take particular care in creating inventions of this kind. [Alberti here gives his famous description, which was one of those used by Botticelli for his painting of *Calumny,* and he follows this example derived from ancient rhetoric with a poetic invention also used by Botticelli for the *Primavera.*] And what shall we say of those three young sisters, whom Hesiod called Aglaia, Euphrosyne, and Thalia? The ancients represented them dressed in loosened and transparent gowns, with smiling faces and hands intertwined; they thereby wished to signify liberality, for one of the sisters gives, another receives, and the third returns the favor, all of which should be present in every act of perfect liberality. You can appreciate how inventions of this kind bring great repute to the artist. I therefore advise the studious painter to make himself familiar with poets and orators and other men of letters, for he will not only obtain excellent ornaments from such learned minds, but he will also be assisted in those very inventions which in painting may gain him the greatest praise.[24]

[24] L. B. Alberti, *De pictura*, 53f. (in L. B. Alberti, *On Painting and On Sculpture: The Latin Texts of* De Pictura *and* De Statua, ed. C. Grayson, London, 1972, pp. 95f.). It is worthwhile commenting on Alberti's use of the word *historia* in this passage, which does not carry the meaning "history," but which also does not mean "story," as it is commonly translated. The word derives from ἱστορία as used by the Byzantine rhetoricians (to whom Alberti is extensively indebted), who were the first to apply it to painting and who meant by it simply "a painting" or "a representation." The closest equivalent still surviving in English is the adjective "historiated," as it is applied to manuscript illumination; it applies to the illumination itself, whether composed of a narrative subject, an assembly of grotesques, a decorative pattern of foliage, or simply an

Two things are especially remarkable about this passage, the first being Alberti's emphasis on new invention, something that is, however, well grounded in a knowledge of letters. Second, and most extraordinary, there appears his statement that a beautiful invention is pleasing of itself alone—*even if it is never painted*. That is to say, its beauty is of a wholly conceptual and poetically self-contained kind—the invention is itself the poem—such that a beautiful invention has the power to provoke an aesthetic response that is in a fundamental sense independent even of the representation of it. I do not suppose that anyone who has not deeply considered the invention of the *Primavera* can fully appreciate the force of that statement. The imagery of Botticelli's painting is informed by such a fine poetic instinct, combined with a philological rigor and tact so exquisitely deployed, that it produces its own aesthetic response.

The material of which the invention of the *Primavera* (plate 1) is made and with which it is ornamented comprises the ancient gods of the spring, each of whom individually and in relation to the others expresses allegorically and metaphorically qualities that define the season and its immemorial meanings. The right-hand side of the painting (plate 2) shows Zephyr, god of the west wind, cheeks distended as he blows, flying through the trees and grasping at Chloris, a nymph of the bare earth. At his touch flowers spring from her mouth (plate 4) and merge with the flowered pattern decorating the dress of the woman next to her, who moves briskly forward in a dancing quickstep (plate 5), scattering the blossoms gathered in the folds of her garment onto the path before her. This is Flora, the goddess of flowers and gardens, into whom Chloris was transformed after her rape by Zephyr. Venus stands in the center of the painting (plate 6), presiding over the garden, and above her head flies Cupid (plate 7). The sequence derives from Lucretius's description of a rustic parade of springtime deities in the fifth book of the *De rerum natura*:

> It ver et Venus et Veneris praenuntius ante
> pennatus graditur, Zephyri vestigia propter
> Flora quibus mater praespargens ante viai
> cuncta coloribus egregiis et odoribus opplet.[25]

> (Spring comes, and Venus, and Venus's winged herald [Cupid] marching before, with Zephyr and mother Flora a pace behind, strewing the path in front with beautiful colors and filling it with scents.)

The primary cast of characters is here accounted for: Venus, Cupid, Zephyr, and Flora, who strews the path with flowers. One figure, Chloris, who is really the same as Flora, appears in the painting but is not mentioned by Lucretius. Her presence is accounted for by glossing a passage from Ovid's *Fasti*, in which Flora explains how she was transformed from Chloris, nymph of the bare earth, into Flora, the goddess of flowering gardens:

abstract decoration. See H. Maguire, *Art and Eloquence in Byzantium*, Princeton, 1981, p. 9; see also E. A. Sophocles, *Greek Lexicon of the Roman and Byzantine Periods*, New York, 1887, s.v. ἱστορία.

[25] Lucretius, *De rerum natura*, v.737–740.

Sic ego, sic nostris respondit diva rogatis
 dum loquitur, vernas efflat ab ore rosas.
Chloris eram, quae Flora vocor: corrupta Latino
 nominis est nostri littera Graeca sono.
Chloris eram, nymphe campi felicis, ubi audis
 rem fortunatis ante fuisse viris.
quae fuerit mihi forma, grave est narrare modestae
 sed generum matri repperit illa deum.
ver erat, errabam: Zephyrus conspexit, abibam.
 insequitur, fugio: fortior ille fuit,
et dederat fratri Boreas ius omne rapinae
 ausus Erechthea praemia ferre domo.
vim tamen emendat dando mihi nomina nuptae,
 inque meo non est ulla querella toro.
vere fruor semper: semper nitidissimus annus,
 arbor habet frondes, pabula semper humus.
est mihi fecundus dotalibus hortus in agris:
 aura fovet, liquidae fonte rigatur aquae.
hunc meus implevit generoso flore maritus
 atque ait 'arbitrium tu, dea, floris habe.'
saepe ego digestos volui numerare colores
 nec potui: numero copia maior erat.
roscida cum primum foliis excussa pruina est,
 et variae radiis intepuere comae,
conveniunt pictis incinctae vestibus Horae
 inque leves calathos munera nostra legunt.
protinus accedunt Charites nectuntque coronas
 sertaque caelestes implicitura comas.
prima per immensas sparsi nova semina gentes:
 unius tellus ante coloris erat.[26]

[26] Ovid, *Fasti*, v.193–222. It is significant that Flora describes herself as enjoying perpetual spring (*vere fruor semper*), for where she is, there also by definition is the spring; she adds that in her garden the year is always in fullest blossom (*semper nitidissimus annus*). The flowers painted by Botticelli in the *Primavera* accordingly do not indicate a particular early or late moment in the development of the season, but instead are representative of the season in its entirety (noted by M. Levi d'Ancona, *Botticelli's Primavera: A Botanical Interpretation Including Astrology, Alchemy, and the Medici*, Florence, 1983). It is significant too that Botticelli depicted Flora wearing a painted dress, just as Ovid had described the Hours in painted dresses (*pictis incinctae vestibus Horae*).

Lightbown, op. cit., I, pp. 69–81, takes Wind to task for his famous mistranslation of line 194 (*dum loquitur, vernas efflat ab ore rosas*) as though it referred to Chloris, hence directly motivating Botticelli's representation of her in the *Primavera*, when in fact Ovid is describing the springtime flowers breathed from Flora's lips when she retrospectively tells of her humbler origins. This is done, Lightbown suggests, "in an effort to sustain his strange interpretation of Flora, Chloris, and Zephyr as a metamorphosis," and he points out that Ovid's passage refers to different moments in time. The objection is, however, extremely literal-minded, for Flora and Chloris are unquestionably the same person, and it hardly seems strange that Botticelli should have imagined Flora's tale as written by the author of the *Metamorphoses* as if it in fact described an earlier metamorphosis. As Wind wrote, "The interpretation here

(So I spoke, and the goddess answered my question thus, and while she spoke her mouth breathed the roses of spring: "I who am now called Flora was formerly Chloris: a Greek letter of my name is corrupted in the Latin speech. I was Chloris, a Nymph of the happy fields, where, as you have heard, dwelt the fortunate men of the olden days. Modesty shrinks from describing my figure: but it procured the hand of a god for my mother's daughter. It was spring, and I was roaming; Zephyr caught sight of me; I retired; he pursued and I fled; but he was the stronger, and Boreas had given his brother full right of rape by daring to carry off the prize from the house of Erechtheus. However, he made amends for his violence by giving me the name of bride, and in my marriage bed I have no complaint. I enjoy perpetual spring; always is the year in fullest blossom; the tree is clothed with leaves, the ground with pasture. In the fields that are my dower I have a fruitful garden, fanned by the breeze and watered by a spring of running water. This garden my husband filled with noble flowers and said, 'Goddess, be queen of flowers.' Often I tried to count the colors in the beds, but could not; the number was past counting. As soon as the dewy rime is shaken from the leaves, and the varied foliage is warmed by the sunbeams, the Hours draw near, clad in painted gowns, and gather my gifts in light baskets. Straightaway the Graces draw near and twine garlands and wreaths to bind their heavenly hair. I was the first to scatter new seeds among the countless peoples; until then the earth had been of but one color.")

"I was Chloris, Nymph of the happy fields, where lived the fortunate men of olden days," the goddess begins, and at the end she explains the significance of her metamorphosis: "Before the earth was of but one color." By glossing Ovid in this way, adding the figure of Chloris (plate 4) as the spirit of the bare earth in the moment of its transformation—literally becoming Flora as the first flowers of the season spew forth from her mouth (*vernas efflat ab ore rosas*)—Botticelli has altered Lucretius's simple description of a rustic parade of springtime deities into his own invention, one that changes Lucretius's sequential listing into a manifestation of the growth and development of the season. Similarly, the meaning of his Ovidian model is transformed, for Ovid does not literally describe a transformation in the *Fasti*, but Botticelli has nevertheless imagined the event as an Ovidian metamorphosis and

offered combines two traditional views which have been regarded as incompatible: first, that the figure strewing flowers is Flora, which it seems difficult to deny; secondly that the nymph pursued by Zephyr is Ovid's Chloris, whom Ovid himself identified with Flora, as did also Politian. But the contradiction vanishes if the scene is recognized *as a metamorphosis in Ovid's style*, suggested by Ovid's own phrase: 'Chloris eram quae Flora vocor' " (*Pagan Mysteries in the Renaissance*, Harmondsworth, 1967, p. 116; italics added). The essence of Botticelli's invention (for he is not illus-

trating literally either Ovid or Lucretius) is in the imagining of a true metamorphosis, which, as Wind pointed out, is shown in the flowers that stream from Chloris's mouth to merge with the flowered pattern on Flora's dress, the flowers of which in turn are shaken from her dress onto the meadow below; in such a way the flowers painted on her dress transform themselves (to adopt a familiar cliché of Renaissance poetry) into the flowers with which the earth is painted in the spring.

thereby rendered, in true Ovidian fashion, the meaning of the event in the actions themselves. In Zephyr's rape of Chloris we are shown the initial growth of the season from the first rough blowing of the inseminating west wind (the *genitalis aura*) over the bare earth, causing it to put forth the first flowers, followed by its early abundance in Flora, strewing the earth with all the flowers of the spring, and completed by its fullness in Venus, the goddess of the month of April and the generative spirit of the season's renewal. Botticelli's own meaning is not directly stated in either Lucretius's or Ovid's verses, but it emerges from their combination.

The gods who appear on the left-hand side of the *Primavera* (plate 3) are in the same way primarily determined by one of Horace's odes, in which the poet addresses an invocation to Venus, asking her to leave her home in Cyprus and come to the Sabine Hills. "O Venus, queen of Cnidos and Paphos," he begins, "forsake thy beloved Cyprus," and he continues:

> fervidus tecum puer et solutis
> Gratiae zonis properentque Nymphae
> et parum comis sine te Iuventas
> Mercuriusque.[27]

(With thee let hasten thy ardent child [Cupid], and the Graces too, with girdles all unloosed, the Nymphs, and Youth, unlovely without thee, and Mercury.)

The cast of characters appearing on the left-hand side of the *Primavera* (Mercury, the Graces, Venus, and Cupid again) is here accounted for but not explained. As it happens, however, the image of the Graces clothed in loosened gowns and accompanied by Mercury (plate 8) is extremely rare in ancient literature, and is uniquely determined by Horace's ode and by the following passage from Seneca's essay *De beneficiis*:

Of the nature and property of [benefits] I shall speak later if you will permit me first to digress upon questions that are foreign to the subject—why the Graces are three in number and why they are sisters, and why they have their hands interlocked, and why they are smiling and youthful and virginal, and are clad in loosened and transparent gowns. Some would have it appear that there is one for bestowing a benefit, another for receiving it, and a third for returning it; others hold that there are three classes of benefactors, those who earn benefits, those who return them, and those who receive and return them at the same time. But of the two explanations do you accept as true whichever you like; yet what profit is there in such knowledge? Why do the sisters hand in hand dance in a ring which returns upon itself? For the reason that a benefit passing its course from hand to hand returns nevertheless to the giver; the beauty of the whole is destroyed if the course is anywhere broken, and it has most beauty if it is continuous

[27] Horace, *Carmina*, 1.30.

33

and maintains an uninterrupted succession. In the dance, nevertheless, an older sister has special honor, as do those who earn benefits. Their faces are cheerful, as are ordinarily the faces of those who bestow or receive benefits. They are young because the memory of benefits ought not to grow old. They are maidens because benefits are pure and undefiled and holy in the eyes of all; and it is fitting that there should be nothing to bind or restrict them, and so the maidens wear flowing gowns, and these, too, are transparent because benefits desire to be seen. There may be someone who follows the Greeks so slavishly as to say that considerations of this sort are necessary; but surely no one will believe also that the names which Hesiod assigned the Graces have any bearing on the subject. He called the eldest Aglaia, the next younger Euphrosyne, the third Thalia. Each one twists the significance of these names to suit himself, and tries to make them fit some theory although Hesiod simply bestowed on the maidens the name that suited his fancy. And so Homer changed the name of one of them, calling her Pasithea, and promised her in marriage in order that it might be clear that, if they were maidens, they were not Vestals. I could find another poet in whose writing they are girdled and appear in robes of thick texture or of Phryxian wool. The reason Mercury stands with them is, not that argument or eloquence command benefits, but simply that the painter chose to picture them so.[28]

Alberti specifically had this passage at hand when he described (in the passage earlier quoted) as an example of a beautiful invention "those three young sisters whom Hesiod called Aglaia, Euphrosyne, and Thalia, [whom] the ancients represented dressed in loosened, transparent gowns [*soluta & perlucida veste*], with smiling faces and hands intertwined, [thereby wishing] to signify liberality."[29] Politian also had recourse to it when commenting on Statius's *Epithalamium in Stellam et Violentillam* (to which I shall return).[30] Seneca characterizes the Graces as clothed in loosened and transparent gowns (*solutaque et perlucida veste*), dancing with their hands intertwined, and accompanied by Mercury. These are exactly the features that distinguish Botticelli's Graces, and indeed, if we turn to his representation of the Graces (plate 8) we find that Botticelli has depicted the triple rhythm of liberality with great precision and subtlety. The central Grace, her full weight placed firmly on one foot, steps resolutely to the left, and presses her left hand gently but firmly against the

[28] Seneca, *De beneficiis*, I.iii.2ff.

[29] Alberti, *On Painting and On Sculpture*, ed. cit.

[30] A. Poliziano, *Commento inedito alle Selve di Stazio*, ed. L. Cesarini Martinelli, Florence, 1978, pp. 201ff., esp. p. 205: "Seneca in libro De beneficiis tres ait esse, quarum una beneficium dat, altera accipit, 3a reddit; vel quia tria beneficiorum genera, promerentium, reddentium, simul accipientium reddentiumque; consertae manibus, quia beneficium ad dantem refertur; iuvenes, quia beneficii memoria non debet senescere; hilares, quales sunt qui dant vel accipiunt beneficia; virgines, quia incorruptae et omnibus sanctae; solutis tunicis, quia nihil in his esse alligati debet; pellucidis, quia beneficia conspici volunt. Nomina apud Hesiodum: 1a Hegle, 2a Euphrosyne, 3a Thalia." There is an interesting later painting in Budapest, attributed to Battista Naldini, which shows the Graces clothed in transparent gowns, dancing, and in the company of a flying *putto* who carries Mercury's caduceus; A. Pigler, *Museum der Bildenden Kunst Budapest: Katalog der Galerie alter Meister*, Tübingen, I, p. 476, no. 173 (207), plate 110.

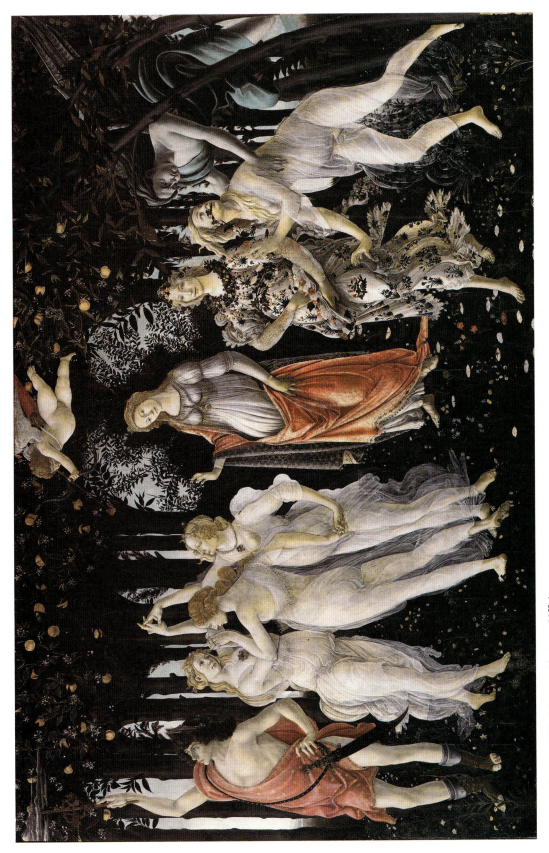

Plate 1. Sandro Botticelli, *Primavera*. Florence, Uffizi.

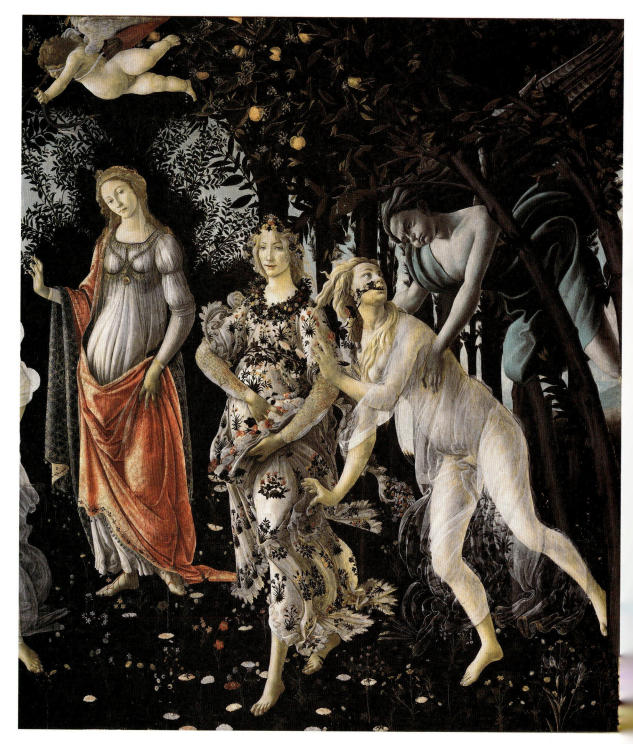

Plate 2. Detail of plate 1, *Primavera*, right-hand side: Venus, Flora, Chloris, and Zephyr.

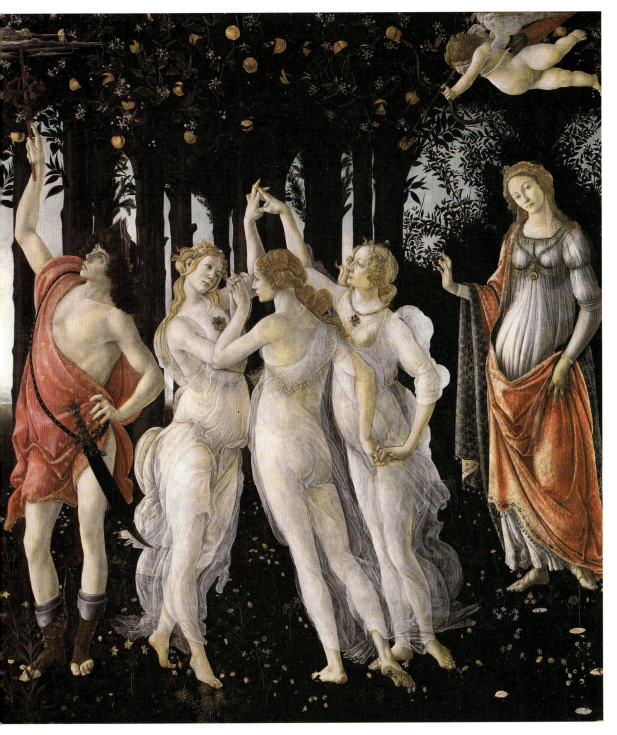

Plate 3. Detail of plate 1, *Primavera*, left-hand side: Venus, the Graces, and Mercury.

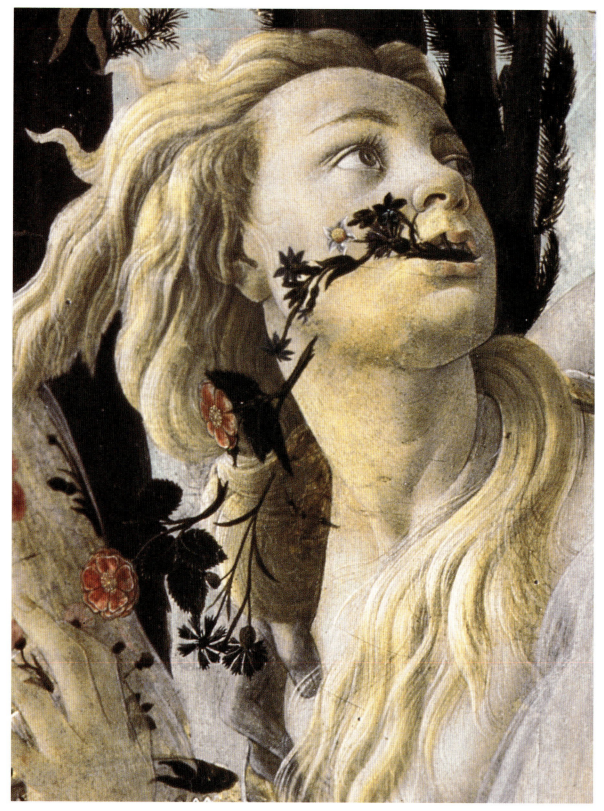

Plate 4. Detail of plate 1, *Primavera*: Chloris's head.

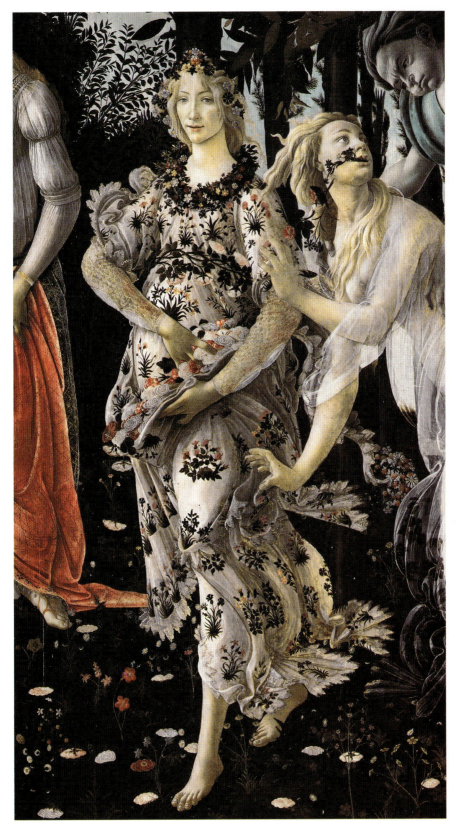

Plate 5. Detail of plate 1, *Primavera*: Flora.

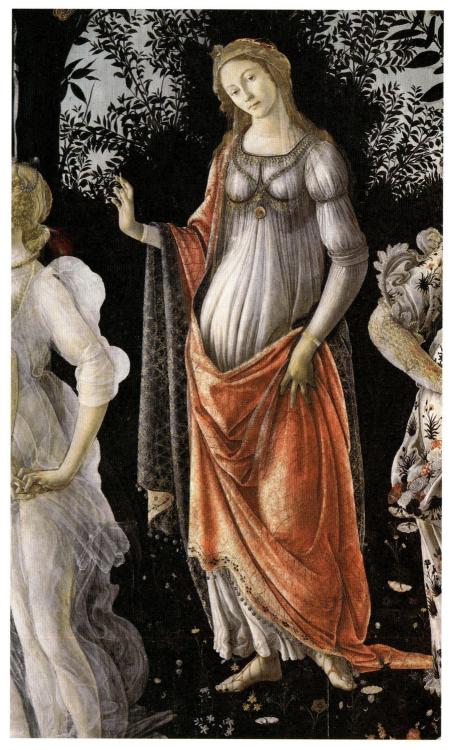

Plate 6. Detail of plate 1, *Primavera*: Venus.

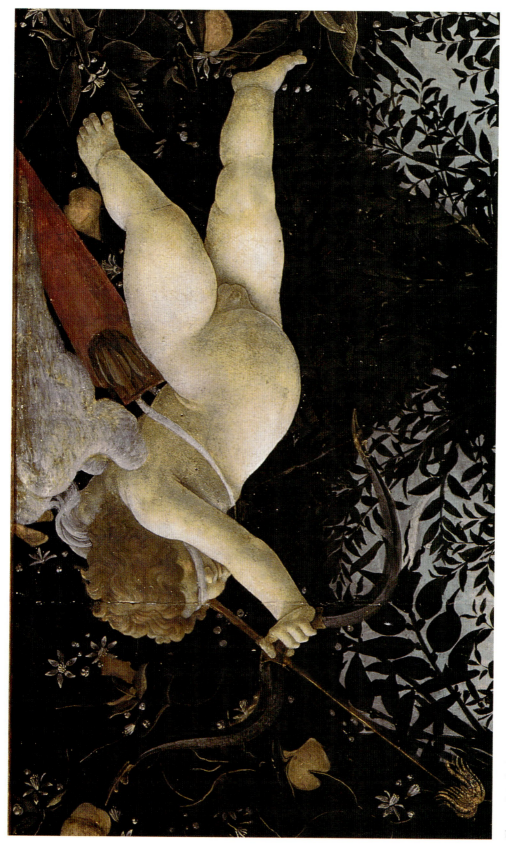

Plate 7. Detail of plate 1, *Primavera*: Cupid.

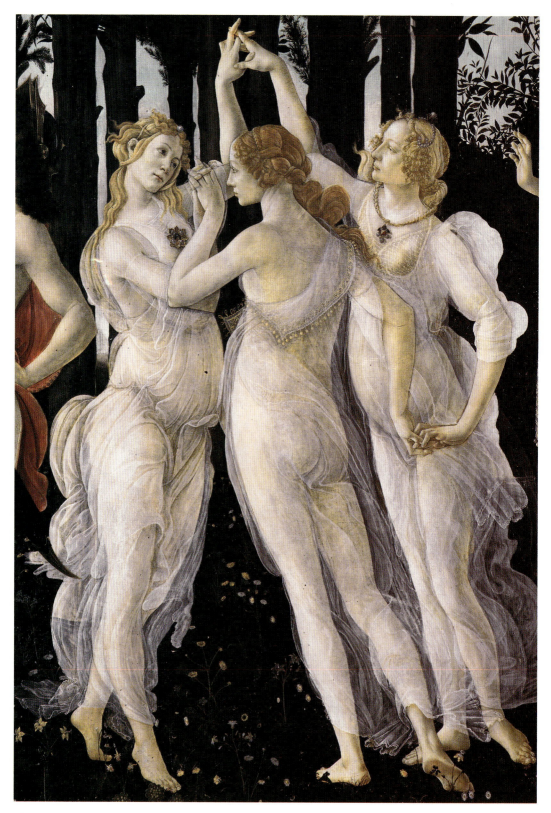

Plate 8. Detail of plate 1, *Primavera*: the Graces.

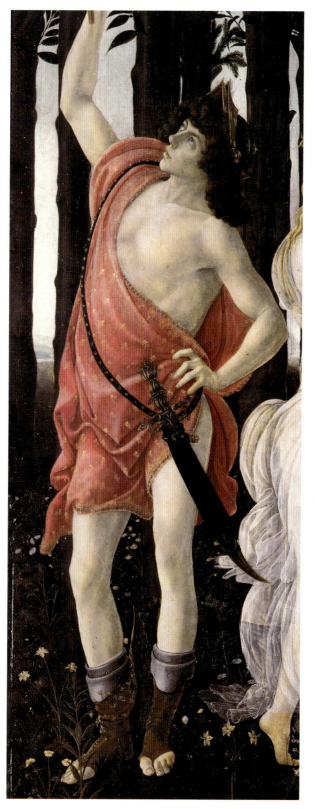

Plate 9. Detail of plate 1, *Primavera*: Mercury.

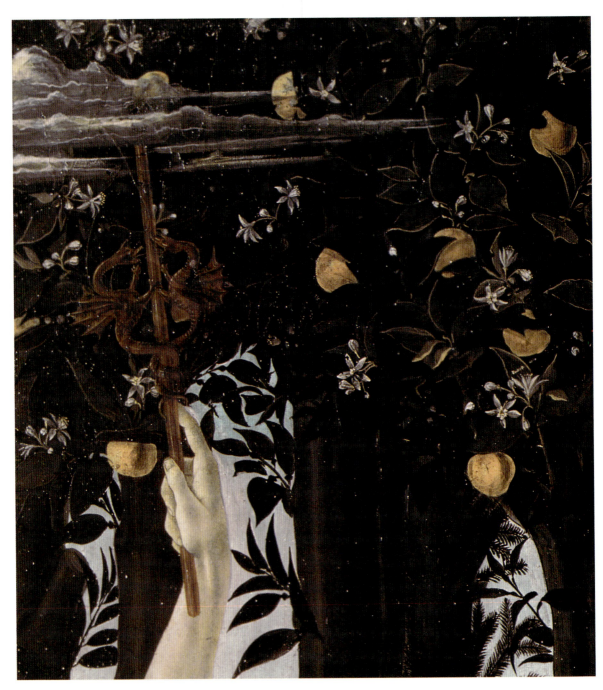

Plate 10. Detail of plate 1, *Primavera*: Mercury's caduceus dispersing the clouds.

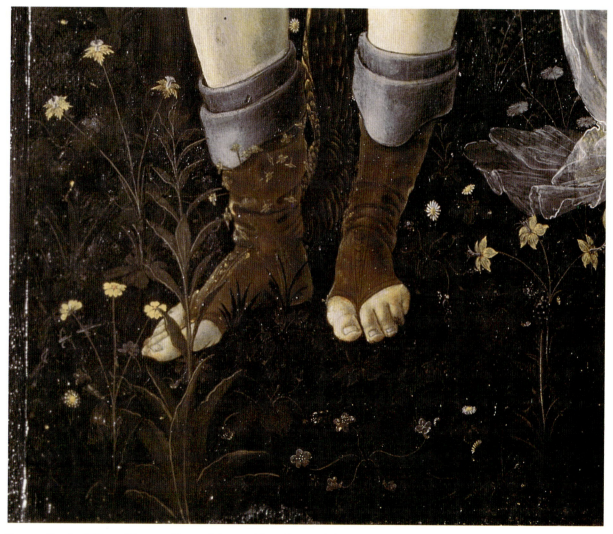

Plate 11. Detail of plate 1, *Primavera*: Mercury's boots with swirling seed clusters.

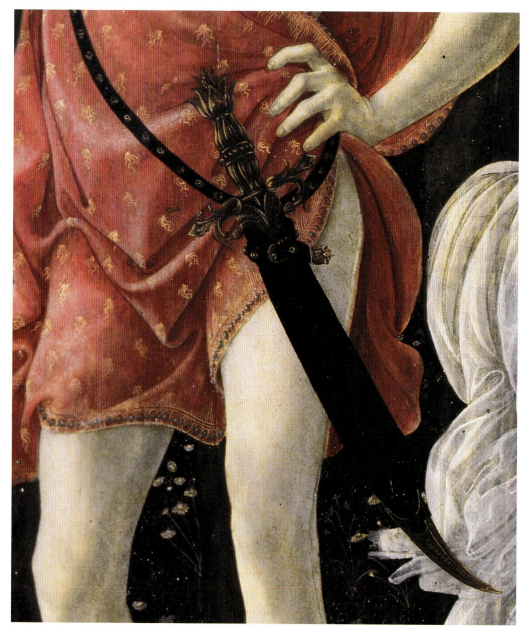

Plate 12. Detail of plate 1, *Primavera*: Mercury's *harpe*.

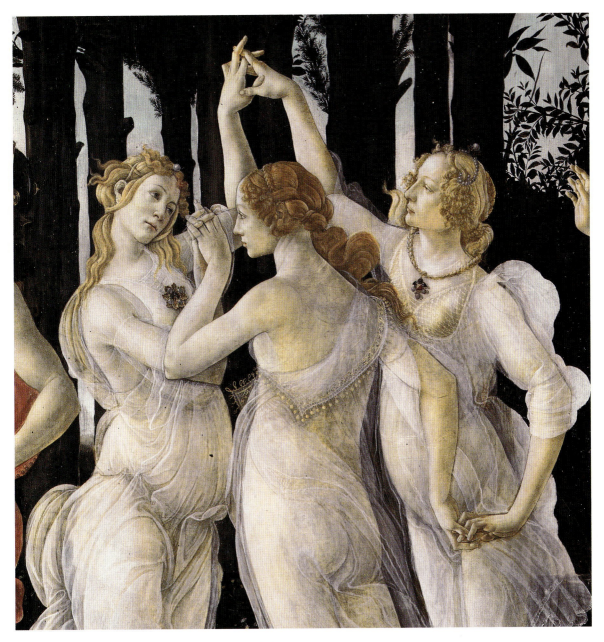

Plate 13. Detail of plate 1, *Primavera*: the Graces (upper half).

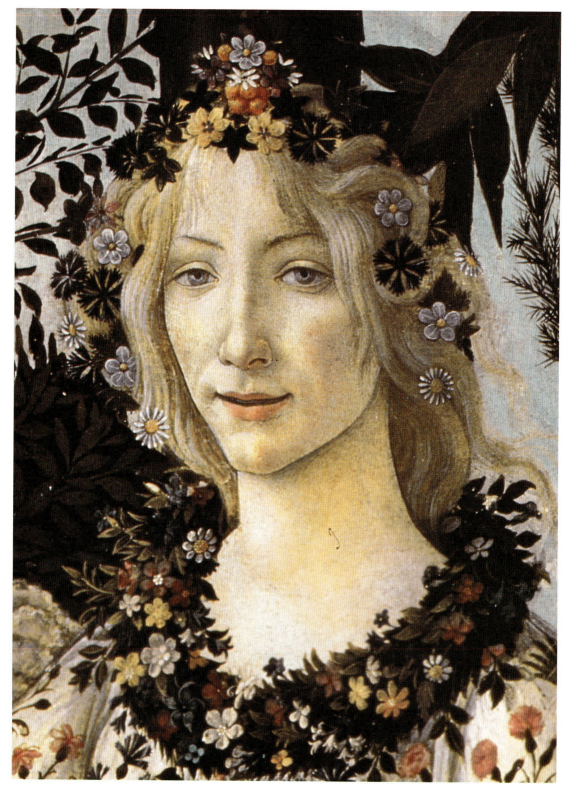

Plate 14. Detail of plate 1, *Primavera*: Flora's head.

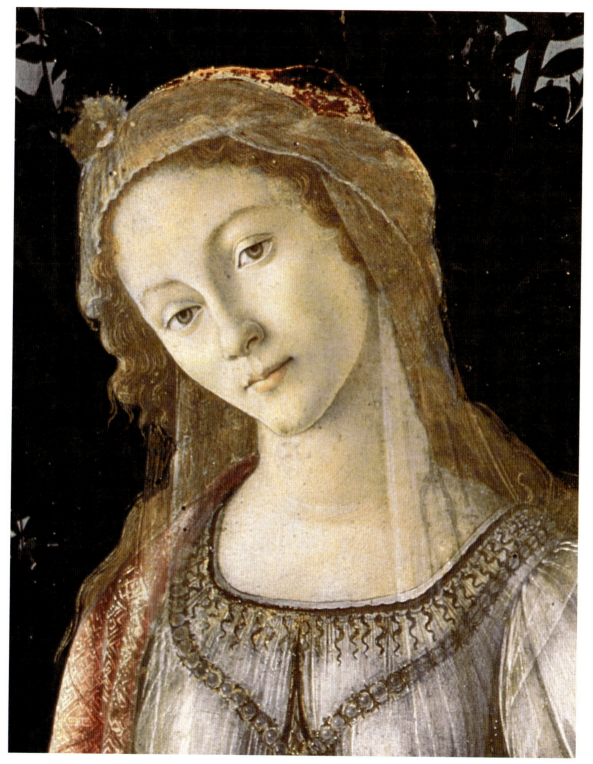

Plate 15. Detail of plate 1, *Primavera*: Venus's head.

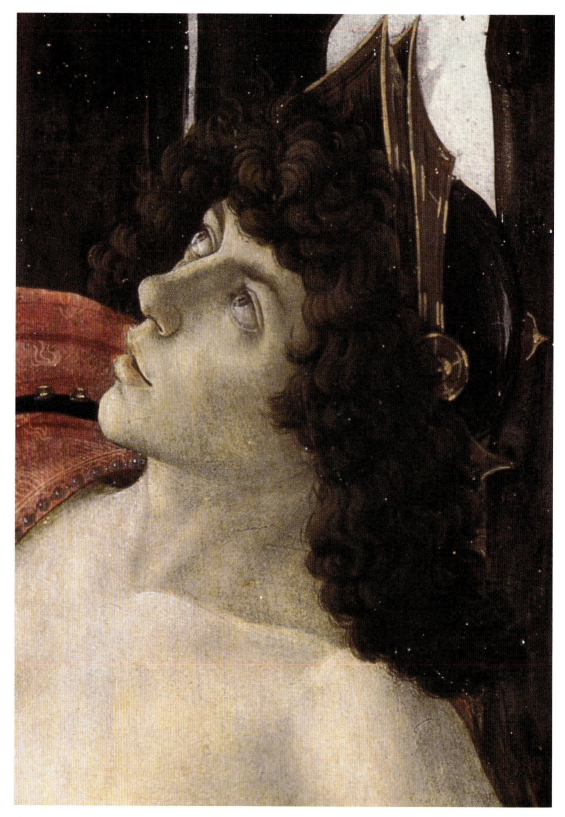

Plate 16. Detail of plate 1, *Primavera*: Mercury's head.

slightly yielding right hand of her neighbor. She in turn, even as she receives this benefit, this act of grace, shifts her feet and passes it on to the third partner of the dance. The right-hand Grace, in the most explicit gesture of all, lightly presses the fingers of her left hand into the upturned, cupped palm of the central Grace. Described purely in terms of gesture, the cycle of the giving, receiving, and returning of benefits could hardly be more poetically and accurately limned, and it is especially fitting that the cycle of liberality should be indicated by gesture alone—in fact purely as dance—since benefits are abstract and intangible in nature. Seneca's account, in which there is little enough poetry, is an amplification of Horace's simple *solutis Gratiae zonis . . . Mercuriusque*, and is legitimately and properly brought as a gloss that reveals the true meaning while utterly transforming Horace's description of the larger group of Mercury and the Graces together with Venus and Cupid.

Seneca also explains that the Graces had been employed by Stoic philosophers as an exemplum for the giving and receiving of benefits, but it is not in this sense that he most truly comments on Horace's invocation of the goddess of love, and accordingly motivates the Graces in the *Primavera*. The passage quoted above makes no mention of liberality, referring only to benefits; but Renaissance humanists well understood that the Stoic adoption of the Graces as an exemplum derived from their being the primitive goddesses of the earth's fruitfulness and liberality, as Alberti is the witness (*liberalitatem demonstratam esse voluere*). They also perceived that Seneca's description of them dancing further identified them with Hesiod's rustic goddesses, whom the ancient Greek had made the companions to the muses and who were also dancers, "the dark earth resounding about them as they chanted, and a lovely sound rising up beneath their feet."[31] As Warburg noticed, the image of Horace's dancing Graces was well known in the Renaissance. A drawing in the Codex Pighianus (fig. 2), after an ancient relief showing three clothed and dancing women, carries an inscription that identifies them clearly as "Gratiae Horatii saltantes," Horace's dancing Graces.[32] Their clothing pointed the author of the inscription to the ode by Horace just quoted. The echo of Hesiod's dancing Graces is also heard in a second ode by Horace, where the same Graces dance, "alterno terram quatiunt pede."[33]

Warburg noted that this in turn inspired the following line in Politian's *Rusticus* from his *Sylvae*: "Ludit, et alterno terram pede Gratia pulsat."[34] The *Rusticus* was

[31] Hesiod, *Theogony*, 68ff.; see also C. Dempsey, "Botticelli's Three Graces," *Journal of the Warburg and Courtauld Institutes*, XXXIV, 1971, pp. 326–330, and Wind, op. cit., chapter 5.

[32] A. Warburg, "La 'Nascita di Venere' e la 'Primavera' di Sandro Botticelli," in *La rinascita del paganesimo antico: Contributi alla storia della cultura*, ed. G. Bing, Florence, 1966, p. 28.

[33] Horace, op. cit., I.4:

Solvitur acris hiems grata vice veris et Favoni

.

iam Cytherea choros ducit Venus imminente luna,
 iunctaeque Nymphis Gratiae decentes

alterno terram quatiunt pede.

("Keen winter is breaking up at the welcome change to spring and Zephyr. . . . Already Cytherean Venus leads her dancing bands beneath the o'erhanging moon, and the comely Graces linked with Nymphs tread the earth with tripping feet."

[34] See Warburg, op. cit., pp. 43f. The relevant passage is from Politian's *Rusticus*, 210–221:

Auricomae, jubare exorto, de nubibus adsunt
Horae, quae coeli portas atque atria servant,
Quas Jove plena Themis nitido pulcherrima partu
Edidit, Ireneque Diceque et mixta parenti
Eunomie, carpuntque recenteis Pollice foetus:

written by Politian to be read as an introduction to his lectures on the georgics of Hesiod and Virgil at the *Studio Fiorentino*, and the dancing Grace he describes by echoing Horace appears there as the primitive deity of the earth sung by Hesiod. Three lines before this Politian described the springtime advent of Venus and the loves as follows: "It Venus et Venerem parvi comitantur amores," a line that directly echoes Lucretius's "It ver et Venus et Veneris praenuntius ante," from the very passage that inspired the right half of the *Primavera*.[35] On the basis of this and other similar imitative analogies between Politian's poetry, ancient poetry, and the imagery of the *Primavera*, Warburg made his argument, based on literary style and philological elegance, that Politian was the author of the invention for Botticelli's painted poem. Especially significant in this respect is the way in which, in both Politian's poetry and Botticelli's painting, a single poetic model was not followed, or simply illustrated. In each, different sources were summoned and recombined in a way that expresses a new and individual poetic idea, even while each simultaneously appeals to a cultural tradition, provoking a poetic response conditioned by the remembered echoes of the ancient poets. Also significant is the philological rigor with which these texts were brought together. The sharpness of focus that results is in itself beautiful, and contributes to the poetry a sense of mystery, of being in the living presence of the spirits of nature that had been so intimately the companions of the primitive peoples of a long-vanished golden age.

Virtually none of the serious scholars who have studied the painting has questioned the essential correctness of Warburg's establishment of the textual foundation for the invention of the *Primavera*. Much disagreement has, however, arisen over the genre of the painting. The texts adduced by Warburg, while they are wholly, and indeed inevitably, appropriate in providing the descriptive detail of Botticelli's imagery, do not have an apparent generic consistency among themselves. As Wind remarked, the parallels between the texts and the painting do not at first sight seem to extend beyond "single traits and episodes," and they appear to establish only "a connexion of mood and taste, and a community of literary interests." Accordingly, scholars have felt impelled to search further for a hypothetical model that would explain the appearances of the *Primavera* by showing that a consistent generic pattern did exist in its conception. What could Lucretius's didactic poem *De rerum natura*,

Quas inter, stygio remeans Proserpina regno,
Comptior ad matrem properat: comes alma sorori
It Venus, et Venerem parvi comitantur Amores:
Floraque lascivo parat oscula grata marito:
In mediis, resoluta comas nudata papillas,
Ludit et alterno terram pede Gratia pulsat.

("Now rejoice, the golden-haired Hours have come down from the clouds, they who guard the gates and halls of heaven, to whom lovely Themis filled with radiant Jupiter gave birth: Irene, Dice, and Eunomia (daughter of Pollux) now pluck the newly budded shoots. Proserpine is with them, made more lovely by

their company as she retraces her steps from the Stygian kingdom and hastens to her mother. Nourishing Venus comes, and is followed by the little Loves; Flora offers welcome kisses to her eager husband [Zephyr]; and in their midst with hair unbound and bared breasts dances Grace, tapping the ground with rhythmic step.")

As Warburg says, *La rinascita del paganesimo antico*, ed. cit., p. 43, "This alone is sufficient to show that Politian was also the advisor for Botticelli's [*Primavera*]."

[35] Ibid., 217 (as quoted in the previous note).

Ovid's *Fasti*, a didactic poem of the Roman calendar, a lyric invocation by Horace, Seneca's philosophical essay *De beneficiis*, and Hesiod's georgics have, after all, in common?

The answer to this lies not in their individual forms or genres, but in the *materia* that was adapted from each of them for the new invention put forward in the *Primavera*. Significantly, Botticelli did not appeal directly to Lucretius's famous invocation to Venus Genetrix for his depiction of the goddess, but instead turned to a much less familiar passage in the *De rerum natura*, in which the poet describes Venus, Cupid, Flora, and Zephyr as participants in a rustic folk pageant celebrating the four seasons. Similarly, Ovid's *Fasti* is a poem explaining the reasons for the various festivals of the Roman calendar, and their primitive and rustic origins; he tells the story of Flora's origin as Chloris, "nymph of the happy fields where dwelt the fortunate men of olden days," in order to explain why the Floralia were celebrated in the primitive agrarian calendar, based on the seasons of the farmer's year, followed in the days before the Julian reform of the Roman calendar. Horace's ode invoking the dancing Graces dressed in transparent gowns and accompanied by Mercury invokes them as primitive and rustic deities (appropriate to the setting of his Sabine farm, to which he summons them); as Seneca is the witness, they are summoned as spirits of the earth's liberality as sung by Hesiod in his early georgics—a form of poetry that describes the turning of the seasons of the farmer's year according to the primitive agrarian calendar. Thus, each of the sources for Botticelli's invention, however much the general content and individual genre of one differ from those of another, has in common with all of them that it describes or invokes the archaic springtime deities of the primitive farmer's year. The *materia* of Botticelli's invention for the *Primavera* is the *materia* of the *Scriptores rerum rusticarum*.

The specifically rustic context of Botticelli's invention is further extended and deepened when we learn that Mercury (plate 9)—whose presence and behavior in an otherwise perfectly conventional assembly of springtime deities has been a major stumbling block to interpretation of the *Primavera*—was a god of the springtime and the month of May in the Roman rustic calendar, and uniquely in the rustic calendar.[36] He lost his identity with the spring at the time of the Julian reform of the calendar, thus obscuring his relationship to the month and the season. So thoroughly indeed was his identity with the spring obscured that scholars, rightly observing that his presence in the *Primavera* was accounted for but not explained by Horace and Seneca, not unnaturally sought to save the phenomenon of Mercury's appearance by appeal to some alternative hypothesis. As Panofsky put it, "It is precisely from his presence and behavior that we may infer the presence and import of a 'metaliteral' significance in Botticelli's composition."[37] And Wind observed that "the crux of any interpretation of the *Primavera* is to explain the part played by Mercury."[38]

[36] The material that follows abbreviates and revises material originally set forth in C. Dempsey, "*Mercurius Ver*: The Sources of Botticelli's *Primavera*," *Journal of the Warburg and Courtauld Institutes*, XXXI, 1968, pp. 251–273.

[37] E. Panofsky, *Renaissance and Renascences in Western Art*, Uppsala, 1960, p. 193.

[38] Wind, op. cit., p. 121. See also W. Welliver, "The Meaning and Purpose of Botticelli's *Court of Venus* and *Mars and Venus*," *Art Quarterly*, XXXIII, 1970, pp. 347–

The calendar followed in the days of the Roman republic was not organized according to the turning of the solar or lunar years, but instead followed the changing seasons of the farmer's year and hence was called the rustic, or farmer's, calendar. It was held to have been instituted by Romulus, and it consisted of ten months. The first of these was March, which Romulus named after his father, Mars, and the second was April, named after Venus (Aphrodite), the mother of Aeneas. The third month of the rustic calendar was dedicated to Mercury, as is apparent from ancient calendar inscriptions dedicating May to Mercury and to Flora; Plutarch also gives testimony to this in his life of Numa.[39] As the god of May, which he named after his mother Maia, Mercury is also a god of the spring. He is so named by Martianus Capella, who calls him the *veris deus* who flies over the earth freshly decorated with flowers while the whole earth rejoices ("Tum vero conspiceres totius mundi gaudia convenire. Nam et tellus floribus illuminata, quippe veris deum conspexerat subvolare Mercurium").[40] In his primitive and rustic origins as the god of spring, Mercury was the wind god who presided over the insemination of the sea and land, the god of sowing; this appears from Remigius of Auxerre's commentary to the passage from Martianus just quoted: "*Mercurius deum veris* dicit quia ipse fertur praeesse seminibus maris et terrae, et ipse est deus sationum."[41] The sowing of seeds caused by the action of the wind explicitly appears in the *Primavera* by Mercury's action in stirring the clouds with his caduceus (plate 10), while clusters of seeds swirl gently to earth around his winged boots (plate 11).

The importance of Martianus Capella in the educational curriculum of the late Middle Ages requires no comment, though it should perhaps be pointed out that Remigius, who wrote the most important and extensive Carolingian commentary to Martianus, was just as familiar, since his scholia were copied out alongside the text of his author in editions of *The Marriage of Mercury and Philology* and were read together with that text in the pages of the same book. It is therefore important to know that a familiar variant reading to his comment "ipse est deus sationum" existed that actually identified Mercury with Zephyr, who is also called Favonius—"ipse est deus Favonius."[42] Whichever reading is followed in fact makes no difference, for Mercury

358, esp. p. 353, where he writes of Mercury that he "is the central enigma of the painting, and the explanation of Mercury's significance is the crucial test of any interpretation."

[39] Plutarch, *Numa*, XIX. 3.

[40] Martianus Capella, *De nuptiis Philologiae et Mercurii*, I.27: "Then will you see the whole world come together in rejoicing: for the earth was adorned with flowers when there was seen flying down the god of the spring, Mercury."

[41] *Remigii Autissiodorensis commentum in Martianum Capellam*, ed. C. E. Lutz, Leiden, 1962, p. 101; Remigius also comments on Martianus's "quippe conspexerat subvolare Mercurium deum veris," that "id est vernalis temporis."

[42] *Martiani Capellae de nuptiis Philologiae et Mercurii et de septem artibus liberalibus*, ed. U. F. Kopp, Frankfurt am Main, 1836, p. 68, with the following comment to Martianus's *veris deum*: "Ad haec Remigius monachus Antesidorensis: 'quod et ipse fertur praesse seminibus maris et terrae, et ipse est dictus Favonius.' Quem locum vide apud Alexandrum in tab. Heliaca p. 83 qui multis defendere studet hanc Martiani opinionem." The reference is to Girolamo Aleandro, Jr. (Hieronymus Aleander, Jr.), *Antiquae tabulae marmoreae solis effigie, symbolisque exculptae, accurata explicatio*, Rome, 1616, 2d ed., Paris, 1617, reprinted in J. G. Graevius, *Thesaurus antiquitatum romanarum*, Leiden, 1694–1699, v, cols. 702–762; for further discussion of Aleandro's commentary, see Dempsey, op. cit., 1968.

as the fertilizing wind god of the spring is by definition the same as Favonius, whose advent marks the beginning of the season. It is the wind that makes the plants and trees fruitful, scattering their seeds abroad, an idea that, as Roscher has noted, passed from classical antiquity into the proverbs of Germany ("Viel Wind, viel Obst") and France ("Année venteuse, année pommeuse").[43] Pliny, in his discussion of the ancient farmer's calendar, dates the beginning of the cycle of nature to the first blowing of Zephyr's warming breath over the cold and barren earth, thus initiating the season of spring, and accordingly he calls him the *genitalis spiritus mundi*, the generative breath of the world, and he derives his name, Favonius, from *fovere*, to foster.[44] Favonius (called *veris pater* by Claudian) softens the wintry sky and opens the seas to navigation after the harsh storms of late winter.[45] Mercury, who is also characterized as a wind god by Virgil, is likewise a god of navigation. He is the son of Maia, most beautiful of the Pleiades, and it is the rising of the Pleiades in early May that signals the reopening of the seas to navigation after the storms of late spring. For this reason the ides of May were sacred to Mercury, and on this day the merchants, whose livelihood depended on sea trade, dedicated a temple to him. Ovid dates the end of the spring to the night of May thirteenth (the date on which the ides fall in May), when all seven Pleiades are first visible in the night sky, and Mercury himself named the month after his mother.[46] Spring thus begins and ends on the same cloud-dispelling wind, which prunes dead branches from the trees and increases their fruitfulness. In Botticelli's painting this appears with the sudden, violent advent of Zephyr to the right, initiating the season, which ends with Mercury softening the clouds at the left, in whose month the season turns to summer.

Botticelli shows Mercury dispersing and softening clouds with his upraised ca-

[43] See W. H. Roscher, *Hermes der Windgott: Eine Vorarbeit zu einem Handbuch der Griechischen Mythologie vom vergleichenden Standpunkt*, Leipzig, 1878. For the winds as the wanton spirits bearing the fruitfulness of spring, see also Alberti's *Flores* in *Intercenales*, III: "Nam, ut primum venti, quibus ver advehebatur, per hortos passim lasciviendo discursitare cepissent, tanta florum ruina consequuta est" (ruin, that is, to those flowers that rashly blossomed before the true arrival of spring and hence were destroyed by the first violent onslaught of the winds, which prune the dead branches from the trees and inseminate the earth with new seeds); for the text, see E. Garin, "Leon Battista Alberti: Alcune Intercenali inedite," *Rinascimento*, IV, 1964, pp. 125–258, esp. pp. 132f.

[44] Pliny, *Naturalis historia*, XVI.39: "Ordo autem naturae annuus ita se habet: primus est conceptus flare incipiente vento favonio, ex a.d. fere VI idus Febr. hoc maritantur viviscentia e terra, quippe cum etiam equae in Hispania, ut diximus: hic est genitalis spiritus mundi a fovendo dictis, ut quidam existimavere flat ab occasu aequinoctiali ver inchoans." See also Varro, *De re rustica*, I.29, and Columella, *De re rustica*, XI.ii.15. The

Romans assigned a day in the calendar, 7 February, to Favonius, and this marked the official first day of spring (although Pliny warns farmers that regardless of the designated day of Favonius's arrival, spring has not really come until his warming breath can actually be felt); see further *Inscriptiones Italiae*, Rome, 1937–1963, XIII, fasc. ii (*Fasti et Elogia*, ed. A. Degrassi), pp. 407 and 421.

[45] Claudian, *De raptu Proserpinae*, II. 73.

[46] Ovid, op. cit., V.599–602:

Pliadas aspicies omnes totumque sororum
 agmen, ubi ante Idus nox erit una super.
tum mihi non dubiis auctoribus incipit aestas,
 et tepidi finem tempora veris habent.

For Mercury's naming the month after his mother, Maia, see ibid., V.103f: "at tu materno donasti nomine mensem, / inventor curvae, furibus apte, fidis." For the dedication of temples to him on the ides of May, see Festus, *De significatione verborum*, p. 133: "Maiis Idibus mercatorum dies festus erat, quod eo die Mercurii aedes esset dedicata." For further references, see *Inscriptiones Italiae*, loc. cit.

duceus in the *Primavera*, a representation of him that unequivocally identifies him as acting in his archaic persona as a springtime wind god. By this action he ends the season that began with the warming west wind blowing its regenerative breath over the bare earth, shown as Zephyr and Chloris, and that reaches its fullness in April, the month presided over by Venus. Edgar Wind, though unaware that Mercury legitimately appears in the *Primavera* as a god of the spring, realized that his actions clearly characterize him as a wind god and disperser of clouds, and he appositely cited the fourth book of the *Aeneid*, where Virgil has Jupiter address Mercury as a leader of the winds: "Vade age, nate, voca zephyros et labere pinnis . . . adloquere et celeris defer mea dicta per auras" ("Go forth, my son, summon the zephyrs and glide on thy wings . . . so carry my words down through the swift winds").[47] Herbert Horne also understood Mercury's actions correctly, observing that Botticelli specifically expressed the powers Virgil ascribed to the caduceus in the same passage from the *Aeneid*, where the poet adverts to the power it brought the god over the wind and clouds: "Illa fretus agit ventos, et turbida tranat / nubila" ("On this [i.e. the caduceus] relying he drives the winds and skims the stormy clouds").[48] The same appears from Martianus Capella's characterization of the caduceus in the same passage in which Mercury is named *veris deus*; at a blow from his staff, the figure of Virtue is literally blown upward into the heavens ("virgae perflatione concussa in caelum itura sustollitur").[49]

Mercury's association with the month of May and the season of spring had been obscured by Julius Caesar's reform of the calendar at the time of the beginning of the Roman Empire, so it is hardly surprising that the *Primavera* is almost unique in its inclusion of Mercury together with the familiar gods of spring. There does exist in the Renaissance, however, a handful of representations of Mercury as a god of the spring; not surprisingly, most of them occur in cycles of the four seasons shown (in the manner of Lucretius's description of spring and the other seasons in the passage from the *De rerum natura* that was the starting point for the right-hand side of the *Primavera*) as festival pageants conceived in the manner of ancient popular celebrations of the four seasons of the farmer's year. Antoine Caron, for example, includes Mercury in his painting *Winter*, one of three paintings of the four seasons commemorating a court pageant conceived in this vein held at Fontainebleau under the auspices of Catherine de'Medici, and in which Mercury with the spring gods announces the end of winter by leading them out of the picture at the left.[50] There are further two suites of prints of the four seasons, one by Virgil Solis of Nuremberg (1514–1562), the other by a Dutch printmaker known only by the monogram AP, both of them clearly deriving from a common source (figs. 3 and 4), both showing personifications of the seasons riding in festival chariots, and both of which show Mercury

[47] Wind, op. cit., p. 122; see also Virgil, *Aeneid*, IV.223ff. See also Boccaccio, op. cit., II.vii: "Vento agere Mercurii est."

[48] Horne, op. cit., p. 58.

[49] Martianus Capella, op. cit., I.26.

[50] For illustrations of Caron's *Triumphs of the Seasons*, see J. Ehrmann, *Antoine Caron, peintre à la cour des Valois, 1521–1599*, Paris, 1955.

as one of the attendant deities and attributes of the spring.[51] The inscription from Ovid (*Metamorphoses*, II.27–30) with which the Monogrammist AP entitled his print (fig. 4) indicates one of his sources for a description of an ancient rustic pageant celebrating the seasons, but at the same time the appearance of the muses in his and in Virgil Solis's print indicates that Martianus Capella was also used, for Mercury as the *veris deus* is described there in the company of the muses, while neither is mentioned by Ovid.[52] Virgil Solis's engraving (fig. 3) is especially interesting in that it shows the season beginning with Mars and Venus, Flora riding a festival float in the center, and Mercury leading the parade, and thus its imagery is clearly founded in the Romulan calendar. The engraving is not of his own invention but depends on a drawing made by Georg Pencz (fig. 5), with whom Virgil Solis was closely associated. Pencz was an artist deeply occupied with Florentine imagery—perhaps his most famous engravings, for example, are Germanic variations on the famous Florentine broad-manner engravings of the children of the planets.[53] There is thus good reason to suppose that the seasonal imagery of both prints, as well as of Caron's painting for Catherine de'Medici, ultimately derives from the imagery of Florentine festival pageantry as celebrated in the days of Lorenzo the Magnificent.

I shall return to this subject in due course. For my present purposes it is appropriate to mention two other works of art in which Mercury is designated as a god of the spring by being represented as a wind god and cloud disperser. The first of these, already noticed by Horne, appears in the marble relief by Agostino di Duccio in the Tempio Malatestiano in Rimini (fig. 6), where the god's power over the wind and clouds is shown by the clouds gathered around Mercury's knees.[54] This example is especially significant in that the sculpture antedates the *Primavera*. The second example is dated late in the sixteenth century. This is an engraving by Jacob Matham after an invention by Spranger (fig. 7). The engraving shows Mercury, astride the blast (in the form of a wind-spout), calming the winds and storms at the springtime advent of Venus. The composition is crowded and agitated, and at first glance one might be tempted to agree with Bartsch in entitling the engraving *The Triumph of Neptune and Amphitrite*. However, the inscription informs us in language and imagery unmistakably Lucretian (with heavy nods to Virgil) that its true subject is the advent of Venus. The goddess is shown at the left:

> Alma Venus, quocunque venis tua magna potestas,
> Imperium sine fine tuum; supera infera Mundi

[51] Dempsey, op. cit., 1968. For Virgil Solis, see further I. O'Dell-Franke, *Kupferstiche und Radierungen aus der Werkstatt des Virgil Solis*, Wiesbaden, 1977, p. 99, cat. e6; for the Monogrammist AP, see F.W.H. Hollstein, *Dutch and Flemish Etchings, Engravings, and Woodcuts*, XIII (Monogrammists of the Sixteenth and Seventeenth Century), Amsterdam, n.d., p. 12, and W. Nijhoff, *Nederlandsche Houtsneden*, The Hague, 1933–1936, plates 153–160.

[52] Martianus Capella, op. cit., I.27.

[53] For Pencz, see H. Zschelletzschky, *Die "Drei gottlosen Maler" von Nurnberg: Sebald Beham, Barthel Beham, und Georg Pencz*, Leipzig, 1975, pp. 134–168; for the drawing, see E. Bock, *Die Zeichnungen in der Universitätsbibliothek Erlangen*, Frankfurt am Main, 1929, I, p. 87, no. 289.

[54] Horne, op. cit., p. 58.

Obsequijs devota tuis: tu gaudia nutris,
Et pecudum omne genus iucundo pascis amore:
Blanda quies homini, divumque aeterna voluptas,
Qua caelum, ventos, tempestatesque serenas.
Te penes arbitrium pelagi, Dominamque fatentur
Neptunusque pater Phorcique exercitus omnis.[55]

(Nourishing Venus, wherever you come with your great power empire without end is yours; heaven and earth celebrate your rites: you nourish joy, and with delightful love you feed your flocks of every kind: soft repose of men, eternal pleasure of the gods, you, who calm the heaven, the winds, and the storms. Father Neptune cedes into your keeping his domain, the rulership of the seas, and all the army of Phorcus.)

The author of the inscription here refers to Venus's power to calm the winds and clouds at her springtime advent, and in so doing he is alluding to Lucretius's characterization of the powers of the goddess in the opening hymn of the *De rerum natura* ("Te dea, te fugiunt venti, te nubila caeli"). Matham's engraving shows this by representing Mercury as the wind god who, at her bidding, gathers the winds and storms around himself in order to calm her springtime passage over the waves.[56] Botticelli's Mercury appears in the same role, with the important difference that he is not shown in the company of the seaborn(e) Lucretian Venus Genetrix, the fully defined nature goddess of the Roman Empire (indeed, showing her together with the Mercury of the rustic calendar is a solecism on Matham's part); instead he correctly appears with her humbler ancestor, Venus as goddess of the fruitfulness of the earth and gardens.

When Horne noticed that Mercury's action of dispersing clouds in the *Primavera* (plate 10) identified him as a wind god, and that the powers of the caduceus to drive the clouds are characterized by Virgil, he also observed that Mercury wears on his feet the *talaria aurea* (plate 11), "which carry him upborne on wings over seas and land, swift as the gale" ("quae sublimem alis sive aequora supra / seu terram rapido pariter cum flamine portant"); he further noticed that Mercury wears at his side the "adamantine *harpe*" (plate 12).[57] Lightbown acutely observed that the form of this sword, curved like a scimitar, identifies it clearly as a Renaissance falchion.[58] The

[55] Bartsch, *Le peintre graveur*, 204.
[56] The composition and cast of characters of Matham's engraving recall Poussin's *Triumph of Venus* in Philadelphia, which also has been mistakenly identified on occasion as a triumph of Neptune and Amphitrite because of the presence of Neptune (in whose realm Venus was, after all, born). Poussin also shows the spout in which the winds are gathered up on Venus's calming arrival, but he omits Mercury as the wind god (and rightly so, for his Venus is the full Venus Genetrix of Lucretius and the Roman Empire, and Mercury as wind god and as god of the spring is pre-

Empire and in his archaic manifestation). For a discussion of the visual and textual precedents for Poussin, see C. Dempsey, "Poussin's *Marine Venus* at Philadelphia: A Re-identification Accepted," *Journal of the Warburg and Courtauld Institutes*, XXVIII, 1965, pp. 338–343, and idem, "The Textual Sources of Poussin's *Marine Venus* in Philadelphia," ibid., XXIX, 1966, pp. 438–443.
[57] Horne, op. cit., p. 58.
[58] Lightbown, op. cit., I, pp. 69–81. For the falchion, or *falx* (*harpe*), as the attribute of Mercury, see S. Reinach's excellent entry, with full classical references (Valerius Flaccus, *Argonautica*, IV.388; Ovid,

falcione is a short curved sword that derives its name from the Latin *falx*, which is synonymous with the Greek *harpe*. The primary meaning of the word in all three languages is "sickle" or "billhook," describing various instruments for pruning vines or trees. Like the machete, the *harpe* could also be used as a sword. It is commonly given to Perseus, who slew the Gorgon with it, but the *harpe* had been given to Perseus by Mercury, whose sword it was, and who had used it to kill Argus. Ancient representations of Mercury's *harpe* conventionally show it as a short sword with a curved billhook attached to one side of the blade, thereby indicating its double function as an agricultural instrument and as the weapon that killed Argus and the Gorgon (thereby distinguishing it from the *harpe* of Saturn, usually represented as a sickle or even a scythe). By giving Mercury a falchion Botticelli denoted Mercury's curved *harpe*; he thereby characterized him not only as a cloud disperser but also as the wind that prunes dead branches from the trees—and indeed the trees in the *Primavera* have been neatly pruned. Botticelli did not attempt to endow Mercury with his ancient *harpe*, but instead gave him a beautifully worked and bejeweled contemporary parade falchion. This is significant, just as it is highly significant that none of the costumes depicted in the *Primavera* is a recreation of an article of ancient clothing. I shall return to this point in its place. For the moment the important facts are that Mercury is shown with his "adamantine *harpe*," that the *harpe* is a sickle-sword used for pruning trees, and that the trees in the *Primavera* are pruned.

Mercury was, then, a god of the May and the spring in the archaic rustic calendar, and in this rustic guise he was a wind god who dispelled clouds, trimmed dead wood from the trees, and inseminated the earth. Botticelli's inclusion of him in the *Primavera* together with otherwise quite conventional and well-known spring deities is accordingly explicable on the grounds that in primitive times he was a *veris deus* whose original nature and actions have been well understood and represented by the artist. The imagery of the *Primavera* noted thus far makes clear that the *materia* of Botticelli's invention is identical to the *materia* of the *Scriptores rerum rusticarum*, the writers on the ancient agrarian calendar, and the seasons of the farmer's year. The appearance of Mercury in the picture helps reinforce the hypothesis that it is in the *materia* of the *Scriptores rerum rusticarum* that the conceptual unity of Botticelli's invention is founded.

Moreover, the conception of Mercury as an archaic god of the springtime suggests the collaboration of a highly knowledgeable and philologically sophisticated mind, a mind (as Warburg already realized) on the order of Politian's. Such a conclusion is reinforced when we find that Mercury is not the only god in the *Primavera* who appears in a primitive and rustic character, and that a similar philological rigor and consistency informs the characterization of the other gods represented in the

Metamorphoses, v.69; Lucan, *Pharsalia*, ix.659–665 ["et subitus praepes Cyllenida sustulit harpen"]; etc.), in Daremberg and Salio's *Dictionnaire des antiquités grecques et romains*, s.v. "falx." Cellini's *Perseus* also wields the *harpe* in the form of a Renaissance falchion

(see J. Pope-Hennessy, *Cellini*, New York, 1985, p. 186 and plate 86); while the correct ancient form of the *harpe* appears in Canova's *Perseus* in the Vatican (M. Praz and G. Pavanello, *L'opera completa del Canova*, Milan, 1976, p. 104, no. 121, and plate XXVIII).

painting. The same qualities are evident, for example, in the selection of Horace and Seneca as foundations for the representation of the Graces, for the maker of that selection perceived that the clothed and dancing Graces they describe in the company of Mercury are uniquely characterized as the archaic and primitive goddesses of the earth's liberality, specifically derived from an ancient tradition that goes back to Hesiod. The more familiar and later tradition is that referred to by Servius, who describes the Graces as nude and standing still, and who does not mention Mercury at all.[59] The more ancient tradition of the clothed Graces had, however, been mentioned specifically as archaic by Pausanias when he pointed out that in more ancient times the Graces were shown clothed, but that later it became the custom to represent them naked.[60] Pausanias's testimony was moreover used by Politian (as was Seneca's) in his commentary to Statius's *Epithalamium in Stellam et Violentillam* (*Sylvae* I.2), in which he noted that it was not known who first made the Graces nude, but that the more ancient sculptors and painters showed them with clothing ("Latet qui primus nudas Gratias fecerit: nam antiquiores et sculptores et pictores cum amictu eas fecerunt").[61]

The idea of images created by *antiquiores pictores*, the more ancient painters, is a significant one in the conception of the *Primavera*. Botticelli's representation of Venus as goddess of the garden (plate 6) is likewise specifically and uniquely an archaic conception, for both Varro and Festus affirm that Venus of the gardens (Venus Hortorum) is an old-fashioned and rustic deity—like Mercury as a god of the spring, she had lost this role by the end of the Roman republic—and that in olden days she was thought to be identical with Flora, who subsumed her function as the *dea hortorum*.[62] Hence Botticelli's Venus, goddess of the fullness of the spring's fertility, appears as the natural completion of the transformation initiated by Zephyr's rape of Chloris. That she appears clothed is also specifically an indication of her archaic guise, as it is for the Graces, distinguishing her sharply from the much more familiar nude and seaborne Venus Genetrix painted by Botticelli in the so-called *Birth of Venus*.[63] Her character as a garden goddess is most fully defined in the tenth book of Columella's *De re rustica*, written as a georgic in imitation of Virgil. The subject of this book is the care of gardens ("Hortorum quoque te cultus, Silvine, docebo"), and Venus is described there as the spirit of April and the spring:

[59] Servius, *In Vergilii Aeneidem*, I.720; see also Wind, op. cit., pp. 31–48, and Dempsey, op. cit., 1971.

[60] Pausanias, *Graeciae descriptio*, IX.xxxv.6: "Who it was who first represented the Graces naked, whether in sculpture or in painting, I could not discover. During the earlier period, certainly, sculptors and painters alike represented them draped. . . . Certainly today sculptors and painters represent Graces naked."

[61] Poliziano, *Commento inedito*, ed. cit., pp. 201f.: "It is not known who first made the Graces nude: but the more ancient sculptors and painters both made them clothed."

[62] Varro, op. cit., I.i.6; see also *De lingua latina*, VI.20; Festus, op. cit., s.v. "Vinalia rustica": "Veneri templa sunt consecrata, quia in ipsius Deae tutela sunt horti"; Pliny, op. cit., XIX.19, and for further references *Inscriptiones Italiae*, op. cit., XIII, fasc. ii, pp. 446f.

[63] I say the so-called *Birth of Venus* because I prefer the title *Advent of Venus*, referring to the annual return of the goddess in the springtime, which hence identifies Botticelli's painting as a return to the same theme of the springtime, though in a more thoroughly classical manner, that he had earlier treated in the *Primavera*. Both paintings thus fully embody the ancient origins and meaning of Lorenzo's motto, *Le tems revient*.

Tuque tuis, Paphie, Paphien iam pange calendis;
Dum cupit, et cupidae quaerit se iungere matri,
Et mater facili mollissima subiacet arvo,
Ingenera; nunc sunt genitalia tempora mundi:
Nunc amor ad coitus properat, nunc spiritus orbis
Bacchatur Veneri, stimulisque cupidinis actus
Ipse suos adamat partus, et fetibus implet.
Nunc pater aequoreus, nunc et regnator aquarum,
Ille suam Tethyn, hic pellicit Amphitriten,
Et iam caeruleo partus enixa marito
Utraque nunc reserat pontumque natantibus implet.
Maximus ipse deum posito iam fulmine fallax
Acriseoneos veteres imitatur amores,
Inque sinus matris violento defluit imbre.
Nec genetrix nati nunc aspernatur amorem,
Sed patitur nexus flammata cupidine tellus.
Hinc maria, hinc montes, hinc totius denique mundus
Ver agit: hinc hominum pecudum volucrumque cupido,
Atque amor ignescit menti, saevitque medullis,
Dum satiata Venus fecundos compleat artus.
Et generet varias soboles, semperque frequentet
Prole nova mundum, vacuo ne torpeat aevo.[64]

(On your calends, Venus of Paphos, plant the Paphian lettuce; while the plant yearns to join with the mother earth, who deeply desires to join with it, and while the mother earth lies softly open for easy plowing, grant her pregnancy. Now is the mating time of the world: now love rushes to union, now the spirit of the world revels in Venus and, driven to frenzy by Cupid's passionate barbs, makes love to her own children and fills with offspring. Father Oceanus now seduces his Tethys, and the ruler of the seas his Amphitrite, and each soon displays to her caerulean lord newly born children, and the sea fills up with swimmers. The king of gods himself lays down his thunder and imitates the ancient loves whereby he deceived Danae, and in impetuous rain descends into the lap of Mother Earth. Nor does the generating mother scorn the love of her son, but inflamed with desire accepts his embrace. Hence the seas, hence the hills, hence even the whole earth is celebrating spring; hence comes desire to men and beasts and birds, and love

[64] Columella, op. cit., x.192–214 (my translation). Columella, like Lucretius, whose popularity he rivaled in the fifteenth century, had been discovered by Poggio Bracciolini, who sold a copy to Giovanni di Cosimo de'Medici. An inventory of the possessions of Piero de'Medici made in 1465 mentions a second copy, which is now in the Laurentian Library. There survive some twenty fifteenth-century MSS of Columella, most of them earlier than the first printed edition of 1472. Luca della Robbia's twelve roundels of the Labors of the Months, now in the Victoria and Albert Museum, were originally part of Piero de'Medici's study in the Palazzo Medici; their imagery is uniquely determined by the *De re rustica*, as has been noted by J. Pope-Hennessy, *Luca della Robbia*, Ithaca, New York, 1980, p. 44.

burns in the mind and rages in the marrow, until Venus is satiated and fills their fruitful parts and brings forth various progeny, and ever fills the world with new offspring so that it will not become sluggish in childless old age.)

These lines ring with the stirring accents of Lucretius's hymn to Venus Genetrix in the *De rerum natura*. The primitive goddess of the gardens, so intimately familiar to the peasant farmers of olden times, is the true embodiment of the ancient Venus Physica, and carries latent within her all the awesome potency of the majestic nature goddess to whom Lucretius made appeal:

> Aeneadum genetrix, hominum divomque voluptas,
> alma Venus, caeli subter labentia signa
> quae mare navigerum, quae terras frugiferentis
> concelebras, per te quoniam genus omne animantum
> concipitur visitque exortum lumina solis:
> te, dea, te fugiunt venti, te nubila caeli
> adventumque tuum, tibi suavis daedala tellus
> summittit flores, tibi rident aequora ponti
> placatumque nitet diffuso lumine caelum.
> nam simul ac species patefactast verna diei
> et reserata viget genitabilis aura favoni,
> aeriae primum volucres te, diva, tuumque
> significant initum perculsae corda tua vi.
> inde ferae pecudes persultant pabula laeta
> et rapidos tranant amnis: ita capta lepore
> te sequitur cupide quo quamque inducere pergis.
> denique per maria ac montis fluviosque rapacis
> frondiferasque domos avium camposque virentis
> omnibus incutiens blandum per pectora amorem
> efficis ut cupide generatim saecla propagent.
> quae quoniam rerum naturam sola gubernas
> nec sine te quicquam dias in luminis oras
> exoritur neque fit laetum neque amabile quicquam,
> te sociam studeo scribendis versibus esse
> quos ego de rerum natura pangere conor
> Memmiadae nostro, quem tu, dea, tempore in omni
> omnibus ornatum voluisti excellere rebus.[65]

(Venus Genetrix, mother of Aeneas and his race, pleasure of men and gods, nurturing Venus, who beneath the smoothly gliding heavenly signs fills to teeming the ship-bearing sea and the fruitful earth, since through you every kind of living thing is conceived and rising up looks upon the light of the

[65] Lucretius, op. cit., I.1–27.

sun: from you, goddess, from you the winds fly away, the clouds of the heaven flee from you and your coming; for you the wonder-working earth puts forth sweet flowers, and for you the wide stretches of the ocean laugh and the heaven grown serene glows with outpoured light. For as soon as the face of the spring day is exposed to view, and the breeze of the generating west wind blows fresh and free, then first the birds of the air make your presence known, goddess, and your advent, pierced to the heart by your power. Then the herds of beasts prance about over the rich pastures and swim across rapid rivers, and each, held captive by your charm, follows with passionate desire wherever you go on to lead. Thereupon throughout the seas and mountains and rushing rivers and the leafy homes of birds and verdant plains, striking soft love into the breasts of all creatures, you cause them with passionate desire to propagate generations after their own kind. Since therefore you alone govern the nature of things, since without you nothing rises into the shining borders of light, nor is anything joyous and lovely made, you I seek as partner in writing the verses that I am trying to fashion on the nature of things for our Memmius, endowed with all gifts, whom you, goddess, have at all times wished to excel.)

Accordingly, Politian brought both Columella and Lucretius to bear in his commentary on the following lines from Venus's speech in Statius's *Epithalamium in Stellam et Violentillam*, in which he characterizes the elemental powers of Venus Physica, the ancient generating Venus of the Romans:

> quas ego non gentes, quae non face corda iugavi?
> alituum pecudumque mihi durique ferarum
> non renuere greges, ipsum in conubia terrae
> aethera, cum pluviis rarescunt nubila, solvo.
> sic rerum series mundique revertitur aetas.[66]

(What peoples, what hearts have I not subjected with my torch? Birds and cattle, and savage herds of beasts have not denied me. I melt the ether itself, when the clouds empty themselves in showers of rain, into union with the earth. Thus arises the cycle of life, and the world's age is renewed.)

Politian observes in his commentary that Statius, in common with Columella and Lucretius, characterizes the fundamental principles of natural generation. He also comments that the gods—Jupiter as the ether, for example—all represent the elemental forces of the springtime weather, which are stirred into regenerative combination by the irresistible powers of love and desire that are unleashed by fructifying Venus. The foundation of his commentary is Servius's comment on a passage from Virgil's second georgic, a passage most aptly adduced by Politian as the particular inspiration

[66] Statius, *Sylvae*, I.ii.183–187 (*Epithalamium in Stellam et Violentillam*). Here, as well as in Lucretius and Virgil, is the classical foundation for Lorenzo's motto, *Le tems revient.*

47

not only for Statius's lines, but also for the characterization of Venus and the generative spring in the passage from Columella just quoted.[67] Virgil writes:

> Ver adeo frondi nemorum, ver utile silvis;
> vere tument terrae et genitalia semina poscunt.
> tum pater omnipotens fecundis imbribus Aether
> coniugis in gremium laetae descendit et omnis
> magnus alit magno commixtus corpore fetus.
> avia tum resonant avibus virgulta canoris
> et Venerem certis repetunt armenta diebus;
> parturit almus ager Zephyrique tepentibus auris
> laxant arva sinus; superat tener omnibus umor,
> inque novos soles audent se gramina tuto
> credere, nec metuit surgentis pampinus Austros
> aut actum caelo magnis Aquilonibus imbrem,
> sed trudit gemmas et frondes explicat omnis.
> non alios prima crescentis origine mundi
> inluxisse dies aliumve habuisse tenorem
> crediderim: ver illud erat, ver magnus agebat
> orbis et hibernis parcebant flatibus Euri,
> cum primae lucem pecudes hausere, virumque
> ferrea progenies duris caput extulit arvis,
> immissaeque ferae silvis et sidera caelo.[68]

(Spring it is that helps the woods, and spring the leaves of the forests; in the spring the soil swells and calls out for the germinating seed. Then the father omnipotent, Aether, descends in fruitful showers into the lap of his joyous spouse, and his might, commingling with her mighty body, nurtures all growths. Then the pathless copses ring with birdsong, and in their appointed times the herds repeat the rites of Venus. The bountiful land gives birth, and the fields lie open beneath the warming westerly zephyrs. Soft moisture overcomes all things, and the grasses safely dare to thrust themselves up to face new suns; the vine tendrils no longer fear the rising south wind, nor a storm driven though the sky by the mighty north wind, but thrust forth their buds and unfold all their leaves. Even such days, I would suppose, shone at the first dawn of the infant world, and even such was the course they held. Springtime that was; the great world was celebrating Spring, and the east winds spared their wintry blasts, when the first cattle drank in the light, and the iron race of man raised its head from the hard fields, and the wild beasts were loosed into the forest and the stars into the sky.)

[67] Poliziano, *Commento inedito*, ed. cit., pp. 247ff., where Lucretius and Columella are also cited in relation to Statius's passage.

[68] Virgil, *Georgics*, II.323–342.

Springtime that was, in the first shining days of the world! Mercury, the three Graces, and Venus are all shown in the *Primavera* in their immeasurably ancient manifestations as the archaic deities of nature's fertility, the renascent gods of the first spring that shone on the face of the earth. So too are Zephyr, Chloris, and Flora, dwellers in the happy fields inhabited by the fortunate men of the olden days, whose archaic origins as gods of the wind and fields were never obscured, and whose appearances in the *Primavera* are in any case explained by Ovid's account of the primitive origins of the feast of the Floralia. Thus I am encouraged in the hypothesis that, contrary to what Wind and Panofsky believed, there is a classical generic consistency to the imagery of the *Primavera*. For the moment we can rest content with calling this a species of *carmen rusticum*. The subject of this ancient farmer's song is indeed the spring, which begins with the passionate, warming gusts of the west wind blowing over the bare earth, and ends with the mild wind that softens and disperses the last clouds from the sky. It is a hymn to the abundance and liberality of the earth, and to the inseminating wind that flies over it, and it is especially a hymn to the regenerative spirit of life in nature, a spirit summarized in Venus Physica, or, to give her her Roman name, Venus Genetrix. Having thus isolated the *materia* of Botticelli's invention in the *Scriptores rerum rusticarum*, it now becomes important to consider the form in which it is presented.

POETRY AS PUBLIC MYTH

The *Primavera* and Vernacular Expression

HEN Poggio Bracciolini returned from his famous trip to St. Gall with the manuscript of Lucretius's *De rerum natura*, it must have been striking and thrilling to the first readers of the poem to discover the utter familiarity of the goddess they found hymned in magnificent Latin in the opening invocation. She is none other than the full ancient manifestation of the goddess Natura written of in much humbler style by Bernard Sylvestris and Alain de Lille in the *De planctu Naturae* and *Anticlaudianus*.[1] In the early Neoplatonism of the School of Chartres, the goddess Natura was conceived as a kind of ministering agent for the God who authored the universe, organizing the *materia* of the visible

[1] See, for example, Alain de Lille's description of the coming of Natura and the *hieros gamos* of the world at her approach (*De planctu Naturae*, *Prosa*, II): "At the arrival of the aforementioned Virgin you would have thought that all the elements, as though they then renewed their kinds, were celebrating. . . . Phoebus too, assuming an unusually gladsome countenance, poured forth all the riches of his light to greet the maiden's arrival. . . . The air, putting off his weeping clouds, with serene and friendly cheer smiled upon her where she came, and whereas he had before been aggrieved by the raging of Aquilo now found ease in the bosom of Favonius. The birds, moved by some kindly inspiration, played pleasing games with their wings and showed to the Virgin a worshipful countenance. Juno, who for a long time had scorned the playful embraces of Jupiter, was now intoxicated with such great joy that she set her husband on fire for pleasing passages of love. The sea, that before had been raging with tossing waves, at the Virgin's coming made a holiday of peace and swore an everlasting calm; for Aeolus had chained the tempestuous winds in their prisons to bar them from stirring up their wars (more than civil) in the Virgin's presence. The fish, swimming on the surface of the water so far as the slowness of their sensuality allowed, proclaimed the arrival of the Virgin with a festive gaiety; and Thetis, joining with Nereus, thought it time to conceive a second Achilles. Moreover certain Nymphs, the greatness of whose beauty would not only steal away man's reason but also force the gods of heaven to forget their divinity, issuing forth from the stream-beds and tributaries presented their queen with little gifts of aromatic nectar. When the Virgin had graciously received these, she showed the Nymphs her love for them by clasping them in long embraces and oft-repeated kisses. And truly the earth, that before lay stripped of her ornaments by plundering winter, acquired a scarlet garment of flowers from the largesse of Spring, lest, dishonored in her old attire she might not decently be seen before the Virgin." *Alain of Lille: The Plaint of Nature*, trans. and comm. J. J. Sheridan (Pontifical Institute of Mediaeval Studies: Mediaeval Sources in Translation, 26), Toronto, 1980. See also C. S. Lewis, *The Allegory of Love*, Oxford, 1968, pp. 106ff., and T. Gregory, "The Platonic Inheritance," in *A History of Twelfth-Century Philosophy*, ed. P. Dronke, Cambridge, 1988, pp. 54–80.

world, and in this figuration as the author of the world's generation she was assimilated into broader literary culture in such works as the *Tesoretto* of Brunetto Latini and the *Roman de la Rose*.[2] In Lucretius's Venus Genetrix there appears the full nature goddess that Venus once was, the true Venus Physica of the ancient Romans, celebrated from time immemorial in the ancient rites and festivals of the primitive inhabitants of the Italian peninsula. Such festivals, as we have seen, are specifically alluded to in the material that was brought together as the foundation for the invention of the *Primavera*, notably in the *Fasti* and in Lucretius's own description of a springtime pageant float in the fifth book of the *De rerum natura*. The classical poetic consistency giving unity to Botticelli's invention lies latent in this material, which I have argued derives its coherence from the *materia* of the *Scriptores rerum rusticarum*. Accordingly, I have identified the foundation for Botticelli's poetic expression with a form of *carmen rusticum*.

For clarity's sake, the following general points should be made about the status of classic rustic song in the Renaissance. The pastoral mode is notoriously difficult to define neatly, even though most of us have a fairly clear idea of what we think we mean by it, an idea based on mood, locale, and descriptive paraphernalia. Our conception of it, however, is in certain respects quite different from that of the earlier Renaissance, and is inevitably colored not only by the poetry of antiquity, but also by the poetry written in the wake of the literary war fought after the publication of Guarini's *Pastor fido* in 1580.[3] At that time, a century after the *Primavera* was painted, the qualities of the pastoral as a separate genre were for the first time fully disputed and given definition, with the purpose of filling the lacuna created by Aristotle's failure to consider the form (which he would have had to be prescient to do). Before then the pastoral in Renaissance criticism, on the basis of excellent ancient authority, was subsumed under the category of the epic, which was divided into high, middle, and low styles, with bucolic defined as the low form of the epic.[4] So far as the georgic is concerned, Minturno's *Poetica Toscana*, written at the time of the Council of Trent and itself characteristic of its own contemporary preoccupation with bringing together Horatian and Aristotelian poetic thinking, is useful in giving a sense of the issues he inherited from previous criticism. Where fifteenth-century scholars had earlier thought the georgic, on the example of Virgil, to be a lower form of poetry, Minturno went so far as to deny on the basis of Aristotle's *Poetics* that the georgic is a form of poetry at all, since verse that is didactic in content does not conform to either of the two fundamental criteria defining poetry: it is not mimetic, nor does it

[2] The literary influence of Bernard Silvestris and Alain de Lille was both wide and profound: see W. Wetherbee, *Platonism and Poetry in the Twelfth Century: The Literary Influence of the School of Chartres*, Princeton, 1972; D. Poirion, "Alain de Lille et Jean de Meun," in *Alain de Lille, Gautier de Châtillon, Jakemart Gielée et leur temps*, ed. H. Roussel and F. Suard, Lille, 1980, pp. 135–151; and P. Dronke, *Dante and Medieval Latin Traditions*, Cambridge, 1986. For Brunetto Lati-

ni's description of Natura, see *Tesoretto*, 194ff. (in B. Latini, *Il Tesoretto* [The Little Treasure], ed. and trans. J. B. Holloway, New York and London, 1981).

[3] B. Weinberg, *A History of Literary Criticism in the Italian Renaissance*, Chicago, 1963, II, pp. 1074–1105 (chapter 21, "The Quarrel over Guarino's *Pastor fido*").

[4] T. G. Rosenmeyer, *The Green Cabinet: Theocritus and the European Pastoral Lyric*, Berkeley and Los Angeles, 1969, p. 4.

display invention.[5] Since the issue of poetic invention is very much at the heart of the problem of the conception of the *Primavera*, it is also of interest to learn that Minturno allows didactic verse to ascend to the level of poetry in the following respects only: first, when the writer avails himself of poetic invention and ornamentation by treating of fables, as Virgil does when he tells the fables of Orpheus and Aristaeus in the *Georgics*, at which point his verse rises to the level of the low epic; and second, when the poet praises or invokes the presence of the gods (as Lucretius does in the opening verses of the *De rerum natura*), at which point his verse becomes melic, or what we would call lyric.

Minturno's definition of mimesis and invention as forming the foundation for poetic expression is well founded in the traditions he inherited, and his work accurately reflects the considerable flux that still obtained with regard to the rustic forms of poetry until well into the sixteenth century. But even allowing for such flux, it is extremely difficult to set the invention of the *Primavera* comfortably in any of the classic genres of rustic song. The *materia* making up this invention is clearly georgic in one important respect, for from the time of Hesiod it is one of the definitions of the georgic that it takes its subject matter from the agrarian calendar of the farmer's year. At the same time, however, the painting notably lacks two other characteristic and essential features of the georgic—its imagery is not didactic in content, nor is there any expression in it of Hesiodic πόνος, the sweat, toil, and even pain of hard labor in the fields. The absence of any such reference we normally associate with a second species of the *carmen rusticum*: bucolic song, or the pastoral. Yet the *Primavera* is also lacking in various conventional attributes of the bucolic, perhaps most conspicuously among them goatherds and shepherds set in some sunlit region of Sicily or Arcadia playing their oaten flutes to the nymphs and satyrs, as may be seen, for example, in Signorelli's so-called *Feast of Pan*, painted for Lorenzo de'Medici, or in Titian's slightly later, Giorgionesque *Concert champêtre*. To attempt to classify the *Primavera* within either the pastoral or the georgic mode raises clear difficulties, and should be avoided. A better case might be made that the painting (which I have already described as a hymn, or song of praise) is conceived as a rustic song cast in the mode of lyric invocation, in the manner of Horace's ode to Venus (*Carmina* I.30), which, as noted, was one of the points of departure for Botticelli's invention. Moreover, as I shall show, the theme of invocation is made explicit in Venus's gesture of salutation to the beholder, indicating that she has heard his plea and responded, that she has compassion (*pietà*) for him. However, the narrative structure of the *Primavera*, whereby the development of the season is unfolded in the guise of an ancient fable, does not conform well with the conventions of classical lyric or lyric invocation, nor does the contemporaneity of the costumes and attributes of the figures represented. They do, on the other hand, strike a clear resonance with the lyric and epideictic conventions of the vernacular *canzone d'amore* and romance epic. We are thus encouraged to think, in the absence of a classical genre for Botticelli's rustic song, and de-

5 A. Minturno, *L'arte poetica*, Venice, 1564, pp. 3f.

spite the precision of the way its classical *materia* was assembled and deployed, that Botticelli's invention was nevertheless conceived in a vernacular mode. In such a form Politian's profound philological learning might reasonably be expected to have been made available to Botticelli, not as a "programme" for the painting, but as material available for the active participation of a painter who, in Vasari's phrase (which scholars have always found puzzling), was an "interpreter of Dante."

A definition of the *Primavera* as a painted poem of lyric praise, summoning forth the presence of Venus, goddess of the immemorial spring, and summoning with her the other deities of the ancient season, appears from the following observations. By taking Venus as the subject of his painting, Botticelli has by definition made love his theme. And by definition he has made spring his theme, for wherever Venus is, there also is the spring. Furthermore, the association of spring with love, youth, beauty, liberality, abundance, and joy is universal, so universal in fact as hardly to require demonstration, forming as it does the argument of thousands of late medieval and Renaissance lyrics in both the Latin and the vernacular tongues. A recognition of the *Primavera* as a lyric invocation cast in a vernacular mode finds further specific support in two recent observations, among the few new observations that contribute significantly to our knowledge of the painting by adding to the phenomena to be explained. Michael Baxandall's discovery that Venus's gesture is one of welcome, specifically derived from handbooks of rhetorical gesture, is a discovery that shows that the beholder himself is part of the painting's conception, for by this gesture, and by Venus's clear-eyed gaze into the eyes of the viewer, Botticelli has indicated that he who looks at the painting presents himself as a votary to love, that the goddess has responded and taken pity (*pietà*) on him, and that with her salutation welcoming him into the vernal garden she has accepted his invocation.[6] And Elizabeth Cropper's observation that the women portrayed by Botticelli conform to the descriptive canons of poetic *effictio* as employed in allusive lyric praise for feminine beauty in vernacular poetry is a discovery that lends much greater precision to an understanding of qualities that had earlier been perceived in the *Primavera* by Warburg, Venturi, and Ulmann.[7] Francastel in particular expressed these qualities beautifully when he wrote the following about Politian's description of Simonetta in the *Stanze per la giostra*:

> She is, at one and the same time, the mistress but also the figure of those ideal women, the equal of Laura and Beatrice. What is certain is that at the center of Politian's poem the figure of Simonetta appears with the same ambiguous grace that fascinates us in the lineaments of the principal figure in the *Primavera* by Botticelli or in Verrocchio's *Femme aux fleurs*. There appears there a kind of composite image from which both artists and poets worked, and for which one finds earlier prototypes in the marvelous figure

[6] M. Baxandall, *Painting and Experience in Fifteenth-Century Italy: A Primer in the Social History of Pictorial Style*, Oxford, 1972, pp. 67–70 (concluding with the observation, "A more subtle and important case is Botticelli's *Primavera*: here the central figure of Venus is not beating time to the dance of the Graces but inviting us with hand and glance into her kingdom").

[7] E. Cropper, "On Beautiful Women, Parmigianino, *Petrarchismo*, and the Vernacular Style," *Art Bulletin*, LVIII, 1976, pp. 374–394.

of Ilaria del Carretto in Lucca as well as in another elegy by Politian, dedicated to the death of Albiera degli Albizzi, the young fiancée of Sigismondo della Stufa, dead in the flower of her age, in 1473.[8]

The convention for creating this ideal, composite image, as Cropper demonstrated, appears especially markedly in the figure of Flora (plate 5), whose golden, curling, and waving tresses (the poetic antecedents of which were extensively traced by Warburg), broad and serene brow, dark and perfectly arched eyebrows, shining eyes, delicately chiseled nose, rounded and delicately cleft chin, coral lips parted to reveal a row of small and pearl-like teeth, gently swelling arms, and ivory and vermilion complexion all respond to the assembled Petrarchan descriptive canons of *effictio*, as especially does her smile, so beautiful and sadly sweet that, as Politian claimed when he responded to the familiar topos to describe Simonetta's smile, "ben parve che s'aprisse un paradiso."[9]

Effictio returns us yet again to the subject of rhetorical and poetic invention, which we left with Alberti, who, as I have noted, named invention as one of the three primary activities of the painter, and who found in invention, which can be beautiful even if it is never painted, the ground shared by the painter with poets and orators. *Effictio* is a means for invention, and in classical rhetoric it is defined as one of the figures of *descriptio*, which may be description of persons, places, seasons, events, and so on.[10] Specifically, it is one of the species of *descriptio personarum*, and it refers to the description of *corporis forma*, the outer physical appearances and characteristics of a person, or the *superficiales*, as these were later to be called. An example of such description, which by the late Middle Ages had become extremely conventionalized, and which followed a strict order proceeding from the top of the head to the soles of the feet (*a summo capite . . . ad ipsam radicem*, in the words of Geoffrey of Vinsauf), I have just rehearsed in describing Botticelli's Flora.[11] The second species of *descriptio personarum* is *notatio*, or the description of a person's inner character, later termed the *intrinsecae*. This appears in references to such qualities as honor, joy, worth, nobility, bearing, gentility, grace, and the like.[12]

[8] P. Francastel, "La fête mythologique au Quattrocento: Expression littéraire et visualisation plastique," in *Oeuvres II: La réalité figurative: Éléments structurels de sociologie de l'art*, Paris, 1965, pp. 229–252, esp. pp. 247f.

[9] A. Politian, *Stanze per la giostra*, 1.50; see also Cropper, op. cit., pp. 389f. See also, for example, Petrarch, *Rime*, CCXCII.6f. ("e'l lampeggiar de l'angelico riso, / che solean fare in terra un paradiso"), Luigi Pulci, *La giostra di Lorenzo de'Medici*, IX ("e misseghiela in testa con un riso, / con parole modeste e sì soave, / che si potea vedere un paradiso"), and idem, *Morgante*, XV.102, where with mocking hyperbole it is suggested that Antea's smile could open not one but six paradises.

[10] Cropper, op. cit., p. 386; see also P. Boyde,

Dante's Style in His Lyric Poetry, Cambridge, 1971, pp. 288–316; R. Dragonetti, *La technique poétique des trouvères dans la chanson courtoise: Contribution à l'étude de la rhétorique mediévale*, Bruges, 1960, pp. 248–272; E. R. Curtius, *European Literature and the Latin Middle Ages*, New York, 1953, pp. 68f.; and E. Faral, *Les arts poétiques du XIIe et du XIIIe siècle*, Paris, 1924, pp. 75–81. The locus classicus for defining *effictio* is in the *Rhetorica ad Herennium*, IV.xlix.63: "Effictio est cum exprimitur atque effingitur verbis corporis cuiuspiam forma."

[11] Geoffrey of Vinsauf, *Poetria nova*, 598f. The text is given an edition by Faral, op. cit., and a translation by M. F. Nims, *The Poetria Nova of Geoffrey of Vinsauf* (Pontifical Institute of Mediaeval Studies), Toronto, 1967.

[12] The locus classicus is again the *Rhetorica ad Herre-*

Although originating in classical judicial oratory, the *descriptio personarum*, of which *effictio* and *notatio* form the two parts, found its later development in the ornate forms of epideictic, the rhetoric of praise or blame, and its natural application in panegyric.[13] As such, it no longer appeared as ornament, but became itself the raison d'être of the work, the very foundation of its invention. It is applicable in both speech and poetry, and *effictio* became specifically a part of poetic theory in the later twelfth and thirteenth centuries with the *Ars versificatoria* of Matthew of Vendôme and the *Poetria nova* of Geoffrey of Vinsauf.[14] Although in French poetry the emphasis on *effictio* given by Matthew of Vendôme in particular seems to have had only a minor effect in practice, in Italy the opposite is true.[15] The influence of Matthew and Geoffrey in Italy in part results from the importance of French and Provençal culture in providing models for emulation; in part it results from the importance of Brunetto Latini (who encouraged the young Dante in his studies) in mediating between the two cultures. Brunetto's *Rettorica*, a translation with extended commentary of the first seventeen books of Cicero's *De inventione*, is highly important in this respect, for when commenting on a passage in the *De inventione* in which Cicero recommends to orators a close attention to the ordering of parts of speech, Brunetto explicitly extends the application of Cicero's principles to the writer of love letters and *canzoni d'amore*.[16] Rhetoric and rhetorical invention thus embrace not only formal speech, but also the writing of poetry in the vernacular.

The ornate, decorated style, to which *effictio* belongs, is of special importance to late medieval and early Renaissance poetics and poetry, and from its late antique application in epideictic panegyric *effictio* found its special place in the vernacular epic romance, especially in the form of a *descriptio pulchritudinis*, or extended panegyric in praise of feminine beauty; it also found its special place in the shortened apostrophe to a mistress's beauty in the lyric song of love.[17] The importance of description to this poetry has often been pointed out; especially significant is Faral's observation that, since more than a third of Matthew of Vendôme's *Ars versificatoria* is devoted to description, it may reasonably be inferred that for Matthew it is "l'objet suprême de la poésie."[18] It is also important to note that within the tradition of the epic romance

nium, IV.xlix.63: "Notatio est cum alicuius natura certis describitur signis quae, sicuti notae quae, naturae sunt adtributa."

[13] Dragonetti, op. cit., pp. 248–272; see also Cropper, op. cit., pp. 386ff.

[14] Boyde, op. cit., pp. 290f. The text of Matthew of Vendôme's *Ars versificatoria* was also published by Faral, op. cit, pp. 106–193. The literature on *descriptio personarum* is immense; aside from the fundamental studies already cited, see G. Poole, "Il topos dell' 'effictio' e un sonetto del Petrarca," *Lettere italiane*, XXXII, 1980, pp. 3–20.

[15] See A. M. Colby, *The Portrait in Twelfth-Century French Literature: An Example of the Stylistic Originality of Chrétien de Troyes*, Geneva, 1965, in which emphasis

is placed on the extreme rarity of *descriptiones superficiales* in Provençal and French lyric and epic poetry, while such descriptions appear in Italian poetry from the thirteenth century onward. The convention is an Italian innovation, and in the *Dottrinale* of Jacopo Alighieri the elements of *descriptio* for feminine beauty are treated as nine celestial gifts: (1) *giovinezza*, (2) *bellezza*, (3) *capelli biondi*, (4) *occhi neri e sopraciglia*, (5) *naso*, (6) *guance e orecchia*, (7) *bocca*, (8) *labbra e denti*, and (9) *braccia, gambe, mani, dita e piedi*.

[16] Brunetto Latini, *La rettorica*, ed. F. Maggini, pref. C. Segre, Florence, 1968, pp. 147f.

[17] A. Jeanroy, *La poésie lyrique des troubadours*, Toulouse and Paris, 1934, II, pp. 106f.

[18] Faral, op. cit., p. 76.

and the lyric love poem two kinds of description dominate. The first is *descriptio personarum*, which is overwhelmingly dominant because of the poet's need to describe the beauties of his lady. The second is *descriptio temporis*, or description of the season, especially (nor surprisingly in the context of love poetry) the season of spring.[19]

The deployment of the descriptive conventions of *effictio* does not appear in the poetry of Dante and the *stil novo*, even though Brunetto Latini again provides one of the most important and influential examples of *descriptio pulchritudinis*, which he puts forward with an elaborate description of the beauty of Iseult and praises as an example of rhetorical color:

> The like did Tristan when he described the beauty of Queen Iseult. Her hair, he said, shines like threads of gold, her forehead surpasses the lily, her black eyebrows are curved like little bows, and a little milky way divides them in the center above her nose in so meet a measure that it is neither excess nor defect; her eyes surpass all emeralds and glow in her face like two stars; her countenance imitates the beauty of the dawn, for it is of rose and white together, in such wise that the one color blends harmoniously with the other; her mouth is small, her lips full and glowing with beauteous hue, and her teeth whiter than ivory, set in order and measure; neither panther nor any spicery could compare with her most sweet breath; her chin is far more bright than marble, her neck whiter than milk, her throat more gleaming than crystal. From her shoulders descend two slender and long arms, and white hands with soft and tender flesh; her fingers are large and round, and on them the beauty of her nails glows; her beautiful breast is adorned with two apples of Paradise, which are as white as a mass of snow; and so slender is she at her waist that a man could clasp it between his hands. But I will be silent on the rest that is hid within, of which the heart speaks better than the tongue.[20]

Petrarch and Boccaccio, however, provide the prime examples for later Italian poets, the former for the abbreviated descriptions of the love lyric and the latter for the extended panegyrics of the romance epic. As an example of form and content that are all but canonical, pertaining, as Cropper showed, not only to poetry but also to the forms of painting, it is useful to quote at length Boccaccio's extended praise of Emilia's beauty, as she goes to her wedding in the temple of Venus, in the *Teseida*:

[19] Boyde, op. cit., pp. 296ff.; see also Jeanroy, op. cit., II, pp. 128–130; Curtius, op. cit., pp. 183–202; and Dragonetti, op. cit., pp. 163–193. Lorenzo de'Medici's poem *Ambra*, which is the title given it by Roscoe, is variously referred to in the manuscripts as *Descriptio hiemis* or *Deschrittione del verno*, thus denoting its point of departure as a description of the season of winter, and it would be just as apt to refer to Botticelli's *Pri-*

mavera as *Descriptio veris* or *Deschrittione della primavera*, for which see C. Dempsey, "Lorenzo de'Medici's *Ambra*," in *Renaissance Studies in Honor of Craig Hugh Smyth*, ed. A. Morrogh, P. Morselli, F. Superbi Gioffredi, and E. Borsook, Florence, 1985, II, pp. 177–189.

[20] Brunetto Latini, *Li livres dou tresor*, ed. J. Carmody, Berkeley and Los Angeles, 1948, pp. 331f.

Era la giovinetta di persona
grande e ischietta convenevolmente,
e se il ver l'antichità ragiona,
ella era candidissima e piacente;
e i suoi crin sotto ad una corona
lunghi e assai, e d'oro veramente
si sarian detti, e'l suo aspetto umile,
e il suo moto onesto e signorile.

Dico che i suoi crini parean d'oro,
non con treccia ristretti, ma soluti
e pettinati sì, che infra loro
non n'era un torto, e cadean sostenuti
sopra li candidi omeri, né fôro
prima né poi sì be' giammai veduti;
né altro sopra quelli ella portava
ch'una corona ch'assai si stimava.

La fronte sua era ampia e spaziosa,
e bianca e piana e molto dilicata,
sotto la quale in volta tortuosa,
quasi di mezzo cerchio terminata,
eran due ciglia, più che altra cosa
nerissime e sottil, tra le qua' lata
bianchezza si vedea, lor dividendo,
né 'l debito passavan, sé stendendo.

Di sotto a queste eran gli occhi lucenti
e più che stella scintillanti assai;
egli eran gravi e lunghi e ben sedenti,
e brun quant'altri che ne fosser mai;
e oltre a questo egli eran sì potenti
d'ascosa forza, che alcun giammai
non gli mirò né fu da lor mirato,
ch'amore in sé non sentisse svegliato.

Io ritraggo di lor poveramente,
dico a rispetto della lor bellezza,
e lasciogli a chiunque d'amor sente
che immaginando vegga lor chiarezza;
ma sotto ad essi non troppo eminente
né poco ancora e di bella lunghezza
il naso si vedea affilatetto
qual si voleva a l'angelico aspetto.

Le guance sue non eran tumerose
né magre fuor di debita misura,
anzi eran dilicate e graziose,
bianche e vermiglie, non d'altra mistura
che intra' gigli le vermiglie rose;
e questa non dipinta, ma natura
gliel' avea data, il cui color mostrava
perciò che 'n ciò più non le bisognava.

Ella aveva la bocca piccioletta,
tutta ridente e bella da basciare,
e era più che grana vermiglietta
con le labbra sottili, e nel parlare
a chi l'udia parea una angioletta;
e' denti suoi si potean somigliare
a bianche perle, spessi e ordinati
e piccolini, ben proporzionati.

E oltre a questo, il mento piccolino
e tondo quale al viso si chiedea;
nel mezzo ad esso aveva un forellino
che più vezzosa assai ne la facea;
e era vermiglietto un pocolino,
di che assai più bella ne parea;
quinci la gola candida e cerchiata
non di soperchio e bella e dilicata.

Pieno era il collo e lungo e ben sedente
sovra gli omeri candidi e ritondi,
non sottil troppo e piano e ben possente
a sostenere gli abbracciar giocondi;
e'l petto poi un pocchetto eminente
de' pomi vaghi per mostranza tondi,
che per durezza avean combattimento,
sempre pontando in fuor col vestimento.

Eran le braccia sue grosse e distese,
lunghe le mani, e la dita sottili,
articulate bene a tutte prese,
ancor d'anella vote signorili;
e, brievemente, in tutto quel paese
altra non fu che cotanto gentili
l'avesse come lei, ch'era in cintura
sotile e schietta con degna misura.

Nell'anche grossa e tutta ben formata,
e il piè piccolin'; qual poi si fosse
la parte agli occhi del corpo celata,
colui sel seppe poi cui ella cosse
avanti con amor lunga fiata;
imagino io ch'a dirlo le mie posse
non basterieno avendol' io veduta:
tal d'ogni ben doveva esser compiuta![21]

(The damsel was of a suitably tall and slender body, and if antiquity tells
true, she was most candid and pleasing; and her tresses beneath a crown
were long and full-bodied, and truly could be said to be made of gold, and
her aspect was humble, and her movement upright and noble. I say that her
tresses seemed of gold, not tied back in braids but falling loose, and combed
so that not a single knot was in them, and they fell on the support of her
shining white shoulders, and never before or after was hair of such beauty
seen; nor did she wear over it anything but a crown, which was greatly
esteemed. Her brow was ample and spacious, and white and level and very
delicate, beneath which in a twisting arch terminating almost in a half circle
were two eyebrows, more than any other thing most black and fine, be-
tween which one discerned a broad whiteness separating them, nor did they
pass due measure in their extent. Beneath these were shining eyes and spar-
kling much more than a star; they were serious and long and well seated,
and brown as others never were; and more than this they were so potent
with hidden strength that no one ever gazed into them or felt their gaze
who did not feel love awakened within himself. I portray them poorly, I
say, with respect to their beauty, and I leave them to whomever feels in love
that he may by imagining see their brightness; but beneath them, not too
prominent nor yet too small and of a beautiful length appeared her finely
chiseled nose, such as her angelic appearance requires. Her cheeks were nei-
ther puffy nor sunken beyond due measure, but on the contrary were deli-
cate and graceful, white and vermilion, of no other mixture than vermilion
roses among lilies; and this was not painted but given her by nature, whose
color showed she was in no need of any more. She had a tiny mouth, all
laughing and lovely to kiss, and it was redder than a berry, with slender
lips, and in speaking she seemed to be an angel to whomsoever heard; and
her teeth could be compared to white pearls, densely clustered, and well
arranged, and small and well proportioned. And more than this, she had a
chin that was little and round as one could ask for in a face; and in its center
she had a tiny cleft which made it ever so much more charming; and it was
tinged slightly with vermilion, which made it seem much more beautiful;

[21] Boccaccio, *Teseida*, XII.53–63.

next was her gleaming white and not excessively necklaced throat, both beautiful and delicate. Her neck was full and long and well seated above her shining white and rounded shoulders, not too thin but smooth and well able to sustain mirthful embraces; next came her breast, slightly prominent in order to display those desirable round apples, which in their firmness were struggling, always pushing outward against her dress. Her arms were sturdy and flowing, her hands were long, and the fingers slender, well articulated and suited for any grasp, lordly and still bare of rings; and, in brief, in all that country there was no other possessed of such gentility as she, whose waist was both slender and compact in worthy measure. Her hips were full and well formed, and her feet were small; as for what that part of the body was that the clothes kept hidden from the eyes, it was later known to him, for whom a long time before she had burned with love; I imagine that even having seen it my powers would be insufficient to speak of it: thus in every good thing she must have been complete!)

Boccaccio's description of Emilia's person is unusually lengthy and detailed, and his poetry follows in subtly elaborated forms the prescribed descriptive sequence, proceeding *a summo capitis ad ipsam radicem*. It is precisely because of his extended catalogue of the normative features appropriate to a young and beautiful gentlewoman that I have followed Cropper in singling it out for quotation, and not in order to suggest that Botticelli necessarily had this passage before his eyes when he imagined and depicted the women of the *Primavera*. It has been quoted instead in order to give a full example, and an extremely influential one, of portraiture by type in the ornamented vernacular style. To describe the portrait of Emilia as an individual is unimportant, for this is to describe only the accidents of her particular appearance; what matters for Boccaccio is her approximation of a universal norm of beauty appropriate to her gentility, expressed according to codified standards of perfection appropriate to her sex, age, nature, position, and temperament. In this respect it hardly matters that it is Emilia who is being described, for she could as well be Brunetto Latini's Iseult, Luigi Pulci's Antea, Politian's Simonetta, or even Ariosto's Alcina, all of whom answer to the same qualitative descriptive characteristics.[22] So too, even though they differ physiognomically among themselves, do the goddesses of the *Primavera*.

All these women, Venus (plate 6), the Graces (plate 8), Flora (plate 5), and Chloris (plate 4), are of youthful aspect (*giovinetta*), as befits the spring; they are noble in bearing yet disarmingly ingenuous (*grande e ischietta*), and open and pleasing in manner (*candidissima e piacente*). Flora (plate 14) is especially notable for her golden tresses (*crini d'oro*), which fall in unbound though not unkempt waves (*non con treccia ristretti, ma soluti e pettinati*) down to her gleaming shoulders (*candidi omeri*). Venus, the Graces (whose gleaming shoulders perhaps appear to better advantage than do

[22] Cropper, op. cit., p. 386; see also P. Orvieto, "La descriptio Anteae," in *Pulci medievale*, Rome, n.d., pp. 48–85.

Flora's), and Flora all have ample and spacious brows (*fronte ampia e spaziosa*) that are pale, broad, and delicate (*bianca, piana, molto dilicata*), beneath which appear perfectly arched and finely delineated eyebrows (*quasi di mezzo cerchio terminante, nerissime e sottil*—the adjective *nerissime* here especially applicable in the case of Flora, whose darkly arched eyebrows contrast notably, and beautifully, with her golden hair). Between these eyebrows can be seen a pleasing expanse of white skin (*tra le qua' lata bianchezza si vedea, lor dividendo*), and beneath them appear shining eyes of translucent brown, serious, slightly elongated, and well set in their sockets (*occhi lucenti, gravi, lunghi, e ben sedenti, e brun*). Each of these women is blessed with a fine nose—especially Flora, whose slightly elongated and refined nose is surely one of the most remarkable in the history of art—noses that are neither too prominent nor disproportionately small, and that give the appearance of being finely chiseled (*non troppo eminente ne poco ancora, di bella lunghezza, affilatetto*). Their cheeks too are neither bloated nor skeletal but duly proportioned (*non tumerose ne magre fuor di debita misura*), delicate and gracious (*dilicata e graziosa*), and of a mixture of lily-white and rosy vermilion coloring (*bianche e vermiglie, non d'altra mistura che intra' gigli e vermiglie rose*) that in its subtle blending is the gift of nature, not of artifice (*non dipinta, ma natura gliel'avea data*), of which they have no need. Their mouths are small, with finely delineated berry-red lips that are eminently kissable (*bocca piccioletta, labbra sottili, più che grana vermiglietta, bella da basciare*), and Flora's lips are parted in an upwardly turning smile that reveals her small, even, well-proportioned, and pearl-like teeth (*ridente, denti si potean somigliare a bianche perle, spessi e ordinati, piccolini, ben proporzionati*). Each has a small and rounded chin, delicately cleft (*mento piccolino, tondo, nel mezzo un forellino*), a white throat that is not excessively adorned but well set off (*gola candida, cerchiata non di soperchio, bella e dilicata*), and a neck that is full, long, and firmly set on shining and rounded shoulders (*pieno collo, lungho, ben sedente sovra gli omeri candidi e rotondi*). Their shoulders are not too thin, but well able to support passages of love (*non sottil troppo, piano, ben possente sostenare gli abbracciar giocondi*). Their breasts swell like firm, round apples (*petto un pochetto eminente de'pomi vaghi per mostranza tondi*). Their arms are sturdy and gracefully long (*grosse e distese*), as are their hands (*lunghe le mani*), which terminate in well-articulated and slender fingers (*dite sottili, articulate bene*). Finally, their hips are sturdy and shapely, and their feet are small (*anche grossa, ben formata, piè piccolin'*).

In sum, there is much in Botticelli's representation of the goddesses in the *Primavera* that responds to a normative convention, a "composite image," in Francastel's happy phrase, "from which both artists and poets worked." This is especially apparent in the figure of Flora (plate 14), whose hair is golden blonde yet whose perfectly arching eyebrows are black, as the conventions of *effictio* specify, and as appears in both Brunetto Latini's description of Iseult and Boccaccio's of Emilia. Even more interesting is the ambiguity of her smile, which results from the fact that the eyes of beauty are always serious (*gravi*), even though the mouth curves upward in a smile (*ridente*); it is this same ambiguity that characterizes the most famous smile of all, that of Leonardo da Vinci's *Mona Lisa*, which Vasari described in an equally famous *bla-*

son.[23] One might go a step further and observe how Botticelli's women present themselves and are represented, wrists and fingers flexed, for example, so that each unit of the body is distinctly and separately articulated, set off in its own special, individual perfection, the whole unified and given a sense of grace and continuous movement by elastic and gently swelling contours. Such plastic distinction and re-unification of the parts of the body, keeping the whole and its parts simultaneously in evidence, follows on the conventions of *effictio*, and indeed is a consequence of them, as is the concept of a pleasing articulation within the parts, as well as the emphasis on gracefully tapering limbs, neither too full nor too thin, but in due measure.

To the implications and consequences of these observations I shall return in due course. For the moment, suffice it to say that the descriptive conventions for praising feminine beauty to which Botticelli appealed are not classical; rather, they belong particularly to the vernacular traditions of poetry. Although certain metaphors and comparisons within the conventions of *effictio* do ultimately derive from classical poetry, the cumulative and ordered qualitative anatomization of individual features that define the convention is specific to the ornate, vernacular style, and indeed is one of the best-known topoi of vernacular romance. I have for the sake of convenience exemplified the use of *effictio* with Boccaccio's extended panegyric to the beauty of Emilia in a romance epic, the *Teseida*. The convention in shorter form is equally characteristic of the vernacular lyric, and is especially deployed in sequential groupings of related sonnets and *canzoni d'amore*, which unfold an internalized narrative of the course of the poet's awakening and gradually maturing experience and understanding of love.[24] If one grasps that the *materia* of Botticelli's invention, which is itself wholly classic, is nevertheless ordered and presented within the conventions of vernacular love poetry, then one has taken an important step toward understanding the context in which the *Primavera* is to be interpreted.

On the evidence of the classical sources that give the basis for Botticelli's invention, it is possible to read the *Primavera*, as I once argued, as cast in a narrative sequence, reading it in an unusual (but hardly unique) way as unfolding from right to left.[25] According to this sequence, the season of spring appears in the beginning with the first gust of the west wind, Zephyr, over the bare earth, Chloris, causing the earth to put forth the first flowers of the season. Flora accordingly next appears as the abundant Hour of the early spring, scattering flowers in her path, and the season reaches its fullness in Venus, the goddess of April and the generative spirit of renewed life in the world. Spring finally ends in Mercury and May, in which month the season turns to summer. However, the painting may simultaneously be read as a portrayal of Venus, the goddess of love who denotes the spring (as Vasari recognized), Venus who is the manifestation of the love and beauty that stirs the world to renewal. This

[23] Cropper, op. cit., p. 390; for Vasari's description of the *Mona Lisa*, see G. Vasari, *Le vite de' più eccellenti pittori, scultori ed architetti moderni*, ed. G. Milanesi, Florence, 1906, IV, pp. 39f.

[24] G. Pozzi, "Il ritratto della donna nella poesia d'ini-zio Cinquecento e la pittura di Giorgione," *Lettere italiane*, XXXI, 1979, pp. 3–30.

[25] C. Dempsey, "*Mercurius Ver*: The Sources of Botticelli's *Primavera*," *Journal of the Warburg and Courtauld Institutes*, XXXI, 1968, pp. 251–273.

follows not only from her central position in the painting but also from the fact, which has perplexed some scholars, that the *Primavera* is not one of a conventional cycle of the four seasons but stands alone, and that for that reason Vasari did not call it the *Primavera* but *Venere dinotando la Primavera*. The *Primavera* accordingly may be understood as having been conceived in praise of Venus, invoking her, as did Horace, together with all the attributes of her nature and power, attributes given mythical and poetic form in the attendant deities that define the fullness of the principle of love she represents.

As noted above, *effictio* is one of the two species of *descriptio personarum* and refers to the outer physical appearance or *superficiales* of a person. The second species of *descriptio personarum* is *notatio*, which refers to the qualities making up a person's inner character, his or her *intrinsecae*. The distinction, as Cropper discussed in a second article, is fundamental to an artistic debate of long standing, the *paragone* of the expressive powers naturally inherent in painting on the one hand and poetry on the other.[26] The issue descends into the Renaissance especially from Lucian's rhetorical text *On Portraiture*, in which it is maintained that while the painter has the power to represent the appearances of outer beauty, only the poet and orator can delineate the deeper beauty of character.[27] Petrarch's famous sonnets on Simone Martini's portrait of Laura, praising the painter for capturing the perfect image of beauty incised on the poet-lover's heart, especially energized later Renaissance treatments of the theme, which is famously rehearsed in Castiglione's *Cortegiano*.[28] There the story is told of Alexander's gift of his mistress Campaspe to Apelles because he saw from the portrait Apelles painted of her that the painter had understood her beauty better than he; when Cesare Gonzaga protests that he sees more beauty in the woman he loves than could Apelles the reply is given that this is because Cesare understands the inner character of his lover, while both Apelles and Alexander could only have been enamored of Campaspe's outer beauties, or *superficiales*. The same point had earlier been made with regard to epistolary art by Giovanni Pico della Mirandola in a letter to Paolo Cortesi:

> It seems to me that between a portrait and a letter there is the following difference, that the former represents the body and the latter the mind. The portrait, as is its office, imitates the color of the flesh and the form [*figura*]; the letter represents thoughts, advice, pains, pleasures, cares, and finally all the emotions, and sends faithfully the secrets of the soul to the distant

[26] E. Cropper, "The Beauty of Woman: Problems in the Rhetoric of Renaissance Portraiture," in *Rewriting the Renaissance: The Discourses of Sexual Difference in Early Modern Europe*, ed. M. W. Ferguson, M. Quilligan, and N. Vickers, Chicago and London, 1986, pp. 175–190.

[27] Ibid., pp. 175f.; see also Lucian, *Essays in Portraiture (Imagines)*, Loeb Classical Library, Cambridge, Mass., and London, 1969, IV, pp. 257ff.

[28] Cropper, op. cit., pp. 181f.; see also Petrarch,

Rime, 77 and 78, and B. Castiglione, *The Book of the Courtier*, trans. C. S. Singleton, Garden City, N.Y., 1959, pp. 81–83. See further Lorenzo de'Medici, *Canzoniere*, 39 ("Sonetto fatto a piè d'una tavoletta dove era ritratta una donna"), in *Canzoniere*, ed. P. Orvieto, Milan, 1984, pp. 89f., and P. Bembo, *Rime*, 19 and 20 (after Bellini's portraits of the poet's lady, in P. Bembo, *Prose della volgar lingua, Gli Asolani, Rime*, ed. C. Dionisotti, Turin, 1966, pp. 521f.).

friend. In the end the letter is a living and efficient form, and the portrait is a silent and dead example. Let us both, then, send each other both of these images of our souls.[29]

As Cropper has argued, Leonardo da Vinci's *Ginevra da Benci* incorporates a painter's response to the question by portraying on one side of the panel the exterior image of Ginevra (fig. 8), her *superficiales*, and on the reverse (fig. 9) giving emblematic expression to her complete beauty by joining together a palm branch and laurel enframing a sprig of juniper and a banderole with the inscription *Virtutem forma decorat*—thereby indicating the prime *notatio* of her inner character, of which her outer beauty is the adornment.[30] Botticelli's invention for the *Primavera* equally responds to the descriptive paradox animating the comparison of painting and poetry, indicating the character of the beauties he paints by means of the allusive *notationes* of fable.

Thus, Venus's *notatio* is the spring, as Vasari understood when he identified the subject of the *Primavera* as Venus "dinotando la Primavera," but the broader principle that defines her character is that of the perfect beauty that inspires love. She equally denotes *venustas*, and the characteristics that in turn define such beauty (as Wind, especially, has shown) are denoted by the Graces, who are as much her attributes as they are her companions.[31] The names Hesiod assigns them are Aglaia, Thalia, and Euphrosyne, which are difficult to translate simply, but which mean respectively Beauty (or Splendor), Blooming (or Goodly), and Mirth (or Gladness).[32] Ficino elegantly rendered their names into Latin as Splendor, Viriditas, and Laetitia, and the same Graces are named Pulchritudo, Amor, and Voluptas (which is just as good a translation) on the famous medal of Pico della Mirandola (fig. 10).[33] Cartari named them in Italian Venustà, Piacevolezza, and Giocondità.[34] Venus is always attended by the Graces, even as perfect beauty is always endowed with the attributes of grace—an added *non so che*, whether defined as Alexander Pope's grace that is beyond the reach of art, or as Castiglione's courtly *sprezzatura*, or as Lorenzo de' Medici's notion of *gentilezza*.[35] *Venustas* emerges from the combination of a simpler, natural physical beauty, *pulchritudo* (which Cartari would have done better to translate as *bellezza*), with a natural blossoming goodliness and a natural gladness. It is the added measure of grace that makes Venus's beauty irresistible; for this reason, as Politian observed, Gratia is the same as Suadela (πειθώ), the goddess of persuasion, accordingly invoked in wedding ceremonies.[36] *Venustas* similarly is defined by the *notationes* of Chloris and

[29] G. Pico della Mirandola, *Opera omnia*, Basle, 1601, I, p. 248.

[30] Cropper, op. cit., 1986, pp. 183 ad finem.

[31] E. Wind, *Pagan Mysteries in the Renaissance*, Harmondsworth, 1967, pp. 26ff.

[32] Ibid.; C. Dempsey, "Botticelli's Three Graces," *Journal of the Warburg and Courtauld Institutes*, XXXIV, 1971, pp. 326–330; for Alberti's naming of the Graces after Hesiod, see above, chapter 1.

[33] Wind, op. cit., pp. 36ff., esp. p. 39, note 4; see also Ficino, *Opera* (1561), p. 828.

[34] V. Cartari, *Le vere e nove imagini de gli dei delli antichi*, ed. L. Pignoria, Padua, 1614, pp. 491–499, esp. pp. 495f.

[35] For Lorenzo's concept of *gentilezza*, see in particular A. Lipari, *The Dolce Stil Novo according to Lorenzo de' Medici: A Study of His Poetic Principio as an Interpretation of Italian Literature of the Pre-Renaissance Period, Based on his Comento*, New Haven, 1936; see also T. Zanato, *Saggio sul "Comento" di Lorenzo de' Medici*, Florence, 1979.

[36] A. Poliziano, *Commento inedito alle Selve di Stazio*,

Flora, who respectively denote greenness and flowering, the two together admirably defining *viriditas*, as Ficino translated the name of blossoming Thalia. They are the youthful Hour of the spring—the Roman Flora, as Emil Jacobsen long ago observed, in her primitive origins being a fusion of Chloris with Thallo, the Greek Hour of spring (not to be confused, as Politian also had pointed out, with Thalia).[37] As such, it really makes no difference whether the Flora in Botticelli's painting is given her rightful name or whether she is called, as in the older literature (and still in much Italian scholarship), a personification of the spring, for in fact they are the same. As the Hour of spring, Chloris-Flora explicitly contributes to a definition of *venustas* the concepts of youth and abundance, and so renders superfluous the need for personifying the *juventas* invoked by Horace as the companion of Venus.[38] The *intrinsecae* of Venus as goddess of love, beauty, and the spring thus emerge from a combination of qualities, certainly including simple comeliness, natural love, joy, blossoming abundance, youth, and liberality—in short, all those qualities that, as noted, are universally associated with the spring, which form the argument of numberless late medieval and early Renaissance lyrics and *canzoni d'amore*.

At this point it is obvious that the means exist to reintroduce a Neoplatonic interpretation of the *Primavera*, in a way that is neither in conflict with the appearances so far observed, nor in conflict with the hypothesis that explains those phenomena on the model of ancient and humanist poetry. An interpretation of the painting in a Neoplatonic key need no longer be invoked as a philosophical model artificially grafted onto a poetic one, as was done by Wind and Panofsky, nor as one in opposition to it, as was done by Gombrich; instead, it appears as a possible consequence of the poetic model. Nevertheless, it is still premature to advance such an argument, since the evidence now leads first toward a renewed investigation of the interpretive decorum implied by the poetry itself. The late medieval conventions of extended and ordered description of the outer appearance and inner character of beauty and the beloved are specific to poetry in a vernacular genre, and indeed are one of the most familiar clichés of the vernacular tradition. It therefore seems likely that the classical *materia* adapted by Botticelli, like the classical *materia* used by Politian in the *Stanze per la giostra* or the *Orfeo*, is conceived and deployed within the conventions of vernacular poetry.

Justification for entertaining this hypothesis also follows from the appearances of the costumes in the *Primavera*. It has long been noticed that, even though he was

ed. L. Cesarini Martinelli, Florence, 1978, p. 201: "GRATIA. Diximus Suadelam, quae graece πειθώ dicitur, invocari solitam in nuptiis. Hermesianax autem elegiacus poeta, ut Pausanias ait, etiam hanc unam esse ex Gratiis asserit, deque ea intelligere doctum poetam arbitror."

[37] E. Jacobsen, "Allegoria della Primavera di Sandro Botticelli," *Archivio storico dell'arte*, ser. 2, III, 1897, pp. 321–340: "La Flora dei Romani è tuttavia una fusione del Thallo greco e dell'Ora della primavera colla sposa di Zefiro, la ninfa Clori." See also Poliziano, *Commento*

inedito, loc. cit.: "Hic Domitius [Calderinus] ait Thallon et Pandroson etiam pro Gratiis coli ab Atheniensibus apparetque hominem non percepisse Pausaniae sententiam, qui et Carpon, quam Domitius omittit, et Thallon, quibus una cum Pandroso honores Athenis habeantur, non Gratias, sed Horas esse ait." As the Greek Hour of the spring, Thallo is identical with Chloris and Flora.

[38] Horace, *Carmina*, 1.30 (and see the discussion above, chapter 1).

painting ancient gods, Botticelli made no attempt whatsoever to show them in au-
thentically ancient costumes. Opinion has been divided over whether the costumes
he did paint ever existed or whether they are entirely fanciful inventions by the artist.
However, much recent research has established that the accuracy with which Botti-
celli represented highly complex tailoring and up-to-date materials and fashions
makes it virtually inconceivable that he had not seen such clothing at first hand, and
observed it very closely. Elizabeth Birbari has pointed out that "there is no simplicity
about the airy wisps worn by the girls in the *Primavera*." Her description of the cos-
tume worn by one of the Graces (plate 13) moreover sheds extraordinary light on the
precision and the poetry with which Botticelli represented the "loosened and trans-
parent gowns" described by Horace and Seneca:

> Although it is not by any means immediately apparent, the Grace in the
> centre of the group wears a chemise which has a collar, and quite a wide
> one. Since the chemise has been slipped off one shoulder so that one arm is
> free, the collar extends from under her left arm to the top of her right shoul-
> der. It is possible to see the centre of the front of the collar under her left
> arm, showing a row of buttons on one half of the collar and loops on the
> other. At the right shoulder we see where the buttons and loops meet at the
> centre of the back. A similar collar can be seen in the detail from Raffaelino
> del Garbo's *Virgin and Child* [in the Metropolitan Museum in New York]
> where it is worn by an angel—evidence that this sort of collar was not
> painted solely by Botticelli.[39]

The row of buttons (like the parallel of Raffaelino del Garbo's painting) is an
important indication that Botticelli was closely observing a contemporary garment,
not only because buttons would be a solecism on ancient shifts, but also because of
the accuracy with which he represented the actual pattern of the Grace's chemise even
though she is wearing it improperly. However, even though the use of buttons is
itself quite old, the arrangement of them in rows to provide a kind of ornamentation
did not appear until the thirteenth century, and it also appears that Botticelli's depic-
tion of them reflects a conscious archaism in the design of the garment, since the taste
for rows of closely set buttons had completely disappeared by the second quarter of
the fifteenth century.[40] Yet in other respects the form of the chemises worn by the

[39] E. Birbari, *Dress in Italian Painting, 1460–1500*,
London, 1975, pp. 40f.

[40] Ibid., p. 78: "A button passed through a hole in
the material, or a specially contrived loop, was one of
the most ancient forms of fastening, but buttons used
in rows and set close together to provide ornamenta-
tion did not appear until the 13th century, when the
possibilities for the enrichment of garments by buttons
of precious metals were soon appreciated, and almost
as soon prohibited by sumptuary laws. . . . By the
middle of the 15th century, and even before, the liking

for rows and rows of very small, closely set buttons
had died out, and although ornamental buttons were
used still, this was done far more sparingly on the
whole. An exception is the chemise worn by one of the
Graces in the *Primavera*, through the neck of which she
has slipped an arm. Under her arm can be seen the two
front corners of her collar which has loops made of
cord round one corner and spherical buttons round the
other. The row of buttons and loops begins in the mid-
dle of the collar, where it passes over her right shoulder
and provides a decorative edging."

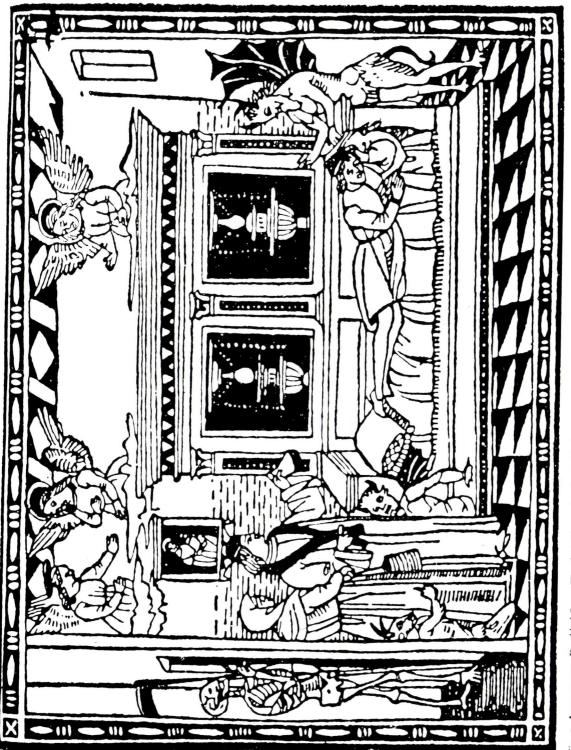

Fig. 1. Anonymous, *Deathbed Scene*. Woodcut illustration from Girolamo Savonarola, *Predica dell'arte del bene morire*, Florence, 1496–1497.

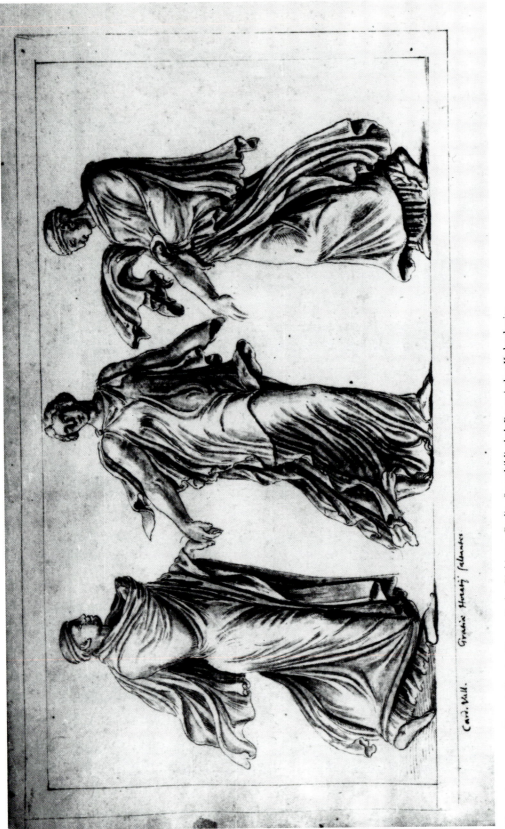

Fig. 2. Anonymous, *Horace's Dancing Graces*. Codex Pighianus, Berlin, Staatsbibliothek Preussischer Kulturbesitz.

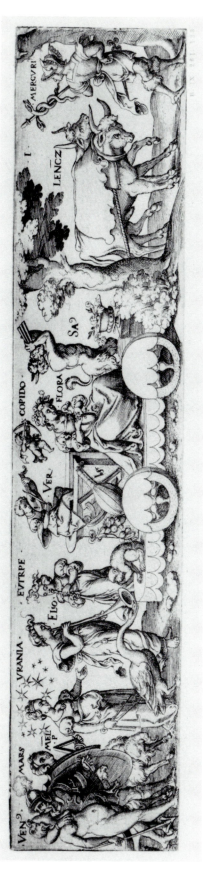

Fig. 3. Virgil Solis, *Spring* (Bartsch IX.261.133).

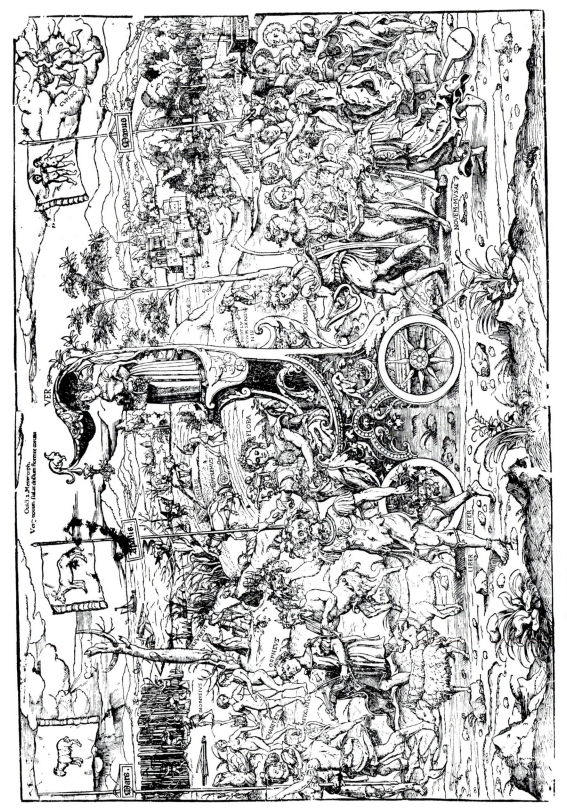

Fig. 4. Monogrammist AP, *Spring*. London, British Museum.

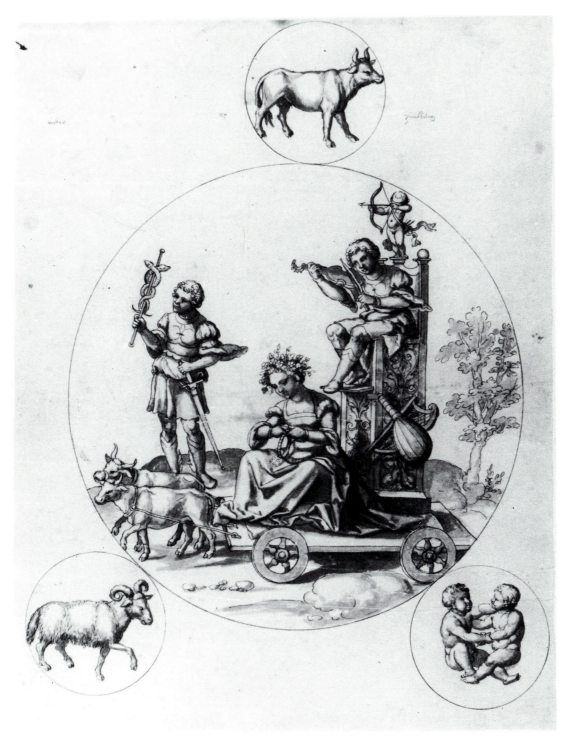

Fig. 5. Georg Pencz, *Spring*. Erlangen, Universitätsbibliothek Erlangen-Nürnberg.

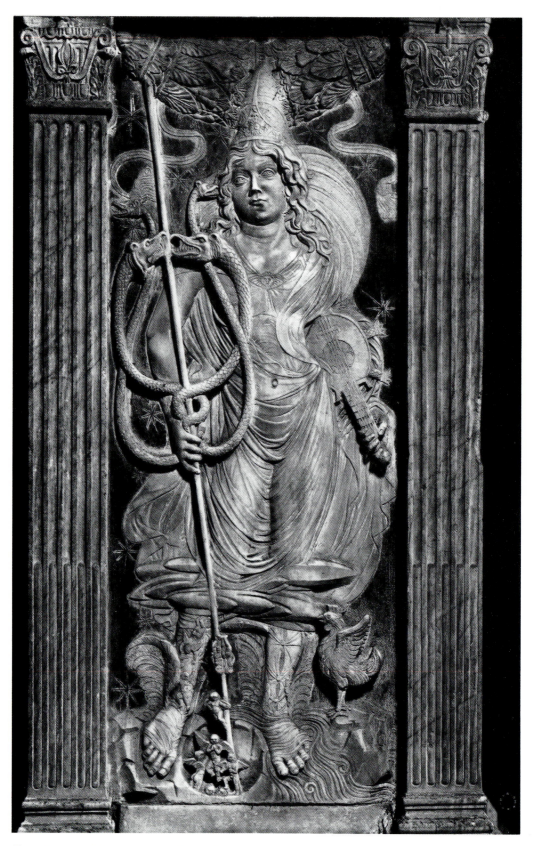

Fig. 6. Agostino di Duccio, *Mercury*. Rimini, Tempio Malatestiano.

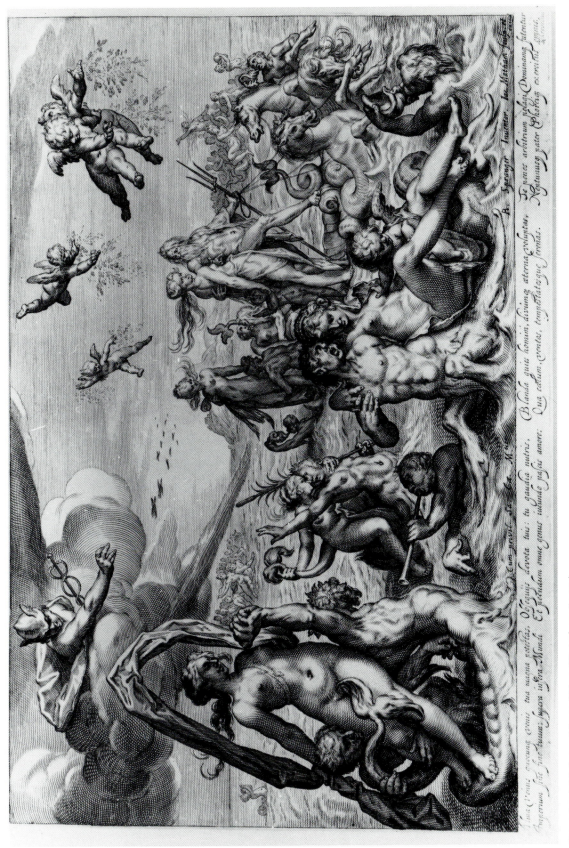

Fig. 7. Jacob Matham, *Advent of Venus* (Bartsch III.183.204).

Fig. 8. Leonardo da Vinci, *Ginevra de'Benci* (obverse). Washington, National Gallery of Art.

Fig. 9. Leonardo da Vinci, *Ginevra de'Benci* (reverse). Washington, National Gallery of Art.

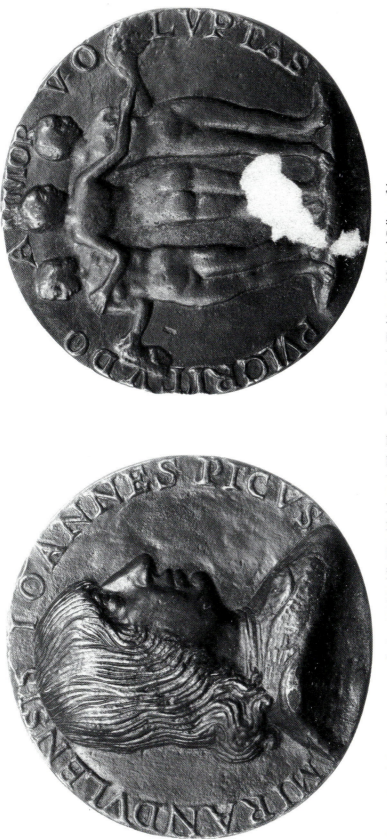

Fig. 10. Niccolò Fiorentino (manner of), *Giovanni Pico della Mirandola* (obverse); *The Three Graces* (reverse). Washington, National Gallery of Art.

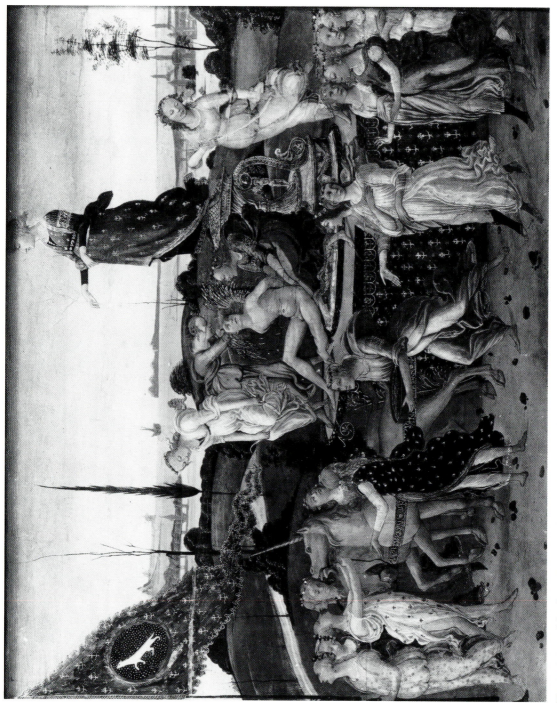

Fig. 11. Jacopo del Sellaio, *Triumph of Chastity*. Fiesole, Bandini Museum.

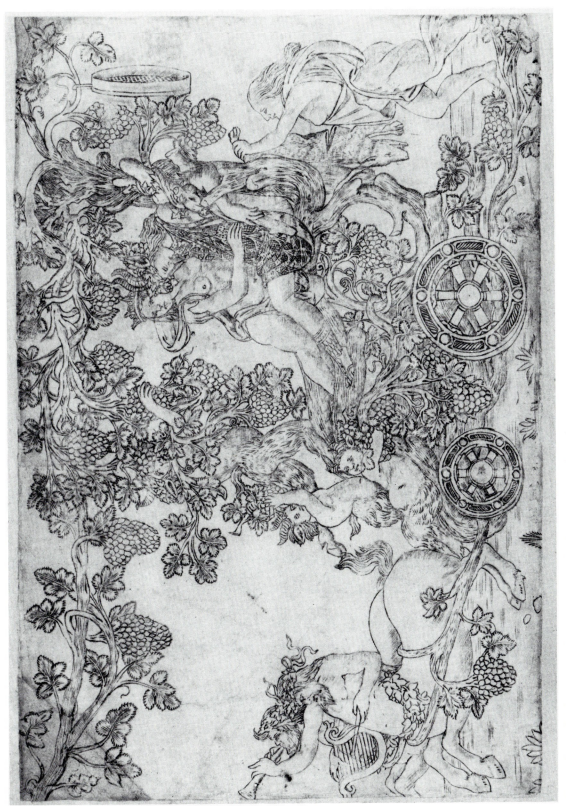

Fig. 12. Baccio Baldini (attributed), *Bacchus and Ariadne*. London, British Museum.

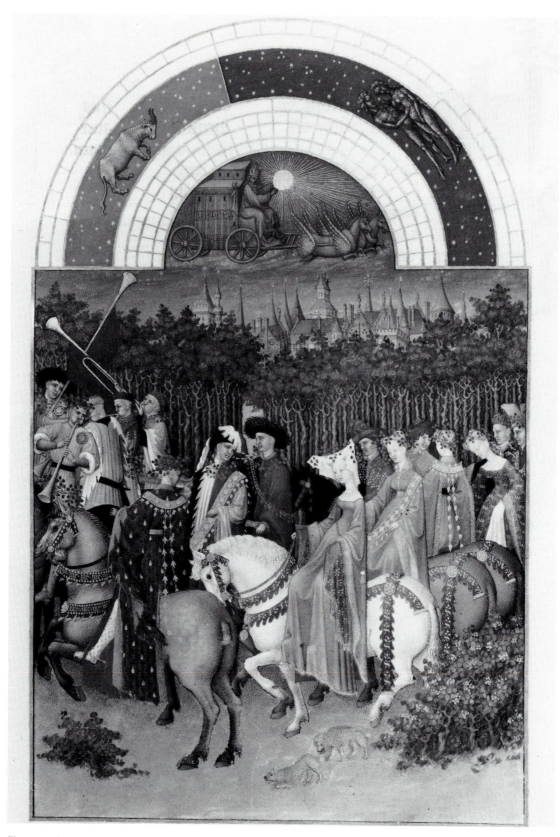

Fig. 13. Pol de Limbourg, *Month of May*. From *Les très riches heures du duc de Berry*, Chantilly, Musée Condé.

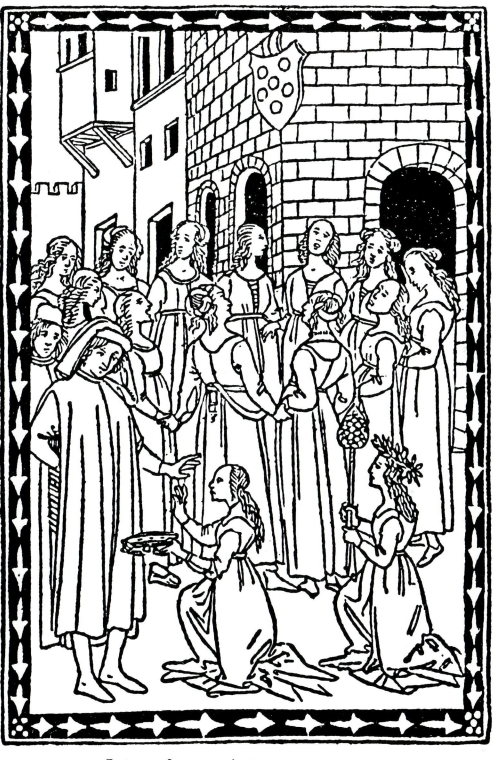

Se intender uuoi della storia leffecto
& diquesta brigata qui presente
uolgi lacharta & leggi quel sonesto

Fig. 14. Anonymous, *Lorenzo de'Medici Receiving Calendimaggio Celebrants*. Woodcut illustration from the *Canti carnascialeschi*, Florence, n.d.

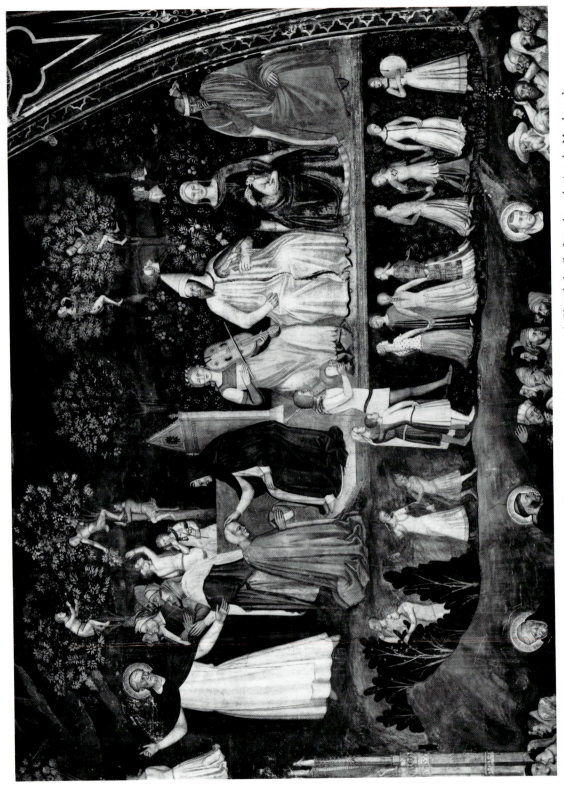

Fig. 15. Andrea da Firenze, *Allegory of the Dominican Order*. Florence, Santa Maria Novella, Spanish Chapel; detail of youths gathering the May branch.

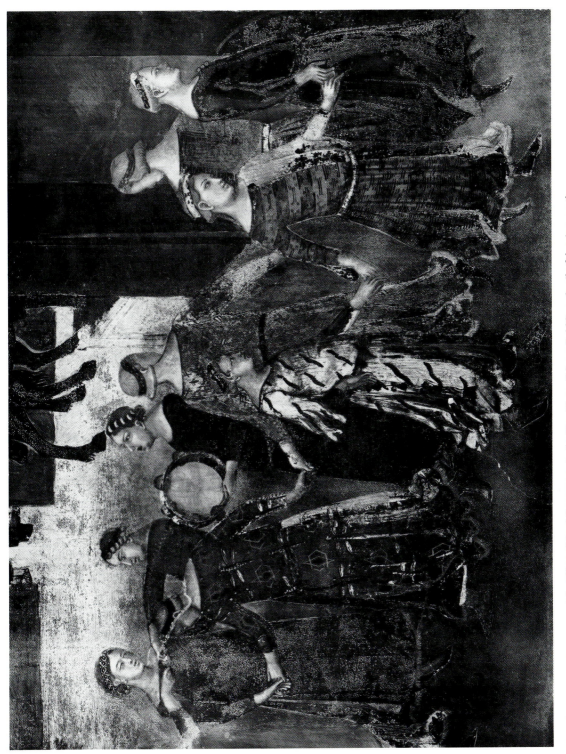

Fig. 16. Ambrogio Lorenzetti, *The Effects of Good Government in the City*. Siena, Palazzo Pubblico; detail of dancing youths.

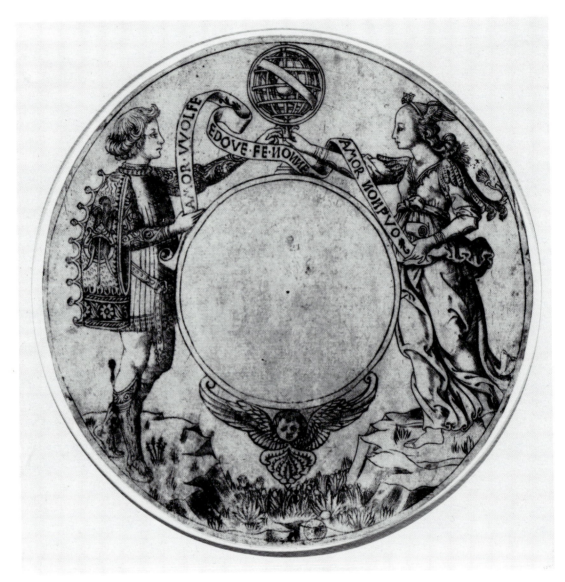

Fig. 17. Anonymous, *Youth and Nymph* (Otto print). Paris, Bibliothèque nationale.

Graces is remarkably up to date. The chemise, or *camicia*, is a woman's undergarment, full length, quite ample, and provided with sleeves that often extended to the wrist. It was originally quite simple, and indeed there are few notices concerning underwear of any description from the earlier years of the fifteenth century, for the simple reason that such items were not considered valuable enough to inventory.[41] The exception to this rule is the *camicia da giorno*, a garment that was quite rare at the beginning of the century but that became common by its end—when, according to Rosita Levi Pisetsky, a lady's wardrobe averaged about a dozen. The reason for this is that the chemise had come to be a decorative garment in its own right, one certainly far too flimsy ever to be worn alone, but which it became the fashion to expose, in particular around the neck and at the sleeves. Indeed, one of the most typical elements of late fifteenth-century fashion appears in the sleeve of the dress worn over the *camicia*, which was laterally open and fastened by ties, creating vents called *finistrelle* set along the length of the arm so that the whiteness of the underlying *camicia* was displayed in little puffs. It was said that *finistrelle* were introduced in order to make movement easier, but the effects of the puffed sleeves of the chemise, as Levi Pisetsky observed, was to lend a singular freshness to the appearance of the dress; this effect may indeed be observed from Botticelli's representation of the conspicuously up-to-date sleeves, laterally open and bound with *finistrelle* revealing puffs of the white *camicia* beneath, of the dress worn by Flora (plate 5).[42]

As articles of fashion, intended to be partly displayed, chemises were made of the finest material, the best being *tela di rensa* (from Reims, and *finissimo* according to Levi Pisetsky), *tela d'Olanda*, and *tela di Cambrai*.[43] They were also beautifully embroidered with colored or golden threads—an inventory of 1498, for example, records that Bianca Sforza possessed a "camicia di tela di Cambrai con maniche grandi fino a terra, con guarnizioni di rete d'oro a seta verde."[44] Such gold embroidery appears in exquisite detail on the chemises worn by Botticelli's Graces (plate 13), notably on the collar that the central Grace has slipped from her neck, and especially elaborately around the breasts of the right-hand Grace. Venus too displays beautiful gold embroidery at the neckline, and adorning the breast of her overdress (plate 6)—

[41] R. Levi Pisetsky, *Storia del costume in Italia*, Milan, 1964, II, p. 285.

[42] Ibid., where Levi Pisetsky observes of the *camicia da giorno* that "la sua crescente preziosita è comprensibile sia per il più elevato tono di vita, sia per la moda di esibirla attraverso le finistrelle delle maniche e intorno al collo"; see also Birbari, op. cit., p. 42: "It was not, however, until relatively late in the century that the chemise (and to some degree the shirt) began to be regarded as a decorative garment in its own right, and although it was always too flimsy to be worn alone by fashionable women other than in private, with the growth of a fashion for exposing large parts of the chemise those parts began to be far more elaborately trimmed and embroidered than could have occurred in the earlier years of the century." For *finistrelle*, see Levi

Pisetsky, op. cit., II, p. 395: "Ma tipici sopratutto del Quattrocento paiono quegli spacchi all'attacco della manica e al gomito, o anche su tutto il braccio, che lasciano sbuffare il candore della camicia e danno una impronta di singolare freschezza alle vesti. Introdotto, come si è detto, con lo scopo di rendere piu agevole il movimento, questi tagli assumono subito un valore decorativo e si propagano su tutta la manica e poi sul vestito con il grazioso nome di finistrelle."

[43] Levi Pisetsky, op. cit., II, p. 285.

[44] Ibid., where it is further observed of *camicie* toward the end of the century that "sono in tela di rensa, d'Olanda o di Cambrai, lunghe e talvolta larghissime, provviste di maniche che arrivano al polso, ornate di ricami d'oro o colorati o neri, infine di trine *ad riticellas*."

a light garment that, as Birbari observed, might be thought to be some sort of reference to the dress of antiquity but that in fact is fifteenth century, made of light material and worn over the chemise in warm weather in order to add charm and a measure of decency without producing heat.[45] Even Chloris—the plainness of whose dress is iconographically determined since she is a "nymph of the bare earth"—has delicate gold trim at the hem of her extraordinarily transparent chemise.

Levi Pisetsky has pointed out that the transparency of such materials, as appears especially in the breathtaking veil worn by Venus, may seem to be an invention of artists like Botticelli and Filippo Lippi, but that in fact documents of the time confirm that such things existed. Veils were worn either falling simply around the face, as Venus wears hers, or arranged in patient folds (as appears in the many Madonnas painted by Botticelli and Lippi) to help bind the hair in place. They too were often embroidered with colored and gold threads, and frequently were combined with pearls strung on a fine wire, called a *vespaio*, which also was used to hold the hair.[46] The right-hand Grace in the *Primavera* wears a *vespaio*, attached to a spectacular *gioiello da testa* (an enormous pearl set in a golden flower), curling round to gather her hair together at the temples. The squared gems set in enameled leaves and flowers ornamented with pearls that appear at the breasts of the right- and left-hand Graces have also been shown to be items of jewelry much in fashion at the time Botticelli painted the *Primavera*.[47]

The gods of the *Primavera*, notwithstanding their own origins in remotest antiquity, are accordingly also very much creatures of the Florentine fifteenth-century present. Because they are, it has seemed appropriate to some scholars, again following in Warburg's path, to seek parallels between Botticelli's imagery and that of contemporary secular poetry celebrating real events. Special attention in particular has been paid to poetry connected with famous Medici tournaments—notably Politian's *Stanze per la giostra*—or inspired by popular festivals like the Calendimaggio, the great springtime celebration that inspired Politian's famous "Ben venga Maggio"

[45] Birbari, op. cit., pp. 67f., exemplifying the overdress with the garment worn by the woman in Sellaio's *Triumph of Chastity*, of which she writes that, "although it might be thought that some sort of reference to the dress of classical antiquity might have been the aim, over-dresses looking very much like this can also be found in straight portraiture." The portrait she uses to exemplify such an overdress is Botticelli's *Smeralda Bandini* in the Victoria and Albert Museum, and on p. 92 Birbari observes that Sellaio's *Venus* in the Louvre also is shown wearing an overdress (as is the Venus in Botticelli's *Mars and Venus* in the National Gallery in London).

[46] Levi Pisetsky, op. cit., II, pp. 295-299, where a *vespaio* is defined as a *vezzo di perle* that binds the hair. See also Pulci's comic *frottola*, "Le galee per Quarac-

chi" (in Luigi Pulci, *Opere minori*, ed. P. Orvieto, Milan, 1986, pp. 21–30), in which *vespai* appear in the extended list of headwear taken by the women for a visit to Bernardo Rucellai's villa on the Arno (line 157). For the full effect of the *vespaio*, with pearls not only threaded on wire as in the *Primavera* but also on thread braided into the hair itself (so that they seem like scattered, lustrous insects), see the two portraits of women attributed to Botticelli or his workshop that are now in, respectively, the Staedelsches Kunstinstitut in Frankfurt and the Staatliche Museen in Berlin (R. Lightbown, *Sandro Botticelli*, London, 1978, II, nos. C3 and C4, pp. 116f.).

[47] Y. Hackenbroch, *Renaissance Jewelry*, London, 1979, pp. 12f.

and Lorenzo the Magnificent's own "Quant' è bella giovinezza," perhaps the most celebrated poem of the Quattrocento. Both poems have been recited numberless times before the *Primavera*, and there are some odd details in the *Primavera* that lend support to such an association. I have already observed, for example, that the dense row of buttons on the chemise of the central Grace is something that had been long out of fashion by the time the picture was painted, even though the chemise itself and its embroidery are very much up-to-date, indeed manufactured in a form unimaginable when the taste for rows of buttons prevailed. Similarly, and much more obviously, Venus's appearance is distinctly old-fashioned (plate 6). She wears a heavy mantle, majestic in red and blue, and though such mantles (derived from Byzantine dress) were common in thirteenth- and fourteenth-century Italy, by the end of the fifteenth century they were worn only in the monastery or by women of relatively advanced age.[48] They were not worn by young girls, and most wives and women of childbearing age did not even own one. The corresponding dignity and gravity with which Venus is thus endowed is enhanced by the way she wears her veil, which modestly covers her hair rather than setting off an intricate coiffure in the manner of the Graces. Her aspect has indeed led more than one writer (occasionally with unlucky iconographic consequences) to compare her with the Madonna. I have already shown, however, that the clothed Venus hortorum was for the ancient Romans specifically a goddess of olden times, and Botticelli seems to have indicated this by investing Venus with the dignity of a distinctly old-fashioned, but nonetheless new and not specifically antique, costume. That she is wearing a costume is suggested not only by the simultaneously old-fashioned and up-to-date character of her dress, but also by the row of pearls that decorates the hem of her mantle. This extraordinary feature recalls the sumptuousness recorded in contemporary accounts of the costumes worn at festival celebrations. The same may be said for Mercury's jeweled falchion. I have already had occasion to mention Lightbown's observation that Botticelli showed Mercury's *harpe* in the form of an exquisitely wrought Renaissance falchion, which is certainly a parade piece and not made for use in the field. It too brings to mind the surviving descriptions of the famous tournaments won by Lorenzo de'Medici in 1469 and by his brother Giuliano in 1475, in which the knights themselves were dazzling in velvet jackets studded with pearls, and whose weapons, harnesses, and standards were designed and executed by the most famous artists of the day, Botticelli among them.[49] Moreover, the sheer springtime overdress worn by Venus, as Birbari showed, may be compared with the overdresses (equally contem-

[48] See S. Newton, *Renaissance Theatre Costume*, London, 1975. I am grateful to Maureen Mazzauoui for discussion and assistance on this point.

[49] For contemporary descriptions of the costumes worn at the *giostra* of Giuliano, see, among others, I. Del Lungo, "La giostra di Giuliano," in *Florentia: Uomini e cose del Quattrocento*, Florence, 1897, pp. 391–412; R. M. Ruggieri, "Letterati, poeti, e pittori intorno

alla giostra di Giuliano de'Medici," *Rinascimento*, x, 1959, pp. 165–196; and (with complete bibliography) S. Settis, "Citarea 'su una impresa di bronconi,' " *Journal of the Warburg and Courtauld Institutes*, XXXIV, 1971, pp. 135–177. For Botticelli as a designer of standards, see G. Poggi, "La giostra medicea del 1475 e la 'Pallade' del Botticelli," *L'arte*, v, 1902, pp. 71–77.

porary) in which Sellaio depicted the costumed nymphs in his representations of Florentine *trionfi* (fig. 11).[50]

Finally, perhaps the most suggestive evidence that the *Primavera* is to be related to contemporary festival pageantry and its poetry appears in the extraordinary dress worn by Flora (plate 5). Stella Newton identified this as a species of theatrical costume, such as that worn in secular pageants, and moreover she pointed out that the Gothic dagged edges (serrated edges) of Flora's dress were, once again, old-fashioned in Botticelli's time, a reminiscence of the high fashion of about seventy years earlier.[51] The dress is richly ornamented, and while such decorated fabrics, in zoomorphic and lettered as well as floral patterns, were popular in the fifteenth century and may often be found in painting, Flora's dress differs in that it does not show the characteristic features of a woven pattern. Indeed, the flowers on her dress could not have been woven, because the pattern is not repetitive. The original of the dress represented by Botticelli must have had a painted pattern, which suggests that its purpose was ephemeral (i.e., theatrical), and that Botticelli—whom Vasari says invented a new and greatly improved technique for painting on cloth for festival displays when he painted the standard representing Pallas carried by Giuliano de'Medici in the tournament of 1475—used as a model a dress designed for just such a festival.[52] It is highly significant for Botticelli's invention that when Ovid described Flora in her springtime garden in the *Fasti* he pictured her accompanied by the Hours "clad in painted gowns" (*conveniunt pictis incinctae vestibus Horae*). It is significant, too, that Flora's dress is very similar, as Warburg was the first to point out, to the dress worn by Simonetta Cattaneo Vespucci as it is described by Politian in the *Stanze per la giostra*, written to commemorate the same tournament of 1475. Simonetta's dress is also painted:

> Candida è ella, e candida la vesta
> Ma pur di rose e fior dipinta e d'erba:

[50] Birbari, op. cit., pp. 67f. For the widespread use of *camicie* for theatrical nymph costumes in the fifteenth and sixteenth centuries, see E. H. Mellencamp, "A Note on the Costume of Titian's *Flora*," *Art Bulletin*, LI, 1969, pp. 174–177; see, for example, Leone de Sommi's fourth dialogue on scenic apparatus and costume in his *Dialogi in materia di rappresentazione scenica* of ca. 1561:—"Alle Nimphe poi, dopo l'essersi osservate le proprietà loro descritte da'poeti, convengono le camiscie da donna, lavorate et varie, ma con le maniche; et io soglio usare di farci dar la salda, acciò che legandole coi manili o con cinti di seta colorata et oro, facciano poi alcuni gonfi, che empiano gl'occhi et comparano leggiadrissimamente" (A. D'Ancona, *Origini del teatro italiano*, Turin, 1891, p. 581).

[51] Newton, op. cit., p. 56.

[52] G. Vasari, *Le vite de' più eccellenti pittori, scultori ed architetti moderni*, ed. cit., III, p. 323; see also Poggi, op. cit. Such a painted costume is described in connection with the wedding entertainments celebrating the marriage of Constanzo Sforza and Camilla d'Aragona in Pesaro in 1475: "Hymeneo . . . reputato deo de le noze . . . era uno giouene formoso cum una cauegliara d'oro et una corona di rose cum una uesta succinta a meza gamba depinta ad annelli di diamanti et nodi et fiame focho tempestato d'oro cum un frixo pur de annelli . . . ligate da uno annello de diamante" (quoted from F. Ames-Lewis, *The Library and Manuscripts of Piero di Cosimo de'Medici* [Garland Series of Outstanding Theses from the Courtauld Institute of Art], New York and London, 1984, p. 68).

> Lo inanellato crin dall' aurea testa
> Scende in la fronte umilmente superba.[53]

(She is gleaming white, and shining white is her dress, though painted with roses and flowers and greenery: the unbound hair of her golden head falls over a brow that is humbly proud.)

And further on:

> Ell' era assisa sovra la verdura,
> Allegra, e ghirlandetta avea contesta
> Di quanti fior creassi mai natura,
> De' quai tutta dipinta era sua vesta.[54]

(She was seated on the grass, mirthfully gay, and she had woven a little garland made of as many flowers as ever nature created, and of these her dress was all painted.)

The parallel between Simonetta and Flora is then completed, as Warburg showed, when to the comparison of their festival costumes is added a comparison of their attributes and actions. Simonetta has gathered flowers in her lap, and as she rises from the ground where she is seated she gathers up her skirt to hold them there ("poi colla bianca man ripreso il lembo, / levossi in piè con di fior pieno un grembo"); with happy countenance she steps serenely across the grass with an amorous grace ("poi con occhi più lieti e più ridenti, / tal che 'l ciel tutto asserenò d'intorno, / mosse sovra l'erbetta e passi lenti / con atto d'amorosa grazia adorno"); and the enraptured Giuliano praises to himself the sight of her sweet, celestial gait and the breeze that catches her beautiful dress ("fra sè lodando il dolce andar celeste / e'l ventilar dell'angelica veste").[55] Simultaneously in the dress and the graceful movements, energized by the fresh breeze blowing through their garments, of the figures in Politian's poem and in the *Primavera*, Warburg found expressed the particular spirit (which he designated a formula for expressing a distinctive pathos) of a new mythological figure, the Florentine nymph.[56]

The classical appearance of the gods in the *Primavera* in a reenactment of their archaic and most ancient manifestation as the animating spirits of the world's first spring is accordingly reinforced by their specific portrayal in a second, doubly archaic manifestation as the gods—the same gods—of the early, vernacular Tuscan past. That we are witnessing a present reenactment, and not a direct depiction of the classical or Tuscan pasts themselves, appears from the simultaneously old-fashioned and contemporary characteristics of their costumes—which do much to endow the

[53] Politian, *Stanze per la giostra*, 1.43.

[54] Ibid., 1.47.

[55] Ibid., 1.47, 55, 56.

[56] A. Warburg, "L'ingresso dello stile ideale antich-eggiante nella pittura del primo rinascimento," in *La rinascita del paganesimo antico: Contributi alla storia della cultura*, ed. G. Bing, Florence, 1966, pp. 283–307.

painting with a character that is at once *antico* and *nuovo*. The figures are playing a part, in other words, appearing as masqueraders dancing out a pantomime based on an ancient myth of the spring. We are witnesses to an imaginative recreation of the forms of the earliest *mascherate*, that form of festival entertainment that reached its fullest development in the Italian *intermezzo* as staged a century later in the Tuscan grand-ducal court, in the French *ballet de cour*, which evolved out of the magnificent mythical and allegorical representations Catherine de'Medici imported into France from her native Italy (recorded in paintings by Caron), and in the English masque as staged by Inigo Jones and preserved in the poetry of Ben Jonson. Such supremely courtly forms of entertainment derived from the *trionfi* and festival celebrations of the earlier Renaissance in Florence, and in particular from those staged at the time of Lorenzo de'Medici, who was the first to adapt the older forms of dance pantomime and festival song to the theatrical presentations and elaborate pageant cars that carried beautifully costumed figures enacting allegorical themes from Tuscan poetry and classical mythology. Warburg was the first to point out, for example, the close correspondence between the famous engraving of *Bacchus and Ariadne* (fig. 12), almost certainly based on a drawing by Botticelli, and Lorenzo's famous carnival song, "Quant' è bella giovinezza"; it was Vasari who wrote that "Lorenzo de'Medici was the first inventor of those *mascherate* that represent something, and which are called *canti* in Florence." The form of the costumes shown in the *Primavera* affords a strong reason for supposing that Botticelli's invention is based in an imaginative representation of such a masque or song.

Many writers have indeed commented on the late Gothic character of the *Primavera*, finding this expressed in the elastic linearity of Botticelli's contours and in his vibrant colorism, both of them irresistably reminiscent of the most refined paintings of the International Style; often, too, Botticelli's depiction of the grove brightly patterned with flowers has been likened to late medieval tapestries. Pierre Francastel, in a remarkable essay, attempted to give critical depth to such observations by emphasizing that the *Primavera*, in precisely the same sense as Politian's *Stanze*, not only and self-evidently exhibits a highly purified concept of style that evokes its origins in the fourteenth century, but also is remarkable for the precision of its imagery— for the representation of things actually seen and experienced. [57] The poignancy of the image depends on the tension between, and the fusion of, the traditions of artifice and the experiences of the present. Part of the "Gothic" character of the *Primavera* is expressed by its figures, who represent the archaic, rustic gods of the ancient spring, appearing in costumes that are at once fanciful and appropriately old-fashioned, but old-fashioned in that they are contemporary recreations of the traditional festival costumes of Botticelli's native Tuscany. They are costumes that Botticelli had actually seen, and even quite possibly had helped design and decorate for jousts and festival *trionfi*. In the same way a part of the distinctive character of Politian's *Stanze*

[57] Francastel, "Fête mythologique," op. cit.

derives from a language unmistakably reminiscent of Petrarch's *Trionfi*, even while it simultaneously describes and mythologizes events and objects that the poet had actually seen in real festival triumphs (for which he composed *canzoni a ballo*) and works of art.

The *Primavera*, like the *Stanze*, might well commemorate (or mythologize) a particular tournament or festival, as indeed might the so-called *Pallas and the Centaur*, which at the end of the fifteenth century hung in the same room as the *Primavera*, and in which the figure of Pallas is shown wearing a painted gown decorated with the interlaced diamond rings that are a familiar Medici device.[58] We have learned from the inventory of the *case vecchie de'Medici* in the Via Larga that the *Primavera* was placed in the wainscoting of a room in the old Medici dwellings, over a *lettuccio*, and Vasari, in a well-known passage from the *vita* of Dello Delli, refers to the systems of decoration used at the time of the earlier Medici, and to their characteristic subjects:

> And the stories they painted on the front [of *cassoni*] were for the most part fables taken from Ovid and other poets; or stories told by the Greek or Latin historians; and similarly hunts, jousts, *novelle d'amore*, and other such-like things, depending upon what each loved best. . . . And what is more they painted in this way not only *cassoni* but also *lettucci*, *spalliere* [wainscoting], and the frames that went around them; and in this way they also made other ornaments for the chamber, which they used to do magnificently in those times, as can be seen from infinite examples throughout the whole of the city. And for many years this kind of thing was the custom, so that even the most excellent painters worked on things made in this way, without being ashamed to paint and gild such works, as many would be today. And that this is true may still be seen to this day, aside from many other examples, in some *cassoni*, *spalliere*, and frames in the chambers of the old Lorenzo the Magnificent, in which were painted by the hand of by no means ordinary painters, but excellent masters, all the *giostre*, tournaments, hunts, festivals, and other spectacles performed in his times, and done with judgment, with invention, and with marvelous art. Examples of such things may be seen not only in the palace and in the *case vecchie* of the Medici, but also some things still remain in all the most noble houses of Florence. And there are some people who, adhering to these old customs, which are truly magnificent and highly honorable, have not had these things removed in order to make room for modern fashions and decorations.[59]

Historians of literature have always known that Politian's vernacular poetry was rooted in chivalric and carnival pageantry, much of it indeed having been composed

[58] Lightbown, op. cit., II, no. B43, pp. 57–60.

[59] Vasari, *Le vite de'più eccellenti pittori, scultori ed ar-* *chitetti moderni*, II, pp. 148f.

for performance in festivals (or, in the case of the *Stanze*, in commemoration of one), and historians of art at least since Warburg have known the same about Botticelli. Francastel forcefully redrew attention to the importance of this common foundation to their invention, and stressed the need to come to grips with it, to grasp, as he put it, the "matière brute" from which both literary and plastic expression arose. In order to do this he pointed to the need to understand the festival celebrations as public ritual. Neither the *Primavera* nor the *Stanze* represents or illustrates an actual pageant in the sense that Sellaio's *Trionfi* and Luigi Pulci's *Giostra* celebrating the tournament won by Lorenzo the Magnificent in 1469 do. Politian's *Stanze*, although celebrating an actual event, the tournament won by Giuliano in 1475, takes as its theme the tournament itself as a symbolic representation, an elegant fictional backdrop for the chivalric trial of Giuliano's martial and amorous virtue. Francastel found in the *Primavera*, as have many others, a precisely similar thematization of an idea of poetic and chivalric love, one that departs from earlier treatments of this theme in the same way that Politian's poem (not least in transforming a courtly festival making use of classical sources into a true *fête mythologique*) departs from its models. Since both the painting and the poem are imaginative representations, Francastel argued that it is all the more necessary to understand what the imaginative experience of the festivals represented in popular as well as higher Florentine culture of the late fifteenth century.

Francastel had been stimulated to this effort by two books in particular, Alessandro D'Ancona's classic history of the origins of Italian theater, and André Varagnac's anthropological study of the folklore of rites of the spring and the May in Europe. D'Ancona had traced the history of the early lyric forms of the Tuscan rural festivals known as the Maggi (which were also called Bruscelli and Giostre—a name at first appearing in the generic sense of *ludi* rather than necessarily entailing passages of arms), especially as they provided a secular counterpart to the *sacre rappresentazioni* in contributing to the primitive development of theatrical representations.[60] Varagnac had attempted his own interpretation of the *Primavera*, suggesting that its meaning derived directly from the folklore of the people instead of the high culture sponsored by Lorenzo the Magnificent. According to his interpretation, Botticelli's imagery directly represents the Maggi, a springtime rite originating in the ancient festival of the Majumae, which in the early days of the Christian era was banned because of the indecorous and licentious behavior associated with it, but which was restored (with appropriate strictures) in the Code of Theodosius and reaffirmed in the Code of Justinian.[61] The custom, well known in Europe in the Middle Ages and continuing in various forms down to the present day, is that of the *arbor maialis*, or May branch, which in antiquity was called the *maius*. On appointed days in spring (for the festivals were variously celebrated at different times in April and May, not

[60] D'Ancona, op. cit., II, pp. 242–270.

[61] A. Varagnac, *Civilisation traditionnelle et genres de vie*, Paris, 1948, esp. pp. 242f.; see also Du Cange, *Glossarium ad scriptores mediae & infimae latinitatis*, s.v. *majuma* and *maius*.

necessarily on May Day itself) a group of young men and women would ride into the countryside and cut the branches from a freshly flowering tree, which then were used to decorate some public place, and the season was celebrated in dancing and singing a song traditionally beginning with the phrase "Ben venga Maggio." The festival was popular throughout Europe, the miniature illustrating *The Month of May* in the *Très riches heures* of the duc de Berry depicting, for example, just such a group of May Day celebrants, accompanied by musicians, riding back from the forest bedecked with greenery (fig. 13).[62] In Italy the custom was to cut flowering branches so that young lovers might attach these, often with presents, to the doors or windows of those for whom they wished to declare their affection and good wishes, who would then be serenaded in song and dance. A famous woodcut for the *Canti carnascialeschi* depicts such a serenade (fig. 14), a youth with the *arbor maialis* being shown kneeling before Lorenzo the Magnificent himself, while a group of singers stands before the Medici Palace;[63] in Andrea da Firenze's fresco of the *Via veritatis* in the Spanish Chapel a charming countryside vignette reveals youths climbing the trees to cut the May branches, while nearby a group of young girls appear dancing (fig. 15).[64] Varagnac's argument was that the *Primavera* itself also depicts the ancient Tuscan spring ritual, and that accordingly the central figure in the painting is not Venus but the Queen of the May, the three dancing nymphs are not the Graces but the three young girls of the *trimazo* (more usually called the *maio*, or *maggio*, deriving from the ancient *maius* and referring to the branch cut from the tree), and the young man at the left was not Mercury but the youth who actually cuts the branches.[65]

Francastel distanced himself (as would I) from the specific details of this interpretation as providing a literal reading of the actions and attributes of the figures in the *Primavera*, but he pointed out that at the same time Varagnac had had a valuable insight in understanding the painting in relation to the ritual celebrations of the Florentine spring. Politian, in perhaps the most famous of all his canzoni, written to be sung by the dancers during their Calendimaggio serenades, indeed wrote his own ritual song of the *maio*, which he represents in a beautiful and justly celebrated metaphor:

> Ben venga maggio
> E'l gonfalon selvaggio:
> Ben venga primavera
> Che vuol l'uom s'innamori.[66]

[62] See the text and plate for the *Month of May* in M. Meiss, *The Très riches heures of Jean, Duke of Berry*, New York, 1989.

[63] See, for example, E. Barfucci, *Lorenzo de' Medici e la società artistica del suo tempo*, Florence, 1964, p. 30.

[64] See M. Meiss, *Painting in Florence and Siena after the Black Death*, Princeton, 1951, pp. 94–104 and plate

94, and E. Borsook, *The Mural Painters of Tuscany: From Cimabue to Andrea del Sarto*, 2d ed., Oxford, 1980, pp. 48ff. and plates 61 and 65.

[65] Varagnac, op. cit., pp. 242f.; see also pp. 142–144.

[66] Poliziano, *Ballate*, IX.1–4 (in A. Poliziano, *Stanze, Orfeo, Rime*, ed. S. Marconi, Milan, 1981, p. 160).

(Well come is the May branch and the forest banner: well come is the spring that makes man fall in love.)

Moreover, the Calendimaggio as a popular festival with roots extending unbroken back into antiquity falls within the period (including both April and May) when the ancient Floralia, or rites of Flora, were celebrated. In the same passage in the *Fasti* in which Flora tells of the origins of this festival in her rape by Zephyr, its celebration is described in terms that simultaneously look forward to the Florentine May Day revelers singing canzoni as the *maio* was tacked to the beloved's door, and back to the not-so-innocent origins of the festival in ancient Rome:

> ebrius incinctis philyra conviva capillis
> saltat et imprudens utitur arte meri;
> ebrius ad durum formosae limen amicae
> cantat, habent unctae mollia serta comae.[67]

(The tipsy reveler dances, his hair bound with linden bark, and incautious he tries the drinker's art; the tipsy reveler sings at the hard door of his lady fair, soft garlands crowning his perfumed hair.)

The popular spring festivals of antiquity, the Majuma and the Floralia, are directly continued by the Calendimaggio and the popular springtime festivals of Florence. The feeling of such national continuity with the Romans, as Eugenio Garin has pointed out, is profoundly characteristic of both Politian's poetry and his philology; it is just such a feeling that one finds in the conception and expression of the *Primavera*.[68] There we see the clearly recognizable Greek and Latin gods of the remote past, the rustic gods of the first spring of the world. We see them in consciously archaic guise, dressed in costumes that are not ancient but old-fashioned, harking back to a second originary past, the vernacular traditions embodied in the spring festivals of an earlier Tuscany—a tradition of ritual civic celebration we can still see memorialized, not only in Andrea da Firenze's frescoes in the Spanish Chapel, but also in the dancing women in hand-painted dresses represented by Ambrogio Lorenzetti in his fresco *The Effects of Good Government in the City* in the Palazzo Pubblico in Siena (fig. 16), and memorialized even earlier in the shared, acculturated imaginative experience that is forever recalled in that fateful Calendimaggio when Dante encountered Beatrice in the streets of Florence, preceded by her friend Giovanna, known as *la Primavera*, and began his *vita nuova*.[69] We also see them, inescapably and with no inconsis-

[67] Ovid, *Fasti*, v.337–340.

[68] E. Garin, "L'ambiente del Poliziano," in *La cultura filosofica del rinascimento italiano*, Florence, 1979, pp. 345ff.; see also the excellent essay by D. De Robertis, "Il Quattrocento e Ariosto," in *Storia della letteratura italiana*, ed. E. Cecchi and N. Sapegno, Milan, 1966, pp. 459–566.

[69] For Lorenzetti's dancing women, see H. Belting and D. Blume, eds., *Malerei und Stadtkultur in der Dan-*

tezeit, Munich, 1989, color plate III and plate 19; for Dante's meeting with Beatrice and Giovanna, see Dante, *Vita nuova*, XXIV, and below, chapter 4. J. Bridgeman, "Ambrogio Lorenzetti's Dancing 'Maidens': A Case of Mistaken Identity," *Apollo*, CXXXIII, 1991, pp. 245–251, has also pointed out that the dancing figures in Lorenzetti's *Effects of Good Government in the City* are wearing quasi-theatrical costumes but she has missed the allusion to the traditional

tency, costumed for the return of the new yet profoundly old Florentine spring (*Le tems revient*) of Lorenzo the Magnificent. In the *Primavera*, as in Politian's poetry, the two great cultures of Italy, Roman and classic on the one hand and Tuscan and vernacular on the other, have become indistinguishable, united and mutually transformed in the new culture of humanism. The ancient topos of the spring is expressed as a new and present reality, a reality in which the truth of ancient experience has been reabsorbed and understood through the poetry that gave it expression, reassimilated within the native lyric traditions of the old country festivals, and in the process transformed by the newly emerging forms and conventions of a living vernacular experience.

This was the point that Francastel had uncovered. The Venus of the *Primavera*, he wrote, "is not the goddess of the mythological genealogies, but the true *Venus physica* hymned by Lucretius as the animating force of the universe."[70] Varagnac had been mistaken in the particulars of his interpretation, not so much because he had not taken into account the attributes and actions in the *Primavera* that identify the figures as classical gods, but because on a more fundamental level he had misconceived the distinction he made between the folklore of the people and the high culture sponsored by Lorenzo the Magnificent. The Neoplatonic interpretation had also been mistaken, not so much because particular arguments might be faulted on a technical level, but because the concept that Botticelli's invention arose from an intellectually abstract Neoplatonism, remote and aulic, rested on the same misconception of Florentine culture. The meaning of Venus in the *Primavera* is also directly wedded to the realities of popular experience and their ritual and poetic expression. Botticelli's paintings and Politian's poems are first and foremost the imaginative expressions of artists, but expressions that Francastel insisted took as their point of departure the forms and experiences of contemporary life. These forms and experiences were not the result of a unitary level of traditional civilization, high or low, and the Florentine culture in which both Botticelli and Politian lived stood in a particularly complex and engaged relationship to the remote and the more recent past. Francastel took the view that it is in their art, paradoxically art that is at its most sophisticated and refined, that one finds most fully expressed the popular forms of the past and present. In combination, these forms were the foundation for the full cultural experience, the reality, in fact, that Botticelli and Politian each expressed. In short, he had come to the same understanding of the cultural context and expression of the *Primavera* as that stated at about the same time by Garin about Politian's vernacular poetry:

Tuscan civic festivals celebrated in times of peaceful good governance, which is what the fresco is all about. She suggests the figures are not women but male *giullari* on grounds of the propriety of their actions ("girls dancing in a public thoroughfare would have been quite shocking"), as well as their ambiguous hair styling and secondary sex characteristics (not a reliable indicator in the case of Lorenzetti, however; cf. the figure of Concordia in the adjacent fresco). Without arguing the point—whether women or men they appear *alla ninfa* in painted costumes—the appearance of *giullari* in a painting devoted to good government, given their dubious legal status as acknowledged in Bridgeman's article, is problematic in itself, while public dancing in the context of festivals was neither shocking nor unusual.

[70] Francastel, "Fête mythologique," op. cit., p. 242.

Not by chance did Politian pass from Greek to Latin and then to the vernacular in refining his style, and his vernacular at its most refined takes up the popularizing tendencies of the Florentine vernacular. "Cum Ciceronem, cum bonos alios multum diuque legeris, contriveris, edidiceris, concoxeris, et rerum multarum pectus impleveris," then, and only then, in the midst of such richness, will you find that supreme purity and simplicity and nudity, which seems a small thing and is everything: and in the description of a rose plumb the whole of reality, and in doing this its totality is accessible to everyone, aristocratic in the extreme and utterly popular, supremely ideal and completely real—*umanissima*.[71]

[71] Garin, op. cit., p. 354.

POETRY AS HISTORY

Lucrezia Donati, Luigi Pulci's
Da poi che 'l Lauro, and Some Poems
by Lorenzo de' Medici

MACHIAVELLI, writing in the *Istorie Fiorentine* of the days of Piero de' Medici and the dissensions strewn in Florence by the rebellious Diotisalvi Neroni, Luca Pitti, Agnolo Acciaiuoli, and Niccolò Soderini, tells of the decision by those worried by the civil discords to ordain some public *allegrezza*, or spectacle. In this way, it was hoped, "since more often than not idle people are an instrument for whoever wishes change," they might "remove idleness and give men something to think about that would take their thoughts away from the state, the year of Cosimo's death [in 1464] having already passed." One of the spectacles arranged was "a tournament, for so they call a battle of men on horseback, in which the leading young men of the city perform together with the most famous knights of Italy; and among the young Florentines the most reputed was Lorenzo, Piero's firstborn."[1] The ritual enacted in this spectacle, set against the backdrop of momentous contemporary experiences and events, and in which public and private myths of the Florentine past and its continuation into the present found a common ground, is essential for an understanding of the forms of

[1] N. Machiavelli, *Istorie fiorentine*, VII.12. Machiavelli is confused about the sequence of events, and places the joust in 1465, at the time of the outbreak of unrest in the city when some hoped to discourage seditious rumors with a celebration of civic virtue, and not in 1469, when it was actually held in order to celebrate the defeat of the rebel faction. The passage is often cited as an example of how, in Machiavelli's view, the Medici diverted public attention away from politics and the affairs of the city with public spectacles. But in fact Machiavelli is claiming that such spectacles kept the public away from the idle gossip and intrigue that helped feed the rebellion. He refers with approval to such military displays as a way of bringing happiness and patriotic unity to the city, being demonstrations both of the "grandezza della casa de' Medici e dello stato" (VII.21). When telling of Lorenzo's death (VIII.36) he again refers to the "giostre e rappresentazioni di fatti e trionfi antichi" as a means of keeping the people united and the nobility honored.

the Laurentian culture that reached its full maturity a decade later, in the years when the *Primavera* was painted. In this chapter, however, I shall be setting aside for the moment the investigation of Botticelli's painting as an expression of that culture in order to explore the ways in which private realities and events were mythologized even as they were happening, and how they were given public expression in works of the imagination, in chivalric spectacle and poetry as well as in painting.

The tournament in fact took place on 7 February 1469, four years later than the date implied by Machiavelli, and it was held not in order to keep the minds of the idle from sedition, but to celebrate the end of the public danger. It was sponsored by Lorenzo de'Medici, then just a month past his twentieth birthday, and was held in the piazza of Santa Croce. Lorenzo carried off the first prize, a helmet worked in silver and gold bearing a crest with Mars standing on his own star, a spear in one hand and a crown of laurel in the other. The second prize, another helmet with a crest of Fame with winged feet and bearing a palm, was won by Carlo Borromeo, a faithful Medici supporter. Perhaps the result was only to be expected, even though Niccolò Valori described Lorenzo as "di corpo solido e robusto, et di tanta agilità che in questo ad alcuno non era secondo," and Machiavelli writes that Lorenzo "non per grazia, ma per proprio suo valore ne riportò il primo onore."[2] Lorenzo himself later wrote in his *ricordi*, with characteristic understatement, that "though the passages of arms and blows were not very strenuous, the first honor was judged mine, to wit a helmet worked in silver with Mars for a crest."[3] His victory was nevertheless commemorated in verse by Luigi Pulci, who wrote a descriptive account of the tourney in his poem entitled *La giostra di Lorenzo de'Medici* (which records Lorenzo's receiving a mighty blow from his cousin Braccio de'Medici, as well as having his horse knocked out from under him by Francesco de'Pazzi).[4] The poem was completed some time in 1474, almost six years after the event, and very soon after, as Pulci announces in the concluding octave, a second joust was scheduled, sponsored by Lorenzo's brother Giuliano.[5] It too was held in the piazza of Santa Croce, on 28 January 1475, and it too, in accordance with custom, tested the valor and skill of well-born young men in their flower by placing them in the field together with seasoned knights ("tirones adolescentes a veteranis militibus in equestri concursu," as Filippo Corsini wrote in a letter describing the joust).[6] Giuliano also won his tour-

[2] Ibid., VII.12; see also B. Buonaccorsi, *Diario de'successi più importanti seguiti in Italia, e particolarmente in Fiorenza dall'anno 1498 in sino all'anno 1512; con la vita del Magnifico Lorenzo de'Medici Il Vecchio scritta da Niccolò Valori Patrizio Fiorentino*, Florence, 1568 (anastatic reprint, Florence, 1973), unpaginated.

[3] "Per eseguire e far' come gli altri giostrai in sulla piazza di Santa Croce con grande spesa, e gran sunto, nella quale trovo si spese circa fiorini 10. mila di suggello; e benchè d'anni, e di colpi non fussi molto strenue, mi fu giudicato il primo onore cioè un elmetto fornito d'ariento, con un marte per cimiero" (first pub-

lished by W. Roscoe, *The Life of Lorenzo de'Medici, Called the Magnificent*, Liverpool, 1795, I, appendix, p. 28).

[4] Luigi Pulci, *Opere minori*, ed. P. Orvieto, Milan, 1986, pp. 55–120 (and see octaves CVIII and CXLIIIf.).

[5] See Orvieto's excellent introduction to the poem in Luigi Pulci, *Opere minori*, ed. cit., pp. 55–60. Pulci writes in a letter to Lorenzo dated in 1474 that he is then hoping to finish the poem, and in the final octave (CLX) he refers to Giuliano's forthcoming joust.

[6] See P. O. Kristeller, "Un documento sconosciuto sulla giostra di Giuliano de'Medici," in *Studies in Re-*

ney, which acquired everlasting fame through the verses of a poet greater than Pulci, Angelo Poliziano (known as Politian), entitled *Stanze per la giostra di Giuliano de'Medici*.[7]

The motivations for both tourneys were complex. Certainly paramount in the case of Lorenzo's *giostra* was the celebration of the peace concluded on 8 May 1468 between, on the one hand, the league of Florence with Milan and Naples, presided over by Paul II, and Venice, on the other hand, which had placed the armies of its chief *condottiere* Bartolomeo Colleoni, the *furor bergamasco*, at the disposal of the Florentine rebels seeking to overthrow the government led by Lorenzo's father Piero. Though the war itself, fought in 1466–1467, had been militarily inconclusive, the peace nevertheless represented a great diplomatic and political victory for Piero, who thereby broke the back of the rebel opposition and at the same time greatly consolidated Medici power in Florence. The participation in Lorenzo's *giostra* of professional men at arms (the famous *cavalieri* to whom Machiavelli refers), who had been sent by *condottieri* of the league, was certainly significant in this respect: Giovanni Ubaldini, for example, representing Federico da Montefeltro, captain-general of the league's armies; Carlo da Forme, representing Roberto da Sanseverino, commander of the Florentine troops; and Piero da Trani and Marco Guasparri da Vicenza, representing Bernardino da Todi and Francesco da Sassatella, two other *condottieri* employed by the Florentines in the war against Colleoni.[8] Significant too were the gifts of horses, armor, shields, lances, harnesses, and caparisons sent by members of the league, as well as by Borso d'Este, who had helped the rebels at first but then mediated the peace of 1468. The king of Naples, Ferdinando d'Aragona, sent two horses, Falsamico and Abruzzese, which were ridden in the tournament respectively by Lorenzo and by Dionigi Pucci, a member of Lorenzo's youthful *brigata*; Borso d'Este sent the horse Baiardo, also ridden by Lorenzo; Alessandro Sforza, commander of the papal armies, sent Branca, Lorenzo's third mount; and Galeazzo Maria Sforza, the duke of Milan, gave the harnessings and caparisons for the horse ridden by Giuliano; he was too young to take an active part in his brother's *giostra*, but he entered the arena as part of Lorenzo's cortege.[9]

The peace that had been concluded as the result of military stalemate was thus celebrated in Florence with all the pomp of an ancient military triumph; Pulci did not hesitate to liken Lorenzo's victory in the *giostra* to those of Aemilius, Marcellus, and Scipio, who had all triumphed *sanza invidia* in Rome. Piero de'Medici, moreover, seriously ill and fated not to live out the year, had designated Lorenzo his successor. The peaceful military triumph celebrated that day was accordingly not only of Florence or even the Medici house in general, but also and especially of Lorenzo,

naissance Thought and Letters, Rome, 1956, pp. 437–450, esp. p. 445.

[7] A. Poliziano, *Stanze per la giostra di Giuliano de'Medici*, in the edition introduced by G. Carducci, *Le Stanze, l'Orfeo, e le Rime di messer Angelo Ambrogini*

Poliziano rivedute su i codici e su le antiche stampe e illustrate con annotazioni di varii e nuove, Florence, 1863.

[8] Luigi Pulci, *Opere minori*, ed. cit., pp. 55ff.

[9] Ibid.

who had adopted for the *giostra* the motto *Le tems revient*, ultimately referring to the imagery of Virgil's fourth eclogue and promising the return of a golden age of eternal peace. As Luigi Pulci wrote (octave CLVIII):

> perché tu fusti, o mio Läur, principio
> di riportar te stesso in sulla chioma,
> di riportar honor, vittoria e 'nsegna
> alla casa de' Medici alta e degna.

(Because you were, O my Lauro, the first to bear yourself [the laurel] on your locks, to carry away honor, victory, and the standard to the noble and worthy Medici house.)

Similarly, when at Lorenzo's bidding Giuliano's *giostra* was given authorization by the Parte Guelfa six years later in order to celebrate the league concluded in Rome on 2 November 1474 among Florence, the State of the Church, Milan, Naples, and Venice (which seemed to assure lasting peace among the Italian powers), this too took on all the coloring of a military triumph. Indeed, in Politian's remarkable *Sylva in scabiem* of about 1480, written in harder times, after the murder of Giuliano and at the end of the Pazzi Wars, the poet reminded Lorenzo of how, just as he had once sung the heroes and mighty battles of the Trojan War, so too he had then celebrated Giuliano in images not unworthy of Homer in the *Stanze per la giostra*, singing of *Iulius armipotens*, "his cuirass boiling with fire, his shield flashing with the rays of the sun, scouring the field on his Iapigean steed," and winning for himself an "eternal triumph."[10]

The private meaning of the spectacle for Lorenzo (coinciding with much of its public meaning, for this was certainly known to the members of his *brigata* and to many of the onlookers), is more complex in nature. Lorenzo had in fact pledged himself to a tournament more than three years earlier, long before the peace made with Venice and almost a year before the expulsion of Diotisalvi Neroni and the principal rebels from the city. This occurred at the wedding party of his close friend Braccio Martelli, who married Costanza de'Pazzi late in 1465, during which Lucrezia Donati, the young and beautiful wife of Niccolò Ardinghelli, had woven a garland of violets for him and asked him to carry it into the field out of love for her. When the *giostra* was at last held in February 1469, Lorenzo carried a banner with Lucrezia's

[10] A. Poliziano, *Sylva in scabiem*, ed. P. Orvieto, Rome, n.d., 245–261:

Ille ego sum, o socii, quanquam ora animosque priores
Fortuna eripuit, qui quondam heroa canendo
proelia et exhaustos Rhoeteo in Marte labores,
ibam altum spirans; quique olim immania bella
Cosmiadae etruscis aggressus credere Musis,
cantabam patulo quantum sese aequore ferret
Iulius armipotens, cum suspiratus amanti

(ah nimium!) nymphae, ferratos durus in hostes
ingrueret sublime volans, claususque minaci
casside et undantem, flammis thoraca coruscoque
umbonem Phoebo radiatus, Iapige campum
persultarit equo, ac tota cervice superstans,
arma, viros victor subversaque quadrupedantum
pectora pulvereis trifida trabe funderet arvis,
altaque magnanimi vel bello exempla secutus
fratris, olympiaco iuvenilia tempora ramo
cinxit et aeternum peperit sibi Marte triumphum.

image, painted by Verrocchio, showing her seated next to a laurel tree beneath the sun and a rainbow, on which the motto *Le tems revient* was written.[11] The story of Lorenzo's pledge to Lucrezia is told in Pulci's *La giostra*, in which Lucrezia is described as Lorenzo's beloved, when he tells the story of Braccio Martelli's wedding party (octaves VII–XI):

> Furonvi tutte le ninphe più belle,
> anzi vi venne ogni amante, ogni dama;
> fra l'altre duo molto gentil' sorelle,
> che l'una ha sol di Costanzia ogni fama
> e l'altra è il sol fra le più chiare istelle,
> quella che il Lauro suo giovinetto ama,
> Lucrezia, d'ogni grazia incoronata,
> del nobil sangue di Piccarda nata.
>
> Venere fece fare una grillanda
> a questa gentil ninpha di vïole,
> e fece che 'l suo amante gliel domanda;
> ella rispuose con destre parole,
> e priegal, ma 'l suo priego gli comanda,
> che gli 'mprometta, se impetrar la vuole,
> ch'al campo verrà presto armato in sella
> e per amor di lei porterà quella.
>
> E missegliela in testa con un riso,
> con parole modeste e sì soave,
> che si potea vedere il paradiso
> e sentir Gabriel quando disse: "Ave".
> Costui, che mai da lei non fia diviso
> e del suo cor gli ha donata la chiave,
> acceptòe il don sì grazioso e degno,
> di prosper' fati e di vittoria segno.
>
> Hor, perché il vero sforza ognun che dice,
> un'altra bella e gentil grillandetta

[11] Luigi Pulci, *Opere minori*, ed. cit., octaves LXIVf. See further P. Fanfani, "Ricordo d'una giostra fatta a Firenze a di 7 febbraio 1468 [*sic*] sulla piazza di Santa Croce," *Il Borghini*, II, 1864, pp. 474–483 and 530–542; and, most recently, P. Orvieto, "In margine all'edizione e commento delle Opere minori di Luigi Pulci," *Interpres*, VI, 1985–1986, pp. 91–123. For Verrocchio as a designer of standards, see C. de Fabriczy, "Andrea Verrocchio ai servizi de'Medici," *Archivio storico dell'arte*, 2d. ser., I, 1895, pp. 163–176, in which is published an inventory for the benefit of Verrocchio's heirs listing works the artist had done for the Medici before their flight from Florence. The first item listed in the inventory is "un quadro di legname dentrovi la fighura della testa della Lucherezia de Donati," the second is "lo stendardo per la giostra di Lorenzo," and the fourth is a "dipintura duno stendardo chon uno spiritello per la giostra di Giuliano." See further G. Poggi, "La giostra medicea del 1475 e la 'Pallade' del Botticelli," *L'arte*, V, 1902, pp. 71–77; and most recently, D. A. Brown and C. Seymour, Jr., "Further Observations on a Project for a Standard by Verrocchio and Leonardo," *Master Drawings*, XII, no. 2, 1974, pp. 127–133.

non fu sì aventurata o sì felice,
della sorella sua, ma tempo aspetta,
ché in gentil core Amor sue cicatrice
non salda così presto, ove e' saetta:
forse che i fior' ancor faranno frutto
a luogo e tempo, e 'l fin giudica il tutto.

Ma certo il Läur mio, sempre costante,
non volle esser ingrato al suo signore;
e, perché egli avea scritto in adamante
quello atto degno di celeste honore,
si ricordò, come gentile amante,
d'un detto antico, che "vuol fede Amore";
e preparava già l'armi leggiadre;
ma nol consente il suo famoso padre.

(All the most beautiful nymphs were there, and indeed every lover came, and every lady. Two most gentle sisters were among the others, one of whom has all her renown from Constancy alone, while the other is the sun among the brightest stars—Lucrezia, crowned with every grace, born from the noble blood of Piccarda, beloved by her young Lauro. Venus made this gentle nymph fashion a garland of violets, and caused her lover to ask it of her. She answered him with deft words, and prayed him (though her prayer was his command) to make a vow to her, if he wished to obtain this garland from her, that he would quickly enter the field, armed and in the saddle, and wear it for love of her. And she placed it on his head with a smile, and with modest words and so sweet that one could see a paradise and hear Gabriel when he said "Hail." He, who will never be divided from her, and who had given her the key to his heart, accepted the gift, so precious and worthy, as a sign of a propitious outcome and victory. But then, for truth compels every poet, another beautiful and gentle little garland woven by her sister met with a less fortunate and happy fate, but waits its time; for Love does not so quickly heal the scar left in a gentle heart by his arrow—maybe the flower will yet bear fruit in its time and place, and the whole will be judged by its end. But it is certain that my ever-constant Lauro did not wish to be ungrateful to his lady, his lord, and because he had inscribed his act worthy of celestial honor in diamond, like a gentle lover he remembered the ancient saying that "Love wants faith." And already he prepared for the happy trials of arms—but not with the consent of his famous father.)

The reason Piero withheld his consent to the tournament was, contrary to Machiavelli's account, the menace of war then being threatened by the rebels, and to his wishes Lorenzo could only acquiesce. Being then of an age when, as Pulci writes, "intenda ogni gentil cor per se stesso," he consoled himself with hunting, writing

poetry, inventing lovers' devices, and staging dances and nighttime masquerades, impatiently awaiting the hour when the war might end and permission be given to hold a *giostra* in Lucrezia's honor (octave XVII):

> E' si dolea, ma con parole honeste;
> poi cominciò a tentar nuove arte e ingegni,
> e or cavagli, hor fantasie, hor veste,
> mutar nuovi pensier', divise e segni,
> e hor far balli, e or nocturne feste
> (e che cosa è questo Amor non insegni?),
> e molte volte al suo bel sole apparve,
> per compiacergli, con mentite larve.

(And he grieved, but with honorable words. Then he began to try new arts and things of wit, to spin new thoughts, sometimes with horses, sometimes in fantasies, sometimes with costumes, devices, and emblems, and sometimes staging dances and nighttime parties [for what is it Love does not teach?]. Many times he appeared to his beautiful sun, in order to please her, in dissimulating masks.)

It might be tempting to dismiss Pulci's story as a pleasing poetic fiction, despite the extraordinary accuracy (measurable against other accounts in contemporary chronicles and poems) of his description of the details and events of Lorenzo's *giostra*, were it not confirmed in its essentials by an earlier poem, written even before the expulsion of the rebels and the outbreak of the Colleonic War, composed by Pulci in quite extraordinary circumstances. This is *Da poi che 'l Lauro*, a canzone sent with a letter—really itself a letter cast in verse, the survival of which is owing only to its preservation in the *carteggio* "Mediceo avanti il Principato" (MAP)—dated 22 March 1466 to the seventeen-year-old Lorenzo in Rome, there to negotiate on behalf of his father a highly advantageous agreement with Paul II on the rights to traffic in alum. In the canzone Pulci writes of his own grief at Lorenzo's absence, but he writes especially of the truly desperate misery of the *ninfa* Lucrezia Donati.[12] Although she had married Niccolò Ardinghelli just less than a year before, on 21 April 1465, Lucrezia was by that time already the poetic lady to whom Lorenzo's own sonnets were dedicated. Lorenzo had moreover been courting her quite openly, entertaining her (as Pulci later wrote in *La giostra*) with masquerades and dances, inventing devices to amuse her, and having pledged the joust in her honor—to all of which Pulci alludes in the canzone through a speech put in the mouth of Lucrezia (vv. 58–71):[13]

[12] I have followed the text printed in Paolo Orvieto's edition of Luigi Pulci's *Opere minori*, cited in note 4 above.

[13] Compare in particular *Da poi che 'l Lauro*, vv. 61–71, with *La giostra*, XVII–XX. The earlier canzone gives important evidence for the essential correctness of Luigi Pulci's account in *La giostra* that Lorenzo had promised to give a joust in Lucrezia's honor as early as late 1465, but was forbidden to do so by his father so long as the wars with the Florentine exiles helped by the armies of Bartolomeo Colleoni were threatening the city. As noted, the joust was finally held on 7 February 1469, the official occasion being the defeat of the exiles through the peace concluded between the Flor-

Quante volte finx'io già ira et sdegno,
per veder con che studio et con quale arte
un generoso core cercasse pacie!
Poi ch'io il vidi temptar già Cynthio et Marte
et scolorire il volto, io mutai segno,
ché 'l perso ben renduto assai più piacie.
Quante fui esca et facie,
quando e' faciea pur feste et nuovi advisi!
Di che sovente già meco sorrisi,
allor che tutto transformato apparve,
et con sue certe larve
credea ad me simular non esser desso.
Ha, puro amante! hor non conosch'io appresso
rose adamasche o mammole vihole?[14]

(How many times did I once feign wrath and scorn in order to see with how much study and what art a generous heart might seek out ways to make peace! Then, when I saw him try the arts of both Apollo and Mars and his face drain of color, I changed signals, for the restoration of what has been lost is much more pleasing. How much was I the kindling and fire when he nonetheless gave parties and made new devices! I often laughed to myself when he appeared, completely transformed, and with certain of his masks thought to deceive me that he was not himself. Ha, a real lover! As though I should not know damask roses from common violets?)

One dance held in Lucrezia's honor, organized by the members of Lorenzo's *brigata* and held in the Sala del Papa in Santa Maria Novella on 3 February 1466, just two days after Lorenzo's departure for Rome, is described in a famous letter to the exiled Filippo Strozzi in Naples, written four days later by his mother Alessandra Macinghi Strozzi.[15] Niccolò Ardinghelli (whose mother was a Strozzi, whose family

entine League and Venice, who were Colleoni's employers and had put his armies in the service of the rebels; Lorenzo's private desire to have a joust well preceded that date, however. The date of Braccio Martelli's marriage to Costanza de'Pazzi is often given as 1466, but A. Rochon, *La jeunesse de Laurent de Médicis (1449–1478)*, Paris, 1963, p. 119, has shown that it occurred some time late in the previous year, as appears from two letters. The first is a letter of 30 December 1465 written by Marco Parenti to Filippo Strozzi ("Essi maritata una figlia di Messer P. de'Pazzi a Braccio Martelli: e delle meglio ci sia; nientidimeno ha una maglia in su uno occhio"); the second is a letter of 11 January 1465 [1466], also to Filippo Strozzi, written by his mother, Alessandra Macinghi Strozzi ("Altro non c'è, ch'i' sappia, da dirti; se no che ara' sentito d'alcuno

parentado fatto di nuovo, della figlia di messer Piero de'Pazzi a Braccio Martegli, e quella d'Antonio a Priore Pandolfini; e ciascuna n'ha dumila di dota. Quella di messere Piero ha un occhio che non vede bene").

[14] Note the play on words between "rose adamasche" and "larve," which are masks. As Orvieto notes, *Opere minori*, ed. cit., "Cynthio et Marte" are references to Lorenzo's poems for Lucrezia and to his promise to dedicate a joust to her.

[15] For Lorenzo's departure for Rome on 1 February 1466, see *Lorenzo de'Medici, Lettere I (1460–1474)*, ed. R. Fubini, Florence, 1977, p. 18; for Alessandra Macinghi Strozzi, see A. M. Crabb, *A Patrician Family in Renaissance Florence: The Family Relations of Alessandra Macinghi Strozzi and Her Sons, 1440–1491*, Ph.D. dissertation, Washington University, 1980.

had also been exiled after the events of 1434, and who owed Filippo money) had just returned with his galleys from a highly profitable voyage to the eastern Mediterranean, whence he had departed almost immediately after the wedding. Alessandra writes her son:

> I am reminded now to tell you that Niccolò Ardinghelli will be able to pay you, for they say he has made a good eight thousand florins. You ought to have heard of the return of the galleys. His wife is here and rejoices, and she has had a new outfit made with a livery upon which there are a few pearls, but large and beautiful; and so at her instance they had a dance on the third in the Sala del Papa in Santa Maria Novella, which was organized by Lorenzo di Piero's *brigata*. And [Ardinghelli] was with a group of youths dressed in her livery, violet mantelets embroidered with beautiful pearls; and Lorenzo's were those who wore brown with the livery of pearls, and of great value! And in this way they celebrated the making of so much money.[16]

In earlier letters, written both before and after Lucrezia's marriage, Alessandra had tartly taken note of Ardinghelli's long absences in his galleys, Lucrezia's extraordinary beauty, and the pleasure she and Lorenzo seemed to take in each other's company. On 26 January 1465 she had written, "Of Niccolò I hear nothing, which is a wonder since he has been betrothed to a woman already for two years."[17] By 7 Feb-

[16] *Alessandra Macinghi negli Strozzi: Lettere di una gentildonna fiorentina del secolo xv ai figliuoli esuli*, ed. C. Guasti, Florence, 1877, p. 575: "Ricordami ora di dirti, che Niccolò Ardinghelli ti potrà pagare; chè si dice ha vinto bene otto mila fiorini. Doverra'lo avere sentito alla tornata delle galee. La donna sua è qua, e gode; che s'ha fatto di nuovo un vedistire con una livrea, e suvvi poche perle, ma grosse e belle: e così si fece a dì 3, a suo'stanza, un ballo nella sala del Papa a Santa Maria Novella; che l'ordinorono Lorenzo di Piero. E fu lui con una brigata di giovani vestiti della livrea di lei, cioppette pagonazze ricamate di belle perle. E Lorenzo è quegli che portono bruno colla livrea delle perle, e di gran pregio! Sicchè fanno festa della vincita di tanti danari."

The passage is not easy to interpret (and was misread in certain respects by A. Warburg in his classic "Delle 'Imprese amorose' nelle più antiche incisioni fiorentine," in *La rinascita del paganesimo antico: Contributi alla storia della cultura*, ed. G. Bing, Florence, 1966, pp. 180–191). As Guasti pointed out, the plural verb "ordinorono" paired with the single noun "Lorenzo di Piero" should be understood to mean that the dance was organized by Lorenzo's *brigata*. The "lui" in the following sentence certainly refers to Niccolò Ardinghelli, and the next sentence, beginning "E Lorenzo è quegli che portono bruno colla livrea delle

perle," again refers to the *brigata* and not to Lorenzo (who had already departed for Rome). It should also be pointed out that Lucrezia's dance was a public event, and the events described by Alessandra Strozzi are all well within the traditions of Florence, including the chivalric and civic decorum of staging the dance in a married lady's honor, as well as the appearance of the members of Lorenzo's *brigata* dressed in her livery. R. C. Trexler, *Public Life in Renaissance Florence*, London, 1980, in an interesting section entitled "The Dance" (pp. 235–240), points out that of the five different such balls held between 1415 and 1435 that happened to be described in the diary of Bartolommeo della Corazza, four were organized by *brigate*, all the members of which attended wearing the same livery, emblazoned with the devices of courtly love. Thus, della Corazza writes of one of these balls (in Trexler's translation): "And all fourteen youths of the *brigata* dressed in the same livery, that is in cloth the color of a peach blossom, which reached down to just below the knee; with blown-up sleeves, the left sleeve embroidered with pearls, that is with an arm that came out of a little cloud and threw flowers down the left arm. The shoes were of the same cloth, except that the left was half red, and a branch of flowers of pearl was woven into it."

[17] *Alessandra Macinghi negli Strozzi*, ed. cit., p. 361.

ruary, however, she had learned he was in Venice and that "he will be married here in April. I have not heard whether he has returned laden with treasure. Nevertheless, his lady already has all her jewels and beautiful things."[18] On 29 March 1465, just two weeks before the wedding, Alessandra had written with more sensational news, telling Filippo that Lucrezia not only was Ardinghelli's *donna* but also was the *dama* of Lorenzo; and she mischievously suggested to her son, for whom she was herself working hard to arrange a marriage, that perhaps a beautiful wife would better help him in his attempts to regain entry into Florence than all the petitions of the king of Naples:

> I have no other news from here, save that today Niccolò Ardinghelli is expected at the gate. He has received a permit of entry for twelve days, and some say he has profited much and some say no. All the same Giovanni Rucellai was the petitioner [on his behalf] to Piero de'Medici, and perhaps [Piero's] son Lorenzo will find some way to please his lady and the fiancée of Niccolò, because he does not: something one often sees! [Such men] hope they will still be found pleasing, and that not much time will pass. May it please God that it be so, and they not be left behind the others. Maybe it will be more advantageous to have a beautiful wife than petitions from the king of Naples![19]

Three weeks later, around 19 April, Lorenzo had departed Florence for Milan on his first important diplomatic mission, representing his father at the marriage of Ippolita Sforza and Alfonso d'Aragona; on the next day, 20 April 1465, Alessandra wrote Filippo that "Niccolò Ardinghelli takes a wife tomorrow, and there will be a great celebration"—adding ominously, "but then, which I think is against God, he will go to the Levant."[20] Indeed, Ardinghelli did leave shortly thereafter (as we know from a letter written to Lorenzo by Bernardo Rucellai on 16 May 1465), while ten days later Alessandra informed her son, "Of Niccolò Ardinghelli there is nothing to tell since he has gone to the Levant; his wife has remained here, and she is very beautiful."[21] However, even before Ardinghelli's departure, and only six days after his marriage to Lucrezia, Braccio Martelli (who had courted her sister Costanza, whose garland he declined at his own wedding party—the second garland referred to in Pulci's *Giostra*) had sent a ciphered letter of 27 April 1465 to Lorenzo in Milan reporting on Lucrezia and the good spirits of the *brigata*, "in the perfection of which certainly nothing is lacking except for your, to us and to Lucrezia also, much-desired presence."[22] He then writes of a party that had occurred two days earlier at the villa

[18] Ibid., p. 379.

[19] Ibid., pp. 385f. The reference to the king of Naples is made with respect to Filippo Strozzi's attempts to have the ban of exile removed, which Ardinghelli shortly was to succeed in doing for himself, thanks to the intervention of Giovanni Rucellai with Piero (see Rochon, op. cit., p. 94).

[20] *Alessandra Macinghi negli Strozzi*, ed. cit., p. 396.

[21] Ibid., p. 408. See also Rochon, op. cit., pp. 94 and 129.

[22] I. Del Lungo, *Gli amori del Magnifico Lorenzo*, Bologna, 1924, pp. 33ff. (first published in *Nuova antologia*, 1 May and 16 May 1913).

of one of the *brigata*, which merits extensive quotation. Names that have been deciphered are restored (which is why Braccio and Lorenzo appear in the third person), while those as yet unidentified are indicated by the numbers Braccio assigned them:

> But what will I say of the evening of the feast of St. Mark, *candido numerando lapido*? That after dinner Braccio, .2., .5., and the husband of O went together to the house of .16. and found there Lucrezia, her sister Costanza, three of Bernardo Rucellai's sisters, the wife of .16., and two of her sisters, and .3. and .0., who had dined there and had all made a beginning to the coming party. Going out on the loggia, and not without wonderment looking upon those resplendant lights, each of us, among ourselves, said: "O Lorenzo, where are you now? Why are you not here, I do not say in place of Niccolò Ardinghelli, but at least in place of one of us, in order to see so many worthy spectacles?" At length we had Lo Spagnuolo, whom we had brought with us, play some music, and do not ask if the thing went well! No roast or pork was lacking, no *gioiosa*, no *chirintana* was not danced, and no *cornamusa* was not played; and always, during such activities I let no convenient or suitable moment go by without making some appropriate and honorable remark so that Lucrezia should not feel party to Lorenzo's boredom and fatigue; I tell her to remember, or really to tell stories to me; and .5., .0., and .2. were not asleep; and often I saw her eyes glisten, moved by your compassion, and then I saw her veil her sadness with a smile. However, I did not forget the existence and needs of Braccio regarding Costanza Donati, such that Braccio was my good procurer, in a way that left Braccio contented and I equally with him; I am speaking of Costanza. I send you no other remembrance save this letter, written by the hand that often touched Lucrezia.
>
> A great part of the evening having passed consumed with such activities, some took it into their heads to sing, ye gods how sweetly! It was a lovely thing to see on one side Lucrezia, Costanza, and Bernardo Rucellai's sister sing with .16. taking the tenor part. But much more beautiful, indeed marvelous, was to consider the meaning of the canzoni, and how well they were adapted to some of us, and most of all to you. It would take too long to tell you of the multitude and variety of them, and therefore it is better to keep quiet. Next it occured to .2., .0., and .5. to dance the *moresca*, during which time Braccio danced with Lucrezia; and before this, from the room where Lorenzo once stayed on the daybed, out came .0. strangely got up, and .2. with .5., who was dressed in Lucrezia's delightful dress, pale blue and embroidered with letters on the sleeves that said SPERI; you well know what I wish to say, etc.; and .0. and .2. often embraced him in a manner that gave rise to laughter, and not a little, from everyone.[23]

[23] Ibid., pp. 37ff.

After the party was over and everyone had gone home, Braccio with two friends and the lute-player Lo Spagnuolo decided to return from the city, and shortly after having passed the old convent of San Giusto alle Mura, then called the Ingesuati, they heard the voices of Lucrezia, Costanza, and one of the Rucellai sisters (who was also married) sweetly singing:

> so that we, crossing the grain fields without any regard or consideration for drenching ourselves, since the dew had already fallen, in a manner so that we would have been no less soaked if we had passed through the middle of the Arno, finally arrived, wet on the outside and burning within, to the desired place; where we had, *honeste tamen*, the greatest pleasures without any comparison to the others, because the honey was without flies [i.e., the women were without their husbands]: and until the sixth hour of the night we remained there in singing and dancing and partying, always speaking, *apte tamen*, of Lorenzo with Lucrezia. [24]

It is accordingly not very surprising to find Alessandra Strozzi repeatedly expressing her concern that Ardinghelli was too often absent and insufficiently attentive to his wife. (In a much later letter, of 27 August 1468, Giovanfrancesco Ventura, a member of Lorenzo's *brigata*, informs him, "I have learned that her .N. will be absent for some time: it is truly a pity to leave such sweet terrain unplowed.") [25] Indeed, we find Alessandra writing on 31 August 1465 (four months after the party described by Braccio), in a letter reporting to her son about her negotiations regarding a wife for him, that she hoped he would not seek to emulate the example of Niccolò Ardinghelli:

> When this has reached a conclusion, tell me what I shall say your opinion is, and that you do not have it in mind to do so many marvelous things as Ardinghelli has done. Regarding him, I tell you that I do not know your thoughts, but I do believe that you will desire your honor in this as in other things; and that she will not ask for so many trifles: and that, God willing,

[24] Ibid., pp. 39f. This extraordinary passage deserves to be quoted in the original, for nothing gives a more vivid sense of Braccio Martelli and the youthful high spirits of Lorenzo's *brigata*: " et entrati nella porta pensosi e tristi, mi venne pensiero di uscire di nuovo fuori; et avviato tutti gli altri, .5.0. et .6. se ne ritornorono, menando seco lo Spagnuolo col liuto etc.; e trovando già la brigata andarne a letto, ci parve buon andarcene; e co'covoni di paglia accesi, voltammo la prora verso el luogo di Bartolommeo Martelli con animo di tornare la matina quivi etc. Nè di molto passati gl'Ingesuati, quasi uno coro d'angeli cantanti, sentimo scolpite voci di □ ÷ e la sorella del cognato di .8., che da ora la battezzo così ÷, gridar in soave modo di canto così: *A, canacci, crudeli, turchi*; e noi vicissim. Di-

poi in molto più soave canto e modo dicevano: *A ballare, a ballare, a ballare*. Onde noi, attraversando e'campi del grano sanza riguardo e considerazione alcuna a bagnarsi, perchè già la rugiada era caduta, in modo che non manco ci immollammo che se passati fussimo per mezzo Arno, capitamo infine, così di fuori molli e dentro ardendo, al disiato loco; nel quale avemmo, *honeste tamen*, piaceri grandissimi sanza alcuna comparazione degl'altri, perchè il mele era senza mosche [i.e., none of the women's husbands was present]: e per insino a vi ore di notte quivi ci fermammo in canti e balli e festa, parlando sempre, *apte tamen*, di .8. con ÷ [i.e., di Lorenzo con Lucrezia]."

[25] Rochon, op. cit., p. 96.

she will not be thirty months waiting to see her husband, like Ardinghelli's wife, who, since she has abided so long without hearing anything has felt the need to pass the time with amusements, ornamenting herself and going to parties: and I believe that had she gone to Bologna after her marriage of four or six months she would not have made or requested to make the expenses they have had. Let it not be so with us.[26]

It was in February of the following year that Lorenzo again left Florence, this time on his mission to Rome; that Ardinghelli returned, laden with profit, from the eastern Mediterranean; and that the celebratory dance in the Sala del Papa was arranged in Lucrezia's honor by the members of Lorenzo's *brigata*. In March, the same month in which Pulci sent his canzone and letter to Lorenzo, other members of the *brigata* were also writing him with news of Lucrezia's misery during his absence. Sigismondo della Stufa had written a letter dated 8 March 1466, two weeks before Pulci sent his letter, informing Lorenzo that she was in complete seclusion and nowhere to be seen, either in Florence or in her villa near San Miniato; he hinted broadly that the reason for her withdrawal was Lorenzo's absence:

> You wanted me to keep you advised of how things are going here; and I, desiring to do so because I believe it will give some pleasure, have never ceased from my researches, in order to have something to write you; and not ever being able to find the principal word, which wondered me greatly, I asked C. B. what was the reason why nothing could be seen, neither outside, nor at the door, nor at the window. He answered me that since your departure she has never wished to venture out of doors. I do not know whether you are the reason for this, but I do know very well that since you left I have never been able to see anything: and this has not been because of my negligence on that account. Yesterday morning, which was Friday after the first Sunday of Lent, being with C. B. in the market I asked him if I should go to find out whether the *brigata* had gone to Santo Miniato. He answered me no; and said to me that he only remained for the sake of .L., and that she is the one who does not want to go out. Now you gloss the rest as seems fit to you.[27]

Five days later, on 13 March 1466, Bernardo Rucellai (calling Lucrezia by the *senhal*—Diana—given her in Lorenzo's own earlier poems) wrote again of her withdrawal from her usual haunts, and he reported that she was attempting to assuage her melancholy by listening to music. Rather than attributing her behavior to Lorenzo's absence, however, he suggested instead that she seemed to be suffering the pangs of remorse: "Diana is listening to music to treat herself for melancholy and sadness, such that I cannot believe there had been so great a passion. She has made such a

[26] *Alessandra Macinghi negli Strozzi*, ed. cit., pp. 465f.

[27] Del Lungo, op. cit., p. 44; Rochon, op. cit., p. 163.

show of it that she is never seen at San Miniato or anywhere else, out of penitence and remorse [*alle perdonanze*]."[28]

As for Pulci, he had only just succeeded, through Lorenzo's good graces, in having the order of exile removed that had been placed on him because of his brother Luca's financial failure, and he cannot resist referring to his own troubles at the start of *Da poi che 'l Lauro*, his canzone for Lorenzo. But his theme is really Lucrezia, whom he describes meeting, miserable, in an unspecified and poetically conventional forlorn place, and who tells the poet of her love for Lorenzo and his courtship of her. She is portrayed (vv. 39–50) as having a beauty comparable to that of Venus, and at the same time as a kind of desert saint, unkempt and sick with grief, her cheeks tinged with the ashen colors of death. The depth of her sighs is so affecting that they might split asunder diamonds (*adamanti*, from Lorenzo's device, punning upon *ad amanti*—also referred to by Pulci in the verses from *La giostra* quoted above), as well as onyx (*niccol'*, in reference to Ardinghelli):

> Ella havea tutte le sue membra tenere
> graffiate, et rossi i piè di sangue et scalzi,
> che ben parean d'angelica colomba,
> per mille pruni lasciati et mille balzi
> quei be' capei che già furon di Venere,
> et quel color c'huom porta all'aspra tomba.
> Ancor nel cor rinbomba
> il tristo suon de' dolorosi pianti,
> ch'avrien per mezzo fessi gli adamanti
> o niccol' o sardonii o duri hyaspidi,
> e' cor' de' frigidi aspidi
> accesi et arsi et fatti al sole un ghiaccio.

(She had all her tender limbs scratched, and her unshod feet, which truly resembled an angelic dove, were red with blood; those beautiful tresses that once belonged to Venus were scattered throughout a thousand thorn bushes and rocky cliffs, and her color was that which a man carries to the harsh tomb. There still resounded in her heart the sad sound of grievous laments, such that would have split asunder diamonds, or onyx, or sard, or hard jasper, and inflame the heart of frigid asps and turn the sun to solid ice.)

She tells Pulci of a desperation that has grown so great that she is contemplating pledging herself to Diana, fleeing the security of marriage and seeking a divorce, exchanging the bridal veil for that of a nun (vv. 85–91):

> et drento al casto pecto m'accendea
> un disio sol di ricercar Dïana,
> mostrando la via piana,

[28] Rochon, op. cit., p. 163.

onde surgean pensier' casti, almi et pulchri,
hor di fuggir gli sponsalitii fulcri,
hor gir flammata, hor far divortio honesto,
et celibe servar le sacre bende.

(And within my chaste breast there is ignited a desire only to seek out Diana, indicating the level path whence arise chaste thoughts, nourishing and beautiful, now urging me to fly from marital security, then to cast away the bridal veil [*flammata*, from the Roman *flammeum*], and then to make an honorable divorce and, celibate, to take the holy veil.)

Even within the realms of poetic fiction this is a startling revelation, but Pulci's message is nevertheless conveyed within the bounds of convention, and it is phrased in a language that suggests rather the confused meanderings of an unhappy mind than a decision taken in earnest. This impression is reinforced when Lucrezia goes on to relate the reason for her misery by telling of a beautiful vision she had had of a laurel tree that seemed transformed into alabaster or glass by the bright rays of the sun, seeming to restore to Daphne her blonde hair. The air, the heaven, and the earth all seemed turned to gold—but suddenly the laurel disappeared and could be seen no more. The laurel tree is the well-known *senhal* for Lorenzo (Lauro), just as the sun is the dominant *senhal* used for Lucrezia throughout all Lorenzo's poetry (Lucrezia = luce = the sun). With the disappearance of the laurel from the sun's illuminating rays, which clearly enough refers to Lorenzo's temporary absence in Rome, Lucrezia is left abandoned and weeping in a wilderness alone.

At this point, however, Pulci's poem takes a quite sudden and sinister turn, its tenor changing from that of a client reporting in the conventional images of love poetry and amatory devices how much Lorenzo is missed by his lady. For it appears that Lucrezia is not alone. She is in the company of a phantasm, a spirit of whose presence Pulci had been completely unaware, and she is in its thrall. The poem takes on a sudden tone of urgency as Lucrezia announces (vv. 121–122):

"Né già per me sarei
condocta qui; ma scorgemi questa ombra."

("Nor have I been led here through myself; but this shadow leads me.")

Pulci, suddenly seized by a panic terror, asks who this ghost may be (vv. 123–126):

Allor fec'io come huom che tosto aombra
per subita parvenza, et dixi: "Hor questa
sì bella et sì modesta
chi è, se 'l Lauro tuo ti doni pace?"[29]

[29] In chapter XXVIII of the *Miscellanea*, published in 1489, Politian defines panic terrors as sudden frights that suddenly strike men, armies, and herds of horses or cattle with no apparent cause, causing them to stampede or rush to headlong flight. They are empty terrors, caused by phantasms or spirits. Alciati also discusses panic terrors in his *Emblematum liber* of 1531, in which he summarizes Politian's definition for his

(Then I acted like a man at once boggled by a sudden fear, and I said: "Now who is this creature, so beautiful and so modest, if your Lauro gives you peace?")

Lucrezia's reply is as prompt as it is cryptic (vv. 127–133):

> Rispose: "Io tel dirò, poi che ti piace.
> Questa tenea Dïana sopra l'acque:
> fugli poi tolta, et a chi vuol si mostra.
> Fu nella ciptà vostra
> famosa sola, et del mio sangue nacque;
> né sanza lei giammai mossi i miei passi".
> Poi chinò gli occhi lachrimosi et lassi.

(She answered: "I will tell you then, since it pleases you. Diana kept her above the waters: she was then taken away, and shown to him who wished her. Once she was famous in your city, and born of my blood; nor do I ever take a step without her." Then she lowered her tearful eyes and sighed.)

Who is this specter in whose steps Lucrezia is constrained to walk? Pulci, "la mente mia tutta confusa per la nuova ombra," professes not to know. Paolo Orvieto, in his excellent edition of Pulci's *Opere minori*, conjectures that her guiding spirit, "la sua ben nata alma" (as Pulci also calls her toward the end of the canzone), is a virgin nymph of some stream ("questa tenea Diana sopra l'acque"), and he suggests she is perhaps Costanza Donati, Lucrezia's sister ("del mio sangue nacque").[30] She is described, however, in the remote past tense, whereas Costanza, the wife of Alfonso Pitti (and Braccio Martelli's paramour) was still very much alive. Pulci's reference is instead, as Stefano Carrai was the first to realize, to the ghost of the blessed Piccarda Donati, who appears in the *Divine Comedy* as the very figure of violated chastity.[31] Piccarda is the first spirit Dante encounters in Paradise, in the slowest sphere, the heaven of the moon reserved for nuns whose vows were neglected or void in some detail (*Paradiso*, III). Luca Pulci, addressing his words to Lucrezia in the first *Pístola* (vv. 103–105), identifies her as the descendant of Piccarda:

> ma sí benigno il cor verso te veggio,
> nuova luce rinata di Piccarda,
> ch'i'sarò all'ombra sua: altro non chieggio.

explication of the emblem *In subitum terrorem*. Pulci's language is quite precise; on becoming aware of the *ombra* he is "come huom che tosto aombra [a word especially used to describe frightened or 'spooked' horses] per subita parvenza." Because such terror is empty by definition, without rational cause, Pulci means to convey to Lorenzo that Lucrezia is obsessed by the idea represented by the spirit that leads her, an idea that will only bring her harm.

[30] Luigi Pulci, *Opere minori*, ed. cit., p. 49, comment to vv. 124–126.

[31] S. Carrai, *Le muse dei Pulci: Studi su Luca e Luigi Pulci*, Naples, 1985, p. 40; see also P. Orvieto, "Nota (e ammenda) a Luigi Pulci, 'Da poi che 'l Lauro,' vv. 128–132," *Interpres*, VII, 1987, pp. 219–220, in which he also identifies Lucrezia's "ombra" with Piccarda Donati.

(But I see the heart so benign to you, new light reborn of Piccarda, that I will be in its shadow: I ask no other.)

She is also so described by Luigi Pulci in *La giostra di Lorenzo*, in the verse already quoted (octave VII), where he names "Lucrezia . . . del nobil sangue di Piccarda nata." Piccarda Donati had been a nun, living under the adopted name of Costanza (to which Pulci also refers in his verse in the same octave about Lucrezia's sister, who "ha sol di Costanzia ogni fama") in the convent of the Clarisse di Monticelli, located above the Arno just outside Florence.[32] By order of her notorious brother Corso, she had been forcibly abducted in 1285 from the monastery and compelled to marry Rossellino della Tosa, Corso's political ally. Petrarch mentions her in the *Triumphus pudicitie* (vv. 160–162), in a passage to which Pulci undoubtedly refers when he writes that Lucrezia's *ombra* was kept by Diana "sopra l'acque":

> Al fin vidi una che si chiuse e strinse
> sovra Arno per servarsi, e non le valse,
> che forza altrui il suo bel penser vinse.

(Finally, I saw one who was shut in and kept above the Arno to preserve her, and it availed nothing, for the force of another overcame her beautiful thought.)

Pulci's letter and canzone were sent to Lorenzo as a private communication uniquely cast in the language of poetry, written by one poet for the understanding of another. His message was not set down in the codes and ciphers of diplomatic correspondence, such as had been used (with good reason) by Braccio Martelli in the letter quoted above, written 27 April 1465 to Lorenzo in Milan to tell of his escapades and those of the *brigata* with Lucrezia and Costanza Donati—and also even informing him of how the host at the party (.16.) had spied on Lucrezia on her wedding night ("sai che Niccolò Ardinghelli ha uno cazzo che pare corno di bue").[33] Nor is Pulci content with a straightforward epistolary narrative, veiled only in the barely disguised pseudonyms and circumlocutions used by Bernardo Rucellai and Sigismondo della Stufa in their letters reporting Lucrezia's seclusion. On the one hand his canzone confirms Sigismondo's intimation that her seclusion was provoked by love for Lorenzo and misery because of his departure. On the other hand it also confirms Bernardo's report that her withdrawal was caused by remorse, undertaken for reasons of "perdonanze." Her soul was divided by the opposed emotions of love and repentance, leading her to seek immediate withdrawal from her accustomed haunts and at the same time even to consider permanent withdrawal from the world. Pulci's message is not only that Lucrezia is unhappy and in emotional turmoil—sufficiently con-

[32] For Piccarda Donati, see the excellent entry by Mario Fubini in the *Enciclopedia Dantesca*, ed. U. Bosco, Rome, 1970–1978.

[33] Del Lungo, op. cit., omits the phrase for reasons of modesty; it is restored, however, by Rochon, op. cit., pp. 125 and 132. In Martelli's cipher it reads as follows: "et smr che .4. hm ync cmzzc chn pmrn cxrnc dr byn," the number 4 being the code for Niccolò Ardinghelli.

fused to be turning over in her mind, and even discussing with her friends, the idea of divorce and entering a convent—but also that she is obsessed with the notion, bewitched by the example of her famous, chaste, and miserably married ancestress Piccarda, known by her conventual name of Costanza. Feeling miserable in her own marriage to a much older man whom she hardly knows, she is not comforted by Pulci's observation that it is really Lorenzo's absence that brings unhappiness to them both. She can see only one honorable path out of her dilemma, which path possesses her, and that is to take the way of withdrawal into the convent that is represented by Piccarda-Costanza. Until the moment Lucrezia mentioned the *ombra* leading her, Pulci had not suspected that her feelings of love for Lorenzo, and her missing him, were commingled with feelings of remorse and penitence.

Lucrezia's preoccupation with divorce and the convent as a solution to her plight is a desperate, crazy idea, certainly so in Pulci's eyes. Such a step would amount to a coup de théâtre bringing scandal down on all parties involved, Ardinghelli, Lorenzo, and Lucrezia herself, and it is one that would certainly worsen Lucrezia's existence in the long run, however attractive the idea of escape might seem as an immediate solution to her problems. So crazy an idea is it that Pulci portrays himself asking her (a question well within the conventions of love poetry but also a shrewd one) why she does not instead emulate the example of the equally desperate Hero and cast herself into the sea. Lucrezia's answer is that since the day of love's first awakening she and Lorenzo shared a single soul, so that killing herself would be to kill him too (again a familiar topos of poetry in the *stil novo*, and one later developed by Lorenzo in his *Comento sopra alcuni de'suoi sonetti*). So discourteous an act would seem shameful to the spirit that leads her on. At this point Pulci acknowledges defeat, and can only seek to solace her (vv. 159–163):

> "Hor ti conforta—dixi—et ama et spera:
> la bella Flora torna et primavera;
> tornano i canti, suoni, feste, armilustri,
> e gl'iddii ne' lor lustri
> verran con lui pel bel campo piceno."[34]

("Now comfort yourself," I said, "and love and hope: the beautiful Flora returns, and the springtime; the songs, the music, the festivals, the tournaments of arms, and the gods in their luster will come with him through the beautiful marshlands.")

There can be no doubt of the essential truth, attested by independent witnesses from Lorenzo's *brigata*, of Pulci's story of Lucrezia's withdrawal into seclusion, her extreme melancholy, and her highly conflicting emotions, torn between her love for

[34] Orvieto notes of this passage that Pulci defined *campo piceno* in his *Vocabolista* as *la Marca*, but suggests that here he seems to mean simply "fertile fields." It is likely, however, that Pulci intends to refer to a particular place, quite possibly Rimaggio, which is the name of a stream that empties into the once often flooded marshlands of the Arno below Bagni a Ripoli, from which Lorenzo inscribed two of his sonnets (see below), the first concerning a nymph dedicated to Diana, and the second her abandonment of Diana for Venus.

Lorenzo on the one hand and her remorse and desire to escape into the chaste state represented by Piccarda-Costanza on the other. How this is to be understood, however, is much less clear. For one thing, it is extremely likely that Lucrezia, whom Bernardo Rucellai said was listening to music to assuage her melancholy, also knew Pulci's canzone, and in that sense the message of his poem is also a message to Lorenzo from her. Moreover, it is highly probable that it was also known to other members of the *brigata*. Braccio Martelli had written to Lorenzo a year earlier, for example, in the letter quoted above, telling him how they had all listened to Lucrezia, Costanza, Bernardo Rucellai's sister, and the mysterious .16. sing beautifully together, to the accompaniment of the *compare* Il Spagnuolo, and that everyone took special pleasure in "il considerare la sentenzia delle canzone, e come bene cadevano a proposito ad alcuni di noi, e maxime a te."[35] Indeed, a month after Pulci sent his canzone to Lorenzo, Braccio Martelli, in another letter to Lorenzo (quoted below), himself quotes from a sestina addressed by Lorenzo to Lucrezia under the *senhal* Diana, which was without doubt written as a response to Pulci's poem and the message contained in it. In other words, Lorenzo's love for Lucrezia was a matter not only of private feeling but also of public analysis and expression. It was a love that was mythologized simultaneously as it evolved, the fortunes of which were cast in the forms of a vernacular tradition of poetry that by definition is about love. It was hence a love ratified as forming the foundation of a concept of gentility, and in fact of a cultural ideal both personal and generalized. But this is not to say that that love was not real, the anguish expressed by the poet Pulci was unfelt by the poet or his subject, or the perturbations tormenting the *ninfa* Lucrezia were not experienced by the living Lucrezia Donati. In ministering to them the music of the poetry is a test of love, a communication demanding response as well as explication through the common culture and experiences of the *brigata* to whose care Lucrezia's spirits were entrusted. In fact, Pulci himself, in the brief note he appended to his canzone, manages at the same time to play down the likelihood of serious consequences arising from Lucrezia's inner turmoil (she is not always so desperate) and to reassert the reality and seriousness of the feelings she wishes to have communicated to Lorenzo (she should even so pay more attention to the possible consequences of taking such actions):

[35] Del Lungo, op. cit., p. 38. A *compare* is an accompanist on the viola or lute, often skilled in improvisatory verse sung to his music. One such is mentioned by Pulci in a famous letter to Lorenzo, written 27 July 1473 ("Vagliano le muse e lla vihuola e lle rime sdrucciole del compare nostro tutto fedele; e troveremo poi rima più là che zucchero"), which clearly refers to the concluding lines of Lorenzo's *Uccellagione di starne* ("E così passa, o compar, lieto il tempo, / con mille rime a zucchero e a tempo"). Since the *Uccellagione di starne*, as well as the vexed *La Nencia da Barberino*, exemplifies just such improvisatory verse, the identity of the *compare* has a bearing on the question of Lorenzo's authorship of these poems, and has much preoccupied scholars of Lorenzo's poetry. The best discussion of the question appears in Rochon, op. cit., pp. 436ff., and much important material also appears in P. Orvieto, "Angelo Poliziano 'Compare' della brigata laurenziana," *Lettere Italiane*, XXV, pp. 301–318. Despite the claim in Orvieto's title, the identity of the particular *compare* in question is still far from settled, and it is complicated by the fact that Lorenzo de'Medici certainly had many accompanists in his employ during his lifetime—as Braccio Martelli's reference to Il Spagnuolo testifies.

However, I will be content for the present with this our canzona; do not become used to the idea, however, that the poor little nymphs of the woods become so desperate every day, for although this time I was for them nothing other than a cooling refuge such as the knights errant were used to being for others asking assistance from within the dark caves and fountains, they do not descend all the time upon your faithful friend, who knows and wants to console them; nevertheless, they might instead take into account the necessity of descending from bad to worse.[36]

Shortly thereafter, Sigismondo della Stufa, in a letter that astonishingly commingles sentiments of piety with sensations of the erotic, wrote of finally encountering Lucrezia on her return from confession on the Vigil of the Feast of the Annunciation:

> I promise you that there is nothing to be seen in any place, neither at Santo Miniato, nor in Fiesole, nor in Santo Gaggio. But it is certainly true that on the Vigil of the Madonna I met her on the paving stones of the Servi, and she seemed to have confessed and been completely penitent of her sins, with no fire at all, such that you never saw a thing so beautiful, with her black clothing and her head veiled, with such soft steps that it seemed the stones and the walls bowed in reverence as she went along her way. I do not want to go on saying more, lest you fall into sin in these holy days.[37]

On the day Lorenzo had arrived in Rome, 8 March 1466, an event of the greatest significance also occurred: the death of Francesco Sforza, the duke of Milan. On the 15th of the month Piero de'Medici wrote his son of his gravest concerns, urging him to press on the pope, a Venetian, the importance of supporting the Milanese state in its hour of crisis and of maintaining the League of Florence with Milan and Naples against the armies of the Serenissima—"Et appresso," he added, "leverai via sonare d'instrumenti, o canti e balli, o simili altre cose d'allegrezza."[38] The negotiations with Paul II on the rights to distribute alum were to consume the rest of March, and on 7 April 1466 Lorenzo departed Rome for Naples in order to consolidate the alliance with King Ferdinando d'Aragona. Despite the constant entreaties of his young friends, he was not to return to Florence until the middle of May. We do not know his response to their continuing stream of notices about Lucrezia's misery, though he cannot have been entirely displeased by the evidence they gave of the strength of her love for him, nor even by her withdrawal from the boisterous company of his *brigata* and her sudden devotion (pace Alessandra Macinghi Strozzi) to publicly chaste behavior. But it is possible in some measure to assess his understanding of her feelings, and of his own in response to them, from his poetry, for it is certain that during the nearly three months of his absence from Florence Lorenzo did not entirely

[36] Luigi Pulci, *Morgante e lettere*, ed. D. De Robertis, Florence, 1984, p. 953.
[37] Del Lungo, op. cit., p. 45.
[38] The letter was first published by Roscoe, op. cit., I, appendix, p. 18.

heed his father's admonition to turn his thoughts from verses and music, and that he did respond to Lucrezia's loneliness and misery in song as well as by letter.

Thus, on 21 April 1466, we find Braccio Martelli writing to Lorenzo, who had just departed from Naples the day before, with news that he had seen Lucrezia, obviously in much better spirits, and urging Lorenzo's timely return. In the letter, to which I have alluded, he also quotes from a poem Lorenzo had sent:

> Nevertheless, though I am certain there is no need, I remind you to return promptly, because it will be easier for you to find here the person you promised to follow always, saying:
>
> > So long as the sun illuminates the leaves
> > and the fountains run through the high hills,
> > I will follow my Diana through the woods,
>
> whom I saw the same evening I had your letter, together with her sister, both of them more beautiful than ever, in such a manner that at that moment, without harm to you, I would have held it a most precious thing to have followed after her, as too have your letters, and your verses enclosed in the one. [If I had followed her] I would most certainly have made a great hit, most pleasing to you, and to her not unpleasing.[39]

The verses quoted by Martelli make up the envoy of a sestina by Lorenzo (*Canzoniere*, LXIII, sestina IV), in which he describes himself as tormented by the heat of the sun, wandering in search of shade and respite in the cool glades of Diana:

> Fuggo i bei raggi del mio ardente Sole,
> silvestra fera all'ombra delle fronde,
> e vo cercando ruscelletti e fonti
> per piagge e valli e pe' più alti poggi,
> ove le caste ninfe di Dïana
> vanno seguendo li animai pe' boschi.
>
> Benché all'ombra de' faggi spesso imboschi,
> cercando di difendermi dal sole,
> non può far ciò che al mondo è di Dïana,
> che mi ricuopra tra le verdi fronde
> dal foco che non teme ombra di poggi,
> né si spegne per l'acqua de' chiar' fonti.

[39] Rochon, op. cit., p. 163: "Niente di mancho, benchè io sia certo che non bisogni, ti richordo il tornare presto, perchè più facile ti sarà trovare qui chi promettesti seguire sempre, dicendo:

> Mentre che 'l sole allumerà le fronde
> e' fonti righeran per gl'alti poggi,
> la mia Diana seguirò pe' boschi,

la quale, la medesima sera ch'io ebbe la tua lettera, io la vidi, et la sorella insieme, più che mai belle, in modo che harei sommamente havuto caro, quando sanza tuo danno fussi seguito, chome le tue lettere chosì anchora havere havuto e' tua ochi [*sc.* odi] rinchiusi in quella lettera, chè certo harei facto un bellissimo getto, a te gratissimo et a quella non ingrato etc."

Ma le lacrime mie fan nuovi fonti,
che, annacquando spesso i verdi boschi,
rigan per li alti e più elati poggi;
né però il foco del mio chiaro Sole
scema, e più verdi l'amorose fronde
rinascon ne' be' luoghi di Dïana.

Io mi credea per l'arte di Dïana
passassi il mio dolore, e' vivi fonti
spegnessi il foco, e l'ombra delle fronde,
la qual cercando vo per tanti boschi,
fussi ostaculo a' raggi del chiar Sole,
e che potessi meno in valle e poggi.

Foco è l'aura che spira alli alti poggi;
son più i pensier' per l'arte di Dïana,
e quanto è più lontan, più arde il Sole;
e foco è l'acqua de' più freschi fonti
e foco è l'ombra delli oscuri boschi,
e foco è l'onde e l'ombre, arbori e fronde.

Che, benché sia in mezzo delle fronde
questa carca mortale, e su pe' poggi,
e, seguendo le fier' per campi e boschi
vada ne' bei päesi di Dïana,
e cerchi il suo rimedio all'ombra e' fonti,
pur non è mai lontano il cor dal Sole.

Mentre che 'l Sole allumerà le fronde,
e' fonti righeran per li alti poggi,
la mia Dïana seguirò pe' boschi.[40]

(I flee the beautiful rays of my burning Sun, a forest beast flying to the shade of the leaves, and I go searching out small brooks and springs through the wastes and valleys and through the highest hills where Diana's chaste nymphs go hunting after the animals throughout the woods. Though I often go to forest in the shade of the beeches, seeking to protect myself from the Sun, I cannot attain what in the world belongs to Diana, by covering myself among the green leaves from the fire that fears neither the shade of the hills nor extinguishes itself in the water of the clear springs. But my tears make new springs, that, often watering the green woods, run through the high and most exalted hills; nor yet does the fire of my bright Sun diminish, and the amorous leaves are renewed in the beautiful haunts of

[40] For the text of Lorenzo's poetry I have followed here and throughout this chapter the following edition: Lorenzo de'Medici, *Canzoniere*, ed. P. Orvieto, Milan, 1984.

Diana. I make myself believe that through Diana's art my pain has passed, that the living springs have extinguished the fire, that the shade of the leaves, which I go searching out through so many woods, has been an obstacle to the rays of the bright Sun, and that it might abate in the valleys and hills. Fire is the breeze that sighs in the high hills, and more intense the thoughts provoked through Diana's art, and the more distant it is the more the Sun burns; and fire is the water of the coolest springs, and fire the shade of the dark woods, and fire is the wave and the shade, the trees and leaves. So that, though this mortal frame is in the midst of the leaves and high up in the hills, and, following the wild animals through the woods and fields, arrives in the beautiful lands of Diana and seeks refuge in the shade and springs, still the heart is never far from the Sun. So long as the Sun illuminates the leaves and the springs run through the high hills, I will follow my Diana through the woods.)

The poem is in the form of the so-called *retrogradatio cruciata*, according to which the unrhymed end-words of each line in the first stanza not only are repeated as end-words (hence becoming rhyming words) in each succeeding stanza (and all six repeated again in the three-line envoy), but are also repeated in a specific order. The end-words of the first two lines of the second stanza are made up of the last and first end-words of the first, the next two lines end with the penultimate and the second end-words of the first, and the final two end with the antepenultimate and the third end-words of the first (ABCDEF, FAEBDC), and so on in rotation (CFDABE, ECBFAD, etc.) until the possibilities are exhausted with the sixth stanza. Aside from the obvious difficulty and high artificiality of the form, the cycle of repetition places extraordinary emphasis on the end-words themselves, and in Lorenzo's sestina two of these are the *senhals* for Lucrezia, Sole and Diana. The poem is unique in his *Canzoniere* in simultaneously employing both, and they are placed, like Lucrezia's own conflicting emotions, directly at war with each other. Moreover, the other four end-words, *fronde*, *boschi*, *poggi*, and *fonti*, are all attributes of the goddess Diana, against which the relentless rays of the sun are pitilessly and insistently directed. The poem's structure thus sets the passions that divide and torment Lucrezia in life—burning love on the one hand and a desire for the relief of chastity on the other—one against the other, and the intense, conflicting feelings that lead her to desperation are also given as Lorenzo's own. "I flee the beautiful rays of *my* burning Sun," he writes, but the further he retreats into the forest shade of Diana's realm the more fiercely do the rays of the Sun burn; and as they burn the trees put forth more leaves, and grow from the springs whose waters his tears increase. Thus, paradoxically, the closer he comes to his desired Diana the more intense is the heat from the Sun that drives him to seek her out. The desire expressed in the poem is a longing for *refrigerium* in the chaste glades of Diana, in the cool shade of leafy beeches standing by rivers and springs in the woods and hills; but what provokes this wish is the ardent Sun, and the burden of Lorenzo's sestina, his message to Lucrezia and his response to Pulci's canzone, is

that his longing for Diana (who is Lucrezia) and his incessant following after her is paradoxically fueled by the ardent passion burning within him, a passion induced by the bright heat of the Sun (who is also Lucrezia). In other words, Lorenzo's message to Lucrezia is that the harder one tries to remain chaste, the more the heat of amorous passion intensifies. One cannot escape love by retreating into the convent.

Sestina IV was quite surely not the only poetic response Lorenzo made to Lucrezia's plight during the period of his long absence in Rome and Naples in the spring months of 1466. But in reaching a further understanding of that response—which, as has often been remarked, demonstrates his extraordinary ability to understand and to adopt as his own the feelings of others—I am now forced to leave the secure chronological moorings that have thus far been available, despite the excellent work that has been done, by Bigi and Rochon in particular, on the sequence of the poems in Lorenzo's *Canzoniere*. Rochon has proposed a dating of those sonnets using the *senhal* Diana, few in number (sonnets IV, XXXVI, XLVII, XLVIII, and LXXXVII, respectively *Canzoniere* IV, XLI, LIV, LV, and XCVIII), all to around the year 1466. His reasons are precisely that this is the name given Lucrezia in sestina IV, and that by this name she was also known to the members of Lorenzo's *brigata* in that year, as shown by Bernardo Rucellai's use of it in his letter of 13 March 1466 and by Braccio Martelli's quotation of the sestina in his letter of 21 April. Two of these, however, sonnets XLVII and XLVIII, were certainly written in the environs of Florence, since both are prefaced with a statement that they were written at Rimaggio, the name of two different *torrenti*, one emptying into the lowlands of the Pian di Ripoli at the foot of the hills of Vicchio and Candeli, and the other (also called Rimaggiolo) a stream descending from Monte Morello into the plain of the Arno at Sesto Fiorentino.[41] Either one, incidentally, would explain Pulci's assurance to Lucrezia in *Da poi che 'l Lauro*, which was quoted above and which baffled Paolo Orvieto, that Lorenzo would return to wander with her through the marshy flatlands—"e gl'iddii ne' lor lustri / verran con lui pel bel campo piceno."[42] Moreover, both would seem to have been written before Lorenzo's departure for Rome, or even for Milan in the previous year, on the eve of Lucrezia's wedding in April 1465, for their contents suggest that they were written at the very beginning of Lorenzo's love for Lucrezia. As Bigi noted, though both sonnets refer to Diana the name does not appear to be a *senhal* so much as a reference to the goddess pure and simple. The first, entitled *Sonetto fatto in sul Rimaggio*, is virtually a paraphrase of Horace (*Carmina*, 1.30), in which Lorenzo asks Venus to leave her home in Cyprus and come with Cupid to this place; he begs her to convert Diana's nymphs to her service (vv. 12–14):

> Togli a Dïana le sue caste ninfe,
> che sciolte or vanno e senza alcun periglio,
> poco prezzando la virtù d'Amore.

[41] The site of Rimaggio is almost certainly the former, which is much larger and where there were many villas of noble families in the fifteenth century; see

G. Carocci, *I dintorni di Firenze*, Florence, 1906–1907, II, p. 14.
[42] See note 34.

(Take from Diana her chaste nymphs, who now run free and without any danger, little prizing the power of Love.)

The second, *Sonetto fatto di Rimaggio a certi che vi s'erano trovati a far festa*, describes one such beautiful and gentle nymph who has indeed been tempted to abandon Diana for Venus, and who now swells the stream with her tears (vv. 5–8):

> Lí duolsi e spesso accusa or questa or quella
> cagion del viver suo tanto aspro e rio:
> poi che lasciò Diana, il suo disio
> s'è vòlto ad ubbidir la terza stella.

(She grieves, and often raises one reason or another as the blame for her so harsh and guilty life: for, since she left Diana, her desire has turned toward obedience to the third star [Venus].)

Sonnet IV, written "per una donna che era ita in villa," has often been closely associated with sestina IV because of the similarity of language and imagery in the two poems. However, though the title might suggest a response to Lucrezia's sudden withdrawal into voluntary rustication, its content also suggests an earlier moment in the story of Lorenzo's love, near its initial onslaught, for it describes the poet's lady not as a chaste Diana, but instead as a new goddess, armed like Diana with bow and arrow, but herself potent with the power of love (vv. 9–11):

> omai finite d'onorar Dïana,
> perch'altra dea ne' vostri regni è giunta,
> ch'ancor ella ha suo arco e sua faretra.

(Now cease to honor Diana, for another goddess has arrived within your realm, and she too has her bow and a quiver of her own.)

Similarly, the sonnet *L'arbor che a Phebo già cotanto piacque* (*Canzoniere*, XIV), in which Lorenzo laments that the sun no longer shines on the laurel ("non so per cui difetto"), looks like an inverted response to Pulci's report of Lucrezia's vision of a laurel tree shining like alabaster under the sun's rays before disappearing, but the imagery is too conventional (or rather, the emphasis is too much on emotion instead of external circumstance) to permit a precise dating to the spring months of Lorenzo's journey to Rome and Naples.

On the other hand, the *Sonetto fatto andando in maremma lungo la marina* (*Canzoniere*, XLI) describes the sea to the poet's right and the land to his left, filled with leafy glades and the reflecting pools of a *nuova Diana*. This can only have been composed during Lorenzo's journey from Rome south to Naples through the maremma of Latium (the Via Cassia being the main road between Florence and Rome, it is highly unlikely that he would earlier have traversed the Tuscan maremma), prompting him to write of how each slow step reminded him of Lucrezia and the sweet pain he carried with him. More specific as a response to Pulci's and his friends' reports of

Lucrezia's feelings, however, is the *Sonetto fatto per un certo caso che ogni dì si mostrava in mille modi* (*Canzoniere*, XXIV), which is too close in language and imagery to Pulci's *Da poi che 'l Lauro* for the similarity to be fortuitous. Here Lorenzo's language pointedly echoes Pulci's description of how he became aware of Lucrezia's guiding *ombra* and was at once stricken, "come huom che tosto aombra / per subita parvenza":

> Fortuna, come suol, pur mi dileggia
> e di vane speranze ognor m'ingombra,
> poi si muta in un punto e mostra ch'ombra
> è quanto pe' mortal' si pensa o veggia.
>
> Or benigna si fa e ora aspreggia,
> or m'empie di pensier', e or mi sgombra,
> e fa che l'alma spaventata aombra,
> né par che del suo male ancor s'avveggia.
>
> Teme, spera, rallegrasi e contrista
> ben mille volte il dì nostra natura:
> spesso il mal la fa lieta, il bene attrista.
>
> Spera il suo danno, e del bene ha paura:
> tanto ha il viver mortal corta la vista.
> Alfin vano è ogni pensiero e cura.

(Fortune, as is her wont, always derides me and every moment packs me full of empty hopes, then changes in a trice and shows that everything thought or seen by mortals is but a shadow. Now she shows herself benign, now bitter, now fills me with thoughts, now empties me of them, and she makes my terrified soul boggle, nor even seem capable of perceiving its own illness. A good thousand times a day our nature fears, hopes, rejoices, and saddens, and is often made happy by the bad while taking sorrow from the good; so short is the sight of mortal existence that it hopes for its own hurt, and fears the good. In the end every thought is vain and burdensome.)

Lorenzo here again attributes to himself, as characteristic of the lover's condition, the confused and empty imaginings that had provoked Lucrezia to desperation, leading her to suppose she might find peace through divorce and the convent. Fortune and Love conspire to fill the lover's mind with false fears and vain hopes, and what he thinks he most wishes is only an *ombra*. His soul is in turmoil, made happy by contemplating what is damaging to true happiness and saddened by what brings it well-being, and his confusion is so great that he ends by desiring his own ill and fearing his good. Like Lucrezia, who is obsessed by the *ombra* of Piccarda, and like the "poverette nynphe pe'boschi" of whom Pulci wrote in the note he attached to his canzone, lovers like himself "potrebbono più tosto fare conto al peggio al peggio d'averne a scendere."

Most interesting of all, however, is Lorenzo's canzone III (*Canzoniere*, XL),

which he entitled *Canzona fatto sendo malata una donna*. Lucrezia, whom Pulci had described in *Da poi che 'l Lauro* as lacerated by cares and of "quel color c'huom porta all' aspra tomba," is characterized in that poem as suffering from a kind of soul-sickness, and Lorenzo responds with a canzone of his own built on the twin themes of faith and constancy. Indeed, so insistent is the repetition of the word *costanzia* in the poem that Paolo Orvieto was led to wonder whether this functions only as a theme-word repeated throughout, or whether it may even be a new *senhal*, poetically masking the identity of a lady whom he again conjectures to be Costanza Donati.[43] This is, however, most unlikely. On the other hand, Costanza was the name that had been taken by Piccarda Donati when she entered the convent at Monticelli. Since it is the *ombra* of Piccarda as Costanza that has enthralled Lucrezia, *costanzia* may be taken as a new *senhal* for Lucrezia, or rather as the spirit that has possessed her and in whose steps she is compelled to tread, to which Lorenzo responds by suggesting that this is a test of his own true *costanzia*. The tension of the poem derives from the play between the terms *costanzia* and *fede*, and it recapitulates the course of a love that also finds narration in Pulci's *Da poi che 'l Lauro* as well as in his later work, *La giostra di Lorenzo de'Medici*. The canzone begins (vv. 1–45):

> Per molte vie e mille vari modi
> provato ha Amor se mia costanzia è vera,
> come li parve e come spesso ho detto:
> e, benché m'abbia aggiunti mille nodi,
> ancor ben chiar della mia fè non era,
> volendomi legar molto più stretto.
> E fece ne' primi anni un suo concetto,
> che, se il celeste viso ornato e puro
> mi si mostrassi duro,
> impaurito lascerei l'impresa:
> onde già mai accesa
> face non fu della mia donna al core,
> ma del mio mal lieta era ne' sembianti:
> non è maggior dolore
> che veder ch'altri rida ne' suoi pianti.
>
> In questo modo un tempo Amor mi tenne,
> senza che mai provassi altra dolcezza
> che contemplar cosa celeste in terra.
> Questo mi prese, e questo mi mantenne:
> stavo contento sotto tal dolcezza
> e lieto in pace in mezzo a tanta guerra.
> Amor, che vede che 'l mio cor non erra,
> ma fermo, fece in sé nuovo pensiero,

43 Lorenzo de'Medici, *Canzoniere*, ed. cit., p. 94.

e l'indomito altèro
cor della donna mia accese alquanto:
non già molto, ma tanto
quanto aggiugnessi a me qualche speranza
per mantenermi vivo in tanti affanni;
e poi con più baldanza
raddoppia in me suo tradimenti e inganni.

Quanto fussimo allora i miei martìri
e quanto dura e cruda la mia sorte,
difficilmente e si dice e si crede:
era i conforti miei pianti e sospiri,
e la speranza già ridotta a morte,
dove credevo sol trovar merzede.
Ma la costanzia mia e intera fede
non manca già per pene e non si perde,
ma rinasce più verde
quanto maggior era ogni mio tormento.
In mezzo a tanto stento
sempre la sua bellezza mi soccorse,
e faceami ogni doglia stimar poco.
Amor di ciò s'accorse,
e fe' nuovo pensiero e nuovo gioco.

(Through many ways and in a thousand different manners Love has tested whether my constancy is true, as it seemed to be to him and as often I have claimed: and, though he had bound me in a thousand knots, still he was not certain of my faith and wished to bind me much more tightly. And early on he conceived the notion that, if her celestial face, pure yet adorned with beauty, should show itself harsh to me I would abandon the enterprise in terror: and so never at that time was any torch ignited in the heart of my lady, but rather she seemed happy at my poor state. There is no greater pain than to see another laugh at one's tears. For a while Love held me in this way, never tasting any sweetness other than the contemplation of a celestial being here on earth. This held me, and this maintained me: beneath such sweetness I was content, and happily at peace in the midst of so much war. Then Love, who saw that my heart did not wander but stood firm, conceived a new idea, and enkindled ever so slightly the untamed, proud heart of my lady: not yet very much, but sufficient to place within me some hope of keeping myself alive in such affliction. And then, with yet greater temerity, he redoubled his treachery and deceptions within me. How great my torments were then, and how hard and cruel my fate, is difficult either to describe or to believe: my tears and sighs were comforts, and hope was then reduced to death, in which alone I believed I could find mercy. But

my constancy and total faith still did not falter under such punishment, and was not lost, but sprang up again so much the greener as each of my torments was the greater. In the midst of such travail her beauty always succoured me, and made me hold every pain in little esteem. Love took notice of this, and came up with a new idea, and a new game.)

Lorenzo's canzone is thus about the many tests invented by Love to prove whether "*mia* costanzia è vera," a phrase that at once identifies Lucrezia with his own *vera costanzia* and sets this true constancy at rivalry with her newly found phantasm of constancy, the *ombra* of Piccarda-Costanza that has captured her thoughts. He recalls the history of his love from its inception, when Lucrezia was as yet indifferent, looking harshly on him in the expectation that he would take fright and abandon his suit. This account of Love's first test echoes the speech put in Lucrezia's mouth by Pulci in *Da poi che 'l Lauro* (vv. 58–60), in which she describes how she would feign disdain for his love: "Quante volte finx'io già ira et sdegno, / per veder con che studio et con quale arte / un generoso core cercasse pacie!" Lorenzo's constancy is nourished by her beauty, however, and having passed this test he is given another. Love softens Lucrezia's heart, but only sufficiently to give Lorenzo a glimmer of hope, and the redoubled anguish this causes him paradoxically only redoubles his constancy and faith. Love then devises a new test, and conspires with Fortune to turn on Lucrezia, to find a way to make her miserable and so deliver her well-being into Lorenzo's hands. She is thus given direct evidence of his constancy and merit, whereupon Love, in the cruelest prank of all, plucks from her heart the golden arrow with which he had pierced it and strikes her instead with one of lead, causing her love for Lorenzo to extinguish itself (vv. 46–75):

> E pregò dolcemente la Fortuna
> ch'ella cercassi d'ogni cosa nuova
> che alla donna mia fussi molesta.
> Ella, che volentier sempre importuna,
> deliberò di far l'ultima prova,
> e di varî dolor' suo cor infesta.
> E di ciò molto addolorata e mesta
> era madonna, e più sarebbe stata:
> ma ne fu liberata,
> come Amor volle e la Fortuna insieme,
> che le saluti estreme
> posono in man del suo fedele amante.
> Allor ne vide esperienzia certa,
> quanto egli era costante
> e quanto la sua fede da lei merta.
>
> Quand'ebbe fatto questo, il suo stral d'oro
> rimisse, e 'l plumbeo trasse che Amor caccia,

e punse il cor della mia luce viva.
Né mai poi da quel tempo al verde alloro
mostrò più il sol benigna la sua faccia,
ma fu d'ogni speranza l'alma priva.
Onde l'amor che dentro al cor bolliva,
come l'animo fa gentil e degno,
quasi vòlto in isdegno,
difficilmente comportò tal torto:
e fu tale sconforto
che 'l cor di tanta ingratitudin prese,
che lasciò quasi l'amorosa scuola;
ma pur poi si raccese,
pensando alla bellezza al mondo sola.

(And he sweetly pleaded with Fortune to seek out some new thing that would be disturbing to my lady. And Fortune, always willing to be troublesome, thought up a way to put the final test, and infested her heart with various woes. By these was my lady greatly afflicted and aggrieved, and would have been more so: but she was freed of them, as Love and Fortune both wished, when they placed final salvation in the hands of her faithful lover. Then it was apparent with the certainty of experience how great his constancy was, and how much his faith was worthy of her. When this had been done, Love withdrew his golden arrow and plucked out the leaden one which he keeps hidden, and he pierced the heart of my living light. Nor ever after from that moment did the benign sun show her face to the green laurel, but left his soul deprived of every hope. For this reason the love that boiled within his heart, since it makes the soul gentle and worthy, almost turned away in disdain, being scarcely able to support so great a wrong: and such was the offense taken by the heart at such ingratitude that it all but abandoned the school of love; but then it rekindled, thinking only of her beauty that is unique in the world.)

The external circumstances (which are in the province of Fortune) causing Lucrezia's misery, and which gave Lorenzo the opportunity to prove his constancy, were provided in the first place by the necessity of Lucrezia's going through with the marriage that had been arranged for her with Ardinghelli, from which she ardently desired an honorable escape. Fortune further conspired with Love to require Lorenzo's absence in Rome, a circumstance that deadened her love for him and led her to seek an idea of constancy elsewhere. Deprived of all hope, and stung by the injustice and ingratitude shown him, Lorenzo's constancy is yet sustained by the image of her beauty—which Love now conspires to take from her (vv. 76–90):

Amor, che vede ogni sua pruova invano,
pensò nuova malizia, e la cagione

de tanta mia costanzia levar vòlse;
perché levato il bel sembiante umano,
li par che sia levata ogni ragione
di mia fede, ed a questo il pensier volse,
e parte di beltà da quella tolse
con fare scolorir quel dolce viso,
fede del paradiso
qui fra' mortali, albergo d'ogni bene.
Questo accresce le pene,
ma non già scema la mia fede antica;
perché da questa mai mi potrà sciôrre
dolor', pianti o fatica,
né tu la sua bellezza li puoi tôrre.

(Love, who saw each of his tests had been in vain, thought of a new malice, and desired the removal of the reason for my great constancy; for if her beautiful human aspect were to be taken away, it seemed to him that every reason for my faith would be removed, and to this he turned his thoughts. He took part of her beauty from her by draining the color from that sweet face, the faith of paradise here among mortals, the lodging place of every good. This increased my torments, but still did not lessen my ancient faith; because pain, tears, and travail could never sever me from that, nor can you take her beauty from her.)

The sickness suffered by Lucrezia, so vividly described by Pulci in *Da poi che 'l Lauro*, is literally a lovesickness caused by Love himself, who, by draining the color from her sweet face, "fede del paradiso," increases Lorenzo's pain but even so cannot shake his "fede antica," which endures all suffering and trial. His concept of "ancient faith" derives from Virgil's *prisca fides* (*Aeneid*, vi.878), but it refers in particular to the pledge of faith he had given Lucrezia at Braccio Martelli's wedding banquet, where he had promised to dedicate his *giostra* to her. This pledge was sealed, as Pulci later wrote (in a passage quoted at length above) in *La giostra di Lorenzo de'Medici*, by "un detto antico, che 'Vuol fede Amore,' " and it is this to which Lorenzo alludes in his canzone. He concludes the poem by pointing out that Love, by despoiling Lucrezia of her beauty, deprives himself of the honor that is his due, and what is more, by extinguishing his own light on earth, the love that is embodied in her beauty, he extinguishes himself. "Love," he pleads, "do not cede to another that which is your own, wherein is your own honor," for in that other—the *ombra* of Costanza—resides the death of love itself. Both Lucrezia and Lorenzo—*ambo noi dui*—stand in mortal danger, and on Love's decision both their lives depend. Lorenzo's *vera costanzia* and his *fede antica* have stood every test, and he sends his canzone with a plea that Love respond, for only love can minister to the wounds that love has opened (vv. 91–125):

Perché, se pur di tue bellezze spogli
questo gentile ed onorato fiore,
e tôi le penne a sì bella fenice,
a te tua prima preminenzia togli,
te privi e spogli del sovran tuo onore,
della cagion la qual ti fe' felice.
Questa del regno tuo è la radice;
questa è la tua baldanza e la tua gloria;
questa eterna memoria
darà di te alla prole futura:
mentre che questa dura,
di questo mondo cieco guida e duce,
durerà la tua forza e 'l tuo valore;
ma, se la viva luce
si spegne in terra, spegnerassi Amore.

Non dar, Amore, in podestà d'altrui
quel ch'è tuo sol, quel ch'è l'onor tuo vero:
deh, mostra contr'a morte la tua forza!
Amor, soccorri al mal d'ambo noi dui,
soccorri alla ruina del tuo impero;
a questa volta i duri fati sforza,
sì che l'alma gentil e la sua scorza,
la qual degno ti fa lieto e giocondo,
si mantenga nel mondo,
a me la vita che da lei dipende.
Per te chiar si comprende
che omai la mia costanzia è ferma e intera.
Non far oramai meco, Amor, più pruove,
ché la mia fede è vera:
riserba le tue forze e ingegni altrove.

Va', canzona; Amor priega
che più non tardi il soccorso a se stesso,
perché veggo il suo imperio in gran periglio;
ed è il suo mal sì presso,
che poco stato non vare' consiglio.

(Because, if you despoil this gentle and honored flower of your beauties, and take the feathers from so beautiful a phoenix, you take from yourself your own prime preeminence, you deprive and despoil your sovereign honor of the very cause of your own happiness. She is the root of your realm; she is your audacious pride and glory; she will give eternal memory of you to future generations, and for so long as she endures, guide and

leader of this blind world, your power and valor will endure. But, if the living light be extinguished on earth, you will have extinguished Love. O Love, do not give into the power of another that which is yours alone, that which is your true honor. Ah, show your power against death! Love, help keep from evil the two of us both, and help keep your empire from ruin; this time break the harsh fates so that that gentle spirit and her outer beauty, which makes you worthy, happy, and youthful, may be maintained in the world, and for me the life that depends on her. You clearly comprehend that from now on my constancy is firm and total. Do not, Love, put me again to the test that my faith is true: hold your powers and devices in reserve for other things. Go, my song; pray to Love that he no longer delay giving succour to himself, because I see his empire in great danger and his own ill so near that soon there will be no remedy for it.)

The tension of the canzone relies on Lorenzo's coupling of the concept of *costanzia*, which does now indeed function virtually as a kind of antithetical *senhal* for Lucrezia and her *ombra*, with the all but synonymous concept of *fede*, the pledge he had given her at Braccio Martelli's wedding. In each of the first, third, fourth, sixth, and eighth stanzas, Lorenzo's own constancy, *mia costanzia*, is made equivalent with his own faith, *mia fede*, the true *fede antica* that enables love (and does not threaten it), summarized in the ancient saying Pulci wrote he had adopted as his motto, *Vuol fede Amor*. Lorenzo's *impresa amorosa*, on which the canzone is itself a comment provoked by a specific occasion, is also preserved in several Florentine fine-manner engravings from a set known as the Otto prints, so named for the German collector Ernst Peter Otto, who acquired them in 1793 from the collection of Baron Philippe de Stosch. The engravings have been attributed to Baccio Baldini (d. 1487), who according to Vasari worked from drawings given him by Botticelli, and though they have been dated to the decade of the 1470s, a date closer to 1465–1466 seems more likely in view of the remarkable closeness of their imagery to the early poetry of Lorenzo, his youthful love for Lucrezia, and the earthy escapades of his *brigata*. They are round or vaguely elliptical in format, and they were made to be affixed to the spice or perfume boxes that young Florentine gallants would present as gifts to their ladies. Their subjects are amorous, and one of them, as Warburg long ago demonstrated in an elegant article, clearly refers to Lorenzo and Lucrezia (who are not literally portrayed, however).[44] The engraving (fig. 17) shows an idealized youth wearing embroidered on his sleeve the famous diamond ring and feathers, universally recognizable as Lorenzo's device. With one hand he reaches out to receive a sphere from an equally idealized young woman, a nymph wearing wings in her hair, who extends it toward him. With his other hand he in turn extends a scroll, which she also accepts, bearing on it the motto with which Lorenzo had pledged his *giostra* and his love to Lucrezia: *Amor vuol fe, e dove fe nonne Amor non puo*—"Love wants faith, and where

[44] Warburg, op. cit., pp. 180–191.

there is no faith Love is powerless." Warburg further interpreted the sphere proferred by Lucrezia as alluding to her motto *Spero*, "I hope" (the very motto described by Braccio Martelli in his letter of 27 April 1465 as "ricamata in sulle maniche [della felice vesta di Lucrezia, cilestra] a lettere che dicono SPERI"); while the sun at the center of the sphere equally alludes to the *senhal* of Lucrezia as Sole, and thus, according to the well-known usages of such lovers' mottoes, renders the sentiment "Sol spero."[45] Similarly, Lorenzo's device of the diamond ring and feathers, the *adamante* or *diamante in paenis*, signifies the suffering state of one who offers his love, *di amante in pena*, to another, *ad amante in pena*, pledging love in faith, and in the hope that it will be accepted. The exchange between the two lovers shown in the engraving thus balletically intertwines a kind of secular, troubadour's lay version of the three theological virtues, faith proffered in return for an offering of hope, the two bound together and guaranteed by love. And it is the death of hope, "la speranza già ridotta a morte" (stanza 3), and the steadfastness of Lorenzo's faith even when "fu d'ogni speranza l'alma priva" (stanza 5), that sounds as a leitmotiv in his canzone, and that leads him to fear for the death of love itself.

Lucrezia Donati did not leave her husband for the convent, and Lorenzo's love for her certainly survived the events of 1466, as we have already seen from the letter written him by Giovan Francesco Ventura in 1468. He kept his promise to hold a *giostra* in her honor, and when in February 1469 he rode into the piazza of Santa Croce with Verrocchio's allegorical image of her bearing the motto *Le tems revient*, he virtually identified her with his fortune and the city's, seamlessly expanding a private and poetic love that had been shared with the members of his *brigata* into a public myth of Florentine peace and renewal. Fortune had also decreed his engagement to Clarice Orsini, whom he married scant months later, but the warmth of Lorenzo's love for Lucrezia lasted, as Picotti and Rochon have indicated, at least into the early years of the next decade, and he kept a portrait of her, also painted by Verrocchio, in the family palace in the Via Larga. Lucrezia remained the lady to whom his poetry was dedicated for a long time thereafter, and she is the lady celebrated in the many sonnets Lorenzo gathered and commented on in his *Comento sopra alcuni de'suoi sonetti*, written after the Pazzi conspiracy of 1478, in which the figure of Lucrezia as the poet's lady assumes a progressively abstracted philosophical and poetic ideal of love, a love that fosters gentility. But it is an ideal based on the remembrance and reevocation of the real experiences of youth.

The mythologizing of Lorenzo's youthful love was embodied in an image simultaneously private and very public, manifest not only to the familiars of his *brigata* but also available to the public imagination. The making of that image into the emblem of the new humanist culture of the city is the principal theme of the following chapters. It is a myth of extreme potency, a secular ideal celebrated in poetry, songs, and art in the tournaments and festivals of the city, sometimes in the persona of

[45] "Spero" is in fact the form commonly used in poetry of the fifteenth century to denote a sphere: see, for example, Luigi Pulci, *Da poi che 'l Lauro*, line 102 ("Sancte carole et spere"), and Lorenzo de'Medici, *Canzoniere*, ed. cit., III ("Già sette volte ha Titan circuito / nostro emispero").

Lucrezia and sometimes of another, whether given the name of Simonetta Cattaneo, Albiera degli Albizzi, or someone else. Whatever name she might assume, the Florentine nymph celebrated in Pulci's *Da poi che 'l Lauro* and in the *Canzoniere* of Lorenzo represented a new cultural and societal ideal whose attractiveness and identity with the aspirations and regime of Lorenzo de'Medici drew against her the thunderbolts of Savonarola when he urged his congregations to consign their *Canzonieri* and *Decameroni* to the fire.[46] Her reality, and that of the myth she represented, drew forth from him the following denunciation in a sermon preached in 1496, thirty years after Pulci sent *Da poi che 'l Lauro* to Lorenzo in Rome, on the text "Et portastis tabernaculum Moloch deo vestro, et imaginem idolorum vestrorum" (Amos 5:26):

> You have dedicated my temple and my churches to your god Moloch. Look at the usages of Florence—how the Florentine women have married their daughters, put them on display, and attired them so that they appear to be nymphs; and the first thing they do is take them into Santa Reparata. These are your idols, which you have placed in my temple. The images of your gods are the images and likenesses of the bodily forms you cause to be painted in the churches; and then the youths go about saying to this woman or to that other, "This one is the Magdalene," and "He is Saint John," and "Behold, there is the Virgin." For you have had bodily forms painted in the churches in the likeness of this woman or some other, which is most wickedly done and shows great disrespect for those things that pertain to God. You painters do evil, for if you knew the scandal they cause, and which I do know, you would not have painted them. You place all the vanities in the churches. Do you believe that the Virgin Mary went out dressed the way you have painted her? I tell you that she dressed like a poor girl, simply, and covered so her face could scarcely be seen. So too did Saint Elizabeth go out simply dressed. You would do great good to destroy these figures, which are painted so dishonorably. You have made the Virgin appear dressed like a whore. So far has the worship of God fallen into ruin![47]

[46] See G. Guasti and I. Del Lungo, *Poesie di Fra Girolamo Savonarola con l'aggiunta di una canzone pel bruciamento delle vanità e precedute da notizie storiche*, Florence, 1933, p. 93; see also M. Ferrara, "L'influenza del Savonarola sulla letteratura e l'arte del Quattrocento," in G. Savonarola, *Prediche e scritti*, ed. M. Ferrara, Milan, 1930, pp. 361–397. For the anti-Medicean and millenarian polemics and prophecies of Savonarola, see D. Weinstein, *Savonarola and Florence: Prophecy and Patriotism in the Renaissance*, Princeton, 1970.

[47] G. Savonarola, op. cit., p. 387 (*Prediche sopra Amos e Zaccaria* [1496]; Sermon for the Saturday after the second Sunday of Lent).

FOUR

POETRY AS HISTORICAL FICTION

Lorenzo de'Medici, Simonetta Cattaneo,

and Lucrezia Donati

Lorenzo de'Medici wrote his earliest poetry around the year 1465–1466, and these first efforts are much in the debt of Petrarch's muse, at least as mediated by Luigi Pulci.[1] Pulci had returned to Florence early in 1466 at the instance of Lorenzo (and no doubt his mother Lucrezia Tornabuoni, herself a poet who encouraged Pulci to write the *Morgante*), and it was then that he sent Lorenzo the canzone *Da poi che 'l Lauro*, telling him of Lucrezia Donati's desperation. In Lorenzo's responses to that poem, as well as in his earlier poetry written at the start of his love for Lucrezia, one sees the reality of that love. One also sees his mastery of the forms and images of the Petrarchan sonnet, his use of the artificial and difficult forms of the sestina, for which Petrarch is again an important model, and his first attempts to adapt classical poetry to the domestic setting of the Florentine *contado* (the *Sonetto fatto in sul Rimaggio* being an imitation of the very Horatian ode that is Botticelli's point of departure for representing the Graces). In his beginnings as a poet, both before and after the joust of 1469, Lorenzo wrote experimental and popularizing verse too, such as the *Nencia da Barberino* (the authorship of which is still debated), the *Uccellagione di starne*, a *burchiellesco* account of hunting with members of his *brigata*, and the equally comic *Symposium*, also called *I beoni*, in which Botticelli—"va Botticello e torna botta piena"—himself appears as one of the drinkers.[2] During this period he further composed two *novelle*, entitled *Giacoppo* and *Ginevra*, and by the early 1470s he had also probably written, aside from canzoni, some

[1] P. Orvieto, *Lorenzo de'Medici*, Florence, 1976, has written a useful overview of Lorenzo's poetic career, with an excellent bibliography. See also the same author's edition of Lorenzo's *Canzoniere*, Milan, 1984, with an updated bibliography.

[2] A. Rochon, *La jeunesse de Laurent de Médicis (1449–*

1478), Paris, 1963, p. 569. Rochon's work on the earlier poems is indispensable. The vexed question of the *Nencia da Barberino* has recently been exhaustively rehearsed in Rossella Bessi's edition, Rome, n.d. (Testi e Documenti di Letteratura e di Lingua, VI).

of the *canzoni a ballo* known collectively as the *canti carnascialeschi*, poems again set in a popular mode, filled with mildly obscene double entendres, which were easily put to music for singing in the Florentine festivals of Carnevale, the Calendimaggio, and the Feast of San Giovanni.

However, beginning in the year 1473–1474 the preoccupations of Lorenzo's early poetry abruptly cease, and his *burchiellesco* modes with their lexical and parodic distortions (in the spirit of Pulci) of popular language and the experiences of the *brigata* give way to themes and a language seeking to incorporate not the outer vestments but the sinew of such Latin models as Horace and Lucretius. His Petrarchan lyrics in praise of the corporeal beauties of his beloved correspondingly cede to a more abstract and spiritual concept of beauty and love that is figured not only in Petrarchan forms but also in the language and metaphors of the poets of the *stil novo*. His initial poetic apprenticeship with Pulci is abandoned in favor of the more exalted figures of Marsilio Ficino and Politian. Early in 1473 Politian had written his great Latin elegy on the death of Albiera degli Albizzi, wife of Sigismondo della Stufa, one of the *brigata* and one of Lorenzo's closest friends.[3] Probably the mastery displayed in that poem induced Lorenzo to take Politian into his household later in the year, and by 1475 Politian had been appointed preceptor to Lorenzo's son Piero and given the task of composing his vernacular poem, the *Stanze per la giostra di Giuliano de'Medici*. Pulci had only just completed *La giostra di Lorenzo de'Medici*, as we learn from a letter of 1474 in which he writes Lorenzo, "I am putting the verses in praise of you and Piero [di Cosimo] in order, for I have been wanting to finish the *Giostra* so that I may pray your desire to grant me favor."[4] In this hope he was to be disappointed, his poem eclipsed by the superior gifts of Politian, whose *Stanze* are distinguished by a truly original inventive capacity and also by a language in which for the first time the vernacular and Latin idioms are wedded in an indissoluble bond, and of which it has truly been said that the Italian speaks a perfect Latin.[5] The domestic muse of Pulci had been superseded, and not long afterward he left the service of Lorenzo, his departure hastened by several unwise acts, among them an open polemic against Ficino.

It was also in 1473–1474 that Lorenzo wrote his *Altercazione*, also called *De summo bono*, his first poem deeply inspired by the philosophy of Ficino, whose *De felicitate* Rochon has shown it in part virtually paraphrases.[6] These years mark Lorenzo's growing involvement with and support for Ficino and the Platonic Academy at Careggi (though he undoubtedly had received prior education in the principles of

[3] A. Poliziano, *Prose volgari inedite e poesie Latine e Greche edite e inedite*, ed. I. Del Lungo, Florence, 1867, pp. 238–248; see also A. Perosa, "Febris: A Poetic Myth Created by Poliziano," *Journal of the Warburg and Courtauld Institutes*, IX, 1949, pp. 74–95. Albiera died on 14 July 1473; for the poetry inspired by her death, see F. Patetta, "Una raccolta manoscritta di versi e prose in morte d'Albiera degli Albizzi," *Atti della R. accademia della scienza di Torino*, LIII, 1917–1918, pp.

324ff.

[4] Luigi Pulci, *Morgante e lettere*, ed. D. De Robertis, Florence, 1984, p. 992; see also Luigi Pulci, *Opere minori*, ed. P. Orvieto, Milan, 1986, p. 57.

[5] See D. De Robertis, "L'esperienza poetica del Quattrocento," in the Garzanti *Storia della letteratura italiana*, ed. E. Cecchi and N. Sapegno, Milan, 1966, III (*Il Quattrocento e Ariosto*), pp. 513–556.

[6] Rochon, op. cit., pp. 495ff.

Neoplatonism, not only from Ficino himself, but quite possibly from Landino's Platonizing lectures on Petrarch's *Canzoniere* in 1465–1466), and in the poem Lorenzo appears in relation to Ficino as Alcibiades to Socrates.[7] His admiration for the philosopher both as a guide to wisdom and as a lover of poetry appears in the following:

> Marsilio abitator del Montevecchio,
> nel quale il cielo ogni sua grazia infuse,
> perch'ei fusse ai mortal sempre uno specchio;
>
> amator sempre delle sante Muse,
> né manco della vera sapienza,
> tal che l'una giammai dall'altra escluse.[8]

(Marsilio, dweller at Montevecchio, in whom the heaven infuses all its grace, because he was to mortals always a mirror; ever the lover of the holy muses, nor lacking in true wisdom, so that he never separates one from the other.)

By 1476 Lorenzo had quite certainly begun work on his *Comento sopra alcuni de' suoi sonetti*, in which he brought together the muses with philosophy in a way that is powerfully indebted to Ficino, and on which he continued to work for the rest of his life.[9] The first four sonnets explicated in the *Comento* were inspired by the death of Simonetta Cattaneo in April 1476, and they were soon after included in the *Raccolta Aragona*, the famous collection of vernacular lyric poetry Lorenzo assembled and sent to Federico d'Aragona in 1477, together with a letter on the history of that poetry from its first rough appearance in the lyrics of Guittone d'Arezzo and the Bolognese Guido Guinizelli through to its refinement in the poety of Guido Cavalcanti and Dante. This letter, which was probably drafted by Politian and which develops the argument put forward a decade earlier by Landino in his prolusion to reading Petrarch's sonnets, is a crucial document, as is the *Comento*, for understanding Lorenzo's profound desire to return to the foundations of Tuscan poetry, and on that basis initiate a further refinement and transformation of the language that would raise the level of the *lingua volgare* to that of the ancient tongues. He made the *Raccolta*, he wrote in a famous passage in the letter, "so that the richness and ornaments [of the

[7] For Landino's lectures, see A. Field, *The Origins of the Platonic Academy of Florence*, Princeton, 1988, pp. 231–268 ("Cristoforo Landino and Platonic Poetry"), esp. pp. 237f. for a possible dating of them to 1465–1466. Field also points out that the location of Ficino's academy at Careggi was perhaps more symbolic than actual (pp. 200f.), and that he certainly lectured on Plato at various locations in Florence; the issue is unsettled, however, though it might be safer to assume (as Field has kindly suggested to me) that *ubi Ficinus ibi*

Academia.

[8] Lorenzo de'Medici, *Altercazione*, chapter II (in Lorenzo de'Medici, *Opere*, ed. L. Cavalli, Naples, 1969, p. 127.)

[9] For the disputed question of the dating of the *Comento*, see Rochon, op. cit., pp. 140f., and M. Martelli, *Studi Laurenziani*, Florence, 1965, pp. 51–133; its beginnings are without doubt in the four sonnets inspired by the death of Simonetta Cattaneo in 1476, all of which were included in the *Raccolta Aragona*.

vernacular] shall be esteemed, and this language not be reputed poor and rough, but abundant and highly polished; nothing that is gentle, florid, lovely, and ornamented, nothing witty, distinguished, ingenious, and subtle, nothing lofty, magnificent, and sonorous, nor finally anything that is ardent, spirited, and excited can be imagined that not only appears in Dante and Petrarch but also in these others."[10] He also sheds valuable light on his conception of the importance and uses of civic tournaments and celebrations, with their new *trionfi* adorned by art and theatrical display, for he writes that the honor of the ancients had won eternal fame through the poetic and oratorical competitions organized in conjunction with the Olympic Games in Greece and with the military triumphs staged in Rome, "con infiniti mirabilissimi ornamenti."[11]

Of all the controversies that have grown up around Botticelli's *Primavera*, none has been less fruitful than that concerning Simonetta Cattaneo, the young wife of Marco Vespucci, whose death in the fullness of her youthful beauty on 26 April 1476 provoked the four sonnets from the *Comento* that Lorenzo included in the *Raccolta Aragona*. Simonetta had been the lady to whom Lorenzo's brother Giuliano had dedicated his valor in the joust of 1475, and she is the central figure in Politian's *Stanze* commemorating that tournament. By an extraordinary coincidence it was on the second anniversary of her death, 26 April 1478, that Giuliano himself died, the victim of murder in the Pazzi conspiracy. Her death was not only mourned by Lorenzo in these sonnets and by Politian in the *Stanze*, but Politian further remembered her in four Latin epitaphs, as did Bernardo Pulci in his elegy *De obitu divae Simonettae* and a sonnet entitled *La diva Simonetta a Julian de' Medici*, Piero Dovizi da Bibbiena in the elegy *Heulogium in Simonettam puellam formosissimam morientem*, Naldo Naldi in two Latin epigrams, Girolamo Benivieni in two sonnets, and Francesco Nursio in the *Carmen austerum in funere Simonettae*.[12] In the last days of her illness Lorenzo sent his personal physician to the house of the Vespucci, and while he was in Pisa he kept himself informed of her progress.[13] Sforza Bettini, writing to tell Lorenzo of her death, was indeed the first to see an analogy between Simonetta and Petrarch's Laura, saying "You could well say that this is the second Triumph of Death, for truly had you seen her thus dead as she was, nothing would have seemed lacking of that beauty and comeliness that she possessed in life."[14] Lorenzo adopted the analogy in his *Co-*

[10] *Prosatori volgari del Quattrocento*, ed. C. Varese (La letteratura italiana: Storia e testi, XIV), Milan and Naples, n.d., p. 987.

[11] Ibid., p. 985: "L'onore è veramente quello che porge a ciascuna arte nutrimento; né da altra cosa quanto dalla gloria sono gli animi de' mortali alle preclare opere infiammati. A questo fine adunque a Roma i magnifici trionfi, in Grecia i famosi giuochi del monte Olimpo, appresso ad ambedue il poetico e oratorio certame con tanto studio fu celebrato. Per questo solo il carro e arco trionfale, li marmorei trofei, li ornatissimi teatri, le statue, le palme, le corone, le funebri laudazioni, per questo solo infiniti altri mirabilis-

simi ornamenti furono ordinati; né d'altronde veramente ebbono origine li leggiadri e alteri fatti e col senno e con la spada, e tante mirabili eccellenzie de' valorosi antichi, li quali sanza alcun dubbio, come ben dice il nostro toscano poeta [Petrarca], non saranno mai sanza fama,

se l'universo pria non si dissolve."

[12] Rochon, op. cit., pp. 246f.; see also A. Neri, "La Simonetta," *Giornale della storia delle lettere italiane*, III, 1885, pp. 131–147.

[13] Rochon, op. cit., p. 248.

[14] Ibid., pp. 246f.

mento when he wrote of the dead Simonetta that "in her was truly verified that which our Petrarch said, 'Death seemed beautiful in her lovely face.' "[15]

Adolfo Venturi in 1892 and Aby Warburg in 1893 were the first to suggest in print, virtually simultaneously, that Botticelli had portrayed Simonetta in the *Primavera*.[16] Warburg pointed out that Simonetta as described by Politian in the *Stanze* so resembles the figure of Flora in the *Primavera* that it is likely that they are one and the same; Venturi suggested that Simonetta appeared in the painting as Venus, that Mercury was an allegorical portrait of Giuliano, and that the painting was an allegorical *novella* on the theme of the tournament. Warburg's more specific comparison was immediately endorsed, together with his overall interpretation of the painting, by Ulmann in the first monograph ever devoted to Botticelli, published in 1893. A few years later Emil Jacobsen published an elaboration of Venturi's argument, interpreting the *Primavera* as dedicated to the memory of Simonetta and showing her entrance, pursued by the Furies, into the Elysian fields.[17]

Many variations on the theme of Simonetta and Giuliano were to follow, even though Jacobsen's thesis was attacked almost at once by Marrai, to devastating effect.[18] He exposed the considerable weaknesses of Jacobsen's argument with ruthless clarity, and went on to argue that the meaning of the *Primavera* could be understood entirely on the basis of the classical texts (Lucretius, Ovid's *Fasti*, etc.) that characterize Flora, Chloris, and Zephyr as spirits of the fertile spring, the season presided over by Venus as the animating force of life in nature. Marrai's account of the classical foundation of Botticelli's invention was excellent, indeed one of the best that has been written. At the same time, however, he posited his classical interpretation as necessarily in conflict with a vernacular model, arguing that since the *Primavera* cannot be said to illustrate an episode from the *Stanze* it cannot be said to resemble it much. No one had yet claimed that the *Primavera* was a literal illustration of the *Stanze* (though this was to come), and Marrai seems to have overlooked the idea that the classical interpretation could be attacked on the same grounds, since it could never be said (as Horne realized after reading Warburg's analysis) that Botticelli literally "illustrated" the various classical texts that quite beautifully define the argu-

[15] *Comento del Magnifico Lorenzo de'Medici sopra alcuni de' suoi sonetti*, in Lorenzo de'Medici, *Opere*, ed. cit., pp. 335–473, esp. p. 350: "Si verifica veramente in lei quello che dice il nostro Petrarca: 'Morte bella parea nel suo bel viso.' "

[16] A. Venturi, "La Primavera nelle arti figurative," *Nuova antologia*, XXXIX, 1892, pp. 39–50, esp. pp. 47ff.; A. Warburg, "La 'Nascita di Venere' e la 'Primavera' di Sandro Botticelli," in *La rinascita del paganesimo antico: Contributi alla storia della cultura*, ed. G. Bing, Florence, 1966, pp. 1–58, esp. pp. 47–58.

[17] H. Ullmann, *Sandro Botticelli*, Munich, 1893, pp. 83–89; E. Jacobsen, "Allegoria della Primavera di Sandro Botticelli," *Archivio storico dell'arte*, ser. 2, III, 1897, pp. 321–340; see also idem, " 'Der Frühling' des Bot-

ticelli," *Jahrbuch der Kaiserliche Preussischer Kunstsammlungen*, XCII, 1898, pp. 495–514.

[18] B. Marrai, "La Primavera del Botticelli," *L'arte*, I, 1898, pp. 500–503. The article was the beginning of a sharp polemic that had been provoked by I. B. Supino, who had placed the following notice in the "Domande e Risposte" section of *L'arte*, I, 1898, p. 220, which was repeated on pp. 374 and 500: "Emil Jacobsen nell' *Archivio storico dell'Arte* diede una spiegazione dell'allegoria del quadro intitolato 'La Primavera' del Botticelli. Desidero sapere se possa accogliersi." Marrai responded that the picture truly does represent the springtime, and Venturi added a brief reply of his own on p. 503.

ment of his invention.[19] Moreover, by concentrating his attack on Jacobsen (and by implication Venturi, whom he later openly attacked ad hominem), Marrai had not sufficiently taken into account (as Jacobsen himself ruefully pointed out in an otherwise not very effective response) Warburg's considerably more sophisticated consideration of classical poetry as an indispensable component of contemporary literary and pictorial expression.[20]

In short, Marrai had won his particular battle with Jacobsen but had failed in his larger campaign. Because the resemblances between the *Primavera* and the *Stanze* are so strong, not only in imagistic particulars but also in mode of conception, a flood of more or less fanciful interpretations began to issue from the presses, all of them taking it as an unquestioned fact that Simonetta and Giuliano are portrayed in the *Primavera*, and that the picture commemorates their poignant and tragically star-crossed love affair. Already in 1908 Herbert Horne warned against critical acceptance of the "legend" of Simonetta, pointing out that there is almost no evidence that Botticelli ever painted an independent portrait of her, that no portrait of her has ever been identified with certainty, that Mercury's features bear no resemblance whatsoever to those of Giuliano, and that in his opinion none of the figures depicted in the *Primavera* appears to be a portrait.[21] His warning had little effect, and indeed its influence was considerably muted by several remarkable literary and historical studies by Isidoro Del Lungo, most notably in his *Gli amori del Magnifico Lorenzo* of 1924 and *La donna fiorentina* of 1926, the latter of which was given wide dissemination in English translation.[22] In 1930, however, Jacques Mesnil again sounded the alarm.[23] He agreed that Warburg had established clearly that a close relationship must have existed between Botticelli and the humanist poets, and that his mythological paintings are "the plastic expression of their fantasies and share their ambiguous nature, based simultaneously in the Middle Ages and in the Renaissance, in chivalric romance and Greco-Roman mythology, in Christianity and paganism."[24] He also claimed, however, that since Warburg matters had not progressed very far. Mesnil justly observed that rather than determining the precise nature of the relationship between the painter and his humanist contemporaries, scholars instead had been content to embroider variations on the theme of the love of Giuliano and Simonetta. He scornfully added, "And these are not English Pre-Raphaelites or unemployed spinsters who play this singular game; these are solemn professors and men of learning, like Wil-

[19] H. Horne, *Alessandro Filipepi, Commonly Called Sandro Botticelli, Painter of Florence*, London, 1908, p. 54.

[20] E. Jacobsen, "Ancora sulla 'Primavera' del Botticelli," *L'arte*, II, 1899, pp. 280–287. The polemic continued, leading Venturi to close the "Domande e Risposte" section in *L'arte*, the most important subsequent contributions being I. B. Supino in his *Sandro Botticelli*, Florence, 1900, pp. 69–82 (generally following Marrai's arguments), Marrai's "La 'Primavera' del Botticelli," *Rassegna internazionale della letter-*atura e dell'arte contemporanea, Anno II, vol. V, fasc. VI, 1901, pp. 365–380, and idem, "La 'Nascita di Venere' e la 'Primavera' del Botticelli," *Arte e storia*, XXVII, 1908, pp. 17–19.

[21] Horne, op. cit., pp. 52–54.

[22] I. Del Lungo, *Florentia: Uomini e cose del Quattrocento*, Florence, 1897; *Gli amori del Magnifico Lorenzo*, Bologna, 1924; and *La donna fiorentina*, Florence, 1926.

[23] J. Mesnil, "Connaissons-nous Botticelli?" *Gazette des beaux-arts*, IV, no. 2, 1930, pp. 80–89.

[24] Ibid., p. 83.

helm von Bode and August Schmarsow, operating, in the expression of the latter, 'on the terrain of the philological-historical method of our science of art history.' "[25]

It was finally Gombrich who, in 1945, all but put an end to attempts to interpret the *Primavera* specifically in light of the love, real or poetically fanciful, of Giuliano and Simonetta. He again made the argument that the painting does not illustrate literally an episode from Politian's *Stanze*, writing that "the visual charm of these lines has again exerted such a spell that many readers were tempted to overlook the difference in the situation there described from Botticelli's figure [of Flora]."[26] He further assembled, in a series of famous footnotes, a broad sampling of such interpretations that seemed to have almost no common ground, together with various concomitant readings of the mood of the picture and of Venus's expression, which (depending on the particular reading proposed) conveyed to different writers every conceivable emotion from extreme melancholy to radiant happiness. In his text Gombrich warned against the dangers of a "romantic" approach to interpreting the past, and he suggested that with regard to the *Primavera* such an approach unfortunately had been encouraged by three things: the "suggestive power" of Vasari's calling the picture *Springtime*, resulting in the scholarly compilation of a "veritable anthology" of poems of May and the spring; the "spell" Politian's *Stanze* had cast over interpreters ever since Warburg had attempted to establish a connection between the poem and the painting; and finally "the legend of the 'Bella Simonetta' . . . the long-cherished romance which linked Botticelli with the Swinburnian beauty who died of consumption at the age of 23 and was mourned by Lorenzo and his circle in verses of Petrarchan hyperbole."[27]

Ever since Gombrich wrote these words, scholars have nearly unanimously been at pains to dissociate the *Primavera* from the poetic myth of Simonetta—a myth that was in fact the creation of Lorenzo and Politian, but that was now ridiculed and branded as "Swinburnian," the stuff merely of romantic legend. Thus the Ettlingers, in their recent popular monograph on Botticelli, not only denied that the artist showed Simonetta in the *Primavera* but also brought into question her significance in Politian's *Stanze*:

> Another myth which has persisted in spite of all evidence to the contrary is the tale of Giuliano de'Medici and his paramour, La Bella Simonetta. The story was first popularized in the nineteenth century by Ruskin in a highly suggestive form. . . . The whole legend is based largely on a romantic misinterpretation of Poliziano's *La Giostra*, the poem which we have already noticed in connection with the *Birth of Venus*. In this unfinished work (which is dedicated to Lorenzo il Magnifico) Simonetta, the young *La Giostra* [*sic*] [and the wife of] Marco Vespucci, is briefly mentioned twice in connection with Giuliano but this association, together with the numerous

[25] Ibid., p. 87.
[26] E. H. Gombrich, "Botticelli's Mythologies: A Study in the Neoplatonic Symbolism of His Circle," in *Symbolic Images: Studies in the Art of the Renaissance*, London, 1972, pp. 31–81.
[27] Ibid., p. 37.

elegies composed on her death, has caused a fog of myth to envelop the protagonists. In fact there is no evidence that Simonetta was Giuliano's mistress.[28]

It is clear at this point that something has gone terribly wrong. Whether or not Simonetta has any role to play in the *Primavera*, and whether or not she was Giuliano's mistress, her role in the *Stanze* is fundamental. She appears there, in Domenico De Robertis's words, as a "terrestrial Beatrice in a terrestrial paradise," and in his famous essay prefacing the 1863 edition of Politian's vernacular poems, Carducci observed that Simonetta does not appear as Giuliano's literal mistress, but instead, like Beatrice and Laura, as the object of a love that is purely poetic.[29] At the same time, Simonetta was a real person with historical existence, and though it is perhaps a matter of poetic taste to characterize Lorenzo's moving sonnets or the exquisite epitaphs composed for her by Politian as so much "Petrarchan hyperbole," the facts of her existence and the idea she embodies in that poetry are not appropriately or historically conveyed by the anachronistic adjective "Swinburnian." The "spell" cast on interpreters by the *Stanze* was not conjured up by a romantic poet like Rossetti, and Vasari's bare report in half a sentence that Botticelli painted a picture called *Springtime* is hardly "suggestive." The "legend" of Simonetta is not the same as Lorenzo's and Politian's poetic myth, and it is not even a nineteenth-century Pre-Raphaelite fabrication. It first saw print with Venturi, and it derived its authority from Warburg's revolutionary attempt to understand Botticelli's painting in the historical context of humanist poetry and culture.

It is true that the ingredients necessary for the creation of such a legend lay embedded in nineteenth-century scholarship and criticism, but they were never pulled together and given concrete expression. Giovanni Rosini in 1841 was the first to notice the striking resemblance between Politian's description in the *Stanze* of a sculptural relief of Venus Anadyomene and the imagery of Botticelli's *Birth of Venus*, and he published this in a footnote.[30] Adolph Gaspary independently in 1888 also noticed this resemblance in the second volume of his *Geschichte der italienischen Literatur*, and it was there that Warburg found the comparison.[31] A portrait in the Pitti Palace attributed to Botticelli was thought to represent Simonetta on the basis of Vasari's statement that in the *guardaroba* of the grand duke there was a portrait by Botticelli of the inamorata of Giuliano; probably on the same basis, there was a tradition (to which Pater referred in 1870) that Botticelli's *Judith* in the grand-ducal collections represented Simonetta.[32] When Dante Gabriel Rossetti published his fa-

[28] L. D. Ettlinger and H. S. Ettlinger, *Botticelli*, New York, 1977, p. 164.

[29] De Robertis, op. cit., p. 539; G. Carducci, "Delle poesie toscane di messer Angelo Poliziano," introduction to *Le Stanze, l'Orfeo, e le Rime di messer Angelo Ambrogini Poliziano rivedute su i codici e su le antiche stampe e illustrate con annotazioni di varii e nuove*, Florence, 1863, pp. xxxi and xlixff.

[30] G. Rosini, *Storia della pittura italiana esposta coi monumenti*, Pisa, 1839–1847, III, p. 152, note 13.

[31] A. Gaspary, *Geschichte der Italienischen Literatur*, Strasburg, 1885–1888, II, pp. 232f.; and see Warburg, op. cit., p. 5.

[32] For the portrait in the Pitti Palace, see R. Crowe and G. Cavalcascelle, *The History of Painting in Italy*, London, 1911, IV, p. 261 (1st ed., 1864): "A bust por-

mous sonnet on the *Primavera* in 1882, he added a note saying that the central lady seemed to be the same as in the portrait of Smeralda Bandini (which he had bought in Paris in 1867).[33] When Ruskin published his Oxford lectures in 1873, he printed a footnote in the fourth appendix to his lecture on Botticelli, in which he quoted a letter from the Reverend Richard St. John Tyrwhitt, written in response to Ruskin's request for confirmation of his suspicion that Botticelli drew from the model; in this letter Tyrwhitt, on the basis of a woeful misreading of Pater, affirmed that Botticelli must have used the same model for nearly all his works, that she must have allowed him to draw her undraped, and that he believed she must have been Simonetta.[34] These, however, remained isolated observations and were never part of any nine-teenth-century "myth" of Simonetta (certainly not one specifically attached to any interpretation of the *Primavera*). The Pre-Raphaelites promoted no such legend, be-ing, as Michael Levey has shown, with the exception of Rossetti (who never men-tions Simonetta), either ignorant of Botticelli altogether or notably uninterested in him, much as the Nazarenes also neglected him.[35] Ruskin published Tyrwhitt's letter without comment in a footnote, and certainly never attempted to popularize, much less create, a myth of Simonetta. The English Aesthetic Movement, which at heart was concerned with the psychology of art and not its anecdotal content, cannot be blamed for creating the myth, and Herbert Horne, the writer on Botticelli aside from Pater himself (who was one of the dedicatees of Horne's book) with the deepest roots in the movement, was the first to maintain openly that the story of Simonetta was a legend.[36] What ignited the legend was brought about by painstaking scholarship and

trait said to be that of 'La Bella Simonetta,' for whom the attachment of Giuliano de'Medici is well known. . . . It seems to represent a person of lower rank than La Simonetta." See also W. Pater, *The Re-naissance: Studies in Art and Poetry*, ed. D. L. Hill, Berkeley and Los Angeles, 1980, p. 47: "He paints the story of the goddess of pleasure in other episodes be-sides that of her birth from the sea, but never without some shadow of death in the grey flesh tones and wan flowers. He paints Madonnas, but they shrink from the pressure of the divine child, and plead in unmis-takeable undertones for a warmer, lower humanity. The same figure—tradition connects it with Simo-netta, the mistress of Giuliano de'Medici—appears again as Judith, returning home across the hill country, when the great deed is over, and the moment of revul-sion come, when the olive branch in her hand is be-coming a burthen; as *Justice*, sitting on a throne, but with a fixed look of self-hatred which makes the sword in her hand seem that of a suicide; and again as *Veritas*, in the allegorical picture of *Calumnia*, where one may note in passing the suggestiveness of an accident which identifies the image of Truth with the person of Venus. We might trace the same sentiment through his en-gravings; but his share in them is doubtful, and the ob-

ject of this brief study has been attained, if I have de-fined aright the temper in which he worked." Pater's reference to Simonetta here is clearly in connection with the *Judith* only, and the "same figure" he discerns in Botticelli's various paintings is an abstract creation of what he understands to be Botticelli's characteristic sentiment, or temper.

[33] Rossetti's sonnet on the *Primavera* was first pub-lished in *Ballads and Sonnets*, London, 1882, with the note, "The same lady, here surrounded by the masque of Spring, is evidently the subject of a portrait by Bot-ticelli, formerly in the Portales collection in Paris. This portrait is inscribed 'Smeralda Bandinelli.' "

[34] J. Ruskin, "Ariadne Florentina," in *Works*, New York, 1887, X, pp. 225ff. Tyrwhitt's letter to Ruskin understands Pater to mean that "the same slender and long-throated model appears in *Spring*, the *Aphrodite*, *Calumny*, and other works," and he then jumps to the conclusion that "she was Simonetta, the original of the Pitti Portrait."

[35] M. Levey, "Botticelli and Nineteenth-Century England," *Journal of the Warburg and Courtauld Institutes*, XXIII, 1961, pp. 291–306.

[36] Horne, op. cit., pp. 52ff.

by historical investigation and interpretation at its very best. It resulted, in other words, from Warburg's investigation into the poetic context of Botticelli's invention.

It will help to see the problem more clearly if labels are dispensed with. Warburg's attempt to interpret and to understand the *Primavera* in the light of contemporary humanist scholarship and poetic models is no more romantic and no less historical than are subsequent attempts to interpret it in the light of Neoplatonic ideas and philosophical models. It is no more romantic and no less historical to attempt to connect the painting to the figures of Politian and Lorenzo the Magnificent than it is to attempt a connection with Marsilio Ficino, Pico della Mirandola, and the Platonic Academy at Careggi, or, for that matter, with Lorenzo di Pierfrancesco de'Medici and Semiramide d'Appiano (Simonetta's niece) and their wedding in 1482.[37] Gombrich's references to the "suggestive power" of Vasari's calling Botticelli's painting the *Primavera*, to the "spell" cast by the *Stanze*, and to the "long-cherished romance" of the "Swinburnian beauty" Simonetta are all heavy-handed attempts to strike at the heart of Warburg's investigation of the poetic culture giving rise to Botticelli's invention by reidentifying its true foundation in Botticelli's contemporary culture with the alternative values of a quite different and later culture as expressed in an alien poetry of which Simonetta paradoxically (and wrongly) is made to figure as the displaced muse. Yet as noted above, no one, including other proponents of the Neoplatonic hypothesis, has been prepared to go so far in insisting that the philosophical model of necessity denies the poetic one; all have agreed that the poetic model, far from being inherently romantic, is the one most securely established historically and philologically, on the basis of the phenomena actually appearing in the painting itself.

Moreover, if we separate Simonetta from the legend that had unquestionably grown up around her in the early years of this century, if we return her to history and to the true poetic myth she embodies in the *Stanze* and in the poetry of Lorenzo the Magnificent, it will appear that Warburg was almost certainly right to realize that Simonetta, or someone very much like her, *must* appear in the *Primavera*. That Simonetta *does* appear is indicated in general by the precision with which Botticelli depicted the details of the festival costumes he showed in the painting, and in particular by the fact that Flora's painted dress is identical to the one Politian described in the *Stanze* as worn by the nymph Simonetta—the *Stanze* being a work of art that Francastel rightly understood to be an independent imaginative construction, a fable or mythologizing of real events and real experiences that both poet and painter had seen and in which they had themselves taken part.[38] But that Simonetta or some other lady inevitably *must* appear follows, not only from the comparison of the paint-

[37] For the hypothesis that the *Primavera* commemorates the wedding of Lorenzo di Pierfrancesco de'Medici and Semiramide d'Appiano, see R. Lightbown, *Sandro Botticelli*, London, 1978, I, pp. 72ff.; for a more recent reading of the painting in terms of the political tensions between Lorenzo the Magnificent and his younger cousins, see H. Bredekamp, *Botticelli*

Primavera: Florenz als Garten der Venus, Frankfurt am Main, 1988.

[38] P. Francastel, "La fête mythologique au Quattrocento: Expression littéraire et visualisation plastique," in *Oeuvres II: La réalité figurative: Éléments structurels de sociologie et de l'art*, Paris, 1965, pp. 229–252.

ing with the *Stanze*, but also from the general laws of the vernacular tradition of love poetry that Lorenzo and Politian worked to revive and transform, and to which Botticelli made appeal in conceiving his invention. The theme of the *Primavera*, announced by the central presence of Venus, is by definition beauty, and in particular the power of beauty to awaken love; the conventions of the poetry of love require the presence of a beloved, chosen by the lover on the basis of a certain natural conformity and proportion of outward beauty and inner spirit (*extrinsecae* and *intrinsecae*) that allows his soul to open to a full understanding of the importance and meaning of love. It is a poetry that derives its very characteristic beauty, its art, from the poignant tension existing between its declared public meaning (love) and its private meaning (the beloved), and which depends on the play between an experience that is forever universal and one that is forever one's own. The question of Simonetta, in other words, is the same as that of Petrarch's Laura, or Dante's Beatrice. From a methodological point of view, the true polemic regarding her is not one fought between a romantic interpretation on the one hand and a historical interpretation on the other, but instead is one between interpretive attitudes about the public and private meanings that together give the work of art its tension and its life. The reason the controversy over Simonetta has been so barren is that, as Charles Singleton wrote of the earlier controversy waged at the same time and in similar ways over Beatrice, it has been contested between

> those scholars who have seen allegory everywhere in the *Vita nuova* and their opponents in a long polemic who everywhere have seen facts and real events. It is typical of these two schools of what passes for criticism that neither the one nor the other has ever been willing to submit to the rule of the image which we have been following and to accept the fact that . . . that image is as the law of the place into which we have entered. We become its subjects. And, on the inside, the realist may not ask his questions of reality nor his opponent his questions of allegory unless this is permitted (and often enough it is not) by the terms of that initial metaphor that governs the whole.[39]

The "initial metaphor" to which Singleton specifically refers is that with which Dante began his *Vita nuova*—"In that part of the book of my memory, earlier than which one can read but little, one finds a rubric that reads: *Incipit vita nova*."[40] Everything one is about to read has already happened, Beatrice is dead, and it is only now that the poet, reading through the book of his own memory, is able to discern the meaning of events and experiences the coherence of which had not been apparent to him when they actually occurred. The same is true of the poetic myth of Simonetta, which is a retrospective invention created after her death.

The relevant external facts of Simonetta's short life, her public existence, are

[39] C. S. Singleton, *An Essay on the Vita Nuova*, Baltimore and London, 1977, p. 30.

[40] Dante, *Vita nuova*, I.

few. She was born in Genoa in 1453 and went to Florence in 1469, when she married the young Marco Vespucci at the age of sixteen. On 28 January 1475 she was the *dama* to whom Lorenzo's brother Giuliano de'Medici dedicated his tournament, and in the following year she was dead. It is possible that she was Giuliano's lover, and Rochon has shown that there are strong circumstantial reasons for thinking that Lorenzo too had conceived an ardent passion for her in the years around the time of Giuliano's joust, after his earlier passion for Lucrezia Donati had ended and Lucrezia assumed a role in his poetry more literary in conception than actual.[41]

Simonetta's poetic existence is more complex, and is indeed inextricably bound up with that of Lucrezia Donati, who, as we have seen, was the *dama* to whom Lorenzo de'Medici had dedicated his own joust held in February 1469, four months before his marriage to Clarice Orsini. In life Lucrezia was born in 1447, was married to Niccolò Ardinghelli in 1465, and died in 1501, nine years after the death of Lorenzo, her childhood friend who without much doubt was passionately in love with her during the years of his adolescence and early manhood. Besides being the *dama* of Lorenzo's tournament, Lucrezia had been from at least 1465 the *donna* of his poetry, and she was to remain so long after the flames of youthful ardor had abated. Her public role as Lorenzo's *donna ispiratrice* is acknowledged by (among others) Luca Pulci (*Pístola*, I), Luigi Pulci (*Lucrezia a Lauro*), Ugolino Verino (*Ad Lucretiam Donatam ut amet Laurentium Medicem*), Michele Verino, Naldo Naldi, and Politian in the *Stanze*.[42] As the muse of his *Canzoniere* she is also the Florentine muse inspiring the poetry of all those working with Lorenzo and under his protection in the campaign to revive, refine, and transform the forms and language of poetic expression, and in understanding this deeply important humanist effort the changing role she plays in his own poetry is of prime importance. Simonetta Cattaneo, on the other hand, did not assume the role of poetic *donna* in life, even though she and Lucrezia were fatefully linked as the ladies to whom the brothers Giuliano and Lorenzo had dedicated their tourneys. But with her death, as Lorenzo himself wrote, "though the blameless conduct of her life had made her dear to everyone, nevertheless compassion for her tender age and for her beauty, which now that she was dead appeared perhaps greater than ever it had in life, left a burning desire for her"; and because "in death her beauty surpassed the loveliness that in life had seemed unsurpassable," all the Florentine wits, including Lorenzo himself, grieved her loss in verse and in prose.[43] In her death Simonetta was transformed, and from this point her fictional persona became inextricably linked with that of Lucrezia Donati.

The fiction is that Lucrezia, who was in fact Simonetta's elder by six years and the lady to whom Lorenzo had dedicated his poetry from at least four years before Simonetta even arrived in Florence, was nevertheless preceded as Lorenzo's muse by another, and that other was Simonetta. By this fiction Simonetta becomes the embodiment of the passing of youth (*la verde età*) and the first budding of beauty and

[41] Rochon, op. cit., pp. 246–248.

[42] Ibid., p. 95.

[43] Lorenzo de'Medici, *Comento*, ed. cit., pp. 350f.

love, and hence of the initial poetic and chivalric aspirations of the young Lorenzo and his *brigata*. She is forever lovely and fresh in the memory, but with her death the greenness of youth is forever a thing of the past, superseded by a new, deeper love that has been tempered in the very experience of loss. In the unfinished second book of the *Stanze*, written after Simonetta's death, Politian invents a different prior fiction, according to which Giuliano's love for Simonetta is kindled before his brother's still ardent love for Lucrezia is returned. He tells of how Love boasts of his conquest of Giuliano by shooting an arrow from the eyes of Simonetta, and how Love also laments his harsh treatment of Lorenzo by withholding Lucrezia's love:

> Di questo e della nobile Lucrezia
> nacquene Iulio, e pria ne nacque Lauro:
> Lauro che ancor della bella Lucrezia
> arde, e lei dura ancor si mostra a Lauro,
> rigida più che a Roma già Lucrezia,
> o in Tessaglia colei che è fatta un lauro;
> né mai degnò mostrar di Lauro agli occhi
> se non tutta superba e suo' begli occhi.[44]

(From Piero and the noble Lucrezia [Tornabuoni] Julio was born, and before him, Laurel: Laurel, who still burns for a beautiful Lucrezia [Donati], while she still shows herself hardhearted to Laurel, more unbending than the Lucretia once of Rome or than she who became a laurel in Thessaly; nor has she ever deigned, unless haughtily, to show her beautiful eyes to the eyes of Laurel.)

As a fiction this is of course at variance not only with the true sequence of events, but also with Luigi Pulci's account in *La giostra* of Lucrezia's acceptance of Lorenzo as her champion in the tourney of 1469, as well as with the event of the joust itself, when Lorenzo entered the field bearing a standard with Lucrezia's allegorical image and the motto *Le tems revient*.[45] However, it also agrees in its inversion of chronology with a beautiful fiction invented by Lorenzo himself in his *Comento sopra alcuni de' suoi sonetti*, a work profoundly based on the model of Dante's *Vita nuova*. Lorenzo begins his direct comment on his sonnets by raising the very question of inversion, observing:

> Perhaps someone will consider the *principio* of my verses unsuitable, for they commence not only contrary to the custom of those who have written similar verses up to now, but they also, as appears prima facie, in a way pervert the order of nature, placing as the *principio* that which in all human affairs is normally the final end; because the first four verses were composed by me over the death of a woman that not only wrung these verses from

44 Politian, *Stanze*, II.iv. I have here followed and made use throughout of the excellent translation by David Quint (*The* Stanze *of Angelo Poliziano*, trans.

D. Quint, Amherst, 1979).
45 Luigi Pulci, *La giostra di Lorenzo de'Medici*, IV–XI (quoted in chapter 1).

me but also universal tears from the eyes of every man and woman who had any acquaintance with her.[46]

The dead woman is Simonetta, and Lorenzo explains that the reason he begins in this way is that "it is a maxim of good philosophers that the corruption of one thing is the creation of another," that other thing being, as the verses and their commentary develop, embodied in Lucrezia Donati and the experience of love she awakens in the poet.[47]

The pain of loss precedes and prepares the heart for love, and Lorenzo's comment on the first of his sonnets, *O chiara stella*, tells how he saw on the night of Simonetta's death a surpassingly bright star rise in the west, which he realized was the departing soul of the gentle lady who had died, whose beauty overwhelmed that of the other stars. The brightness of that star, however, is a herald of the dawn and the appearance of a yet brighter light, the sun that is Lucrezia.[48] Simonetta, in other words, appears as the muse that comes first, preparing the way, and with her loss she is immediately supplanted by a greater still, the true and particular beauty that animates the poet's heart. The conceit indeed is a beautiful variant on a famous episode that is the turning point of the *Vita nuova* (the last time the god of love himself appears in the book), which it is necessary to quote at length. Dante has just recounted the last of three visions he experienced that told of Beatrice's death to come, the true meaning of which had been hidden from him at the time. It came to him when he was grievously ill, and in this vision Dante actually saw the death of Beatrice, but on waking he had misconceived what he had seen, thinking it not a true vision but only the empty imaginings of a delirious mind:

> After this empty imagining, it happened one day that I was sitting, thoughtful, in some place, and I felt the onset of a trembling in my heart, just as if I had been in the presence of this lady. Then I say that an imagining of Love appeared to me; whom it seemed I saw coming from that place where my lady was, and whom it seemed joyfully spoke to me in my heart: "Think to bless the day that I took thee, for nevertheless you must do this." And certainly it seemed that my heart was so joyful, that it did not seem that it was my own heart because of its new condition. And shortly after these words, which the heart spoke to me with the language of love, I saw coming toward me a gentle lady who was famous for her beauty, and who had once been the beloved of my first friend. And the name of this lady was Giovanna, except that because of her beauty, as some believe, she had been given the name of Springtime [*Primavera*]; and thus she was called. And after her, as I looked, I saw the marvelous Beatrice coming. These ladies passed by me thus one after the other, and it seemed that Love spoke to me in my heart and said: "The first one is called *Primavera* only because of this coming today; because I moved the giver of her name thus to call her *Pri-*

[46] Lorenzo de'Medici, *Comento*, ed. cit., pp. 347f. [48] Ibid., pp. 351ff.
[47] Ibid., p. 348.

mavera, that is, *prima verrà* [she-will-come-first] on the day that Beatrice will show herself according to the imagination of her faithful servant. And if you wish also to consider her original name, this is as much as to say '*prima verrà*,' since her name Giovanna [Joan] derives from that Giovanni [John] who preceded the true light, saying *Ego vox clamantis in deserto: parate viam Domini.* And it also seemed that he said to me, afterward, these words: "And if one wishes to consider subtly, the lady Beatrice could be called Love because of the great similarity she bears to me." Whence I then, re-thinking, proposed to write in rhyme to my first friend (keeping certain words silent that it seemed should be silent), thinking that again his heart would marvel at the beauty of this gentlewoman *Primavera*; and I recited this sonnet, which begins *Io mi senti svegliar*:

Io mi senti svegliar dentro a lo core
un spirito amoroso che dormia:
e poi vidi venir da lunghi Amore
allegro sì, che appena il conoscia,

dicendo: "Or pensa pur di farmi onore;"
e 'n ciascuna parola sua ridia.
E poco stando meco il mio segnore,
guardando in quella parte onde venia,

io vidi monna Vanna e monna Bice
venire inver lo loco là 'v'io era,
l'una appresso de l'altra maraviglia;

e sì come la mente mi ridice,
Amor mi disse: "Quell'è Primavera,
e quell'ha nome Amor, sì mi somiglia."[49]

[49] Translation based on that of C. S. Singleton. Dante, op. cit., 24: "Appresso questa vana imaginazione, avvenne uno die che, sedendo io pensoso in alcuna parte, ed io mi sentio cominciare un tremuoto nel cuore, così come se io fosse stato presente a questa donna. Allora dico che mi giunse una imaginazione d'Amore; che mi parve vederlo venire da quella parte ove la mia donna stava, e pareami che lietamente mi dicesse nel cor mio: 'Pensa di benedicere lo dì che io ti presi, però che tu lo dei fare.' E certo mi parea avere lo cuore sì lieto, che me non parea che fosse lo mio cuore, per la sua nuova condizione. E poco dopo queste parole, che lo cuore mi disse con la lingua d'Amore, io vidi venire verso me una gentile donna, la quale era di famosa bieltade, e fue già molto donna di questo primo mio amico. E lo nome di questa donna era Giovanna, salvo che per la sua bieltade, secondo che altri crede, imposto l'era nome Primavera; e così era chiamata. E appresso lei, guardando, vidi venire la mirabile Beatrice. Queste donne andaro presso di me così l'una appresso l'altra, e parve che Amore mi parlasse nel cuore e dicesse: 'Quella prima è nominata Primavera solo per questa venuta d'oggi; ché io mossi lo imponitore del nome a chiamarla così Primavera, cioè prima verrà lo die che Beatrice si mosterrà dopo la imaginazione del suo fedele. E se anche vogli considerare lo primo nome suo, tanto è quanto dire "prima verrà," però che lo suo nome Giovanna è da quello Giovanni lo quale precedette la verace luce, dicendo: *Ego vox clamantis in deserto: parate viam Domini.*' Ed anche mi parve che mi dicesse, dopo, queste parole: 'E chi volesse sottilmente considerare, quella Beatrice chiamerebbe Amore, per molta simiglianza che ha meco.' Onde io poi, ripensando, proposui di scrivere per rima a lo mio primo amico (tacendomi certe parole le quali pareano da tacere), credendo io che ancor lo suo cuore mirasse la

(I feel awakening within my heart an amorous spirit that is sleeping: and then I see Love come from afar, cheerful, so much so one scarcely knows him, saying: "Now think only to do me honor"; and with each word he gives a laugh. And, my lord abiding with me a little while, looking toward that place from whence he came, I saw Lady Giovanna and Lady Beatrice coming toward the very place I was, one marvel after another; and as my mind retells it, Love said to me: "The one is Springtime, and the other has the name of Love, so much does she resemble me.")

Lady Giovanna is the poetic mistress of Dante's first friend, Guido Cavalcanti, to whom the sonnet is addressed.[50] She prepares the way for the greater beauty that is to come, and so she is called *Primavera*, or *prima verrà*, she who will come first. She is the secular muse of the troubadours and the first writers in the vernacular tongue, a *nuova lingua* uniquely framed for the expression of the new cultural idea embodied in a *nuovo eros* (as Dante writes in the next chapter, "the first one to write as a poet in the vulgar tongue did so because he wished to have a lady understand his words," adding that he writes this "against those who write in rhyme on any theme that is not amorous, inasmuch as such a way of writing was in the beginning devised in order to write of love").[51] She represents an idea of love that Dante then subsumes into the greater beatitude that is the Christlike Beatrice, and hence she stands in the same relation to that beatitude as John the Baptist stood to Christ himself. This new direction and conception of love (which in the *Vita nuova* retains its erotic overtones), as Singleton wrote, means a new subject matter for love poetry, "and this, if style be faithful to inspiration, means a new style in poetry."[52]

In the retrospective vision of the *Divine Comedy* (a vision affecting the way in which a fifteenth-century reader would have understood the *Vita nuova*) this new style, breaking the knot separating the secular style of the troubadours (for whom the lady is the supreme source and object of love) and that of the now clearly Christian devotion (for which God is the supreme source and object of love), receives its name from the famous meeting of Dante with Bonagiunta from Lucca in *Purgatorio*, XXIV:

> E io a lui: "I' mi son un che, quando
> Amor mi spira, noto, e a quel modo
> ch'e' ditta dentro vo significando."

bieltade di questa Primavera gentile; e dissi questo sonetto, lo quale comincia *Io mi senti svegliar*." For the sonnet, see the text above.

This passage was first associated with the *Primavera* by M. Escherich, "Botticelli's Primavera," *Repertorium für Kunstwissenschaft*, XXXI, 1908, pp. 1–6. Unfortunately, the connection has never been taken seriously because of the author's argument that in the end the *Primavera* is neither Dantesque nor antique, nor even

Italian, but is instead "die rückhaltlose ahnungsvolle Hingabe an den fatalistischen Geist der germanischen Weltanschauung."

[50] See further Singleton, op. cit., p. 21.

[51] Dante, op. cit., 25; see also A. Asor Rosa, "Lingua ed eros," in the Einaudi *Letteratura italiana*, ed. A. Asor Rosa, Turin, 1986, v (*Le questioni*), pp. 24ff.

[52] Singleton, op. cit., pp. 78ff., esp. p. 92.

"O frate, issa vegg'io," diss'elli, "il nodo
che'l Notaro e Guittone e me ritenne
di qua dal dolce stil novo ch'i'odo!

Io veggio ben come le vostre penne
di retro al dittator sen vanno strette,
che de le nostre certo non avenne."[53]

(And I to him, "I am one who, when Love inspires me, takes note, and goes setting it forth after the fashion which he dictates within me." "O brother," he said, "now I see the knot which kept the Notary, and Guittone, and me, short of the sweet new style that I hear. Clearly I see how your pens follow close after him who dictates, which certainly befell not with ours.")

In Lorenzo de'Medici's *Comento*, the writing of which was initiated at a moment virtually contemporary with the conception of Botticelli's *Primavera*, it is Simonetta, wreathed in images of the spring—"this most excellent lady died in the month of April, in which season the earth is ornamented with diverse flowers most pleasing to the eye and of great recreation to the soul"—who is given the role of the *prima verrà*, the first to come.[54] She appears as Lorenzo's first muse, replacing Lucrezia Donati who had played this part in history, and it is her death (the passing of the warm and youthful idea of love that Lucrezia formerly had embodied) that wrung poetry from him and "tutti i fiorentini ingegni." She is the morning star that heralds the brighter sun of a new *donna ispiratrice*, a new concept of love that Lorenzo refigured anew in Lucrezia Donati. In Botticelli's *Primavera* it is Flora who takes the role of the first to come, she rather than the morning star who is the metaphor for the first idea of love that finds its transformation and fulfillment in the figure of Venus. As Flora she is by definition *Primavera*, the abundant Hour of the first blossoming goodness of the youthful spring, the goddess who precedes and prefigures the full potency and beauty of the season—its *venustà*—that is denoted by Venus. She is also by definition *prima verrà*, the first muse who precedes and prefigures the complete concept of love that is again denoted by Venus. That new concept is not based in the idea of Christian beatitude that is Beatrice, an idea of love that might more appropriately be imagined as Caritas than as Venus. It is instead, as Lorenzo's *Comento* makes clear, founded in something else, simultaneously *antico e nuovo*, an ancient and at the same time very modern idea of *gentilezza*. This new idea, moreover, which subsumes and trans-forms Dante's idea of *nobiltà*, roots itself in a moral and spiritual idea of love (for which the summum bonum is now the supreme source and object of love) that had been given formal coherence by Ficino in the philosophy of Neoplatonism. As a new

[53] Dante Alighieri, *The Divine Comedy*, trans. with commentary by C. S. Singleton (Bollingen Series, LXXX), Princeton, 1973, *Purgatorio*, XXIV, 52–60.
[54] Lorenzo de'Medici, *Comento*, ed. cit., p. 352.

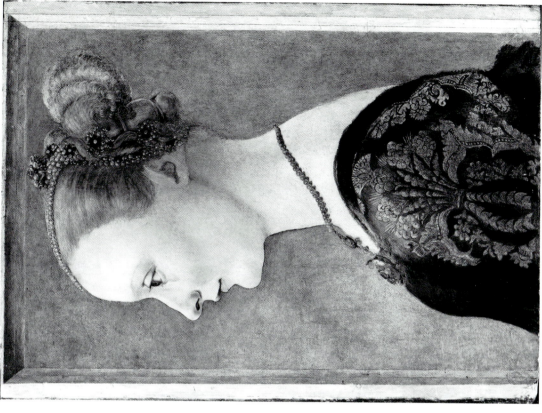

Fig. 19. Piero Pollaiuolo, *Portrait of a Young Woman*. New York, Metropolitan Museum of Art.

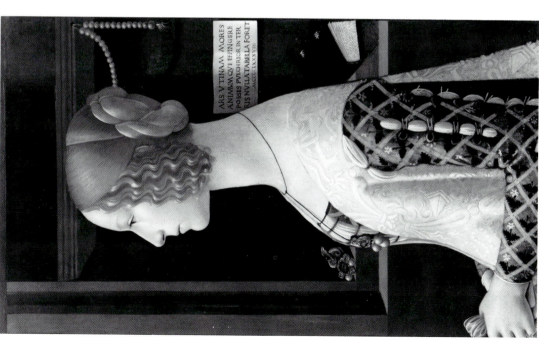

Fig. 18. Domenico Ghirlandaio, *Portrait of Giovanna Tornabuoni*. Thyssen-Bornemisza Collection, Lugano, Switzerland.

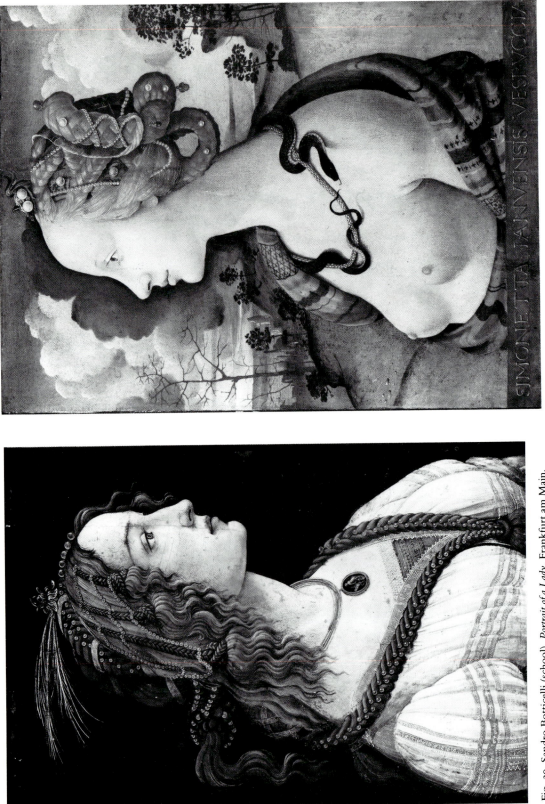

Fig. 21. Piero di Cosimo, *Portrait of a Lady (the So-called Simonetta Vespucci)*. Chantilly, Musée Condé.

Fig. 20. Sandro Botticelli (school), *Portrait of a Lady*. Frankfurt am Main, Staedelsches Kunstinstitut.

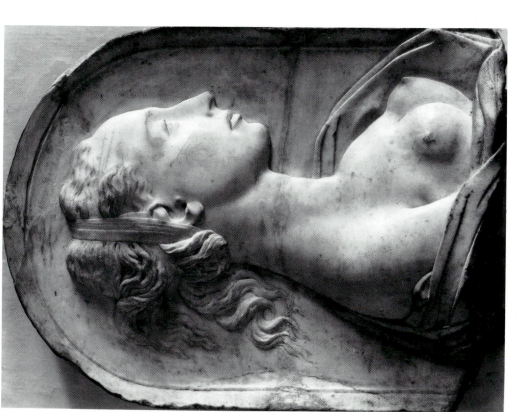

Fig. 22. Andrea del Verrocchio (school), *Head of a Young Woman*. London, Victoria and Albert Museum.

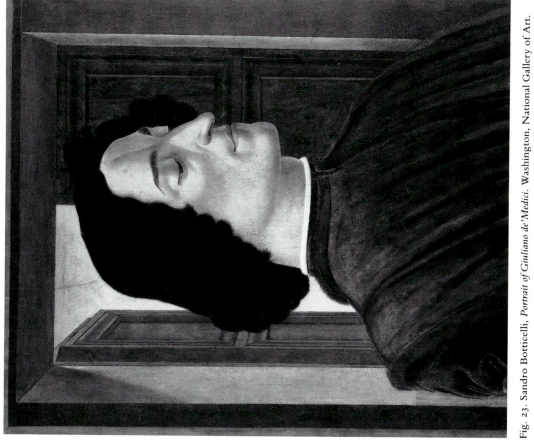

Fig. 23. Sandro Botticelli, *Portrait of Giuliano de'Medici*. Washington, National Gallery of Art.

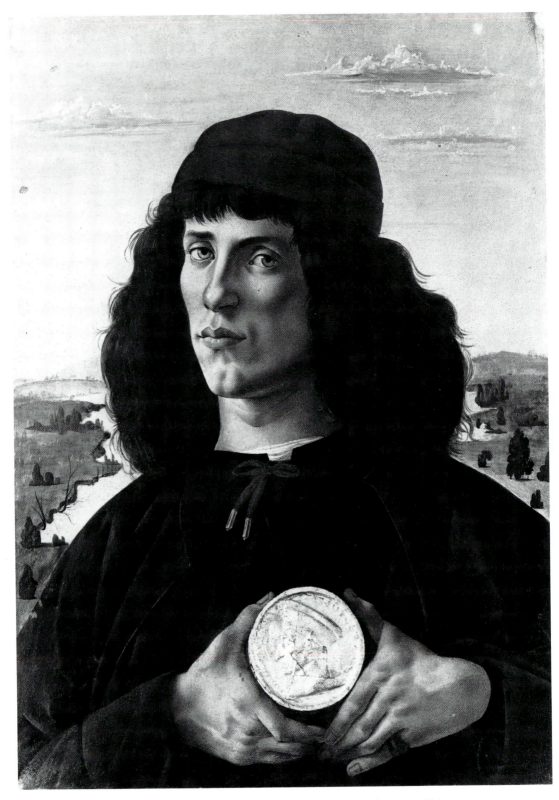

Fig. 24. Sandro Botticelli, *Portrait of a Youth Holding a Medal of Cosimo de'Medici*. Florence, Uffizi.

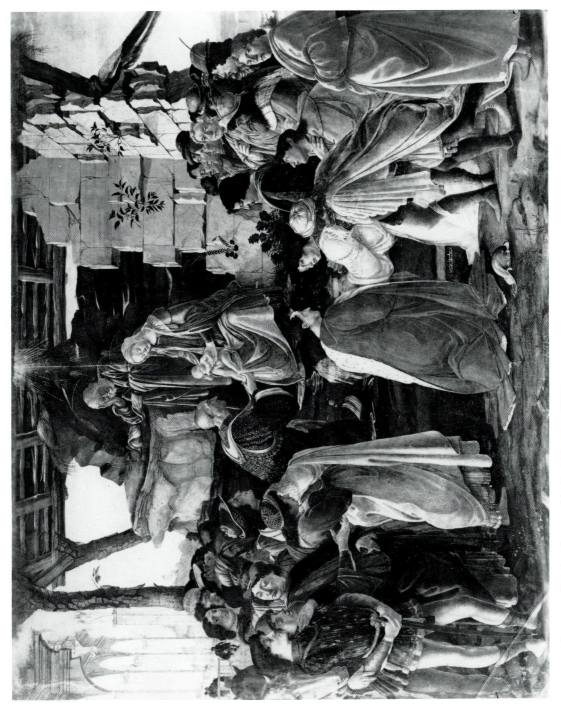

Fig. 25. Sandro Botticelli, *The Adoration of the Magi*. Florence, Uffizi.

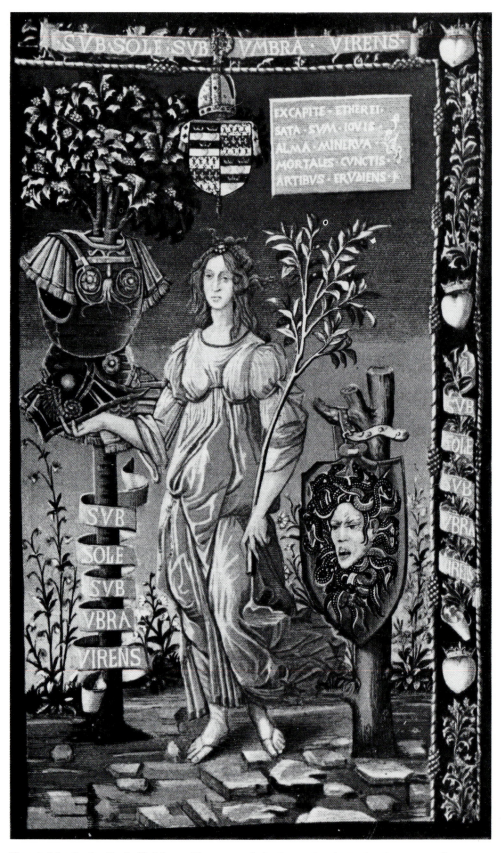

Fig. 26. After Sandro Botticelli, *Minerva*. Tapestry made for Comte Guy de Baudreuil in 1491. Collection vicomte de Baudreuil, Favelles.

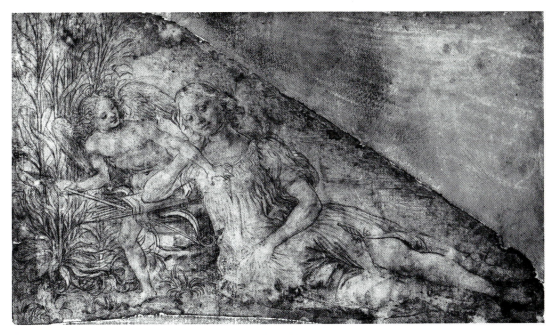

Fig. 27. Andrea del Verrocchio, *Nymph* (study for a standard). Florence, Uffizi.

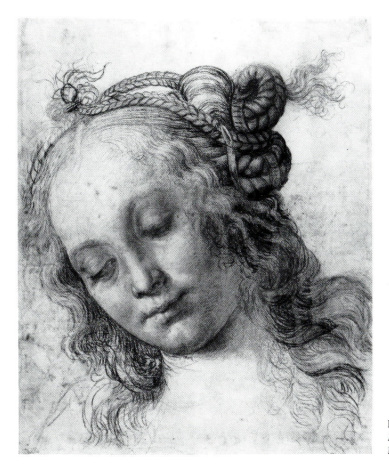

Fig. 28. Andrea del Verrocchio, *Female Head*. London, British Museum.

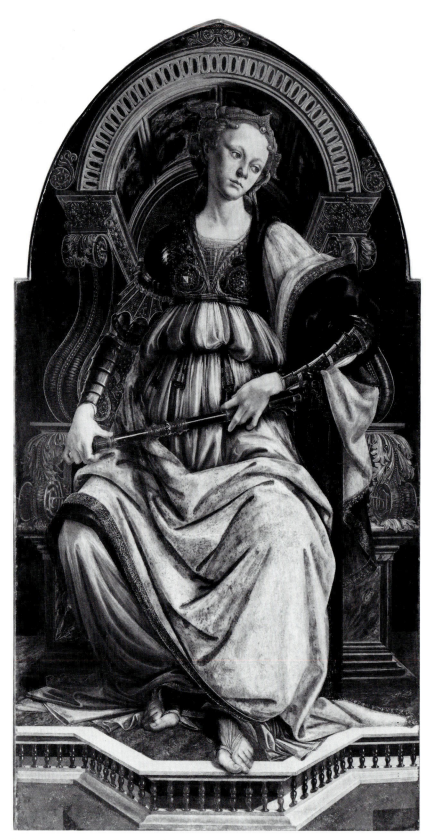

Fig. 29. Sandro Botticelli, *Fortitude*. Florence, Uffizi.

concept, a new subject matter for poetry, it too required a new muse, a new style for its expression.[55]

Warburg's identification of Botticelli's figure of Flora with Simonetta Cattaneo was founded on the close resemblance her painted dress bears to the one described by Politian in the *Stanze*, in which Simonetta makes her appearance clad in a *candida vesta*, a shining white dress painted with roses, greenery, and "quanti fior creassi mai natura." Once the false characterization of this hypothesis as "romantic" has been discarded, the primary remaining objection raised against it has been that there are no securely identified surviving portraits of Simonetta (nor indeed of Lucrezia Donati). Such an appeal to negatives is notoriously one of the weakest of historical arguments. Against this objection, the research of historians of costume strongly supports Francastel's argument that both Politian and Botticelli derived their poetry from real experiences of the present and that each portrayed in imaginative reconstruction things each of them had actually seen. The costumes in the *Primavera* reproduce real prototypes, in the design and decoration of which Botticelli may actually have taken part. They mingle in their design the styles of traditional Tuscan festival costumes with more up-to-date fashions, and therefore indicate a context for Botticelli's and Politian's separate inventions in quasi-theatrical celebrations like the joust and festivals like the Calendimaggio. Such celebrations are themselves also imaginative representations, *mascherate*, re-creations of a public myth that is also the point of departure for the poetry and argument put forward by Lorenzo in his virtually contemporary *Comento*. Since Botticelli appears to have shown Flora attired in Simonetta's festival dress in the *Primavera*, and Politian appears to have described Simonetta wearing the same dress in the *Stanze per la giostra*, it becomes necessary to return with an open mind to Warburg's hypothesis that Botticelli portrayed Simonetta in the mythological guise of Flora. This is especially true insofar as the conventions of the public manifestations and the poetry of the period evolve from the positing of a real and particular *donna* in whom each lover identifies his aspirations, each knight his honor, and each poet his ideal of love.

It is important, however, to avoid as far as possible the tendency to bog down in descriptive particulars when considering the problem of portraiture in the *Primavera*. Lucrezia appeared in allegorical figuration in the banner painted by Verrocchio for Lorenzo's joust of 1469, and Simonetta was also cast in a role, a mythical guise, in Botticelli's standard for Giuliano in 1475. Simonetta is never directly named in Politian's *Stanze*, nor are she and Lucrezia ever named in the whole of Lorenzo's poetic production. Their identity is masked, in accordance with convention, as in Lorenzo's reference to his beloved only under the *senhals* of Diana and the Sun. They are, moreover, described only in the normative tropes of poetic *descriptio pulchritudinis*, and though their actuality pervades the poetry, they remain aloof and indistinct

[55] For Lorenzo's understanding and development of the *stil novo* theme of *gentilezza*, see A. Lipari, *The Dolce Stil Novo according to Lorenzo de'Medici: A Study* of His Poetic Principio as an Interpretation of the Italian Literature of the Pre-Renaissance Period, Based on His Comento, New Haven, 1936.

as individual beings, their own personalities subsumed within the lover's idea of them, painted not in their own image, but as the portrait of love.

Undoubted portraits of real women in fifteenth-century painting, on the other hand, not surprisingly show them made up and accoutred in approximation of the generic poetic ideal, their eyebrows meticulously plucked to form perfect arches, their foreheads shaven to increase the serene expanse of their smooth brows, and their hair bleached to a comely blonde shade. Francastel cited as examples the sculptural effigies of Ilaria del Carretto and the Leonardesque *Lady of the Violets*, but more directly relevant to the women of the *Primavera* are painted portraits such as Ghirlandaio's *Portrait of Giovanna Tornabuoni* in the Thyssen-Bornemisza Collection (fig. 18), Filippo Lippi's *Portrait of a Lady* (Angiola Scolari?) and the *Portrait of a Young Woman* attributed to Piero Pollaiuolo in the Metropolitan Museum (fig. 19), and especially the *Portrait of a Lady* in Frankfurt, which has variously been ascribed to Botticelli or his school (fig. 20).[56] Whether or not the remarkable beauty shown in this last example is a real portrait or an imaginary one has been much debated (though with perhaps insufficient attention given to how remarkable an imaginary "portrait" would be at such a date). It is especially significant, however, that she wears suspended from her neck a famous ancient carnelian that is now in Naples but that then belonged to Lorenzo de'Medici, which carries the inscription LAV.R.MED and which is carved with the quintessential poetic subject, Apollo as the god of poetry vanquishing Marsyas, his cruder rival in song.[57] Since the gem seems to identify her at one and the same time as Lorenzo's and as the poet's, the conclusion seems inescapable that we are here contemplating an image of Lorenzo's poetic *donna*.

Equally suggestive is the famous painting by Piero di Cosimo in Chantilly (fig. 21), which shows an allegorical portrait of a woman with bared breasts, and which has often been discussed in relation to the *Primavera* because it once belonged to the Vespucci family and bears a later inscription identifying her as Simonetta.[58] Regardless of whether or not the inscription is to be trusted, the portrait conforms to a type of poetic representation of young women that may be exemplified by the remarkable marble relief in the style of Verrocchio, once belonging to the Valori in Florence and now in the Victoria and Albert Museum in London, which gives the profile portrait of an extraordinarily beautiful woman with bared and agitated breasts (fig. 22).[59] The

[56] For the question of the attribution of Botticelli's Berlin portrait, see Lightbown, op. cit., II, p. 117, cat. C4. For the Metropolitan Museum portraits, see the excellent number of the *Metropolitan Museum Bulletin*, XXXVIII, Summer 1980, given over entirely to J. Pope-Hennessy and K. Christiansen, "Secular Painting in Fifteenth-Century Tuscany: Birth Trays, Cassone Panels, and Portraits."

[57] For the question of the attribution of Botticelli's Frankfurt portrait, see Lightbown, loc. cit.; for the carnelian, which Lorenzo's grandfather Cosimo had

had mounted by Ghiberti for his son Giovanni, see most recently (with further bibliography) P. P. Bober and R. Rubenstein, *Renaissance Artists and Antique Sculpture: A Handbook of Sources*, Oxford and New York, 1986, pp. 74f., no. 31.

[58] See M. Bacci, *L'opera completa di Piero di Cosimo*, Milan, 1976, p. 86, no. 6.

[59] J. Pope-Hennessy, assisted by R. Lightbown, *Catalogue of Italian Sculpture in the Victoria and Albert Museum*, London, 1964, I, pp. 168f., no. 142.

question of portrait and imaginative re-creation, of the interplay between reality and poetic representation, is not easily resolved, and certainly not by a simplistic appeal to "common sense." Its complexity is witnessed by the lively discussion in recent years over such issues as whether sixteenth-century portraits like *La Bella* by Titian are ideal representations only, or whether mythological inventions like the principal figure in the *Venus of Urbino* are also portraits of particular women.[60] I have already quoted Savonarola's sermon protesting, not paintings destined for private houses like the *Primavera*, but altarpieces for the churches of Florence in which the Madonna and saints themselves appeared in the similitude (if not the exact likenesses) of the young people of the city. In his words one hears clearly the first rumblings of the reformers of the next century, whose voices too were raised against the humanist and secular values infecting church art. But even as the Counter-Reformation itself was on the verge of its triumph, in 1562, Bronzino unveiled his *Christ in Limbo* in the Zanchini Chapel in the church of Santa Croce, in which, to Vasari's apparent approval but to the shock of Borghini, he included many portraits from life, including several local beauties, among them Costanza da Sommaia, the wife of Giovambattista Doni, and Camilla Tebaldi del Corno.[61] So extraordinarily beautiful are they, and so in conformity with the perfection of Bronzino's own style of painting, that it is by no means certain they would ever have been understood as portraits were it not for the ample sixteenth-century testimony to this fact. In Bronzino's painting the problem of portraiture is especially difficult precisely because of its refinement as art, as is also true of the work of his master Pontormo and Botticelli himself, toward whom both Pontormo and Bronzino look back (as is the case with so much of the culture of Cosimo I) as an exemplar of early Medicean achievement.

The same aesthetic refinement also characterizes undoubted portraits by Botticelli, such as the extraordinarily abstracted and epicene *Portrait of Giuliano de'Medici* (fig. 23), which survives in more than one version, and the high stylization of which is owing in part to its being a posthumous record. Yet the same abstraction is also true of images of the living, as in Botticelli's *Portrait of a Youth Holding a Medal of Cosimo de'Medici* (fig. 24), whose features are indeed all but indistinguishable from

[60] See in particular E. Cropper, "The Beauty of Woman: Problems in the Rhetoric of Renaissance Portraiture," in *Rewriting the Renaissance: The Discourses of Sexual Difference in Early Modern Europe*, ed. M. W. Ferguson, M. Quilligan, and N. Vickers, Chicago and London, 1986, pp. 175–190.

[61] See G. Vasari, *Le vite de'più eccellenti pittori, scultori ed architetti moderni*, ed. G. Milanesi, Florence, 1906, VII, pp. 109f., and R. Borghini, *Il riposo*, Florence, 1584, pp. 109f. ("Di già abbiamo noi ragionato [rispose il Vecchietto] quanto mal fatto sia le figure sacre fare così lascive. Ora di più vi dico, che non solamente nelle chiese, ma in ogni altro pubblico luogo disconvengono. . . . Perciò quanta poca laude meriti il Bron-

zino in cotesta opera, voi medesimo, dilettandovi nel rimirare quelle donne lascive, il confessate: ed io son sicuro, che ciascuno che si ferma attento a rimirare questa pittura; considerando la morbidezza delle membra, e la vaghezza del viso di quelle giovani donne, non possa fare di non sentire qualche stimolo della carne: cosa tutta al contrario di quello, che nel santo tempio di Dio far si doverebbe.") See further M. B. Hall, *Renovation and Counter-Reformation: Vasari and Duke Cosimo in Santa Maria Novella and Santa Croce, 1565–1577*, Oxford, 1979, pp. 150f., and R. Gaston, "Iconography and Portraiture in Bronzino's 'Christ in Limbo,' " *Mitteilungen des Kunsthistorischen Instituts in Florenz*, XXVII, 1983, pp. 41–72.

those of Mercury in the *Primavera* (plate 9). We are in no doubt that the former is a portrait because the youth is dressed in easily recognizable contemporary costume and the format of the painting conforms to our expectations of how a portrait should look, whereas in the *Primavera* we are much less certain that someone is portrayed as Mercury because the costumes have been taken to be imaginary creations, while the figures are all represented in narrative action, playing their assigned roles in a poetic fiction. However, now that we know the costumes are indeed imaginary creations but not ones devised for the painting of the picture, that they are real and were created for the real fictional enactments that accompanied the jousts and festivals of Florence, and moreover that one of them (as Warburg was surely right to argue) is very likely a representation of a painted dress belonging to Simonetta Cattaneo, then we ought not to close our minds to the distinct possibility, and even the likelihood, that Botticelli filled them with real people, or rather imaginatively represented real people playing fictional parts in the *Primavera*.

With regard to the *Primavera*, the problem of portraiture is especially complex because Simonetta Cattaneo had quite certainly died not long before Botticelli painted his picture; it becomes even more complicated when account is taken of the part she plays in the encompassing poetic myth of Lucrezia Donati. Simonetta's myth, as we have seen, is not hers alone, but part of the dominant myth of Lucrezia. In that larger myth, in my opinion, Simonetta represents the end of the youthful ideal of Laurentian Florence that had forever been shattered with the murder of Lorenzo's brother Giuliano in 1478 on the second anniversary of her death.[62] However that may be, if Simonetta as the secondary and superseded *donna* of a larger Laurentian myth appears in the subsidiary role of Flora in the *Primavera*, this would mean that the dominant figure of the same Laurentian myth, Lucrezia Donati, the *donna* of Lorenzo's poems, must also appear in the dominant role of Venus.

Literalist interpreters of the *Primavera* have tended to become mired in descriptive particulars, raising objections of the kind reviewed in this chapter to the problems posed by the unquestionable existence of Simonetta Cattaneo or Lucrezia Donati as the muses of Laurentian culture—pointing out, for example, that the figures shown do not seem to be literal portraits of the sort that appear in Botticelli's *Adoration of the Magi*, a nearly contemporary painting for the funerary chapel of Guasparre di Zenobio del Lama in Santa Maria Novella (fig. 25).[63] This painting is especially remarkable, however, for its depiction of identifiable historical figures acting out parts in a religious rather than a poetic drama (reminding us again of Savonarola's

[62] This proposition, which I hope to develop in another context, raises the complex problems of dating Lorenzo's *Comento*, Politian's *Stanze*, and the *Primavera*. In brief, I believe that all three were conceived shortly after the Pazzi conspiracy of 1478. Lorenzo's point of departure was the four sonnets he had written for a different occasion, the death of Simonetta in 1476, which he later gathered as the *principio* for his

new fiction of Lucrezia. In my view, Politian's poem, although unfinished, still represents a coherent retrospective scheme centered on the joust as representative of the old, fatal ideal of Lorenzo's youth. The *Primavera* is also retrospective but carries with it a promise—*Le tems revient*, in an even more noble form.

[63] See R. Hatfield, *Botticelli's Uffizi "Adoration": A Study in Pictorial Content*, Princeton, 1976.

denunciation of just such vanities painted in the churches of Florence). In this picture, although Lorenzo and Giuliano are easily recognized, even the male portraits are certainly abstracted in accordance with courtly norms, with the result that the exact identity of several of them is still a matter of keen debate. Especially ideal is the figure of Cosimo de'Medici, again realized in a posthumous likeness, who takes the role of the eldest Magus and who had been dead for more than a decade, and so too are the portraits of his sons Piero and Giovanni, who play the parts of the remaining two Magi and who likewise were dead when the picture was painted; so idealized, in fact, that were it not for Vasari's testimony it is by no means certain that any of them would have been recognized by posterity. Even so, although Botticelli's imagination transformed his models (which probably included wax masks taken both in life and after death) more radically than Ghirlandaio's did the portraits he painted in the Tornabuoni and Sassetti chapels, nevertheless Botticelli's figures inhabit a recognizable if fictionally refigured present, and can be seen to be portraits in a way that is impossible with regard to the portrayals of Lorenzo de'Medici and Lucrezia Donati in the Otto print discussed in the previous chapter (fig. 17) or, on a more exalted plane, Michelangelo's completely ideal portrayals of the Medici dukes in the New Sacristy in San Lorenzo.[64]

With regard to the *Primavera*, on the other hand, although the women clearly conform to the conventions of portraiture by type, they are by no means identical. The Graces are clearly distinguished one from another as individuals, and the right-hand Grace in particular, slightly older, of an impressively haughty bearing and with a slightly aquiline nose, is stamped with all the marks of a particular human personality. So too is Flora, tall and thinner than the rest, with elongated face, lean cheeks, and distinct lines around the mouth, and whose unusually long nose I have already mentioned. However, we are at once confronted with the paradox that if Simonetta truly appears in the *Primavera* posthumously figured in the person of Flora as the *prima verrà*, then it must surely follow that Lucrezia is represented as Venus. Yet Venus seems younger than Flora, as well as more generically ideal, while Lucrezia was in fact the older woman, twenty-nine years of age when Simonetta, six years younger than she, died on 26 April 1476. (Since it was this occurrence, incidentally, that inspired Lorenzo's poetic and fictitious invention of Simonetta as the one who comes first, reversing the true order of events, if my argument be accepted this date would seem to be a secure *terminus post quem* for the parallel invention expressed in the *Primavera*.)[65] If the figures in Botticelli's painting wear the costumes of Florentine civic festivals, notably celebrations of the Calendimaggio (which is by definition the

[64] In this respect the challenges posed by Warburg to the problems of Florentine portraiture, from the absolute literalness of wax images to the complete abstraction of chivalric and poetic portrayals, have still not been adequately met. See A. Warburg, "Arte del ritratto e borghesia fiorentina: Domenico Ghirlandaio in Santa Trinita: I ritratti di Lorenzo de'Medici e dei suoi familiari," in *La rinascita del paganesimo antico: Contributi alla storia della cultura*, ed. cit., pp. 111–146.

[65] I believe, however, for the reasons given above, that the conception of the *Primavera* dates from 1478.

festival of the *Primavera*), then how could Simonetta's appearance as Flora square with the circumstances (including the white dress painted with flowers and greenery) celebrated by Politian in the *Stanze*, which commemorate a tournament held in Piazza Santa Croce on 29 January 1475?

Botticelli almost certainly did figure Simonetta on the famous banner that he painted for Giuliano de'Medici to carry as his standard into the *giostra*; although the banner itself is lost, the allegorical lady shown on a tapestry in the collection of the viscount of Baudreuil (in some sense deriving from Botticelli's design for Giuliano's standard) closely resembles Flora in the *Primavera*, especially in the particular of her blonde and unbound hair (fig. 26).[66] Yet it is much more to the point to observe that we are dealing with inventions by poets; that the springtime aspect of Simonetta in Politian's *Stanze* identifies her as the figure of love that has conquered Giuliano's heart, regardless of the actual time of year; and that Simonetta appears on Giuliano's standard (as she does in the *Stanze*) with the *senhal* Pallas, and again in the *Primavera* with the *senhal* Flora. Her identity is allegorically masked, and like Lucrezia as the figure of perfect beauty her existence in the *Primavera* is itself metaphorical, her own past beauty (for she is dead) limned in the normative tropes of poetic *effictio*. Similarly, on a literal level we might also recall that Verrocchio had almost certainly figured Lucrezia on the standard he painted for Lorenzo's *giostra*, and that, although this banner too is lost, the allegorical nymph appearing in a drawing he made for a banner in the Uffizi (fig. 27), whose features are repeated in a study for her head in the British Museum (fig. 28), could well be expected to be a portrait by type based on her. The process of idealization we sense in such images, in other words, is not one simply following an antique norm, but one that in particular derives from the conventions for describing the exterior beauties of the beloved. The same face appears, almost in a reversal of Verrocchio's cartoon, in an abstract, allegorical context in Botticelli's remarkably Verrocchio-like *Fortitude* in the Uffizi (fig. 29), in which is established the same norm that appears in the even more idealized face of Venus in the *Primavera*. For, even as Simonetta is dead and her beauty a shining image created out of the past as it is preserved in the heart and in the memory, so too are Lucrezia's beauty and youth also dead, things of the past, an ideal created out of a retrospective fiction. Moreover, just as Lucrezia's fictional role in Lorenzo's poetry is that of the younger (because more ancient), perfected idea of love that comes after Simonetta (who represents Lorenzo's first, passionate love for Lucrezia), so Venus, the fullness and maturity of the spring that is announced by youthful Flora, is simultaneously and by definition necessarily younger, the purest embodiment of the season's perfect youth.

Youth (*iuventas*), as noted above, is one of the *notationes* of Venus, together with

[66] It should be emphasized, however, that the imagery of the Baudreuil tapestry may in no sense be understood as literally duplicating that of Giuliano's standard; for the most thorough recent discussion, with complete bibliography, see S. Settis, "Citarea 'su una impresa di bronconi,' " *Journal of the Warburg and Courtauld Institutes*, XXXIV, 1971, pp. 135–177.

the spring and such defining qualities as love (*amor*), natural beauty (*pulchritudo*), grace (*gratia*), happiness (*laetitia*), blossoming abundance (*viriditas*), and liberality, all of which define the fullness of her *venustas*. As the figure of the poet's lady becomes subsumed within the figure of Venus herself (as Beatrice had been subsumed within the perfect figure of Christian beatitude), so her individual beauty, perfected in the eyes and understanding of the lover, merges with the ideally perfect beauty of Venus, becoming indistinguishable from it. What is more, the qualities and attributes of Venus are activated by her person and presence. The poet's lady has the power to soften and calm the wintry sky, to make the air serene, and to cause the flowers of spring to rise up beneath her step. Love's flaming arrow is loosed from her shining eyes, and she creates around her the garden of paradise that she inhabits always. Springtime is itself an effect of her beauty and the love activated by it, its character-istic setting and attributes being metaphors or allegories of the perfect love she rep-resents. "All the gifts and powers of the Graces are in her beauty," wrote Lorenzo in the *Comento*, and since the natural home of the Graces is in Venus's garden, he writes of his lady's smile that it is there that "the Graces have their dwelling place, which is above all gracious and gentle."[67] Venus is the metaphor and the portrait of the poet's lady, and the *notationes* of her perfect beauty are those of the lady, in whose person Venus is empowered and made active. Such beauty is beyond the capacities of literary *descriptio*, and even beyond the literally descriptive power of painting, for this is itself only a metaphor. Even painting can only represent the attributes and effects of per-fect beauty at second hand. The true image of such beauty is a composite ideal cre-ated by love and carried uniquely in the lover's heart.

Of such a perfect portrait Lorenzo wrote the following in the *Comento*:

> One must, then, presume that the picture with which my heart was adorned was most worthy; because three things, in my judgment, come together in a perfect work of painting, namely, a good support (whether it be a wall, a wood panel, a piece of cloth, or whatever else may be) upon which the picture is laid out; a master perfect both in drawing and in color; and beyond this, that the things painted be in their nature welcome and pleasing to the eyes: because, even if the picture be perfect, that which is painted could be of a quality that would not be in accord with the nature of the person who must see it. For there are some who delight in cheerful things, like animals, greenery, dances, and similar festival entertainments; others would prefer to see battles, both on land and sea, and similar martial and fierce things; and others landscapes, and buildings both foreshortened and proportioned by perspective: and so, wishing the picture to be entirely pleasing, it is necessary to add here this part: that the thing painted also give delight in itself.[68]

[67] Lorenzo de'Medici, *Comento*, ed. cit., p. 410: "Quel riso, dico, ove le Grazie hanno fatto loro abita- colo, che è sopra tutti gli altri grazioso e gentile." [68] Ibid, p. 395.

Again, literalist art–historical interpreters have taken these words at their apparent face value (ignoring, however, that the picture to which Lorenzo refers is one painted on his heart by love). They have been found "significant in that they differ so much from what has often been deduced, or speculated to be his interest . . . in Neoplatonic and other symbolically complex imagery."[69] It has been maintained instead that Lorenzo (even though the *Comento* was specifically written to explicate the Neoplatonic and symbolically complex imagery of his sonnets) merely intended to enumerate humbler artistic criteria of the sort ordinarily found stipulated in artists' contracts. As Creighton Gilbert put it in his extremely useful collection and translation of fifteenth-century documents and sources for the history of art, Lorenzo seems in this passage to limit himself to naming the materials to be used, stipulating care in craftsmanship, and specifying generic subject matter of a sort "normal in 'industrial art' contexts of the time, such as *cassoni*," intarsia panels, and the like, "all intellectually humble and old-fashioned preferences, and all to the exclusion of choices familiar in the works of leading individual masters in Florence."[70] Again, on this same literal level we might simply recall Vasari's report of the pictures made by painters *non mica plebei* "in the rooms of the old Magnificent Lorenzo de'Medici," showing "the *giostre*, tournaments, hunts, festivals, and other spectacles performed in his times," and done, moreover, with marvelous art, judgment—and poetic invention.[71] But it is much more to the point to observe that Lorenzo is in this passage invoking the art of painting as a metaphor in order to characterize the *angelico viso* traced by the shiningly white finger of his lady on his heart. His heart must accordingly be of a substance worthy to receive such an inexpressibly beautiful image, a gentle heart that has been primed and purified of all its hardness and *viltà*.[72] What is more, because of its natural conformity with his lady's particular gentility and virtue, Lorenzo's heart swells with special delight in receiving the imprint of a subject so precious as his lady's portrait. "My heart," he writes,

> was matter and support specially primed to receive any impression, and never was there so gentle and learned a hand as that of my lady for the making of such a picture, nor could anything more welcome be expressed

[69] C. E. Gilbert, *Italian Art, 1400–1500: Sources and Documents*, Englewood Cliffs, N.J., 1980, p. 128.

[70] Ibid.

[71] G. Vasari, *Le vite de' più eccellenti pittori, scultori ed architetti moderni*, ed. cit., II, pp. 148f. (The passage is quoted above, chapter 3.)

[72] Lorenzo de'Medici, *Comento*, ed. cit., p. 394: "Trae del cuore ogni durezza e viltà, le quali remosse, si fa gentile, cioè diventa subito atto a ricevere ogni degna forma e gentile impressione. Seguita di questo che, subito che il cuore è diventato materia gentile, tanto può stare senza la forma gentile, quanto può la materia senza forma. E perchè lo amore congiugne la

materia e la forma, cioè un naturale desiderio che ha l'uno dell'altro, così Amore, che mosse quella mano a fare gentile il mio cuore, fa ancora che di nuovo si muove a darli tanta gentile impressione. E, trovando il mio cuore sanza durezza, cioè mollificato ed atto a ricevere ogni impressione, comincia col dito a scrivere in lui il nome della donna mia, quel nome, dico, al quale Amore consecrò il mio cuore. . . . Dipinge ancora quel candido dito l'apparenza del viso della donna mia, e quelle perturbazioni e passioni che a gentile donna si convengono, come è qualche modesta letizia e qualche dolce perturbazione."

than the sweetest accidents both of my lady's face and name; and therefore
so perfect was this picture to the judgment of my heart that it desired to
keep it within itself and so conserve it forever.[73]

[73] Ibid., p. 395: "Era il mio cuore materia e subietto
molto atto a ricevere ogni impressione; mai non fu
mano tanto gentile e dotta a tale pittura, quanto quella
della donna mia, né più grate cose potevano essere es-
presse nel mio cuore che i dolcissimi accidenti ed il viso
ed il nome della donna mia. E però quanto al giudizio
del mio cuore era tanto perfetta questa pittura, che de-
siderava si perservassi e che eternamente così in esso si
conservassi."

Arthur Field has pointed out to me that Lorenzo's
language in this passage is Scholastic. He speaks of *ma-*
teria (= Latin *materia*) and *subietto* (= *subjectum*) as
things that have forms, or accidents, impressed on
them. His use of *atto* (= *aptus*) is also Scholastic, and
though my translation of it as "primed" is perhaps too
eloquent, nevertheless it follows from my rendering of
subietto as "support" rather than "subject," which
clearly is Lorenzo's meaning in the passage immedi-
ately preceding (p. 394, quoted in the text above),
where he refers to "il subietto buono, o muro, o legno,
o panno, o altro che sia."

READING THE POEM

WHEN I began my investigation with the classical *materia* that provides the foundation for the poetic invention of the *Primavera*, I stressed that Botticelli did not illustrate a particular Latin or Greek text. The ancient sources brought together in the conception of the painting were assembled in order to make fully manifest the unimaginable beauty and power of the immeasurably old, yet eternally youthful, nature goddess that Venus once was for the primitive peoples. As Venus Physica, the goddess Natura herself and author of life's generation from the shining moment of that first great spring of the world, the Venus of the *Primavera* (attended by the inseminating wind gods and the fecund earth nymphs beneath whose pulsing feet the flowers rise up) concretely represents an idea of love that is raised to an eternal principle of life in the universe. As Venus she is love by definition, and by definition love is the theme of Botticelli's portrait of her. She is the animating spirit as well as the tangible embodiment of the *renovatio mundi* (*Le tems revient*), a concept as ancient as the idea of love she represents is new. In her very antiquity, derived from a truly assimilated engagement with the materials and forms of classical fable, she also personifies a second *renovatio*, a renovation of the concept of love, as well as of the poet, the poet's lady, and the poet's audience.

Such a *renovatio* in the idea of love had its own historical precedent, with the most profound consequences for the poetry of Dante, which he made explicit in the *Vita nuova* in his contrast of Cavalcanti's *donna*, Giovanna, with his lady, Beatrice. In the same way, based openly on the model of the *Vita nuova*, Lorenzo de'Medici had signaled his own *renovatio* in the idea of love by contrasting the youthful, courtly, and erotic idea figured in Simonetta with the more abstract and Neoplatonic idea embodied in his newly conceived *donna*, the renewed and altered Lucrezia Donati. Similarly, notwithstanding (and indeed resulting from) Botticelli's casting of the classical invention for the *Primavera* within the conventions and interpretive traditions of vernacular love poetry, because of his complete assimilation of the classic within the vernacular, it becomes clear that the Venus he painted also represents a *renovatio* in the idea of love. She certainly does not represent the idea of Christian love, or charity, that Dante imagined in Beatrice, nor is she the more purely poetic idea represented in Laura by Petrarch, nor yet is this truly classical, pagan goddess

merely a return to the sensual, courtly idea of love celebrated by the troubadours. She is instead the generative force of nature itself, the incarnate manifestation of a new and forever antique idea of love that encompasses the whole of life in the world, the openly expressed essence of a vital energy celebrating sensual and terrestrial existence in an entirely positive manner, with no recantation attached.[1]

Moreover, her existence is contemporary, not retrospective, fundamentally because the language of the poetry she represents and speaks is Tuscan, but also because she presides over a garden filled with the Hesperidean orange trees that are a well-known Medici device, and that were identified with their *palle*. Furthermore, she makes her appearance in a fashionable, gold-embroidered, pearl-decorated fifteenth-century Florentine party and festival costume that combines elements of the new with older, traditional Tuscan festival dress, a costume of the sort described by Braccio Martelli, that had made Alessandra Macinghi Strozzi marvel at its expense, and that had later provoked Savonarola's rebuke to the young women of the city for ornamenting themselves in a way "che paiono ninfe." In this sense, although the fullness of Venus's beauty as set forth in the *Primavera* finds philosophical justification as well as perfected expression in the language and poetic forms of the ancients, the painting also (like the poetry of Pulci's *Da poi che 'l Lauro*, Politian's *Stanze*, or Lorenzo's *Canzoniere* and *Comento*) is, as Francastel recognized, in its own contemporary terms the material manifestation of an *allégorie réelle* that is every bit as concrete as those expressed in Courbet's *Atelier* or Manet's *Bar aux Folies Bergère*.[2] It is a painting that at one and the same time is "about" itself as a work of art that renews antique beauty within the forms of renewed vernacular expression, which thereby attain a higher perfection, and is "about" cultural and social reality, a present that renews itself in the peaceful forms of ritual and song, and seeks perfection as a work of art.

The new idea of love that finds its initial pictorial representation in the *Primavera* is given its material expression within vernacular and even popular conventions that would have been automatically accessible to Botticelli's contemporaries and to his audience. Venus and the idea she embodies do not appear as straightforward or unmediated revivals of the classical past, for Botticelli made no attempt to duplicate the classic forms or antiquarian detail of genuinely ancient art. But neither do she and her companions appear merely as adventitious citations from Latin literary culture artificially grafted onto the forms and conventions of contemporary expression. They are not conceived in the spirit, for example, of International Style paintings with ancient themes (from which the more domestic idiom of *cassone* paintings gen-

[1] Recantation is a topos, indeed a tradition within the tradition of courtly love, and it derives from the conflict between the love of woman and the love of God. It is highly significant that in the *Primavera* there is no turning away from the world, but instead an unabashed and total embrace of the principle of life as represented by Venus. The theme of recantation is extensively treated in C. S. Lewis, *The Allegory of Love*, Oxford, 1968. See also C. Singleton, *An Essay on the Vita Nuova*, Baltimore and London, 1977, esp. pp. 63ff.

[2] P. Francastel, "Un mythe poétique et social du Quattrocento: La Primavera," in *Oeuvres II: La réalité figurative: Éléments structurels de sociologie de l'art*, Paris, 1965, pp. 253–266, esp. p. 261.

erally derives), or Pulci's unassimilated Latinisms in *Da poi che 'l Lauro* ("sponsalitii fulcri" from *fulcrum* and "flammata" from *flammeum*), or merely as the elementary classical definitions Pulci painstakingly collected in his *Vocabolista* ("Venere: figliuola di Giove, et dicono la Ciprigna, genere di istiuma di mare et idea degli amanti, et chiamasi Ciprigna perchè fu reina in Cipri, et Citarea perchè soleva andare ispesso a caccia al monte Citaron [*sic*]").[3] She appears in her true classical persona, and at the same time she is completely absorbed within a living tradition. She is a living presence conceived neither as a "revived" classical statue made flesh, nor yet as an adventitious or pseudolearned classical citation. Her Latinity is as genuine as that of Politian in the *Stanze*, and her native style is as purified and elevated as is his Tuscan. Her Tuscan presence securely locates her as an erotic concept within the endlessly repeated ritual of love rehearsed in the poetry of the troubadours and the poets of the *stil novo*.

Furthermore, the invention of the *Primavera* finds its place in a specific sequence of works of art, both public and private, each of which expresses its own, particular response to the same, shared theme. This common theme turns broadly on an idea of love that is expressed freshly in the work of each individual artist, whether painter or poet, and it treats of a concept that derives its energy from real experiences and events, and that also evolves and matures through a definable period of time. It is a theme that finds its unity and pertinence in these common experiences, in the shared civic aspirations and rituals of contemporary Florence, as well as in the person of Lorenzo de'Medici. It was Lorenzo who made of the new idea of love an image of living culture deeply rooted in the traditions of the city, an image ideal but also personal to everyone, an image adaptable to changing experiences and thus capable of expressing an evolving understanding of the unpredictable and often brutal contingencies that govern mortal life. This image made its earliest appearance around 1465 in the poems Lorenzo devoted to the first idea of love figured in Lucrezia Donati, and though originating as the fictionalization of a purely private passion, by being cast in a dialogue with traditional poetic forms and concepts of love it was also from

[3] For an excellent general discussion of Luigi Pulci's poetic style and language, see D. De Robertis's chapter, "L'età laurenziana" in the Garzanti *Storia della letteratura italiana*, ed. E. Cecchi and N. Sapegno, Milan, 1966, III (*Il Quattrocento e Ariosto*), esp. pp. 461ff.; for a more particular study of Luigi Pulci and ancient mythology, see S. Carrai, "L'inedito repertorio mitologico di Luigi," in *Le muse dei Pulci: Studi su Luca e Luigi Pulci*, Naples, 1985, pp. 35–52, from which the above quotation is taken. A useful analogy in painting may be found in the works of Apollonio di Giovanni, especially in his miniatures for the Riccardiana *Virgil* and his *cassone* panels decorated with scenes from Homer, Virgil, and Roman history, in all of which ancient stories are presented in a chivalric vernacular style ornamented with classical details, the effect of which is more exotic than truly classical; see E. Callman, *Apol-lonio di Giovanni*, Oxford, 1974. Similar earlier examples may be found in the work of the Paris Master, for which see H. Wohl, *The Paintings of Domenico Veneziano, ca. 1410–1461*, New York and London, 1980, plates 184–188 (and see plate 196 for a beautiful *Rape of Helen* imagined as a chivalric romance by a close follower of Fra Angelico); Domenico Veneziano's own tondo of the *Adoration of the Magi* in Berlin, though treating a Biblical theme, excellently exemplifies this manner. So too (in a later manifestation) do those Florentine fine-manner engravings attributed to Baccio Baldini, many of which (according to Vasari) were done after Botticelli's drawings; the difference in style separating the more domestic Baldini from Botticelli is analogous to that distinguishing Pulci's *La giostra* from Politian's *Stanze per la giostra*.

its beginning the expression of a public idea. It was evolved and transformed in Lorenzo's own poetry, it was shared from the start with the members of his *brigata*, and it was set forth in the many sonnets and canzoni sung at dances and parties (such as the one described by Braccio Martelli) and after the hunt, sung to the accompaniment of a lutenist or *compare della viola*. It was adapted in the vernacular poetry of Luca Pulci and Luigi Pulci, as well as in the Latin poetry of Naldo Naldi and Ugolino Verino, and it was given its widest public expression in the poetry, music, and masquerades created for the great annual feast celebrations, for noble weddings, and in the devices invented for the *giostre* of Lorenzo and his brother Giuliano.

It was, in other words, a theme identified with the myth of Florence itself (called *il gentil fior* by Lorenzo), a myth that was actively being transformed into a Laurentian myth.[4] To treat the theme of love in poetry or art was inevitably to invoke this myth, and to contextualize it in ritual and in the present. Venus is the goddess of peace and serenity, and it was only with the signing of a treaty of peace among the powers of Italy that Lorenzo had been permitted by his father to keep his promise of three years before to dedicate a *giostra* to Lucrezia Donati. In so doing he was repeating a chivalric rite and civic ritual older than Villani, who wrote of a festival held in 1283 that "essendo la città di Firenze in felice e buono stato di riposo, e tranquillo e pacifico stato," a *compagnia e brigata* of youths all dressed in white pledged themselves to "un signore detto dell'Amore."[5] The theme of love is enacted in the rituals of the city, which per se endow the first experience of love with the sacredness of a rite that is forever renewed (*Le tems revient*) in opportune times and places. So too had Dante first fallen in love with Beatrice during the Calendimaggio celebrations of 1274.[6] For Lorenzo the death of Simonetta Cattaneo was a public sorrow that provoked all the Florentine *ingegni*, "as though brought together by some public calamity, variously to lament, some in verses and some in prose, the bitterness of her death"; for him the new idea of love that followed her death (*questa nuova vita*, he writes) arose when "a public festival was held in our city, in which many men and almost all the noble and beautiful youths flocked together." It was then, according to the revised poetic autobiography of the *Comento*, that he first beheld Lucrezia Donati.[7]

Lorenzo's account of this meeting and the circumstances that led up to it is a poetic fiction. In his earlier poetry the ideal of love (and art) that is celebrated can be identified in part with a popular language and with a chivalric ideal already deeply

[4] Lorenzo de'Medici, *Ambra (descriptio hiemis)*, ed. R. Bessi, Florence, 1986, octave 12: "Quel monte che s'oppone a Cauro fero, / che non molesti il gentil fior."

[5] *Cronica di Giovanni Villani a miglior lezione ridotta coll'aiuto de' testi a penna*, Florence, 1823, II, p. 281 (VII.89: "Come nella città di Firenze si fece una nobile corte e festa, vestiti tutti di robe bianche").

[6] The year and moment in the season, as is well known, are deducible from Dante's precise indications in the *Vita nuova*, II. Boccaccio's biography of Dante specifies that the meeting took place during the Calendimaggio celebrations. See *Il comento di Giovanni*

Boccaccio sopra La Commedia con le annotazioni di A. M. Salvini; preceduto dalla Vita di Dante Alighieri scritta dal medesimo per cura di Gaetano Milanesi, Florence, 1895, I, pp. 10f. See also G. L. Passerini, *La vita di Dante (1265–1321)*, Florence, 1929, p. 61, and C. A. Dinsmore, *Life of Dante Alighieri*, Boston and New York, 1919, p. 101.

[7] *Comento del Magnifico Lorenzo de'Medici sopra alcuni de' suoi sonetti*, in Lorenzo de'Medici, *Opere*, ed. L. Cavalli, Naples, 1969, pp. 331–478; for the quotations given above, see pp. 350 and 360.

rooted in Florentine traditions and culture (of which his own and Giuliano's *giostre* are direct manifestations). But after 1473 his conception deepens under the influence of Ficino (even as his language is purified under the influence of Politian), and the theme of love taken up in his youth then first finds its full maturity in the lustrum from about 1476 to 1481, in which three great works of art were virtually simultaneously conceived, though only one of them was completed: Botticelli's *Primavera*, Politian's *Stanze per la giostra*, and Lorenzo's *Comento*. The three works have in common a highly purified concept of style, which in each case derives from a vernacular foundation that has been elevated and poised by the acquisition and absorption of a true Latinity—especially in the case of Politian. The three works also have in common a point of departure that is expressed in the figure of a recently dead woman, Simonetta Cattaneo, who, as I have shown, owes her poetic existence to Lorenzo's postmortem invention of her as his own first love, figuring the idea of love that had in fact first been figured in Lucrezia Donati, and so identifying Simonetta with an ideal, youthful love that is forever in the past. All three express a new and altered idea of love (for Lorenzo an idea refigured in Lucrezia Donati) that is consequent on Simonetta's death. And all three locate their themes of love within the rituals and festivals of the city, thus specifically identifying them with the aspirations and fortunes of Florence. The parallels are thus quite strict, and the association of the *Primavera* with the *Stanze*, initially demonstrated by Warburg, and with the *Comento*, extensively set forth by Francastel, is essential to a full understanding of Botticelli's imagery and the context in which it is to be interpreted.

The *Primavera*, then, is a painting the classical invention of which is expressed in the conventions of the vernacular *canzone d'amore*, but it is important to remember that Botticelli no more illustrated a single vernacular text than he did a classical one. The *Primavera* is the unique figuration of an independent poetic and artistic imagination. Neither Lorenzo's *Comento* nor Politian's *Stanze* provide interpreters of Botticelli's imagery with what Panofsky hypothesized as a necessary "basic text" for reading the picture. Rather, all three—as individual works of art—express their own poetic ideas and interpretations of common experiences and events shared by each artist and his audience. In the same way Politian (in 1485) and Lorenzo (probably in 1491) were later to develop quite different poetic ideas, and even mythological histories, for the figure of the nymph Ambra, who was the genius loci or tutelary spirit of Poggio a Caiano, a place well known to both and to which each dedicated a poem, and who was at the same time the vehicle for representing sentiments about the place that were quite particular to each.[8]

As an independent invention, the *Primavera* no more duplicates an idea or particular conception motivating some other poem than Lorenzo's own poetic idea of

[8] See C. Dempsey, "Lorenzo de'Medici's *Ambra*," in *Renaissance Studies in Honor of Craig Hugh Smyth*, ed. A. Morrogh, P. Morselli, F. Superbi Gioffredi, and E. Borsook, Florence, 1985, II, pp. 177–189. For the poems, see A. Poliziano, *Ambra*, in *Le selve e la strega: Prolusioni nello Studio fiorentino (1485–1492)*, ed. I. Del Lungo, Florence, 1925, pp. 67ff., and Lorenzo de'Medici, *Ambra (descriptio hiemis)*, ed. cit.

Simonetta explains the role she plays in Politian's *Stanze*. In the *Primavera*, Simonetta appears retrospectively idealized as Flora, the Hour of spring who is the first-to-come, and as such she perfectly summarizes Lorenzo's youthful springtime motto, *Le tems revient*, promising a renewal that will become even more glorious in the fullness of Venus's perfected youth, love, and beauty. In Lorenzo's sonnets she is imagined as the brightest star in the night sky, soon to be eclipsed by the yet brighter sun, and she stands for a less perfect conception of love that in dying must necessarily generate and be eclipsed by a love that is perfect, since the beginning of such love is death to other things. In the *Stanze* she appears in a much darker and (in my opinion) even menacing guise, as a cold and unstable Fortune tempting Giuliano in a false dream of glory (*al fallace sonno*) that ends in his destruction, bringing with it the corresponding end to the ideal figured in Simonetta.[9] Despite their differences (and it is clear that the *Primavera* and Lorenzo's *Comento* express conceptions that are more parallel to each other than to the *Stanze*), in all three works of art Simonetta stands for a dead ideal of youth, however beautiful. In this sense I believe she may be understood as a figure summarizing in herself the actual death of Giuliano, who had dedicated his *giostra* to her and who had been murdered on 26 April 1478, the second anniversary of her death.[10] She stands for Lorenzo's first idea of love, replacing Lucrezia in this role; so too the chivalric ideal of Lorenzo's youth forever ended with the murder of Giuliano, who had enacted the role of the young Lorenzo in his *giostra* of 1475, and who had dedicated his chivalry to the idea represented in Simonetta. Be that as it may, whether she is viewed as a figure who carries within herself the promise of a return of lost youth and happiness, or as a less perfect idea of love that in dying generates a fuller and more complete understanding of love, or as an ideal that was false from the beginning, Simonetta still represents a common experience and concept, the meaning of which is variously recalled, understood, and expressed in the individual creations of different artists.

We have seen that the assembling from various ancient sources of the *materia* for Botticelli's invention was disciplined and unified by the generic laws and decorum of the mythopoetic imagination, and insofar as the analogies that have for so long been perceived among the *Primavera*, the *Stanze*, and Lorenzo's sonnets and commentary to them have not been misconceived, the same laws and conventions apply to the vernacular expression of that invention. The *Comento* and its foundations in Dante and Ficino provide an indispensable guide to understanding, not *what* literally is rep-

[9] See Politian, *Stanze*, II.30. In the context of the poem the translation "false sleep" makes no sense, and hence the standard Italian dictionaries all cite precisely this passage as exemplary of the rare meaning of "sogno." So do the standard editions of the poem (see, e.g., A. Poliziano, *Poesie italiane*, ed. S. Orlando, Milan, 1976, p. 98, in which the phrase "fallace sonno" is glossed as "sogno ingannatore"). See also G. Ghinassi, *Il volgare letterario nel Quattrocento e le Stanze del*

Poliziano, Florence, 1957, p. 168. "Sonno" in the sense of "sogno" was also used by Lorenzo de'Medici, *Comento*, ed. cit., p. 411: "E se pure questo fussi impossibile, almeno non sieno questi sonni vani e bugiardi, come quelli che passano per la porta eburnea."

[10] For the date of Simonetta Cattaneo's death, see A. Rochon, *La jeunesse de Laurent de Médicis (1449–1478)*, Paris, 1963, p. 246.

resented in the *Primavera*, but *how* we are to read the images that make up its unique allegory. However, in turning to Lorenzo's commentary, supplemented by the *Stanze*, as a guide to the conventions and decorum for reading Botticelli's poem and its allegory, we enter a land closed to the literalist interpreter, for neither the *Comento* nor the *Stanze* in any sense provides what Wind hypothesized as a necessary "programme" for the *Primavera*. They do, however, provide an indispensable guide to understanding how the painting functions as metaphor, not only insofar as it represents an allegory of love but also, and far more important, insofar as the beauties of its conception and execution as a work of art are themselves the highest allegory and expression of an idea of love that is beautiful beyond human imagining.

The *Comento* and its sonnets are structured around a series of metaphorical approximations that are marshaled in order to extol an idea of beauty that is literally beyond description, or even, as Lorenzo writes, the powers of the imagination. Though his lady—the poet's lady—is real, she is also a metaphor created by the thoughts of love that are clustered around her. In Dante's words as quoted by Lorenzo, "e bello è tanto quanto lei somiglia"—beauty itself is great only so far as it resembles her.[11] Accordingly, the painting of her image on his heart means much more than the simple recording of her portrait, and entails the imagination and direct representation of all the amorous thoughts that taken together create the idea that is the true image of the beloved—which is also the image of love. As Lorenzo writes, "my thoughts, contained in my heart, virtually of necessity contemplated my lady, incised upon the heart by Love, and there they saw her most beautiful and gentle, *as she was in fact*; and then, with the eyes of my thoughts I delighted in my heart that was truly beautiful, my beautiful lady being incised upon it, and my imagination was so strong that, imagining within myself, I then felt the same pleasure *as if my eyes had seen the real thing*."[12] The image of the lady is of course not the real thing. It is an image of love painted by Love, created by the thoughts of the lover on the basis of "the accidents both of my lady's face and name." It is an image of perfect beauty, which in the *Primavera* is denoted and described as Venus, who is by definition the sum total of all the metaphors of a perfected love with which the poet (or painter) expresses his thoughts and feelings as a work of art, creating an ideal portrait of his lady's goodness so powerful that it will endure in the heart forever.

The lover's heart having been thus made gentle, purged of its initial coarseness and hardness by virtue of his lady's hand, and Love's (for they are the same thing) having prepared it to receive the lineaments of her name and likeness, Lorenzo then desires that its hardness return in newly tempered and purified form, and that "the eyes of my lady might have that strength and virtue one reads the face of Medusa once possessed, and that, just as her aspect changed men to stone, so the eyes of my lady might convert my heart, thus painted and thus beautiful, into a hard diamond."[13] Accordingly he wrote the following sonnet:

[11] Lorenzo de'Medici, *Comento*, ed. cit., p. 388; see also Dante, *Convivio*, canzone II.50.

[12] Lorenzo de'Medici, *Comento*, ed. cit., pp. 455f.; italics added.

[13] Ibid., p. 396.

Quanta invidia ti porto, o cor beato,
che quella man vezzosa or mulce or stringe,
tal ch'ogni vil durezza da te spinge;
e poi che sì gentil sei diventato,

talora il nome, a cui t'ha consecrato
Amore, il bianco dito in te dipinge,
or l'angelico viso informa e finge
or lieto o dolcemente perturbato.

Or li amorosi e vaghi suoi pensieri
ad uno ad un la bella man descrive,
or le dolci parole accorte e sante.

O mio bel core, oramai più che speri?
Sol ch'abbin forza quelle luci dive
di trasformarti in rigido adamante.[14]

(How much envy I bear you, oh blessed heart, which that gracious hand now soothes and now presses, so that all vile hardness is driven from you; and after you have been made thus gentle, the white finger sometimes paints in you the name to which Love has consecrated you, and sometimes forms the angelic face, feigning it sometimes happy, and sometimes sweetly perturbed. And now the beautiful hand describes the amorous and lovely thoughts, one by one, and then the sweet words, wise and holy. Oh, my beautiful heart, for what more could you hope? Only that those godlike lights [her eyes] might have the power to transform you into rigid diamond.)

The portrayal of such beauty, eternalized in the diamond of the heart, is necessarily beyond the power of poetic or painterly description, the particular beauty of the beloved having been subsumed within the broader, but very personal, ideal of love she represents. She has thereby been transformed into the particular muse (whether bearing the accidental name of Beatrice, Laura or Lucrezia) with which she has been identified. Petrarch's two famous sonnets on Simone Martini's portrait of Laura provide the vernacular locus classicus comparing the descriptive capacities and limitations of poetry and painting in portraying the beloved, and the theme was also taken up by Lorenzo in his *Sonetto fatto a piè d'una tavoletta dove era ritratta una donna* and later developed by Pietro Bembo in his two sonnets on Giovanni Bellini's portrait of his own beloved.[15] As noted above, Elizabeth Cropper has shown how the paradoxical problems of representing the beauties, not of a particular woman per se, but of the beloved, derive from the ancient rhetorical traditions of *descriptio persona-*

[14] Ibid., p. 392.

[15] Petrarch, *Canzoniere*, LXXVII, LXXVIII (in *Opere*, ed. M. Martelli, Florence, 1975); Lorenzo de'Medici,

Canzoniere, ed. P. Orvieto, Milan, 1984, XXXIX; and P. Bembo, *Rime*, 19, 20 (in *Prose della volgar lingua, Gli Asolani, Rime*, ed. C. Dionisotti, Turin, 1966).

rum taken together with the *paragone* of the poetic and painted portrait.[16] Discussion of them finds a point of departure in Lucian's famous dialogue, the *Essay in Portraiture*, which is often cited by Renaissance philosophers of love, but they are problems that reached the Renaissance (when the text of Lucian was recovered) already transformed by the conventions of lyric poetry and courtly love. At bottom they call into question the respective abilities of either the painter or the poet to describe or represent, not so much the outer lineaments of the beloved's beauty (*effictio*) on the one hand, or the beauty of her inner character (*notatio*) on the other, but the very idea of beauty itself, the idea of love permanently carried in the image of the beloved inscribed on the lover's heart. Leonardo da Vinci put the question succinctly when he wrote with astounding audacity, and naturally in defense of his own art, "What poet with words will put before you, O lover, *the true effigy of your idea* with such truth as will the painter? Who is it that will show you the sites of rivers, woods, valleys, and fields wherein are represented your bygone pleasures with more truth than the painter?"[17] In a more modest and more traditional vein, Lorenzo de'Medici observed at the beginning of his *Comento* (in an interesting variation on Bembo's later claim that to write poetry it is necessary first to have loved)[18] that since description of his own beloved was beyond his powers he was forced to fall back on the testimony of Love alone. He adds that this is something not to be believed by hard and discourteous hearts, but is available only to those whose hearts have acquired the gentility only Love can bestow:

> It was very difficult for me either to imagine or to tell of that which appeared to my eyes; because her beauties, as Dante says, exceed our frail intellect "come raggio di sole in fraile viso." And therefore I left to Love what was impossible for me, since he, always being with her and dwelling, as we have said, within her eyes, was better able to know and express absolutely such excellence. What is more, as I was claiming that her beauty, loveliness, gentility, and compassion were things impossible either to tell of or to imagine, and such a thing appearing to the reader marvelous and all but impossible, it seems especially suitable to produce an authentic witness in faith of this; and no one is a better witness than Love, most of all for

[16] E. Cropper, "The Beauty of Woman: Problems in the Rhetoric of Renaissance Portraiture," in *Rewriting the Renaissance: The Discourses of Sexual Difference in Early Modern Europe*, ed. M. W. Ferguson, M. Quilligan, and N. Vickers, Chicago and London, 1986, pp. 175–190.

[17] *Lionardo da Vinci: Das Buch von der Malerei nach dem Codex Vaticanus (Urbinas) 1270* (Quellenschriften für Kunstgeschichte und Kunsttechnik des Mittelalters und der Renaissance, xv), ed. H. Ludwig, Osnabrück, 1970 (originally published 1822), I, p. 28, no. 18 (italics added). ("Qual poeta con parole ti mettera innanzi, o amante, la vera effigie della tua idea con tanta verità, qual farà il pittore? qual fia quello, che ti dimostrera

siti de'fiumi, boschi, valli e campagne, dove si rappresenti li tuoi passati piaceri con più verità del pittore?") For a discussion of the debate, see I. A. Richter, *Paragone: A Comparison of the Arts by Leonardo da Vinci*, London, 1949.

[18] Bembo, *Gli Asolani*, ed. cit., pp. 335f. It is significant that it is with *Gli Asolani*, probably written between 1497 and 1502 and in part inspired by Bembo's acquaintance as a young man with Politian, that (as Dionisotti discusses in his introduction to the edition cited) the next step is taken in bringing together the vernacular and the classical humanist conceptions of love, beauty, and linguistic expression.

having been present, and he merits credence too at least from those who are his subjects—who, as we have said in the proem, must needs be elevated and gentle spirits, for whom it suffices to have faith in suchlike amorous miracles. And if these are not credited by those who are outside this number, it is not a good thing that coarse, discourteous hearts, rebels against Love, should taste of such gentility.[19]

In the discussion of the descriptive conventions of *effictio* and *notatio* in vernacular love poetry, I referred to the dominant role played by *descriptio*, not simply as a means of adornment, but as the very essence of invention. I also mentioned the prime importance of two descriptive species in generating lyric invention, *descriptio personarum* and *descriptio temporis*, both of which the *Primavera* exemplifies. *Descriptio*, which had become with Geoffrey of Vinsauf and Matthew of Vendôme the "supreme object" of vernacular love poetry, is the Latin equivalent of the Greek rhetorical term *ekphrasis*.[20] Its particular rhetorical and poetic virtue derives from its ability to place an image so clearly before the mind and eye that it becomes permanently impressed on the heart and memory. The most vivid *descriptio* of all, at least so far as the *extrinsecae* are concerned, is that given by a painting, which has the special power to be able to place literally before the eyes images that words can only describe at second hand. But the true reason for the dominance of *descriptio*, which painting most supremely realizes, is that it not only sets forth the external circumstances but also provides the metaphorical structure for expressing and understanding the poet's love. Strictly speaking, the *Primavera* is itself a metaphor for the true idea of love carried in the heart. It is an encompassing metaphor made up of the descriptive parts that compose the whole, which function as a series of subordinate metaphors sanctioned by long tradition and repetition, and which reinforce the power of the painted image to lodge itself in the memory. As Bembo was later to observe, those who have been raised in the retreats of the muses cannot fail to recall them when later playing the games of Venus, so that when themselves writing of their perpetually new love, the *amorosa pintura* they paint is even lovelier in the eyes of the beholder for recalling the older fictions. "Who does not know how to say his tears are rain and the wind his sighs," he writes, "and who does not immediately know how to make his beloved into an archer, pretending her eyes strike wounds with the keenest arrows?"[21]

Thus the cycle of love enacted in the *Primavera* begins with the harsh and stormy advent of Zephyr on the right, which quite legitimately may be taken as a metaphor

[19] Lorenzo de'Medici, *Comento*, ed. cit., p. 367.

[20] *Ekphrasis* does not mean, as it is so often taken to do in art-historical writing, first and foremost the description of a work of art, nor is it really to be understood as a Renaissance form of art criticism. It is a rhetorical means of persuasion, and indeed a means of setting before the eyes and making present the reality that lies behind the actual experience of the thing described. It is therefore a means of interpretation, and in the dominance given *descriptio* in the vernacular po-

etic traditions I have been discussing it becomes (as noted above) integral to the invention of the work of art itself, and hence points the way to an understanding of the conventions necessary for comprehension of it. See, for a useful and clear-headed recent discussion of the problem in an art-historical context, L. James and R. Webb, " 'To Understand Ultimate Things and Enter Secret Places': Ekphrasis and Art in Byzantium," *Art History*, XIV, 1991, pp. 1–17.

[21] Bembo, *Gli Asolani*, ed. cit., II.8, pp. 395f.

for the violent passions, uncertainties, and tears of the first onslaught of love, which are then resolved when Mercury softens and disperses the sighing winds and few remaining clouds. Springtime itself is a metaphor—as Politian wrote of Simonetta, wherever she turns her serene eyes, in which Love hides his torch, the weather becomes serene: "l'aier d'intorno si fa tutto ameno."[22] Where there is the beloved there too is Venus, and where there is Venus there also is the spring and the first day of the world. When love blossoms in the heart springtime is there, whatever the actual time of day or season of the year. Claudian provides the locus classicus describing Venus's eternally vernal garden,[23] but it is more appropriate to quote from Politian's redescription of it:

> Né mai le chiome del giardino eterno
> tenera brina o fresca neve imbianca;
> ivi non osa entrar ghiacciato verno,
> non vento o l'erbe o li arbuscelli stanca;
> ivi non volgon gli anni il lor quaderno,
> ma lieta Primavera mai non manca,
> ch'e suoi crin biondi e crespi all'aura spiega,
> e mille fiori in ghirlandetta lega.[24]

(Cold snow or tender frost never whitens the locks of the eternal garden; icy winter dares not enter there, nor does a wind ever wear against its bushes or grass; here the years do not turn over their calendar, but joyful Spring is never absent: she unfolds her blonde and curling hair to the breeze and ties a thousand flowers in a garland.)

The season too is created by the presence of the beloved, and it was with this in mind that Lorenzo conceived a sonnet that more than once has been connected with the *Primavera*, most effectively by Francastel. In the *Comento* Lorenzo states that the sonnet was written in the month of April, when it was the custom for men to withdraw with their families to villas in the country, because "the year is as much more beautiful in this season as first youth is more beautiful than all the other seasons of man."[25] Lucrezia Donati had accordingly retired to her own *dilettevole villa*, and Lorenzo was urged by a friend to join her there. He surprisingly declined, replying that his desire to see her "neither increases nor can diminish in any season," and adding that "even if the whole world be more beautiful and ornamented in this season than any other, the place inhabited by her must needs have been more beautiful than elsewhere, since wherever she is requires neither sun, nor the new season, nor any other power to make the earth germinate and put forth flowers, or the trees fill out with leaves, the

[22] Politian, *Stanze*, I.44.

[23] Claudian, *Epithalamium de nuptiis Honorii Augusti*, lines 49ff. (See especially 52–55: "hunc neque candentes audent vestire pruinae, / hunc venti pulsare timent, hunc laedere nimbi. / luxuriae Venerique vacat. pars acrior anni / exulat; aeterni patet indulgentia veris.")

[24] Politian, *Stanze*, I.72. I have followed David Quint's translation in his edition, *The Stanze of Angelo Poliziano*, Amherst, 1979.

[25] Lorenzo de'Medici, *Comento*, ed. cit., p. 448.

birds to sing, and all the other effects associated with the springtime."[26] The sonnet he composed to express this thought begins thus:

> Ove madonna volge gli occhi belli,
> senz'altro sol questa novella Flora
> fa germinar la terra e mandar fora
> mille vari color di fior novelli.[27]

(Wherever my lady turns her beautiful eyes, with no other sun does this new Flora cause the earth to germinate and to put forth the thousand various colors of the new flowers.)

The same metaphor was employed by Politian when he described the serene air created by the warmth of Simonetta's eyes, and the flowers rising up beneath her step:

> Poi con occhi più lieti e più ridenti,
> tal che 'l ciel tutto asserenò d'intorno,
> mosse sovra l'erbetta e passi lenti
> con atto d'amorosa grazia adorno.
> Feciono e boschi allor dolci lamenti
> e gli augelletti a pianger cominciorno;
> ma l'erba verde sotto i dolci passi
> bianca, gialla, vermiglia e azzurra fassi.[28]

(Then with happier laughing eyes, such that the sky grew serene around her, she slowly moved her steps over the grass, an action adorned with amorous grace. Then the woods made sweet lament, the birds began to weep; but the green grass beneath her sweet steps flowered white, yellow, red, and blue.)

The setting for the *Primavera* is hence highly miraculous, a garden of love of which Venus is mistress, the attributes and fecundity of which directly express the amorous potency of the beloved.[29] From this we can begin to understand the force of Leonardo's address to the lover, quoted above, asserting the power of painting to place before him his idea of love by representing its bygone pleasures as the amenities of rivers, glades, valleys, and open fields. Botticelli's painting is miraculous on a literal level because the garden is filled with the gods who generate all the flowers of the complete season rather than only the particular blossoms of a late or early moment in it; but it is miraculous especially as an image of the paradise created by the presence of the beloved, of whom it is both the creation and the portrayal. The metaphor is indeed one of the most familiar of all topoi in the tradition of love poetry.

[26] Ibid.
[27] Ibid., p. 447.
[28] Politian, *Stanze*, I.55.
[29] P. F. Watson, *The Garden of Love in Tuscan Art of*

the Early Renaissance, Philadelphia, 1979, ends his study with the acute suggestion that the imagery of Botticelli's *Primavera* might well be considered in relation to the tradition of the Garden of Love.

When, for example, Guido Guinizelli wrote his famous poem beginning with the abbreviated *blason*, "Io voglio del ver la mia donna laudare / ed assembrarli la rosa e lo giglio," he condensed in the colors of his lady's cheeks the general image of the *locus amoenus*, making of her a synecdoche for the garden of paradise.[30] It is this garden that is unlocked when the poet's lady smiles upon her lover, and as such it was invoked by Petrarch ("E 'l lampeggiar de l'angelico riso, / Che solean fare in terra un paradiso"), reinvoked by Pulci (as noted) when telling how Lucrezia Donati placed a wreath of violets on Lorenzo's brow with a smile in which "si potea vedere un paradiso"; and invoked yet again by Politian in describing Simonetta turning toward Giuliano with a smile so sweet and lovely that "ben parve s'aprisse un paradiso."[31] So it is that Lorenzo writes in the eighteenth sonnet of the *Comento* the line, "Ben guardo ove la terra è più fiorita," and explains that in his desire to see the eyes of his lady he kept returning to the place he had last seen her; he found that "wherever her feet had trod, the earth had put forth flowers, her feet having acquired such power and grace from the air that had been penetrated by her eye and face."[32] Earlier he had recalled the day and the place where he first saw her, writing that "with regard to the time, there is no doubt that it was day, made so at least by the sun of her eyes."[33] The power of the light emanating from his lady's eyes is a governing metaphor of the sonnets, deriving from the *senhal* already noted of Lucrezia Donati as light and as the sun. The amorous heat of her sparkling eyes alone causes the earth to put forth flowers, so that, writes Lorenzo, "given that this was so, the place of necessity was paradise."[34] He concludes:

> Because "paradise," for whomever wishes to define it correctly, means nothing other than an exceedingly agreeable garden, teeming with everything that is delightful, trees, fruits, flowers, living and running waters, birdsong, and in effect all the amenities of which the heart can think. One can verify by this that it was Paradise wherever a lady so beautiful was, because there was the fullness of every amenity and sweetness that the gentle heart can desire.[35]

Even at their most vivid, the images so deliberately gathered together and so lovingly described and redeployed in the *Primavera* must remain only weak approximations of a beauty that is beyond description or even the capacities of the imagination. The spring and its flowers, the garden of paradise, the sun, and *ekphrasis* (which is nothing other than the work of art) are all metaphors for the true picture painted in the heart by Love, whose dwelling place is in the eyes, whence he looses the burning arrow that inflames the heart. The image is a familiar topos of poetry in

[30] This observation was also made by Watson in the context of pictorial representations of the Garden of Love, ibid., p. 75.

[31] Petrarch, *Canzoniere*, CCXCII; Luigi Pulci, *La giostra*, IX; Politian, *Stanze*, I.50.

[32] Lorenzo de'Medici, *Comento*, ed. cit., pp. 403f.

[33] Ibid., p. 367.

[34] Ibid., pp. 367f.: "E, dato che questo fussi, il luogo di necessità era paradiso, perchè dove era tanto splendore, bellezza e pietà, certamente si può dire paradiso."

[35] Ibid., p. 368.

the *stil novo*, and one often repeated in later poetry (as seen in Bembo's invoking the image as a cliché). Politian, for example, employs it in the *Stanze* in a passage imagining Love in an attitude (as has often been pointed out) strikingly similar to that of Botticelli's Cupid in the *Primavera* (plate 7):

> Tosto Cupido entro a' begli occhi ascoso,
> al nervo adatta del suo stral la cocca,
> poi tira quel col braccio poderoso,
> tal che raggiugne e l'una e l'altra cocca;
> la man sinistra con l'oro focoso,
> la destra poppa colla corda tocca:
> né pria per l'aer ronzando esce 'l quadrello,
> che Iulio drento al cor sentito ha quello.[36]

(Quickly, Cupid, hidden in those beautiful eyes, adjusts the notch of his arrow to his bowstring, then he draws back with his powerful arm so that the two ends of the bow meet; his left hand is touched by the point of fiery gold, his right breast by the string: the arrow does not begin to hiss through the air before Julio has felt it inside his heart.)

Though the lineaments of Botticelli's figure of Love derive formally from ancient relief sculpture, his action and specific attributes—namely the flaming arrow he shoots and the blindfold he wears—entirely depend on the conventions of vernacular lyric.[37] Much ink has been spilled over the question of where Love literally aims his dart, whether at the central or right-hand Grace in the painting, but the fact is we cannot be sure. The arrow is notched in the bowstring, which is only half pulled so that the *oro focoso* is still distant from Love's left hand, while the bow is still straight, its ends not yet arching toward each other with the heavy force of Love's arm. He is in the midst of his action, his hand turned toward the front of the picture, so that the arrow will be shot toward the foreground; indeed, when Love's action is completed and the bow is pulled to its fullest tension it would be easy to imagine the arrow being loosed in the direction of the viewer. But here we are again in danger of becoming mired in a literalist debate, for the truer question set by Botticelli's figure of Love has to do with his signification as metaphor. Love dwells in the eyes of the poet's lady, and the love-light darting from her eyes when their gazes meet carries

[36] Politian *Stanze*, I.40.

[37] I think Horne was right in observing of Botticelli's Cupid (*Alessandro Filipepi, Commonly Called Sandro Botticelli, Painter of Florence*, London, 1908, p. 57) that "in this figure alone is there any reminiscence of antique design in the picture: the attitude is to be traced to one of those flying 'putti' of the Roman sarcophagi." In so writing, he was tacitly rejecting Warburg's tentative association of Botticelli's Flora with an ancient statue of the same goddess known to have been in the Palazzo Pitti at least from the middle of the sixteenth century (see *La rinascita del paganesimo antico: Contributi alla storia della cultura*, ed. G. Bing, Florence, 1966, pp. 39f. and fig. 15). As Warburg wrote, there is an undeniable analogy in the treatment of the drapery, and this has convinced many of the rightness of the connection, but in my view the specific dissimilarities of costume as well as the non-antique conception and proportions of Botticelli's Flora vitiate the comparison.

the shaft that inflames his heart.[38] The significant (and signifying) directional indication painted by Botticelli therefore does not concern where Love's arrow happens to be pointed in midpull (plate 7), but toward whom the eyes of Venus gaze (plate 6), and this is clearly into the eyes of the viewer. Her gesture of welcome moreover signifies that she feels compassion (pietà) for him, and the flaming arrow of love follows in the split second after the eyes of the lover and the beloved meet.[39]

Put another way, Botticelli has represented the initial greeting and acknowledgment of the lover by the beloved, and by making Venus the giver of the salutation he has indicated that the love she acknowledges and returns is true. In painting Venus's salutation he has also irresistibly and pointedly recalled the most famous salutation in the history of Italian poetry, when Dante encountered Beatrice and "questa mirabile donna" turned her eyes toward his trembling figure and greeted him so miraculously that he seemed to see before him the full range of possible bliss: "[Ella] volse li occhi verso quella parte ov'io era molto pauroso, e per la sua ineffabile cortesia, la quale è oggi meritata nel grande secolo, mi salutoe molto virtuosamente, tanto che me parve allora vedere tutti li termini de la beatitudine."[40] Immediately afterward Dante sees the god of love in a dream vision, holding his sleeping lady in one hand and a flaming heart in the other, uttering the words "ego dominus tuus" and "vide cor tuum." Unlike the *Vita nuova*, however, in the *Primavera* the heart of the lover-beholder is not possessed by an idea of Christian *salute*, but belongs to a different idea, one invested in Venus.

The *stil nova* image of love hidden in the eyes of the beloved is also one of the controlling metaphors of Lorenzo's *Comento*, from the moment when Lucrezia makes her first appearance in the fifth sonnet as the sun whose light overpowers the bright star of the dead Simonetta, to its abrupt cessation just after the forty-first sonnet, when Lorenzo abandoned writing. He repeats at the end that "the seat of Love, and his true dwelling place, was in her most beautiful eyes," and thereby recapitulates his beginning, where Lorenzo had told of his first meeting with Lucrezia, who stood out "among the other women as one of the highest beauty to my eyes, of such sweet and attractive semblance that upon beholding her I started to say, 'Though she possesses that beauty, wit, and manner that we have told of in the woman who is dead, the beauty and loveliness and strength of her eyes is certainly much greater' "—so much so indeed that "in them was strongly verified what Dante says in one of his canzoni, speaking of the eyes of his lady, 'Ella vi reca Amor come a suo loco': 'She holds Love there as in his dwelling place.' "[41] The first onset of

[38] Lorenzo de' Medici, *Comento*, ed. cit., pp. 364f. and 426f. As noted above, the image is one of the most familiar topoi of poetry of the *stil novo*.

[39] An extremely witty, and disconcerting, variation on the theme appears in Guercino's famous *Venus, Mars, and Cupid* in the Pinacoteca Estense in Modena, in which both Venus and Cupid look straight into the eyes of the viewer, toward whom she points, and Cupid takes dead aim with his bow, fitted with an altogether too convincing steel-tipped arrow. The effect is

to create confusion and consternation in the beholder, since it is by no means clear whether the arrow belongs to Venus or to Mars, and hence whether the wound it will inflict brings life or death. For the painting, see L. Salerno, *I dipinti del Guercino*, Rome, 1988, p. 242, no. 151.

[40] Dante, *Vita nuova*, III.

[41] Lorenzo de'Medici, *Comento*, ed. cit., p. 361; see also Dante, *Convivio*, canzone II.58.

love—the moment shown by Botticelli—is provoked by the love-light flashing from the beloved's eyes when they first meet those of the lover. It is a precarious moment, for when the lover first feels love's fire he has as yet no means of knowing whether the passion he feels is truly reciprocated, and whether the lady whose glance has aroused such passion will take pity on him and return his love.[42] He must put his trust blindly in the love that has aroused him, for which reason Botticelli has shown Love blindfolded—a second indication that the moment shown is the beginning of love. Lorenzo expresses the same idea in the following sonnet, in which he tells how Lucrezia's glance inflamed him with love for her outer beauty, *quell'apparente bellezza*, and he was filled with an "incredible desire" to know whether those things that were not apparent to the eyes made her worthy of his love:

> Lasso a me! quand'io son là dove sia
> quell'angelico, altero e dolce volto,
> il freddo sangue intorno al core accolto
> lascia sanza color la faccia mia.
>
> Poi, mirando la sua, mi par sì pia,
> ch'io prendo ardire e torna il valor tolto:
> Amor, ne'raggi de' belli occhi involto,
> mostra al mio tristo cor la cieca via.
>
> E parlandoli allor dice: "Io ti giuro
> pel santo lume di quest'occhi belli,
> del mio stral forza e del mio regno onore,
>
> ch'io sarò sempre teco, e ti assicuro
> esser vera pietà che mostran quelli."
> Credeli, lasso! e da me fugge il core.[43]

(Woe is me! When I am there in the presence of that angelic, proud, and sweet face, the cold blood gathered round my heart leaves my face drained of color. Then, when I gaze at her own, it seems to me so compassionate that I take courage and my vanished valor returns: Love, entwined in the rays of her beautiful eyes, shows the blind path to my sad heart. And speaking from them he then says: "I swear to you by the holy light of these beautiful eyes, the strength of my arrow and the honor of my realm, that I will always be with you, and I assure you that the compassion shown by these eyes is real." I believe him, oh woe! And my heart flees from me.)

The *materia* for this sonnet Lorenzo explains as having arisen from the moment when "my heart was completely ignited and inflamed by the beauty and gentility of this my lady, and if any part remained in me that was not in accord with another, the reason for that was the misgiving I had that some harshness and lack of compassion

[42] Lorenzo de'Medici, *Comento*, ed. cit., pp. 364f. [43] Ibid., p. 363.

might be joined with such beauty and gentle manners."[44] For this reason fear seized his heart, and the blood drained from his face:

> But then, looking again upon her face, it seemed to me there were so many signs of compassion [*pietà*] that my heart put aside its fear and recovered some of its ardor. And with this the vital spirits returned to the place whence first they had fled, and with them returned the valor and color that had at first departed, and with much greater strength than before. Because, looking into her eyes, I saw Love entwined in the rays of those beautiful eyes, and these rays showed the path by which he had been able to flee from me into the eyes of my lady. This path one might call blind, because the heart did not then have any certainty save for the words of Love, and it then walked in uncertainty and self-doubt, so much the more so because Love, who was the guide on this journey, is also painted blind.[45]

We have now progressed no little way toward understanding how the metaphor of blindfolded Love shooting his flaming arrow functions in the *Primavera*. Lorenzo here speaks of the beginning of a journey, which as the *Comento* unfolds is shown really to be an ascent toward a purer and more spiritualized idea of the complete goodness of love. It is an idea developed in slow stages by the thoughts that gradually become concentrated around the image of the beloved, while the evolving experience of love slowly steeps the heart in a heightened understanding and bestows gentility on it.[46] These amorous thoughts are represented by the sonnets and given narrative order by Lorenzo's prose, and as they accumulate they gradually perfect the image of his lady and transform it into the image of love itself.[47] At the outset Love is painted blind, for at this point the heart of the lover has been struck through the eyes by the accidents only of his particular lady's physical beauty and bearing—*quell'-apparente bellezza*—and he cannot yet know whether she feels compassion for him, nor whether she is truly worthy of his love. For love to be able to grow the lover can only act on trust, pledging his faith; in this act of giving faith is the true meaning of the *detto antico*, "vuol fede Amore," with which Pulci wrote Lorenzo recorded his faith when Lucrezia Donati crowned him with violets and requested that he dedicate his tournament to her.[48] In return the beloved can only rely on the hope that the pledge of faith is true (for "dove fede nonne, Amor non puo"); this is the true meaning of the motto "SPERI" that Braccio Martelli wrote was embroidered on Lucrezia's dress, and which was summarized in the *impresa* of the sphere (*spero*) she is shown offering Lorenzo in the Otto print discussed earlier.[49] Faith, hope, and love combine

[44] Ibid., p. 364.

[45] Ibid., pp. 364f.

[46] For a discussion of Lorenzo's idea of gentility as developed in the *Comento*, see A. Lipari, *The Dolce Stil Novo according to Lorenzo de'Medici: A Study of His Poetic Principio as an Interpretation of the Italian Literature of the Pre-Renaissance Period, Based on His Comento*, New Haven, 1936.

[47] Lorenzo de'Medici, *Comento*, ed. cit., pp. 455f.

[48] Luigi Pulci, *La giostra*, XI (quoted above, chapter 3).

[49] See above, chapter 3; see also A. Warburg, "Delle 'Imprese amorose' nelle più antiche incisioni fiorentine," in *La rinascita del paganesimo antico: Contributi alla storia della cultura*, ed. cit., pp. 180–191.

conceptually to form an indissoluble bond in Lorenzo's philosophy of love, and of these three the greatest is love, which in the beginning inspires faith and hope and in the end justifies them. The image of love is permanently painted on the gentle heart that has been transformed into *rigido diamante*; in this is the meaning of the device of the diamond (*diamante*) with the three feathers colored white, green, and red, the same traditional colors Dante had assigned to the three theological virtues, faith, hope, and charity.[50]

In Lorenzo's *Comento* an understanding of love is opened to the reader by a narrative progression unfolded in the prose explication of the succeeding amorous thoughts—the sonnets—that taken together create the image and the idea of the beloved that in its wholeness is the portrait of love. In the *Primavera*, on the other hand, the amorous thoughts that taken together define the image and the idea of the beloved are each instantaneously present and manifest in the painting, as is proper to painting and as only painting can do. The painting in its wholeness is the portrait of love. Both the beginning and the end of the progress of love are represented, from the first opening of the heart to love to its final transfiguration into Love itself. In the beginning Love is painted blind, because the one struck by his arrow is aware only of the outer perfection of the particular beloved's beauty, which is the beginning of love. But he cannot yet know her heart, and her heart is the same as love, which her glance has awakened in him. Pledging faith is the necessary first step, since, writes Lorenzo, the happiness of lovers is made up of two properties that are in the beloved, "the first of which is outer and apparent beauty, and the second of which is love, *id est* the heart of the beloved."[51] Love strikes first through the senses (the flaming shaft shot from the eyes lodges in the heart of the beholder), and the heart *instantly* desires its own transformation into the heart of the beloved—into love itself. "For the eyes are the first to be moved," Lorenzo continues, "and the heart follows them because having approved her exterior beauty it directly follows, without any mediation, that the heart desires not only this beauty but also that of the heart of the beloved."[52]

All action in the *Primavera* commences with the gaze of the beholder, who is placed before Venus as a votary to her, and hence to the pure idea of love and beauty she represents. It is the fact of his presence (and there can be no doubt that the beholder is a man) that provokes her return gaze and her welcoming gesture, a salutation addressed to no one but him, which acknowledges him and denotes her compassion. She has taken pity (*pietà*) on him, and there can be no doubt that the image of love she offers is real. The gaze of the beholder meets her shining eyes, and in that precise moment, eternalized in art, Love draws the bow and strikes the heart *immediately* with the *oro focoso*, the flaming gold of his arrow. Although in Lorenzo's prose comment Love is painted blind because at this precarious moment the lover cannot know whether the love aroused by the exterior beauty of the beloved is real, nevertheless he simultaneously attests to its reality by representing it *as it truly was* in the

[50] It is wearing these three colors that Beatrice makes her initial appearance in the *Divine Comedy* (*Purgatorio*, xxx).

[51] Lorenzo de'Medici, *Comento*, ed. cit., p. 457.
[52] Ibid., p. 458.

157

sonnet accompanying the commentary. The sonnet expresses the amorous thought (which is the work of art) that even in its initial stages love works to transform the image of the beloved into the true portrait of her heart, which is the portrait of love itself. Similarly, in the work of art that is Botticelli's painting, though Cupid is blind, it is certain that the beholder's vision—*our* vision—of love, as set forth in all the amorous metaphors that make up the *apparente bellezza* that is the picture, is true from the start. Set before our eyes are not merely the accidental appearances of the beloved's beauty, but the image of love itself, Venus surrounded by all the manifold effects and attributes of her fecund grace, the fully perfected idea of love as it was in fact truly represented in the heart of the beloved even before this could have been known. It is the goddess who indicates compassion for the lover-beholder (and the truth of the beloved's *pietà*) by vouchsafing him her salutation and accepting his suit with a gesture welcoming him into the eternal garden that is the heart of the beloved, the heart of love itself. This garden is the same as his own heart, a paradise created and perpetually renewed by her flourishing step, her radiant smile, and the warmth of the light flashing from her eyes. The faith required of the lover, who is the be-holder, and the hope aroused in his heart by the light of love striking from the eyes of the beloved, are instantly ratified by the true image of love that the painting pre-sents to him, and of which the whole of the painting is itself the portrait.

The poetic myth reinvented and reembodied in the *Primavera* is a retrospective creation, and like Dante's myth of Beatrice in the *Vita nuova* (which so directly and profoundly inspired Lorenzo in the writing of the *Comento*) it renders an imaginative account of the significance of experiences that occurred in the past, the true meaning of which was not known at the time. Simonetta is dead, and in her death she takes the place of Lucrezia Donati as Lorenzo's first love and the muse of his early poetry. That first poetry and the love that inspired it are, like Lucrezia's own youth, and Lorenzo's, things of the past, and it is only with the passage of time that their mean-ing becomes clear. As for Dante the meaning of Beatrice as the beatitude of Christian love, or charity, was not known until after her death, so for Lorenzo the true meaning of the love of his own *verde età* could only be discovered in later years, after the confusing mists of youthful passion had long since been dispersed. But Lorenzo's experience of love had been real, and the first step in a journey toward a deeper and more complete understanding of love. Though he could not know it at the time, the true image of love was always permanently present in the evolving image he carried of his lady in his heart. His emerging awareness of her perfect goodness and beauty was developed over time as the amorous thoughts—the works of art that are his sonnets—slowly accumulated around and revealed the perfection of that image, showing it to be *what it had always truly been*, the idea of Love in all its perfection and potency.

This particular idea of love is the moving force behind the invention of the *Pri-mavera*, though the painting manifests a concept of perfection that is not developed through time. There is no accompanying prose commentary giving narrative order and explanation for the amorous thoughts gathered together in the *Primavera*, which

instead presents them as immediately and completely present in the whole of the painting. The painting is the sum total of all the amorous thoughts—the eternally vernal garden of paradise with its flowers and orange trees, the never-ending dance of Flora and the Graces, the perpetual loosing of Love's flaming arrow, the unceasing abundance of Venus in her plenitude—that gathered together in their fullness create the perfected and ideal portrait of love that is forever painted in every true lover's heart. But the *Primavera* is the copy of only one such portrait, which began as that of Lucrezia Donati (though not even at the outset as an unmediated record of the accidents of her particular beauty), the Laurentian prototype for Albiera, Simonetta, and a thousand Florentine *ninfe*. It was the portrait of her heart, of love itself, that had been transformed into the heart of her lover, of which it was especially the portrait, on the pure diamond surface of which was forever painted the image of an eternally youthful love (*Le tems revient*), an image only dimly copied by Botticelli in the *Primavera*.

It is important to repeat that Botticelli's *Primavera* is an independent artistic creation of great originality and subtlety, taking as its theme the humanist muse of the new Florentine culture dreamed of and shaped in manifold ways by Lorenzo and celebrated by him and the poets and artists he gathered around him. The painting deploys in its conception the characteristic images and devices of a Laurentian civic myth, being centered on a profound and deeply poetic exploration of the multiple origins and inclusive meaning of Lorenzo's own motto *Le tems revient*, and it also explicitly includes the Medicean *impresa* of the orange trees among its many ornaments. As a work of art it supremely exemplifies Lorenzo's ambition to attain a new level of civic and cultural perfection by bringing together, and in the process transforming, the two great past cultures of Italy, ancient and *trecento*, thereby fulfilling the dream of a true cultural *renovatio* by subsuming both into a greater unity for which there was no precedent.

At the same time, the particular meaning inherent in the poetic invention of Botticelli's *Primavera*, though it is deeply embedded in the new Laurentian myth of Florence, neither directly explains nor is itself explained by the particular invention and arguments put forward in Lorenzo's *Comento*. Both works of art draw on a stock of images and metaphors derived from the traditions of ancient and vernacular poetry, and both exhibit a heightened refinement of stylistic expression that bears the unmistakable stamp of a newly Latinized native Tuscan. Even so, the ideas of love represented are not identical. In the *Primavera* love is set forth in Venus, the true ancient goddess of life in the world, Venus Physica resplendent in all her primitive beauty and glory. In the *Comento*, on the other hand, love is not represented literally as Venus (however many of her attributes it may be seen to bear), but as itself, Amore, in which is expressed an idea of philosophical happiness and goodness, the summum bonum in fact, a state of perfection attainable here on earth. They hold in common, however, an idea of love that finds its true fulfillment in the life of the world.

In the same way, although Lorenzo's *Comento* makes extensive use of images

that naturally, like Botticelli's *Primavera*, draw on familiar Medici devices and amorous *imprese*, it cannot be read as a simple exposition of their meaning per se. The device of the diamond ring and feathers, for example, had been the *impresa* of Lorenzo's father Piero before it was adopted by Lorenzo as a youth, but the device is itself a cluster of metaphors for an idea of love that is not static but evolving.[53] The white, green, and red feathers in Piero's device were motivated by the conventional colors associated with the virtues of faith, hope, and charity, understood in the same, familiar sense in which Dante had also invoked them. The pledge of love these images signify as first adapted by Lorenzo in the 1460s, however, as expressed in his own early poems and in Pulci's *Giostra*, as well as in the Otto prints, links the concepts of faith, hope, and love (not charity) into a secularized troubadour's triad. Moreover, in the *Comento* these same concepts are further adapted to the particular purposes of a sustained philosophical and poetic argument, not a theological one. In this argument, the third of the theological virtues, charity, continues to be reconceived as love pure and simple. The new triad of faith, hope, and love thus expresses an entirely terrestrial poetic interrelationship that originates in sensual existence and in human passion, in life itself.

So it is that Lorenzo's sonnets are addressed to his *donna* as the expression of a perfect goodness and gentility attainable here on earth and revealed as the very essence of love and beauty. The *Primavera* is similarly addressed, not to an otherworldly Christian concept of love such as might be expressed in the personification of charity or in the Madonna, but to the worldly idea expressed in Venus and in the poet's *madonna*. This lady is none other than the figure proposed by Lorenzo to the *ingegni* of Florence for representation in art, whether as Albiera degli Albizzi, Simonetta Cattaneo, or Lucrezia Donati, whether in poetry, prose, or painting, and it is in her image that the young women of Florence transformed themselves. No matter for whom the *Primavera* may have been originally intended, it is Lorenzo's *donna* who is celebrated there. She is the figuration of the new concept of love and gentility, the new humanist muse created out of the traditions of the Latin and Italian pasts, transfiguring them in Venus, who is in her essence and by definition the perfection of love and beauty.

The concept of love given concrete representation in the *Primavera* and Lorenzo's sonnets, as well as exposition in the *Comento*, though deeply (and necessarily) rooted in the traditions of Rome and Tuscany, is at the same time a new one. For Dante the idea of charity represented by Beatrice had been in its own day a new idea of love that subsumed and transformed in the poetry of the *dolce stil novo* the older idea represented in the poetic muse of his first friend, Guido Cavalcanti. In Lorenzo's *Comento* it is a new idea of love that completes faith and hope, an idea expressed in a language that in its turn subsumes and transforms the language and conventions of the *stil novo*, as well as of Petrarch, and that as a concept directly derives from Ficino's

[53] For the diamond device, see F. Ames-Lewis, *The Library and Manuscripts of Piero di Cosimo de'Medici* (Garland Series of Outstanding Theses from the Cour- tauld Institute of Art), New York and London, 1984, pp. 63ff.

idea that the rational soul of man is possessed of the capacity to unite the finite with the infinite. In arguing the identity of philosophy with religion, Ficino had maintained that while it is religion that expresses the infinite that is actually present in the rational soul of man, the very ability of the rational soul to encompass the infinite carries with it the potential to make man divine in the sense that it is not God's charity alone that endows man with immortality, but also the ability of the human will to immortalize, and indeed deify, man by uniting temporal experience with a comprehension of the universal goodness of love.[54] From this conception there derived the idea that God for no other reason became man but that man "in some ways and in some times would become God." From this in turn there derived the concept, dear to the humanists, that through the attainments of ancient philosophy man had at one time in the past virtually achieved such perfection, a perfection that God, by choosing the days of Augustus to assume flesh, had acknowledged and blessed. The idea of love thus expressed in Ficino's philosophy accordingly conjoined and reconciled Christianity with the discoveries of the ancients. In the process of reconceiving the relationship of God and man, of Caritas and Amor, he had fused and in the process transformed both Christianity and antiquity in the melting pot of present-day experiences and thought.

It is in such an idea of love that the *Primavera* finds its true connection with Ficino's Neoplatonism, not insofar as Botticelli expressed it through a direct and literal-minded fusion of pagan Amor with Christian Caritas per se, but rather as he made concretely manifest in art the idea of a divine infinite that is within nature, represented as the true ancient Venus Physica whose mystery encompasses the pure and eternal strength and goodness of life. Botticelli's invention also bears a connection with the Neoplatonism expressed in Lorenzo's *Comento*. At the same time it parts company with the *Comento* in the very purity of its antique conception and the rigor with which, as I have shown, it is constructed as a true ancient fable. Love is none other than Venus, and its perfection is given definition by her *notationes* and by those of her companions, who are her attributes and love's adornments: *venustas, amor, pulchritudo, voluptas, laetitia, splendor, viriditas, florentia, juventas, liberalitas, gratia, suadela, humanitas*, and so on. The worldliness of the conception of love expressed by Botticelli in the goddess Venus, manifesting the divine in nature, sets his idea securely in the realm of Neoplatonism. The subsidiary terms that help define love in the *Primavera* also find their formal interrelationships variously argued, as Wind especially showed, within humanist and Neoplatonic dialectics of love. Botticelli's expression of this new idea in the *Primavera*, however, follows on the conventions and inventive decorum of a poetic tradition that, like Lorenzo's *Comento*, though profoundly rooted in philosophical speculation, makes manifest its ideas of love in metaphorical form, as works of art and not as formal demonstrations composed of definitions and dialectical modes of argumentation. As Lorenzo wrote of Ficino, the

[54] For Ficino's philosophy, see C. Trinkaus, *In Our Image and Likeness: Humanity and Divinity in Italian Humanist Thought*, London, 1970, II, part 3, chapter 9, and P. O. Kristeller, *Il pensiero filosofico di Marsilio Ficino*, Florence, 1988.

philosopher was as much the "amator sempre delle sante Muse" as he was filled with *vera sapienza*, never separating the one from the other.[55] Ficino, however, as a lover simultaneously of poetry and philosophy, understood the differences between enthymematic and syllogistic forms of representing an argument.

The *Primavera* is the portrait of love, the representation of a Laurentian and humanist dream in recollection and in a moment of recognition. This means not only the remembrance of youth and a time when the meaning of love could not be known, but also a discovery of love's meaning by reaching still further back into the past and the accumulated experiences of love eternalized in art. In this way love makes its amends for present sorrow and loss by placing them in history, and the new myth that love has created and contemplated in art is allowed to reveal its full meaning and its promise—*Le tems revient*. In Botticelli's painting we see love in all its majesty and beauty at the very moment of the inception of natural life in the first great spring of the world, we see it as it had been celebrated in the primitive pageants of the ancient country peoples, we see it as it had been re-created in the new tradition of poetry arising from the canzoni sung in village feasts consecrated to times of peace and prosperity, and we see it as manifested in the poetry and festivals of Lorenzo's youth. We see it as coeternal with the world, and as the principle of endlessly renewing life in the world, completely *antico* and perennially *nuovo*.

This new, humanist, Laurentian concept of love, eternally of the present and forever ancient, that is set forth all at once in the *Primavera* and only gradually developed in the sonnets and narrative sequence of Lorenzo's commentary to them, a concept whereby the finite experience represented in the figure of the beloved is transformed into a recognition and comprehension of the universal idea of love in all its infinite beauty, was not capable of finding full expression in the forms of art inherited by Botticelli. Nor was it expressible in the forms of poetry Lorenzo had adopted as models in his youth. As Singleton remarked of the idea of love that Dante had embodied in Beatrice, as a new concept it required a new style for its expression if style were to be at all true to its subject. The elements of the new poetry and painting that I have been tracing partake of antiquity, the Tuscan past, and the shared experiences of the Florentine present; taken together they combine in a mutually regenerative and transforming way to express an idea that is in the end indistinguishable from the work of art itself. These separate elements and their active interrelationship were especially clearly discerned by Francastel when he emphasized that both Botticelli's *Primavera* and Politian's *Stanze* not only and self-evidently exhibit highly purified concepts of style that evoke their twin origins in Latin antiquity and in the Tuscan fourteenth century, but also are remarkable for the precision of their imagery, for the representation of things actually seen and experienced.[56] In the intersection of style and the myth acted out in the festivals and jousts of Laurentian Florence, sung in its poems and recorded in its art, we encounter the reality that

[55] Lorenzo de'Medici, *Altercazione*, chapter II (quoted in chapter 4).

[56] P. Francastel, "La fête mythologique au Quattro-cento: Expression littéraire et visualisation plastique," in *Oeuvres II: La réalité figurative: Éléments structurels de sociologie et de l'art*, Paris, 1965, pp. 229–252.

provoked Savonarola not long after Lorenzo's death to cry out against the daughters of the city who attired themselves *che paiono ninfe*, and as such appeared as the new idols painted in the altarpieces of the churches. In Savonarola's denunciation one hears with particular vividness one answer, on a social as well as a cultural level, to the question asked at the outset: what is the myth, the true reality, expressed in the *Primavera*?

In beginning to answer that question more fully—and to end my investigation with a beginning—I must raise the question of style itself, style as the vehicle and concrete manifestation of the beauty revealed by the new concept of love. The lineaments of such beauty as portrayed by Botticelli in the *Primavera* are in the end indistinguishable from its theme, for the painting's own particular beauty is the final metaphor for the idea of love that is figured in Venus. In the same way that the poetic forms on which Botticelli's invention is based are rooted in history, Botticelli's stylistic foundations are set in pictorial forms and traditions that had been well established in paintings of the International Style, supremely exemplified in the work of Simone Martini, the painter of the idea of beauty Petrarch had figured in Laura. Simone's art can be seen as the highest expression of an Angevin courtly style, and in informing his idea of beauty he made a direct appeal to the normative, sequential, and essentially disconnected inventive conventions of *descriptio pulchritudinis* as these were employed by Petrarch and later imitated by Pulci, Lorenzo, and Politian. The differences between Petrarch and the Laurentian poets emerge especially clearly when one compares the uses each of them made of a common stock of conventions and tropes; it is similarly useful to compare Simone's and Botticelli's appeals to the conventions of *descriptio*.

In the *Primavera*, in obedience to the vernacular convention, each discrete element of the corporeal beauties of the individual women depicted is isolated and considered separately before being recombined within the whole—on occasion with apparently contradictory, but beautiful, results: the perfectly black, arching eyebrows of Flora, for example, shown together with the spun gold of her hair, and the seriousness of her eyes contrasting mysteriously with her softly laughing smile. Recent analysis of Botticelli's technique in rendering the flesh tones of his women, whereby semitransparent whites, cinnabars, and red lakes were laid over one another in such minute brush-strokes as to render the gradations all but invisible, has shown that he conceived their colors in accordance with the conventions of poetic metaphor. His infants and children are endowed with more intensely colored, ruddier complexions created by using cinnabar glazes and accents in red lake, while his men appear with darker flesh modeled from ochre glazed over a black wash underdrawing, establishing the more deeply shadowed male bone structure in such features as the eye cavities. By contrast, the faces of his women are exquisitely pale and porcelainlike, with the faintest of vermilion blushes in the areas of the cheeks, nose, and mouth, and they are conceived not only in conformity with but also as the embodiment of the familiar Petrarchan metaphorical conventions comparing the perfect face of the beloved's beauty to a privet tinged with roses. What originated as a poetic metaphor,

in other words, appears in Botticelli's hands as reality itself, but a reality transfigured into art. Especially interesting in this respect is his use (in a technique called *a conchiglia*) of finely powdered gold mixed with an adhesive and applied like any other color, which he often used, for example in the *Birth of Venus* and the *Madonna of the Magnificat*, though not in the *Primavera*, to represent highlights in the hair of his women, again rendering literal the Petrarchan likening of the poet's lady's tresses to spun gold (*crini d'oro*).[57] It is a part of Botticelli's meaning that the grounding of his conception in poetic convention is clear to the beholder, just as such grounding had also been a part of Boccaccio's meaning in describing the beauties of Emilia, and was part of Pulci's meaning in his *descriptio Anteae*.

Accordingly, Botticelli maintained the distinctiveness and integrity of each separate feature of the bodies he painted, a perfectly swelling arm tapering naturally into a flexed wrist, a head gently rotated on a slender neck, so that each part of the body, from the largest to the smallest, is displayed to its fullest advantage as a unit. Botticelli's art distinguishes itself from Simone's, however, by the natural perfection with which each part is articulated and presented to the viewer, and by the way in which the individual parts are unified in a whole that is enlivened by means of continuously flowing, elastic contours that endow each figure with a fluent energy and natural grace that betrays Botticelli's early absorption of the proportional principles of form and motion established in antiquity, and that were to find further development and expression in his painting the *Birth of Venus*. No observer of the *Primavera* has come away unimpressed by the rhythmic harmonies not only modulating the outlines of the figures but also regulating their actions—the violent encounter of Chloris and Zephyr is resolved in the dance of Flora, for example, who quicksteps forward in a lively *moresca* as she strews the path with flowers, while the three Graces step slowly in a measured *rondo* that draws the season toward its serene close. It is in the sense of harmonic coherence regulating the parts and the whole of the *Primavera*, arising from an appeal to an abstract concept of number palpable in the proportions and movements of the figures, and explicitly keyed in the dance of Flora and the Graces, that Botticelli's concept of a eurythmic stylistic beauty is distinguished from Simone Martini's and from anything that had come before. In this the conventions of the vernacular *descriptio pulchritudinis*, or *descrizione della bellezza*, were transformed into something new and elevated, as in the poetic numbers and diction employed by Politian in the *Stanze*, or by Lorenzo in such later poems as the *Ambra*, into a true *descriptio venustatis*.

In the *Primavera*, in other words, as in the poetry of Politian and Lorenzo, the vernacular style is for the first time raised by the acquisition of a true Latinity, and the idea of beauty there celebrated faithfully reflects the conviction and intention expressed by Lorenzo in the letter introducing the *Raccolta Aragona*. After centuries of neglect, he wrote, the deserted field of the Tuscan language had again been culti-

[57] For a detailed, comparative discussion of Botticelli's technique in the light of many recent restorations and technical investigations, see *L'Incoronazione della* *Vergine del Botticelli: Restauro e ricerche*, ed. M. Ciatti, Florence, 1990.

vated by the first Italian poets so that "in questi nostri secoli tutta di fioretti e d'erba è rivestita"; in this newly flourishing garden, he added, *questa toscana lingua* will never again be scorned as "poco ornata e copiosa" in comparison to the ancient tongues, but will be entirely their equal.[58] It is this garden of which Venus is the mistress, and in her decorated and copious beauty, embellished by the splendor, grace, and blossoming youth of her dancing companions, she perfectly expresses and completely manifests that *concinnitas* that Alberti had reconceived on the basis of the ancient rhetoricians as the final expression of beauty in art.[59]

One of the starting points for the conception of the Graces in the *Primavera* had been Alberti's recollection of Seneca's and Hesiod's description of them in the *De pictura*, and the same passage was later to inspire his painting of *Calumny*. Alberti employs the term *concinnitas* in the *De pictura*, but his fullest definition of it occurs in the *De architectura*, first published in 1485 with a dedication written by Politian to Lorenzo de'Medici, who closely followed the preparation of the book for publication, and whose own architectural interests were profoundly formed by his long friendship with Alberti.[60] The aesthetic foundation for the *De architectura*, as Paolo Portoghesi has elegantly characterized it, derives from a vivid interest in present experience, in nature understood as a unified living form regulated by abstract principles of number and harmony deduced by the ancients and applied by them in their arts. *Concinnitas*, or ἁρμονία, is a quality that arises from the elegant arrangement and joining of parts in a way that produces stylistic beauty, deriving from a fitting together of components that are dependent on outline, number, and placement so that there is revealed "a further quality in which beauty shines full face." *Concinnitas* is nothing less than the open manifestation in art of the absolute and fundamental law of nature, and it is adorned with every grace and splendor:

> Every body consists entirely of parts that are fixed and individual; if these are removed, enlarged, reduced, or transferred somewhere inappropriate, the very composition will be spoiled that gives the body its seemly appearance. From this we may conclude, without pursuing such questions any longer, that the three principal components of that whole theory into which we inquire are number [*numerus*], what we might call outline [*finitio*], and position [*collocatio*]. But arising from the composition and connection of these three is a further quality in which beauty shines full face: our term for

[58] Lorenzo de'Medici, *Opere*, ed. A. Simioni, Bari, 1913, p. 5.

[59] Alberti uses the term *concinnitas* in the *De pictura*, but his most extended definition of it occurs in the passage from the *De architectura* quoted below. Its meaning in antiquity is that of a cunning joining together of parts, and *concinnitas* finds its special application in the principles of Ciceronian rhetoric, where it is used to mean both elegance and beauty of style, especially deriving from the skillful interconnection of words and clauses. Of special relevance in this context are the arguments concerning the analogy between periodic sentence structure and pictorial composition put forward by M. Baxandall, *Giotto and the Orators: Humanist Observers of Painting in Italy and the Discovery of Pictorial Composition, 1350–1450*, Oxford, 1971. See also E. Panofsky, "The First Page of Giorgio Vasari's 'Libro,'" in *Meaning in the Visual Arts*, New York, 1955, pp. 169–225, esp. pp. 190f.

[60] See the introduction to L. B. Alberti, *On the Art of Building in Ten Books*, trans. J. Rykwert, N. Leach, and R. Tavernor, Cambridge, 1988.

this is *concinnitas*; which we say is nourished with every grace [*gratia*] and splendor [*decus*]. It is the task and aim of *concinnitas* to compose parts that are quite separate from each other by their nature, according to some precise rule, so that they correspond to one another in appearance. That is why when the mind is reached by way of sight or sound, or any other means, *concinnitas* is instantly recognized. It is our nature to desire the best, and to cling to it with pleasure. Neither in the whole body nor in its parts does *concinnitas* flourish so much as it does in Nature herself; thus I might call it the spouse of the soul and of reason. It has a vast range in which to exercise itself and bloom—it runs through man's entire life and government, it molds the whole of Nature. Everything that Nature produces is regulated by the law of *concinnitas*, and her chief concern is that whatever she produces should be absolutely perfect. Without *concinnitas* this could hardly be achieved, for the critical sympathy of the parts would be lost. So much for this. But if this be accepted, let us conclude as follows. Beauty is a form of sympathy and consonance of the parts within a body, according to definite number, outline, and position, as dictated by *concinnitas*, the absolute and fundamental rule in Nature.[61]

Such is the idea of love dreamed of by Lorenzo and celebrated in the poetry of the humanists he gathered around him. This love is the animating spirit of a true *renovatio mundi*, a renewal and renovation of life in the world—a renaissance in fact—and it is a *renovatio* made fully manifest in the perfected natural beauty of Botticelli's *Primavera*. It is an idea of love that appears there in the form of nature, as Venus Physica, who is accordingly figured in a perfected style founded in the living traditions of the Tuscan present. It is also a new idea of the present and of the possibilities and goodness of life here on earth (which is the same as love), one that has discovered and redefined its historical and artistic continuity with that more remote Latin past that first gave life and nourishment to the secular forms of Tuscan ritual and song. In Botticelli's painting of the new idea of love, as in the newly refined and more Latinate vernacular expression given it in Politian's *Stanze* and the later poetry of Lorenzo, we accordingly see the Florentine present invested with a heightened dignity and beauty in which we hear as much as see the faint but unmistakable rhythms of ancient number, disposed in a new harmony governed by that *concinnitas* that is regulated by and that is Venus, in whom *tota pulchritudinis facies mirifice collucescit*.

[61] L. B. Alberti, *L'Architettura (De re Aedificatoria)*, Latin text and translation edited by G. Orlandi, introduction and notes by P. Portoghesi (*Trattati di Architet-* *tura*, ed. R. Bonelli and P. Portoghesi), Milan, 1966, book IX.5, pp. 813ff. I have followed Rykwert's translation (op. cit.).

INDEX